The Perpetual Guest

D1598131

The Perpetual Guest
Art in the Unfinished Present

BARRY SCHWABSKY

VERSO

London • New York

First published by Verso 2016
© Barry Schwabsky 2016

The essays collected here originally appeared in the pages
of the *Nation* between 2006 and 2014

All rights reserved

The moral rights of the author have been asserted

1 3 5 7 9 10 8 6 4 2

Verso
UK: 6 Meard Street, London W1F 0EG
US: 20 Jay Street, Suite 1010, Brooklyn, NY 11201
versobooks.com

Verso is the imprint of New Left Books

ISBN-13: 978-1-78478-324-2
ISBN-13: 978-1-78478-323-5 (HB)
eISBN-13: 978-1-78478-325-9 (US)
eISBN-13: 978-1-78478-326-6 (UK)

British Library Cataloguing in Publication Data
A catalogue record for this book is available from the British Library

Library of Congress Cataloging-in-Publication Data

Names: Schwabsky, Barry, author.
Title: The perpetual guest : art in the unfinished present.
Description: New York : Verso, 2016. | "The essays collected here originally
appeared in the pages of the Nation between 2006 and 2014."
Identifiers: LCCN 2015042580| ISBN 9781784783235 (hardback) | ISBN
9781784783242 (paperback)
Subjects: LCSH: Art. | BISAC: PHILOSOPHY / Political.
Classification: LCC N7445.2 .S385 2016 | DDC 700—dc23
LC record available at http://lccn.loc.gov/2015042580

Typeset in Perpetua by Hewer Text UK Ltd, Edinburgh, Scotland
Printed in the US by Maple Press

For Davida and Willa and their unfinished future

Contents

III. Old Vagabond

IV. Unfinished Tradition

Introduction

Art was no part of my milieu when I was growing up, so neither was art criticism. I must have first heard tell of that profession in the movies. I have a vague recollection of a horror film about the enmity between an artist, who declares, "I live by my hand!" and a critic, whose motto is, "I live by my eye!" After the critic murders the artist, a pair of disembodied hands takes revenge by tearing out his eyes.

And yet I remember, too, the grade-school art teacher who showed us reproductions of Picasso and Matisse. When I made a crayon drawing of some downhill skiers—of course I'd never seen a ski slope any more than I'd met an art critic—she gave particular praise to my decision to show one of the skiers cut off by the bottom edge of the paper. She thought this was very sophisticated. I didn't understand what the big deal was. That was probably my first practical experience of art criticism. It gave me my first dim awareness that what someone sees in a picture is not necessarily just what its maker meant to put into it.

Many years later, I learned of Marcel Duchamp's view, usually paraphrased as "the viewer completes the work." It's a slogan I repeat regularly. More precisely, Duchamp proposed that "the creative act is not performed by the artist alone; the spectator brings the work in contact with the external world by deciphering and interpreting its inner qualification and thus adds his contribution to the creative act." I suspect he didn't know—as I didn't until after I was already familiar with Duchamp's dictum—that Walt Whitman had long before declared that "the reader is to do something for himself, must be on the alert, must himself or herself construct indeed the poem, argument, history, metaphysical essay—the text furnishing the hints, the clue, the start or frame-work. Not the book needs so much to be the complete thing, but the reader of the book does."

It was thus Duchamp who gave me a ready answer to an artist friend who once challenged me with the question, "Why do we need art critics?" After all, she continued, "Scientists don't need science critics. Why is art any

different?" And it's true, there are no science critics. Yes, scientists doing a peer review are in a sense acting as judges of their fellow scientists' work— but only in a sense: they are acting as fellow practitioners, not as critics. That's because science is not founded on this compact between maker and receiver. The art critic is a person who formalizes and deliberately exemplifies the role of the spectator who realizes the artist's work, not by leaving it just as it is, but by adding something to it, making a personal contribution.

If the art critic is, as I say, merely the self-appointed representative of the spectator who is ontologically essential to art's existence, then the validity of the critic's role ought to be assured. But that doesn't seem to be the case. It's not, as might have been true at times in the past, that the critic is too powerful, figuratively murdering with his evil eye the poor artist who's just trying to live by his hand. Instead, or so one gathers from all the articles and symposia on the crisis of art criticism, the critic seems to be losing all influence. The overheated, ever-expanding art market on the one hand and the explosive growth in the number of big international public exhibitions on the other has rendered the critic's aesthetic judgment of taste superflu-ous—that seems to be the idea. The critic no longer has the power to participate in forming a consensus of value. Somewhere above his or her head, the collectors and the curators are doing that. The critic can either tag along after or get left behind altogether.

There's some truth to this story of the critic superseded by collectors and curators. The roles and the motivations of collectors and curators are different, but they have this in common: they command material resources (private in one case, usually public in the other) that can help chosen artists to produce their work, to make a living, and to gain exposure and reputa-tion. Critics have only words at their disposal—literally so, more and more, as the transformation of publishing by the Internet has made it ever harder for writers and journalists of any description to earn a living. And in the neoliberal economy of recent decades, with its relentless upward redistri-bution of wealth, money talks louder than ever, drowning out other forms of discourse.

I have to admit that the art critic's loss of power doesn't worry me much. I don't see my job as mainly that of making or breaking artists' reputations, or of informing collectors or curators of what they ought to like and buy. I'm just as happy that they don't listen to me. I have other responsibilities toward art. The meaning of an artwork is finally independent of its price and of its exhibition history because it's made and remade by anyone prepared to formulate a contribution to the creative act already embodied in it.

If there were a real crisis for criticism, it would have to do instead with an inner transformation in the nature of art itself. What if it no longer requires a public, that is, someone like the active spectator of whom Duchamp spoke? Then there really would be a conundrum , for the critic would no longer have a position from which to grasp the artwork. It's not impossible, and it's not even a new idea. Back in 1966, for instance, Allan Kaprow was calling for "the elimination of the audience." In recent years, in great part as a result of their revulsion from the financialization and globalization of art, more and more artists have been taking this idea more seriously, wanting to work without an audience but only with participants, collaborators, communities. Nicolas Bourriaud, in his 1998 book *Relational Aesthetics*, quoted Félix Guattari's question, "How can you bring a classroom to life as though it were an artwork?" As it turns out, the question for many was more like: How can you turn an artwork into a classroom? Whether this would be worth doing is not the issue here; it's that to succeed in doing so—to eliminate the disinterested public—would also be to eliminate any role for the critic. A subjective response from a participant would lack the sense of spectatorial distance essential to criticism; and an objective account would not be criticism but reportage.

As for me, I'd like to think that I prefer Duchamp's model of the spectator who nonetheless, in and through his or her distance from the artist's creative act, makes an independent contribution to it—and I don't think the idea is original to Duchamp or even to Whitman; it was implicit in the practice of great critics like Diderot and Baudelaire—not simply because I like my job and want to keep it, but because I think this idea of the critical distance of the spectator is in itself worth preserving and developing. And my experience tells me that a great deal of art is still being made with this kind of viewer in mind.

That experience is the subject of this book. These essays were written between 2006 and 2014 for the *Nation*, and most of them are responses to particular exhibitions. Although the book's title, *The Perpetual Guest*, is taken from one of the few essays that does not take the form of an exhibition review, the phrase encapsulates something of my feeling about being an art critic, in two senses. First, there's a general sense of what it means to do art criticism in this strange time. If ours is really the age of a neoliberal art world dominated by market forces, and of biennials that are ostensibly immune to the vagaries of the art market but in fact are promoted as part of the global tourist industry, then the critic seems to be *in* the art world but not *of* it—a guest at the party who's there on sufferance, contributing much less to the art world's functioning than was once the case. Really, I

sometimes feel like the critic is welcome just because he's been on the scene for so long that, even if few can quite remember how he got there, it's more trouble than it's worth to eject him. Besides, his occasional malicious comments can be witty and entertaining.

In the second place, my sense of being a perpetual guest reflects my specific position as the art critic for a publication whose focus is on political and social issues. Bhaskar Sunkara, the editor and publisher of the lively new magazine *Jacobin*, recently told an interviewer,

> We generally try to avoid cultural content. To the extent we do cover culture, it's mass culture. So we'll run something about the latest *Planet of the Apes* movie or the latest *Superman* movie, covering mass culture in a way that's reminiscent of Michael Gold—my favorite Stalinist writer of the 1930s. Our cultural content is intentionally very directly political, very polemical. But we'd never cover an opera or a play, or avant-garde culture.

That's not the viewpoint at the *Nation*, but if I were editing a political magazine, I might do as Sunkara does, wanting (as he says) to "make sure there's a political take-away for people who aren't particularly interested in culture for its own sake." But this is exactly the opposite of what I try to do for the *Nation*. My rationalization for this? It possibly has something to do with what French artist Robert Filliou is supposed to have said: that art is what makes life more interesting than art. I agree, and would add that, by the same token, politics makes life more interesting than politics.

So, instead of trying to find a political angle from which to write about art, I let the critical distance between art and politics—between my writing and its context—display itself. The writing reflects, and sometimes reflects on, its not-quite-at-homeness. I work from within—within the particular artwork, within the history and conventions of art as a whole—to find the edges where art, as Duchamp said, "comes into contact with the external world."

Perhaps the profound connection between art and politics—as I suggest in the essay "Signs of Protest"—is in their being essentially unfinished and unfinishable. "The viewer completes the work" really means that the work is never complete because, as long as the work still has life in it, others are always going to be completing it differently, making their own contribution to its ideal future. There are those who plausibly maintain that in our second Gilded Age, in which art has become one more "asset class"

in a portfolio of investments, and a lifestyle ornament for the latest cohort of robber barons (now protagonists of finance rather than industry), the only conscionable position is a withdrawal of one's labor—to renounce art and the art world. But I'm not ready to give up on art. The obscure needs it fulfills, the imaginative doors it opens, are not entirely at the disposal of the object's owners.

"The best account of a picture," as Baudelaire said, "may well be a sonnet or an elegy." All the more so, it can be another picture. The viewers who do the most to complete the artist's work are other artists. I write about contemporary art in its relation to the art of the past because much of what artists do consists of a loving criticism of their precursors, although that's not always as obvious as it should be. "Painting reinvents time," as Stanley Whitney puts it in my essay on his and Jacqueline Humphries' abstraction.

Much of today's art is in appearance entirely unlike that of centuries past, or even of fifty years ago. Where art once meant pictures and statues, usually with edifying religious or mythological stories attached, now, after abstraction, the readymade, and conceptualism, it seems that art can be embodied by almost anything—or next to nothing. For some, the lesson would be that a clean break has been made, that art has reinvented itself from scratch and that criticism should do the same. This book exists to argue otherwise. Art as we see it today is an outcome of a cultural shift that's been a long time in the making, and slow to reveal all its implications. Around the middle of the nineteenth century—not accidentally, in the wake of the failed revolutions of 1848—various European artists, mostly French, began to believe that the self-proclaimed guardians and continuers of tradition were in fact its betrayers, its gravediggers. The tradition had to be rescued—and in the process, reinvented. Church and court, the institutions by which art had been sustained for centuries, were no longer relevant; art had been thrown upon the tender mercies of the market. How would it manage to thrive in this unfamiliar situation? One thing at least was clear: art could no longer address its public from a position of borrowed authority. Its only authority would be its own aesthetic validity, of which there could be no final judge. Art and its public—perhaps, now, its consumer—would have to meet on a plane of equality. And neither its subjects nor its forms could be specified (or excluded) in advance.

Although new institutions now claim to anchor art in a secure consensus—museums and schools of contemporary art—they have hardly attained the authority once enjoyed by church and court. And it's hard not to hear a different institution, the art market that has flourished so fearsomely in recent

decades, ventriloquizing behind their moving lips as they make their pronouncements. No more today than in Manet's time can aesthetic judgments be anything but contentious. And no more today than in Manet's time can we hope to understand the art of the present by forgetting, as Zola wrongly imagined, everything learned in the museum in order to somehow see things as they really are. Manet knew that, in order to represent the present, the art of the past could not be forgotten but would have to be reimagined. And it would have to be reimagined as not finished, not complete, and therefore not sealed away into the past—but rather as radically unfinished and for that very reason operative in the present. It's for this reason that a book whose fundamental concern is with contemporary art—or, better, with what art can be today—includes an essay on Manet, and begins with one on Manet's favorite painter, Velázquez, whom he reimagined as a contemporary of his own. It might be true that Duchamp changed everything and that we have to understand the philosophical status of the art object differently having come to know his work—but as I suggest in my essay, Duchamp's peregrinations around the idea of the object are not alien to those of the seventeenth-century painter. Those who see Duchamp—or Warhol, or whoever—as marking an absolute break with the art of the past represent the latest way of betraying the past, which (as Walter Benjamin wrote) has a secret agreement with the present: this betrayal does not try to freeze history in place by formulating its dictates as a set of rules, as the old academies did, but by imagining that it's possible to cut loose from the past—a misinterpretation of the modernist avant-gardes that would condemn us to a kind of historical provincialism, denying us any perspective on the present.

In my writings for the *Nation* over the past eight years I have tried to open up such perspectives without, I hope, belaboring them. Although each of these essays is a separate undertaking, the recurrent themes that thread their way through them and make of these writings a single project are probably only discernible when they are read together. But that's not to say that gathering them in one place ties all the threads together and knots them into a conclusion. These essays aim to keep art unfinished. One of the ways I have tried to keep the essays open-ended in gathering them here has been to avoid grouping them by categories—for instance, into a section of essays on abstract painting, another on photography, and so on. My groupings aim to bring out other threads, with section one, "Negative Theology," tracing ideas about the object and language; section two, "Faces out of the Crowd," emphasizing senses of the self; "Old Vagabond," the third section, drawing attention to the quintessentially modern experience of the contacts and

conflicts between the European art tradition and its "others"; and, finally, "Unfinished Tradition," putting the accent on the way art stays alive through its incompleteness.

This book could not have been unfinished in precisely the way it is without the help of many people. First among them are Adam Shatz, my first editor at the *Nation*, and his successor, John Palattella, who has been my editor during the period when most of these essays were written. Their help and encouragement have been immeasurable, and the same is true of Colin Beckett at Verso, without whom this would not exist as a book. Thank you, all. For an always venturesome, never-finished conversation about art and everything else, I am grateful to Carol Szymanski.

I

Negative Theology

(a sort of theology passed on by whispers dealing with matters discredited and obsolete)

—Walter Benjamin, to Gerhard Scholem, June 12, 1938

Negative Theology: Diego Velázquez

When the Italian Baroque artist Luca Giordano declared *Las Meninas* "the theology of painting" in 1692, he was paying an extravagant compliment, "by which he intended to convey," as Giordano's friend and Velázquez's biographer Antonio Palomino put it, "that just as theology is superior to all the other branches of knowledge, so is this picture the greatest example of painting." But just as a passage from Pierre Menard's *Don Quixote* is, according to Jorge Luis Borges, "almost infinitely richer" than the original by Cervantes, so this phrase becomes infinitely richer if we imagine it being pronounced by a later admirer, such as Édouard Manet, who certainly did consider Velázquez the greatest of all painters. A visit to the exhibition of the Spanish master's work at the National Gallery in London makes it very hard to disagree with Manet, even despite a big handicap: of necessity, the show lacks many of the artist's most celebrated works—including *Las Meninas*. Most remain home in Madrid, as the great portrait of Pope Innocent X does in Rome. Still, the Prado, along with other institutions and a few very fortunate private collections, has been generous with its loans, and since London already domiciles the largest concentration of Velázquez's works outside Spain, the National Gallery has been able to round up forty-six paintings, about a third of the surviving oeuvre, to give a powerful précis of this astonishing career.

What an artist like Manet rather than Giordano could have understood by "the theology of painting," the more profound force of this statement, emerges when one contemplates the obvious truth that in the seventeenth century, unlike the nineteenth, the primary subject matter of painting was indeed theology. Painted images had their highest import in the service of religion; they were devotional and didactic in purpose. But there's a great difference between the painting of theology and the theology of painting. Velázquez offers a glimpse of a strange and haunting idea, one that should have been nearly unthinkable in his own time—that painting could have what we might today call spiritual significance, not because of its exalted

subject matter but, somehow, in itself; that painting, through the intensity of its realization, could transmute its subject into something holy.

As odd as this fateful idea would have seemed to Velázquez's contemporaries (other than, perhaps, Rembrandt), as peculiar as it must have seemed even to him as he entertained it, it's not one that was ever likely to have had many adherents. Manet himself, worldly man that he was, would have been leery of putting it so bluntly. Today, when artists are not supposed to be religious, most painters would probably find it embarrassing. And yet the relentless urge in modern art to assume the most humble and abject aspects of human existence, the most trivial and insignificant objects, surely finds one of its roots here. Duchamp's readymades may amount to a kind of sophisticated joke about this idea, but it's a dead serious joke, all the more so for his radical insistence on choice—on being able to see something in a certain way—as a sufficient form of realization. In this sense, all the Duchampian postmodernists, no less than their modernist granddads, are children of Velázquez; that's why, although Duchamp's melancholy *aperçu* that art only stays art for fifty years before declining into art history is generally true, certain paintings by Velázquez strike us as powerfully contemporary.

The first of this exhibition's four rooms is devoted to Velázquez's early days in Seville, when he emerged from the informal academy of a prominent local artist who was richer in erudition than in talent, and who was soon to be his father-in-law. But Velázquez must have had more in mind than taking over the family business even as an eighteen-year-old earning his license, in 1617, as "master painter of religious images, and in oils and everything related." Awkward and disjointed as his first independent paintings can be (*Three Musicians*, a little like Picasso's similarly titled work three centuries later, might be a puzzle put together from unmatched pieces), they possess an eerie power. Caravaggism had swept through Europe, and while Velázquez probably never saw an original work by Caravaggio until years later, his followers' efforts would have been sufficient to suggest to the ambitious young painter that a way forward might pass through the Italian master's dramatic naturalism.

Although he was soon painting religious subjects and portraits as well, Velázquez first established himself as a specialist in what were called *bodegones*, scenes of everyday life set in kitchens or taverns, and in which still life elements were prominent. (Later on, the term came to refer specifically to still life, but Velázquez never painted a pure still life.) But these are not typical lowlife scenes, such as might be found in Dutch genre painting. There

is an uncanny gravity to them, as if there were something more in these people than they themselves might ever know. An old woman cooking eggs looks off into some unspecific distance as if receiving a prophecy. A massive old man selling drinks of water looks like a pope in rags. A maid bends over the crockery on a table looking at it as intently as if it were a supernatural apparition.

Later on, of course, Velázquez would paint popes and prophetesses, and he would see more in them, too, than they could ever know. In fact it's extraordinary how often the teenaged Velázquez reaches for effects whose true weight he would only be able to show forty years later, when he'd reached the height of his powers. If one misses *Las Meninas* here, it's not only in its own right as an étude in transcendental technique, to borrow Liszt's phrase, but as a fulfillment of what the painter was more crudely aiming at in his first experiments with scenes-within-the-scene, in *Kitchen Scene with Christ in the House of Martha and Mary* (1618), and *Kitchen Scene with Christ at Emmaus*, from around the same year. It may be true that, as Xavier Bray puts it in the exhibition catalog, "such pictures helped the faithful to integrate the world of work with that of the spirit." But in the absence of any obvious allegorical connection between the foreground kitchen scenes and the dreamily sketchy Biblical episodes in the distance, one feels rather that the paintings embody a reproach against an absence of integration between daily life and sacred history.

In 1623, thanks in part to his father-in-law's good connections among the Sevillians at the royal court in Madrid, Velázquez was appointed painter to Philip IV—a mediocre king but a remarkable connoisseur. Now the painter of *bodegones* became a full-time portraitist. Access to the royal collection gave him a new intimacy with sixteenth-century Venetian art, especially that of Titian. The paintings here from the early years in Madrid betray an uneasy experimentation with a variety of styles—a portrait of the count-duke of Olivares, 1624, if it really is by Velázquez, seems to look back to the Mannerism of the late sixteenth century, for instance—but two events helped solidify Velázquez's mastery. First, the arrival of Rubens in Madrid in 1628, not as a painter but as a diplomat; he snubbed the other Madrid court painters for the duffers they were, but spent much time with Velázquez, praising the "quality and simplicity" of his style. The Flemish painter's manner had little direct influence on that of his Spanish colleague, but his immense abilities, not to mention his standing as an intellectual and man of the world, opened new horizons. So did Velázquez's first trip to Italy a year later. Not only could he gain new insight into his beloved Venetians, but he could take

the measure of contemporaries like Poussin, Guercino, and his countryman Ribera, now established in Naples.

A pair of remarkable history paintings done in Rome around 1630 shows just how far the trip to Italy had taken him. While Velázquez had always been trying to use many different sorts of painterly effect in a single work, the results had always shown a certain disjointedness. In *Joseph's Bloody Coat Brought to Jacob* the transition from the play of light and the sculptural solidity of the figures on the left, three of the sons who've sold their brother into Egyptian slavery, to the shadowy half-tones that becloud the deceived father on the right is achieved with great suavity. And his employment of rhetorical gesture and facial expression throws down the gauntlet to his Roman colleagues, as if to say, "See how your technique shows feigned emotion more easily than the real thing." Such posturing had its uses, but would play little part in the Spaniard's mature work, which is emotionally restrained rather than demonstrative. And just to prove the point, what almost amounts to a companion piece, *Apollo at the Forge of Vulcan*, shows a dramatic moment of exposure rather than deception—the sun god is breaking the news that Vulcan's wife, Venus, has been dallying with Mars—but entirely without those conventional gestures that lend themselves to insincerity. In both paintings the naturalism Velázquez had practiced a decade before is still at work but now with a sort of classicism subtly subsumed. Part of the paintings' effectiveness lies in the ordinariness of the models; Vulcan and his helpers look like real workmen, though they lack the grime that Caravaggio might have included, yet as Dawson Carr remarks in the catalog, their bodies also reflect the artist's study of classical sculpture. Reality and the ideal, contingent and eternal fuse together as they could not do earlier on.

Velázquez returned to Madrid in 1631, and except for a second journey to Italy in 1649–51 remained at court the rest of his life, acquiring new privileges and responsibilities all the while—most notably, becoming the curator of Philip's ever-expanding art collection. Had he been a less canny courtier we might now possess more of his paintings. Much of the rest of the exhibition consists of portraits, both formal and informal. It's important to keep in mind that both sorts were part of the job—that the depiction of a court dwarf like Francisco Lezcano, 1638–40, which probably hung along with several similar works in the Torre de la Parada, a sort of royal hunting lodge, was as much of a duty as the celebration of the king himself, or of his young wife Queen Mariana of Austria, 1652, as a victim of extreme fashion. Envious competitors among the painters at court had made the specialization in portraiture a reproach; Velázquez, they whispered, only

knew how to paint heads. The implication was that his was a servile and literal-minded art able only to reproduce nature, not an exercise of the intellect. Or, as we would put it today, insufficiently conceptual. Velázquez is said to have replied: "They favor me greatly, for I do not know that there is anyone who can paint a head."

Now, the old biographies are full of conventional praise and recycled anecdotes—when Palomino, writing sixty years after the artist's death, reports that King Philip mistook one of those painted heads for a real courtier, saying, "What, are you still here?" we dismiss it as a cliché. But in the oblique and paradoxical remark, "I do not know that there is anyone who can paint a head," we hear a living voice, one imbued, moreover, with that "phlegmatic temperament" that the monarch himself came to rue in his favorite painter. All the more telling, then, that this voice suddenly emerging from the stately hum of the document is one we are tempted to call modern. Isn't it strange that, in the seventeenth century, we are already hearing of the impossibility of painting, the absurdity of our desire to represent, and precisely from one who had devoted his life to just that? With this remark we find ourselves approaching the world, still unthinkable to Velázquez and his colleagues, in which Cézanne would devote a hundred sittings to a portrait which no one would ever mistake for the person it represents; "If a head interests me, I make it too large," he is said to have apologized. Or the world in which Giacometti could muse, "If I could just do a head, one head, just once, then maybe I'd have a chance of doing the rest, a landscape, a still life. But it's impossible." And yet between the Spaniard's cool irony and the Modernists' anxiety lies a world of difference.

Contemporary artists who are far indeed from anything resembling the Modernism of Cézanne or Giacometti still feel that their undertaking is problematic or self-contradictory in this way. The American painter Carroll Dunham recently put it quite simply: "I'm only interested in painting that's aware of its own dilemma." For Velázquez, the dilemma was already there, but how many artists have even been able to derive so much concentrated energy from their dilemmas? If anything is missing from this exhibition, it's a sense of just how restlessly experimental Velázquez remained all his life. It's astonishing how many "exceptions" there are in this oeuvre—paintings of a sort one would never have expected. Among them is a glory of the National Gallery's own collection, *The Toilet of Venus* (1647–51), better known as the Rokeby Venus, part of the exhibition's final section, "Portraying the Ancients." For one thing, it's the artist's only female nude, a subject Spanish painters of this period were not expected to handle. With an odd sort of

hypocrisy, such things were acceptable but only as Italian or Flemish imports; thus was the tension between ecclesiastical condemnation and aristocratic delectation defused. More than that, the goddess's pose is entirely original, as is the peculiar mixture of exposure and mystery that results from it. The body shown so beguilingly from behind holds an undeniable sensual realism, though understated by the standards of a Titian or a Rubens, but the face glimpsed so darkly in the mirror suggests an even more powerful unknowability. The consummate art, according to Velázquez, is not the one that brings reality close to us as an object of voyeuristic inspection, but rather the one that reminds us of our difficulty in grasping it at all.

Although painted a decade earlier than the Venus, Velázquez's disenchanted *Mars* (1638), might well represent her implicit onlooker. He is nearly nude himself and, though he faces the viewer, his countenance, too, is half hidden, shadowed by the helmet that sits on his head so incongruously without the rest of his armor. And yet his eyes pierce the obscurity with their melancholy. Pensive, chin on hand—could this Mars have been a source for Rodin's *Thinker?*—he sits on the edge of a disheveled bed, but the tryst has clearly not been a success. Sensuality is seductive but fleeting. Velázquez's technique was, of course, ideally suited to conveying this sense of transience. Working, in his later years, with an astonishing economy of means, he was able to conjure a sense of the most concrete reality with a few seemingly almost random swipes of the brush, and yet the illusion dissolves as soon as one draws near. Maybe Luca Giordano was wrong after all. If there's a theology here, it's a negative one. In Velázquez's early years, the holy may have revealed itself in everyday reality, but once he'd learned to see reality as an illusion, where did that leave the holy he'd found in it? He must have been glad not to have had to paint religious subjects any more.

2006

2

An Ambiguous Medium: Lee Ufan

There's a stranger at the Guggenheim. An artist we hardly know has occupied its great spiral. Although his paintings and sculptures have only rarely been shown in North America, Lee Ufan, a Korean who makes his home in Japan, is widely esteemed in Europe as well as Asia. Yet the Guggenheim's big Lee exhibition, "Marking Infinity," seems to have been somewhat overlooked, provoking little discussion. That's a shame, because Lee more than deserves from museumgoers and critics here the sort of attention and acclaim he has received abroad. With stones and steel as well as colors on canvas, he has conceived an art of rare transparency and lightness.

Lee himself might not be surprised that "Marking Infinity" has not been met with ready plaudits. He seems sanguine about being the odd man out. Whereas "Koreans see me as being Japanized," he has said, "the Japanese see me as being fundamentally Korean, and when I go to Europe, people set me aside as an Oriental . . . I am left standing outside the collective, seen on the one hand as a fugitive and on the other as an intruder . . . The dynamics of distance have made me what I am." Regarding Japan, he's probably exaggerating his outsider status; he was a leading figure of *Mono-ha*, or the "school of things," a major movement in Japanese art of the late 1960s and '70s, and the equivalent of Western tendencies like postminimalism, antiform, and Arte Povera. Yet there's an irony in Lee's being touted as the figurehead of a quintessential Japanese movement: he is not only a foreigner but an émigré from a country that Japan once occupied and with which it officially normalized relations only in 1965, nine years after Lee emigrated, aged twenty.

In the setting of the Guggenheim, a danger for Lee could be getting "set aside as an Oriental," either marginalized as the embodiment of an immemorial Asian culture that commands respect but may seem of little relevance to modern life except as an antidote, or treated as someone suspiciously familiar, a mere imitator of aesthetic practices already commonplace in their Western guises. The exhibition's curator, Alexandra Munroe, seems well

aware of at least the second of these pitfalls. Her essay on Lee in the catalog for "Marking Infinity" begins with an extended comparison between his work and that of Richard Serra, and goes on to address Lee's connections to other Western contemporaries like Carl Andre and Joseph Beuys, as well as to an elder artist Lee has acknowledged as an influence, Barnett Newman.

Munroe attributes Lee's return to painting in the early 1970s, after several years focused on sculpture, to an encounter with Newman's work—and indeed, one of the many paintings Lee has titled *From Line*, in this case dated 1978, could easily be seen as an *hommage* to the Abstract Expressionist. It presents a single blue line bisecting the canvas, not unlike one of Newman's famous "zips"; though, unlike Newman's, Lee's line is not a fastidiously painted band of color but a single stroke of the brush, thick with pigment at the top of the painting and diminishing in density toward the bottom. Munroe ascribes Lee's difference from his American precursor to a return to Asian tradition: Lee was invoking literati painting, a type of art he had studied with a Chinese master as a boy in Korea. "The literati principles instill point and line with cosmic meaning," she explains, and certainly Lee's translation of Newman's zip, whose beginning and end points are off-canvas, into a finite line emanating from a single point of contact between brush and canvas becomes more resonant with this gloss in mind. The medium Lee used in making the paintings in the *From Line* series (and the *From Point* paintings he was making a little earlier) confirms the recourse to this heritage: "He mixed ground mineral pigment with *nikawa*, the animal-skin glue that is the traditional medium of East Asian painting on silk."

Still, I wonder how much this apparent adherence to tradition should be emphasized. Yes, we Western viewers should be directed to art-historical allusions and echoes that might be unfamiliar to us but second nature to our Asian counterparts—though not at the cost of making innovative art like Lee's seem nostalgic or convention-bound. Munroe avoids doing so, but I worry that her emphasis on Lee as a proponent of "distilled gestures, guided by restraint," in which "the self coalesces with an expanded situational wholeness," may inadvertently evoke a central-casting view of Eastern wisdom and reticence, of the timeless Asia of Buddhas and temples but not the modern world of industrial and commercial tigers. The Asia that Lee inhabits is both at once and more besides.

I'm not suggesting that Lee has banished tradition from his work. His paintings draw on the conventions of both Asian ink painting and European oil painting. His sculptures—which almost always use found, unworked stones, among other materials (most often steel sheets)—inescapably evoke

Zen gardens as well as minimalism. And his writings, although they reflect his immersion in the ideas of Western philosophers like Merleau-Ponty and Heidegger, whom he studied at Nihon University in Tokyo, sometimes have similar overtones, such as when he speaks of his wish to "lead people's eyes to emptiness and turn their ears to silence." (A selection of Lee's writings is included in the catalog for "Marking Infinity"; a larger cache can be found in his book *The Art of Encounter*, published by the Lisson Gallery in London in 2008.)

But there's another dimension to Lee's art that these sibylline utterances belie: a down-to-earth quality, and sometimes a humor, that is neither Eastern nor Western but universal, as a sly and subtle wit can be. Yes, he wants to convey "the way of being of everything as it is, of the world just exactly as it is," but he is shrewd enough to discover that even inanimate things, at least under a human gaze, cannot help being other than what they are. They cannot help feigning. "In my sculpture," he admits, "untreated industrial steel plates pretend to be more nature than artifice, while untouched natural stones play more artifice than nature." His sculptures all bear the same title, *Relatum*, and in a 1971 *Relatum* (originally titled *Language*) a group of stones sit on colored pillows, like little princes or maybe Buddhas. A related work from 1969 (originally called *Perception A*) consists of a single stone on a royal purple pillow that's backlit, as if it were emanating illumination. Looking at these stones, one sees something laughable in their pretension to sensitivity, their apparent need to be cushioned to protect them from direct contact with the hard floor. Another *Relatum*, dated 1978/1990, uses two steel-and-stone pairs: one stone sits openly, confident as can be, on a steel rectangle situated on the floor; the other seems to peek out from behind the second metal sheet leaning against the adjacent wall. Again, the anthropomorphism is comical, and comically self-defeating. We viewers, failing to resist being lured into reading human or at least animal behavior into a thing, can laugh at the thing's failure to fully succeed in its affectation of animate behavior. What we should be laughing at is how our perceptions contradict themselves, not at the things themselves.

Lee's art implies that we cannot entirely objectify things in the world any more than we can securely find an echo of our subjectivity in them, and that therefore we should conceive of people and things as neither antithetical nor comparable. The artwork, in his view, exists to dramatize this state. In a striking passage from a 1969 essay, "Word and Structure—Collapse of the Object (Thoughts on Contemporary Art)," Lee compares the function of artworks to that of the Buddha. He calls the Buddha an "ambiguous

medium"—using the terminology of art rather than of spiritualism—because he revealed something about the world by revealing himself. "The world is the world acting as the world with or without the presence of the Buddha, but it is by the Buddha's presence that the world is revealed." For that reason, in principle anyone could be the Buddha, "a person who shows that the world penetrates him and is simultaneously of the world of reality and the world of cognition." Actually, this is just the normal way of things, in Lee's view; elsewhere he writes, "The world does not remain external but penetrates the body and permeates its interior." In discussing the work of his Mono-ha colleague Sekine Nobuo, Lee concludes, "Structure is characterized by nonsense and humor, and through it, the performer is at the same time performed on." By "performer" Lee seems to mean "artist," but by the logic of his argument it could just as well mean "viewer."

Lee does not use the nonrepresentational materials of his sculpture—primarily stones and steel—to create images. He presents stone as nothing but stone, metal as nothing but metal. He doesn't even construct anything out of them, simply juxtaposing them. *Relatum*, the title he gives to each of them, is a word of Latin origin that refers to one of the objects between which a relation is said to hold. The title conveys how the elements out of which the sculptures are arranged exist in some relation to one another, just as the sculpture at some point in time exists in some relation to its beholders. The relation is the whole situation, so it is misleading to attribute cognition, desire, or perception to humans alone. These are attributes of situations we share with things, which is why it can sometimes make sense to speak of an inanimate thing like a steel plate "pretending," while it can equally make sense to speak of a person, such as Siddhartha Gautama, being "penetrated" by reality.

Lee's sculptures remain abstract, even as, through the relations they embody, they may also seem to suggest other sorts of relations that only the language of feeling and intention can convey. There is less temptation to speak this way of Lee's paintings. They possess a more "objective" character than the sculptures, perhaps because they do not share our space with us. Consider a set of paintings from the series *From Point*, consisting of works made in the 1970s. They are painted in a systematic manner. Using a single color, the artist has dipped his brush and made a succession of marks horizontally across the white canvas, each small mark depositing progressively less color until the last marks become practically indiscernible; then the process starts again. In some of the *From Point* paintings, each horizontal line of marks represents a single load of pigment gradually being exhausted, so

that the entire left side of the painting is heavily marked while the right side is nearly bare; in others, the sequences of marks begin and end at unpredictable points along the line, leaving the light and heavy marks distributed in an even rhythm across the canvas.

What one sees in looking at the *From Point* series is not a relation among the brush marks or sequences of marks, but both the entire field and the individual marks, none of which is quite identical to any of the others, although each is the product of the repetition of a similar gesture. In either case, however, the visual dynamic of the paintings is contrary to the order of their making: although it is evident that the spots of paint were brushed onto the canvas starting on the left, the visual rhythm of the paintings goes from right to left, from lighter to darker. Lee turns the literalism of his process against itself, generating a subtle illusion that prevents the painting from becoming a simple demonstration or illustration of the process.

The presence of illusion in Lee's work is important, and it is something that distinguishes him from many of his Western contemporaries. Artists in the tradition of minimalism and postminimalism have generally sought to make their work as literal as possible by eliminating illusion and metaphor—a goal most famously summed up in Frank Stella's brutally tautological dictum "What you see is what you see." It's interesting to learn that, by contrast, Lee was influenced early in his career by a tendency in Japanese art called *torriku*, that is, "tricky"—work that, as Munroe explains it, uses optical illusion "to upset normal perception." It would have been helpful to know more about *torriku* and Lee's relation to it. (In general, while Munroe's essay is a worthy introduction to Lee's work, it could well have been much longer, conveying more about his immediate artistic context, which is unfamiliar to most Western art lovers.) In any case, artistic illusion is clearly something that fascinates Lee. The illusion is much more powerful in the *From Line* paintings, particularly those from early in the series, done in the 1970s, than in *From Point*. In addition to a paradox of direction similar to that found in the *From Line* series—although the lines have been painted from the top down, the energy they evoke is ascending, with the strokes seeming to push up toward the sky—the paintings in *From Line* also produce an intense sensation of light: the white canvas seen through the dark brush strokes seems to glow as if the paint were backlit. In later *From Line* works the lines are shorter and more widely and irregularly dispersed on the canvas. Their illusion is not so much of light as of space; without recourse to any device of perspective or color interaction but simply through the placement of the monochromatic marks on the canvas, Lee creates a suggestion of three-dimensional space.

The titles Lee gave his paintings from the 1980s through the beginning of the '90s, *From Winds* and *With Winds*, suggest a greater emphasis on the metaphorical overtones of his work. At times it really does seem as if some tremendous wind had blown Lee's previously well-ordered brush strokes hither and yon. But still, the marks are rigorously nondescriptive; they do not construct larger shapes, and only rarely does a hint of landscape sneak in, notably in a *From Winds* dated 1989. These are the most unpredictable of Lee's paintings, and unlike those of his earlier series they don't seem to be the extended working-out of the implications of a single idea. Yet in a broader sense they are the proof of that idea, that the individual brush stroke "must become a living organism brimming with energy in its relationship with otherness." In his earlier paintings, the simple dabs of color or the linear strokes manifested their energy most vibrantly, yet that energy was also constrained to some extent by their preconceived ordering—an imposition of the artist's rationality. The windswept, turbulent yet casually volatile movement of the marks in Lee's paintings of the later 1980s should not be seen, I think, as a form of expressionism—they are not necessarily the manifestation of some inner turbulence, another way for the artist to impose himself on his materials. Rather, they seem to reflect a freeing up, a will-ingness to follow rather than control the movements of the brush.

I wonder whether Lee eventually sensed that this kind of liberty could not be maintained indefinitely. To think otherwise would be to pretend to be one with nature—and as Lee knows, we cannot be one with things as they are any more than we can detach ourselves from them. In his essay "Word and Structure" he suggested that it was just such a hope that eventually drove Jackson Pollock to madness. In any case, Lee's more recent paintings, called *Dialogue*, are the most severe, simplified, and formulaic he has ever done. Each painting presents one, two, or three large, squarish, gray brush marks. The marks have a heavy physical presence; the paint is dense and tactile. You can see how the big brush pushed the paint against the canvas, leaving ridges along the edges of the mark. Each mark is something like a self-contained painting within the painting—a picture of paint painting itself. Each mark has its own atmosphere—the paint is not a solid gray but rather contains a tonal range within each brush stroke, with the gray being lighter, nearly white, at one edge and becoming gradually darker (though never close to black) toward the other. It's as if the physical mark were one thing and its tonality something that had been applied completely independently.

There is a disturbing sense of artifice to these big, imposing traces of paint. And yet as one observes the paintings, it becomes clear that the traces

exist not for their own sake but mainly to activate the empty canvas that surrounds them. This is the "dialogue" evoked by the title—the dialogue between rhetoric and silence, excess and emptiness. They coexist uneasily; there is a slight but unmistakable tension between them. All of Lee's work is marked by the recurring problem of how something can have a relation to a place. Lee shows this not as a specifically human problem, much less a social or cultural one. On the contrary, he seems to find it in some inherent logic of existence, latent even in inanimate things. And yet, after all, one can hardly disentangle Lee's fascination with this conundrum from his self-chosen condition of displacement. He is a *relatum*, one might say. And his will toward opening into relation with that which he is not, in allowing himself to be penetrated by it, is exemplary.

2011

The Stone Dies Away Also: Jimmie Durham

In many of his writings and interviews, Jimmie Durham, an artist of the most profound seriousness, uses one word more than any other, one that best sums up his attitude toward the world and himself. The word is "silly." He uses "crazy" and "stupid" a lot, too, and more than occasionally other related words like "ridiculous" and "nonsense." Many of us use these expressions fairly regularly, even if not as often as Durham. But except for when we're talking to children, we use "silly" much more rarely, which makes the artist's attachment to the word so striking.

What does Durham mean by "silly"? He uses it in its broadest sense when, in an interview with the Belgian art historian and curator Dirk Snauwaert, he explains the political valence of his art. "I can be part of the discourse by completely disagreeing with it, but I can do it intelligently instead of just making an interruption. I can make this audience itself strange to itself and I can try and expand an audience and make it not so silly." This sounds a bit condescending: Durham seems to be suggesting that the audience for art, the good old bourgeois public, is, as ever, in the wrong, and though the scare tactics of the good old avant-gardes—so many ways of *Offending the Audience*, to use the title of the almost self-parodically paradigmatic 1966 theater piece by Peter Handke—may have become obsolete, a gadfly artist can still provoke an audience in ways that are subtle and pointed, and therefore likely to goad it into some state of enlightenment.

This way of thinking isn't entirely foreign to Durham, an artist who should be better known than he is in his native country of the United States, but it's not the whole story. He doesn't necessarily think of himself as a high priest, some Zen master whacking his disciples upside the head. He, too, can be silly, and silly precisely (so he's said) in wanting to be active. When asked on another occasion about his hectic exhibition schedule, Durham replied, "Since 1994, I've tried to do everything that people asked me to do, and that has got me extremely busy, often doing quite silly things that cost me money and a lot of time. But I like it all. I like being very

busy and I like doing things." Here, silliness signifies self-contradiction: the artist acts in ways contrary to his own interest, but from which he derives pleasure; it's like smoking, only less harmful. That might be a personal defect, or more broadly a *déformation professionelle*, but there are nigh-universal forms of silliness also. Sometimes this is caused by the natural limitations conditioned by the human sense of time, as when a material such as stone—a constant in Durham's art—comes to be seen as eternal. "It has become the foundation of architecture, of the cathedrals and build-ings, with the idea that it is unchanging," he remarks. "Of course it is NOT unchanging. Our silly lives are so short that we don't notice that the stone dies away also. So in Europe, and therefore in cities in general, we have a large heavy falsity built around stone."

The self-contradictions that make us silly do not necessarily arise from our actions, or the lack of connection between actions and beliefs. Our beliefs themselves, our ways of explaining ourselves to ourselves, can be silly, in part because our words are inadequate, our concepts childish: "I think basically the same as I used to think when I was a child," Durham told the English critic Mark Gisbourne. "If you make something right, or with some sort of integrity, in a way I can't quite explain, potentially it can be alive, it can have some sort of power. I do not like to use the word power, it is such a silly word, but such as to be some sort of active power." The artist doesn't disavow his dependence on the notion of power, or that it is the basis for something like an aesthetic credo. In fact, he insists on it, even while remarking its silliness and, implicitly, that of the barely credible animism that he (like nearly every artist I know) secretly or not so secretly espouses: that a life resides in things, and art is a way of discovering or giving birth to it. The kind of rationality an artist offers does not dissolve this belief; rather, it is the "negative capability" that allows him to observe dispassionately his own self-contradictions without being too quick to try to resolve them. It's what allows an artist (or anyone else) to be silly without necessarily having to cure himself of his silliness.

But if the artist is licensed, somehow, to be silly, on the condition that he remain aware of it, then why should he set out to make his audience "not so silly"? Because there are different ways of being silly, more and less self-aware ways. If Durham proposes to make us "not so silly," that doesn't mean he's given himself the harder, probably impossible task of making us not silly at all. He wants to make the audience "strange to itself," to encourage it to see itself as an outsider, as an alien would see it, and thereby to become more self-aware. The difference between artist and public is relative, not

absolute, and it resides—so Durham seems to believe—in the practice of self-consciousness, or more specifically (as Durham is primarily a sculptor) in noticing human-made states of change in *things* as indicative of states of mind imbued with self-consciousness.

When asked about the violence with which he sometimes attacks his materials, Durham denies it. "I don't really destroy things, I just change them, I change their shape, just like any sculptor does," he once explained. One of his best-known pieces, *St. Frigo* (1996), is a sculpture made by stoning—yes, lapidating—a common household fridge. There's even a picture of him throwing the stones to prove it. (The stones are cobblestones, like the ones once used in Europe as readymade weapons as well as material for barricades in workers' uprisings.) Durham mused in retrospect: "If I try to imagine looking at this refrigerator in a museum, as someone who doesn't know it—it's a silly exercise, but I can do it a little bit—I would notice human intelligence having done something to this refrigerator, by the fact of stoning it so often. I might not call it intelligence, I might call it human work or human deliberateness." Someone else might say the "silly exercise" isn't looking at a lapidated fridge in a museum so much as the stoning of the refrigerator itself, and I think Durham wants to keep this option open. He imagines that although his own silliness and that of the audience may not be equivalent, they are equally real, and the open-ended nature of the experience he wants to create as an artist depends on the audience not according him the kind of authority a disciple accords a master. The relationship should probably be a bit more playful, a bit more skeptical, perhaps even a bit more combative than that, like sparring: Durham doesn't want to knock you out, but he does want to jab at your weak spots so you know where they are.

If you're in the mood to spar, you could go a few rounds in Belgium at M HKA, the Museum of Contemporary Art Antwerp, where a retrospective of Durham's work, "A Matter of Life and Death and Singing," curated by Bart De Baere and Anders Kreuger, is on view. Durham may be the most important American artist whose work you've never had a chance to see— unless you travel frequently to Europe. He hasn't had a one-man show in the United States since 1995, except for a small show last spring, which— perhaps to make a point of his status as an exile—was held at the Swiss Institute New York. While his works have been seen in the occasional group show, the exposure they've received has mostly been low-profile; his work is more likely to be shown at an alternative space like Art in General or the late, lamented Exit Art, both in New York City, than at either commercial

galleries or big museums. Abroad, things are different: it's been only three years since Durham's last retrospective, at the Musée d'Art Moderne de la Ville de Paris, and he is a usual suspect for inclusion in big exhibitions like Documenta (where he appeared this year for the second time) and the Venice Biennale. In Europe, somehow, as the Italian curator and critic Giacinto di Pietrantonio put it, even when Durham's "work is part of a local language, it always tends toward the supranational-universal."

It may not please Durham to be described as an American artist. Born in 1940 in Washington, Arkansas, he lived in Geneva (where he attended the École des Beaux-Arts) from 1968 through 1973, when he returned to the States. In an anguished text published in 1987, the last year he lived in this country, he wrote, "Here is the real truth: I absolutely hate this country. Not just the government, but the culture, the group of people called Americans. The country. I hate the country. I HATE AMERICA." Did he really mean it? I don't know, but that year Durham moved from New York to Cuernavaca, Mexico, where he stayed until 1994, and ever since then he's dwelt in various cities in Europe—Brussels, Marseille, Berlin, Venice, Rome, Berlin again. Being abroad has been good for him, apparently: in his writings and interviews, he is no longer consumed by righteous fury. It's certainly improved his prose style. And his art has flourished.

Durham is Cherokee, and he has absented himself from America for so long because America is the country that dispossessed him. Having spent much of the 1970s as an activist in the American Indian Movement, he ended up believing that, owing to political confusion and government infiltration, "there is no AIM to leave." Today he laments that Indians "bought this Hollywood idea about our own spiritualism, and we are becoming religious fanatics in the most idiotic sense of American spiritualism." Alienated from his nominal country of birth, disillusioned with any commu- nity to which identity politics would solder him (and to which he devoted years of his life), Durham is now in the strange—I don't have the heart to call it silly—position of being a man who nonetheless heartily believes in art as a collective endeavor, who tells his students that "one is not smart on one's own, but in dialogue," who says he "would always rather participate in a group show than have a solo show," and for whom "the social discourse about art is part of the practice of art," while also being a figure of profound detachment, who likes living in Europe because there he "can be homeless and still be engaged." There's a great loneliness somewhere back of his art. Speaking of a book he tried to write and didn't finish, Durham said it was "just trying to continue a conversation with the world that the world never

wanted and still doesn't want." I never expected this artist to echo Emily Dickinson, with her "letter to the world / That never wrote to me." But maybe every artist knows this situation.

Perhaps I have things backward. I've said Durham is an important sculptor, yet I've hardly mentioned any of the objects I saw at M HKA. I've focused mostly on his words. But then the artist himself has said, "I have never made a separation between writing and making sculptures." They're not the same, but "they do not bother each other." Durham's sculptures—and his videos, photographs, and drawings, too—may have a visceral impact, but they are intellectualized as well. You have to see them and you have to read them. Often the sculptures demand reading in the most literal sense: there's a lot of writing in them, and in a Babel of languages, at least some of which are likely to be foreign to each comer. Those who can read the inscriptions in English (which is most of them) may or may not be able to puzzle out the bits in German or French or Spanish. Generally, though, the linguistic chal- lenge isn't too imposing. You probably don't need to know that much French to figure out, say, *Une machine désire de l'instruction comme un jardin désire de la discipline*, the sentence handwritten in block letters on a sheet of paper pinned next to what look like the tops of a pair of wooden coat trees trans- formed into bobbins, in the 1996 work of that name. Despite the apparently dismissive stance toward the fantasy that things like machines or gardens can desire, the sculptural portion of the work is strangely anthropomorphic. It's easy to see one of the wooden cylinders as a recumbent figure, the other as struggling to lift itself up off the floor.

Durham is still caught up in his childish will to see things as alive, and he wants to persuade us that we should be, too—but he doesn't want us to forget that this is childish, silly. Many of his sculptures are figurative, usually in the lowest, most ridiculous ways. Because it has been visibly battered, *St. Frigo*, that old refrigerator, is meant to stand in for some martyred saint: "I started stoning it and then it wasn't neutral anymore," Durham says. "It started being brave." Often enough, it's even easier than that: just draw a couple of eyes and a mouth on anything and you've given it a face—and by giving it a face, you've made it hard not to see life in it. It's a trick that Durham resorts to time and again; it always works and, yes, it's always childish. He likes from time to time to smash a car (and even, at least once, a small airplane) by dropping a big boulder onto it; in this case, it is not the vehicle that is humanized, but the innocently destructive stone itself with a goofy face painted on it, head and body all in one. And Durham has even bigger things in mind: in 2000 he made a model, *Une maquette pour un désastre*

horrible, with those words painted on a wooden sign above a stone of contented countenance that appears to have landed splat on a bit of earth, leaving various humans (represented by found plastic figurines) trapped under it. Let's hope he never gets a chance to realize this idea. In any case, by this silly gesture of painting a face on a stone, Durham not only vivifies an inanimate thing and gives it a character, but he also endows a thing that is heavy—and its evident effect on the thing it has fallen on demonstrates this heaviness, and the danger implicit in that—with a sort of lightness. He makes it almost unreal.

Durham is—he insists on it—an intellectual artist, with something of the philosophical penetration of Marcel Duchamp and the broad historical perspective of Joseph Beuys. Painting faces on stones is not everyone's idea of intellectual work, but the transformation in perception that every child achieves by such simple means is an intellectual event because it happens in the mind. *Pittura é una cosa mentale*, as Leonardo said—and that's child's play, as Durham implies. Of course, there's something disingenuous in his claim that he doesn't destroy things but merely changes them. Often enough, it is through destruction that he changes them, and he destroys with relish and without inhibitions, as a child might. You want to get a stone into a glass vitrine? OK, toss it in, and then the broken shards of glass will be on exhibit too. You will notice the stone now, as you are asked to notice anything in a display case, and this way you will notice the glass as well, which you might have ignored otherwise as simply an expected part of the display case. Having been destroyed, the character of the glass has changed: it's clear, but no longer transparent. A lot of Durham's art is like that.

2012

Putting the World into the World: Alighiero Boetti

An artist's career is a chronicle of deeds as much as a catalog of works. Like most artists, Alighiero Boetti occasionally wrote the chronicle himself, albeit sometimes in a jumbled way, as in this autobiographical text from 1967:

> In 1948 I tore up a big brown sheet of paper making small quadrangular pieces, which I stacked up and used to erect a rather unstable column . . . In 1950 I had about twenty small ice-cream glasses, which I'd collected laboriously, and I fitted them one inside the other so as to form an arch. In the same year I filled a small plastic box with about a dozen match boxes . . . In 1949 I rolled up a yellow tape measure and pushed my little finger into it forming a kind of tower of Babel . . . The first pile of matches and the first bundle of pencils date back to 1947.

The young Boetti's prescience is impressive. During the postwar years, most Italian artists were still wrestling with the question of whether their future lay in the politically committed figurative painting of Renato Guttoso, influenced by Expressionism and the political side of Picasso, or in the various forms of abstract painting then just emerging. That Boetti had made exquisite harbingers of post-minimalist art in such a climate is astonishing, and all the more so because the artist, born in Turin in 1940, would have been no more than a schoolboy.

Reading this deadpan text, in which Boetti seems to attribute the formal consciousness of art to himself at an age when he was happy to play with whatever stray objects or materials were at hand, I'm inclined to think he is lampooning someone. But who? Perhaps the artists of his own generation, who thought that even the most banal activity could be lent aesthetic status just by being documented. On Kawara made that prototypical nonevent, getting up in the morning, into an artistic exercise by mailing a couple of postcards each day rubber-stamped with the legend I Got Up at . . . followed by the exact time. Similarly, the sculptor Richard Long made a line on the

ground by walking back and forth until the grass was sufficiently flattened beneath his feet—and then photographed it. Bas Jan Ader rode his bike into a canal in Amsterdam "because gravity made itself master over me," and took care to have his childish, "accidentally on purpose" stunt filmed for posterity.

Or maybe Boetti is demystifying a deeply ingrained habit—the romanticization of the artist as an elect being whose destiny is heralded in childhood. This tradition goes back at least to the thirteenth century, when Cimabue is supposed to have discovered the young Giotto as an untutored shepherd boy skillfully drawing his sheep. Then again, maybe Boetti's straight-faced humor is trickier than it seems. What if telling a joke is his preferred way of expressing what he really means? After all, in one of his first exhibitions Boetti adopted the seemingly paradoxical epithet "Shaman Showman," and then held fast to the dichotomy—authentic visionary and self-proclaimed charlatan—for the rest of his life. What if he did believe, or would have liked his public to believe, that his seemingly mundane art was a gift of the gods, and that the artist is the figure elected to remain closest to the spirit of childhood, to the activity of putting objects in order and then constructing a different order with the same objects, conquering boredom by expending energy on boring things so determinedly that they become a source of wonder? After all, Boetti did like making art for actual children. In 1980, a year after he had enlisted a group of kids to color in his drawing *Faccine* ("Little Faces"), he published a colorful counting game, *Da Uno a Dieci* ("From One to Ten"). "Zen tales are the only tales that really make me laugh," he once told an interviewer, "and my laughter's like a little boy's." Just as he was both shaman and showman, Boetti was also skeptic and enthusiast, joker and romantic, self-absorbed dreamer and calculating employer. Somehow he manages to make oppositions collapse, probably because he delighted in contradiction.

When Boetti died of a brain tumor in 1994, he was something of a cult figure and still mostly identified with Arte Povera, even though he had begun to distance himself from the movement a year after the curator and critic Germano Celant proclaimed its advent in 1967. Since Boetti's death, his fame has only continued to grow, and in many ways has begun to eclipse the reputations of artists who seemed more central to Arte Povera. For Celant, Boetti's gestures "appear as an immediate apprehension of every gestural archetype . . . the cut as cut, the heap as heap, mathematical equations of real = real, action = action. A univocal sign language that expresses 'all the possible formative and organization processes' freed from every

historical and worldly contingency." Today Boetti's works look anything but univocal, and that is part of their strength. The figures on the two sides of the equals sign are never reconciled in his art; there are two kinds of real, two kinds of action, just as he insisted that he had to be seen as two, not Alighiero Boetti but, as he later renamed himself, Alighiero e Boetti (Alighiero *and* Boetti), perhaps a pair of twins, as he pictured himself in a 1968 photomontage.

I don't think Boetti's work has ever been presented in quite so grand a manner as in "Game Plan," an exhibition curated by Lynne Cooke, Mark Godfrey, and Christian Rattemeyer, and featuring more than 130 of his works showing the full range of his activity. Currently at Tate Modern, London, the exhibition originated at the Museo Nacional Centro de Arte Reina Sofía in Madrid. The show is accompanied by a helpful catalog, and Godfrey has also just published a thorough monograph on the artist, *Alighiero e Boetti*. One admirable facet of "Game Plan" is that the presentation of Boetti's work enables a visitor to understand and coordinate the various, sometimes self-contradictory aspects of his activity as an artist. I'm thinking not only of the many types of objects displayed, some of them (postcards, jigsaw puzzles) seemingly antithetical to anything that in earlier times could have been deemed art, some of them (drawings, photographs, a variety of freestanding objects that can by default be referred to as sculpture) closer in appearance to what artists of previous generations had made, and others more like what were once called crafts. What I also have in mind are the different kinds of roles Boetti played as an artist: not only the producer of objects and images but also the initiator of processes and the coiner of thoughts.

The last of these is the Boetti who most immediately engages me. This artist is a writer but of a very particular sort, a cross between poet and sloganeer, aphorist and Zen master, finding (when he can) or inventing (when he must) gnomic phrases that could be deployed again and again in various ways. Unfortunately, the writer is downplayed by "Game Plan," because the embroidered "word squares" in which he arranged the letters of phrases that fascinated him are treated as minor works. Sometimes Boetti's sibylline paradoxes turn up as titles. An iron framework from 1969 holding twelve glass windows and leaning against a wall, as if waiting to be installed somewhere, may look like a Minimalist readymade, but the title given the work, *Niente da vedere niente da nascondere* ("Nothing to See Nothing to Hide"), lends it an emblematic value that no true-blue Minimalist would have countenanced. Thanks to the title, the work's emptiness becomes full, its transparency

clouds over—it becomes a parable. And oddly enough, the parable seems to contradict both the showman, who always offers something to see, and the shaman, whose magic functions in part through secrecy.

But more often than their use as titles, aphorisms were often the actual content of Boetti's work, embroidered in word squares, used as secondary elements in larger embroideries, or detailed in drawings, either those Boetti made himself—using both hands as if they were two different protagonists in a drama, one the Alighiero and one the Boetti—or his "biro drawings." The latter were executed in ordinary ballpoint pen according to a grid system whereby each horizontal line on a piece of paper represents a letter of the alphabet. The grid was filled in column-by-column by hired assistants (always one male and one female), except for the portion representing a given letter. The "absences" can be read from left to right, encoding Boetti's drawings with a text that is not evident on the surface yet can with effort be deciphered. Visually, the result is a constantly variegated field of vibratory blue hatchings. As for the texts themselves, they often flirt with self-contradiction, as with *Niente da vedere niente da nascondere*. Others, by contrast, present themselves as tautologies, for instance *Mettere al mondo il mondo* ("Put the World into the World"). Whatever can that mean? A slogan later used by one of Boetti's successors, Martin Creed, offers a gloss: "the whole world + the work = the whole world." The world being infinite, it can be added to without thereby being increased, yet what was present in it has been made more apparent. The pendant to *Mettere al mondo il mondo* is *Dare tempo al tempo* ("Give Time to Time"). The meaning of this phrase may seem more self-evident, though no less telling for that, a scrap of cracker-barrel philosophy worth committing to memory: devote some of your time to simply observing time pass, and you'll have more of it. Yet Boetti also maintained the opposite. Other works bear the words *Amazzare il tempo* ("Kill Time"). Of course, what some people would call killing time—spending it on unproductive activities such as contemplation—might be what Boetti means by giving time to time.

In considering other Boetti maxims, I don't know if they are forms of tautology or contradiction, as is the case with *La notte dà luce alla notte* ("Night Illuminates Night"), a phrase of, apparently, Sufi origin. Many use puns or other forms of wordplay: *Fuso ma non confuso* ("Fused but Not Confused"—or "Stoned but Not Confused"), which undoubtedly indicates the state of mind in which some of these phrases were invented. *Mettere i verbi all'infinito* ("Put the Verbs in the Infinitive"—or, "Into Infinity") simply describes an aspect of Boetti's method in these writings. In a broader sense,

so does *Lasciare il certo per l'incerto* ("Leave Certainty for Uncertainty"), while *Accanto a me ci sono* ("Next to Me Is Where I Am") recalls his idea of a duple identity. Others reflect a not-unfamiliar wisdom that shuttles easily between lyricism and irony: *Ciò che sempre parla in silenzio è il corpo* ("That Which Always Speaks in Silence Is the Body")—a sentiment found in the writings of Norman O. Brown, the dimly remembered prophet of polymorphous perversity, whose *Love's Body* was among Boetti's favorite books. *Non parto non resto* ("I Don't Leave I Don't Stay"). *Bisogna essere leggeri come gli uccelli e non come le piume* ("We Must Be Light as Birds, Not as Feathers"). One suite of black-and-white panels embroidered with phrases is called *Far quadrare tutto* ("Make Everything Fit In or Add Up"), but because the title is based on *quadro*, the word for square, which also happens to mean picture or painting, it suggests that everything should be put into a square or become a picture. Boetti has done just that with the phrases, all of them composed of sixteen letters—including the one that gives the suite its title—and therefore eminently squarable.

My appetite for these trippy apothegms may seem inexplicable to some, as may many of the objects Boetti made in a similar spirit, especially early in his career. If the idea of wristwatches (*Orologi Annuali*, from 1977–94) that display only the year, ignoring the hours and minutes, doesn't tickle your imagination as a clever way to remind yourself to give time to time, well, time's up. But Boetti's oblique, riddling notions don't always result in oblique, riddling objects. He never particularly insisted on what Marcel Duchamp had called "visual indifference . . . in fact a complete anesthesia" as a prerequisite for conceptually advanced work. For Boetti, "Beauty is an expression of thought," rather, "and of the urge to express it."

If beauty comes from putting the world into the world, what better way to do so than to make a map of it? By the time Boetti started making art, Jasper Johns had already mapped his way into painting, and Boetti's Arte Povera comrade Luciano Fabro repeatedly made the recognizable outline of the Italian boot a subject of his sculpture. But Boetti did not focus on a single country, not even his own, or on mapmaking realized through painting or sculpture. He had already made works using the forms of Israel's occupied territories as motifs, such as *Dodici forme dal 10 giugno 1967* ("Twelve Forms from June 10, 1967"), a piece done in 1971, when many European artists and intellectuals were still oblivious to the wrongs suffered by the Palestinians. It was also in 1971 that Boetti conceived of commissioning Afghan embroiderers (first in Afghanistan and later, when war made this impossible, among

the Afghan refugee population in Pakistan) to produce large-scale representations of the world map, with each country's territory filled in, not by a single color but with the pattern of the country's flag. "For me," Boetti famously said, "the work on the embroidered Map achieved the highest form of beauty. For the finished work, I myself did nothing, chose nothing, in the sense that the world is as it is (I didn't draw it) and the national flags are as they are (I didn't design them). In short, I did absolutely nothing."

He continued doing this nothing for the rest of his life. When making his word squares, he often left the choice of colors to the embroiderers; similarly, with the maps he left many aesthetic choices to the Afghans. The edges of the maps are typically decorated with legends in various languages; some were selected by Boetti, including many of his favorite apothegms, but many, in Persian, were composed by the embroiderers, and therefore are illegible to most Westerners. Yet these texts contain urgent messages: Godfrey translates one to say,

> The needlework of Alighiero e Boetti an Italian artist was produced in collaboration with Abduljalil Afghan in the city of Peshawar in Pakistan. It is important to note that this work was handcrafted by unnamed Afghan women in the refugee camps in the city of Peshawar in Pakistan. These women had to leave their beloved homes in Afghanistan due to fear from the invading Russians.

The highlight at the Tate is a large room filled with some of Boetti's largest and most elaborate embroidered maps—a concerted blaze of decorative grandeur such as one hardly expects in an exhibition of contemporary art. Boetti's intuition that through such materials and scale he would realize the highest form of beauty is largely verified here. Putting the world into the world, making things without adding anything to what exists—these sound like doctrines of austerity, but in the maps they are formulas for splendor. Boetti came to understand this only in Afghanistan, where he spent much of his time between 1971 and 1979. His love of the country was rooted in the idea that necessity creates conditions for beauty. He wrote that "the villages are built on mountain-sides, so as not to fritter the rare areas of fertile land in the valleys. Nothing is added to the landscape, either. Rocks are moved, and used to build cube-houses (as in Klee's watercolors). Trees are felled to make the frame."

In the exhibition catalog, Godfrey rightly asks whether Boetti did not "essentialize Afghanistan by treating it as an ideal, an object of desire, a

concept rather than as a complex place." He might also have asked whether Boetti's use of Afghan labor to execute his artworks was not a form of exploitation. The answer lies in the fact that the Afghan people he employed were never simply executing his ideas but drawing on their own aesthetic and culture. The resulting work is a hybrid in which European conceptual art and Afghan craftsmanship, individual authorship and anonymous artisanal work, are overlaid as distinct sets of values that, far from interfering with one another, together create a form of beauty that each would not have separately been able to attain. In this room, at least for a while, everything adds up.

2012

5

The Devil, Probably: Maurizio Cattelan

"All," the title of Maurizio Cattelan's exhibition at the Solomon R. Guggenheim Museum in New York, could be taken to mean that the entirety of the Italian artist's oeuvre is on view. While that's not true, it's close enough: the 128 objects in the exhibition constitute the greater part of the work Cattelan has made since his artistic career began in 1989. The title also calls attention to a single work, one of the artist's recent pieces, likewise titled *All* (2007). It consists of a group of marble sculptures—as always with Cattelan's sculptures, they were made by commissioned artisans—depicting recumbent figures, corpses presumably, covered by shrouds. *All* evokes mortality and mourning, surprising themes for an artist widely acclaimed or disdained, according to taste, as the art world's court jester, a slinger of provocative but ultimately ephemeral visual one-liners. Cattelan has always been something more than that, but given his announced intention of retiring from art-making after this exhibition, the meaning of *All* could be something like Porky Pig's "Th-th-th-that's all, folks!"

Cattelan wouldn't be the first artist to stage a dubious disappearing act. Marcel Duchamp renounced art in favor of a more gentlemanly pursuit, chess, but it turned out that he spent the last two decades of his life tinkering with a single bizarre anti-masterpiece, *Étant donnés: 1° la chute d'eau, 2° le gaz d'éclairage* (1946–66). Looked at coolly, the exit strategy certainly worked for Duchamp. "The great artist of tomorrow will go underground," he declared toward the end of his life, long after he had done just that. His absence from the scene having been a most noticeable one, reticence only added to his mystique, which the posthumous revelation of his hidden labors only deepened. "The silence of Marcel Duchamp is overrated," was the judgment of Joseph Beuys; in retrospect, Duchamp's reserve seems more powerful than Beuys's prolixity, which was always most effective when it revealed itself as just another, more actively dramatic form of muteness. Explaining pictures to a dead hare, as Beuys did in a famous 1965 performance, is surely another way of speaking into the void, letting circumstance convert speech into silence.

As for Cattelan, some observers—among them Roberta Smith of the *New York Times*—think he is running out of ideas, but a close look at the exhibition's checklist suggests otherwise. His production has not slowed down of late, and while his efforts have always been hit-or-miss, the misses have not become more noticeably numerous. Besides, a work like his 2010 public sculpture *L.O.V.E.*—a thirty-six-foot-tall marble hand giving the middle finger, originally installed facing Milan's Stock Exchange—seems timely enough, if that's what you're after; Cattelan occupied the Piazza degli Affari before anyone had ever thought of occupying Wall Street. Besides, what could be more astute than the way Cattelan has installed his show at the Guggenheim? Instead of following convention and installing his sculptures along the museum's ramp, he has hung them all from its ceiling, like a galaxy of marble mobiles. The potential metaphorical upshot of this gesture can be parsed in many ways, but notice what Cattelan has done: he has made literal, with simplicity and elegance, the everyday word—*hang*—for putting up an exhibition.

In doing so, Cattelan has also turned his life's work into a single great sculptural group, showing in the most obvious way possible that his *oeuvre* is more than the sum of its parts. It's a theatrical coup, of sorts, but even more, a truly sculptural one. To circle around the installation in the Guggenheim's corkscrew interior is always to see it from a different height; the individual pieces as well as the totality present a diversity of angles, not only from many sides but from below and above as well as straight on. The arrangement constantly shows you unexpected aspects; you always see it differently.

A horse walks into a bar. The bartender says, "Hey, why the long face?" That used to be one of my daughter's favorite jokes. (She's still too young to have ever walked into a bar.) The joke could be extended: The horse replies, "Because Cattelan wants me to hang out at the Guggenheim." *Novecento* (1997), one of the few works at the museum that were always meant to be suspended from the ceiling, is a taxidermied horse hanging droopily in a leather harness, its long legs seemingly stretched toward the earth and its head bowed low in ultimate resignation. Like Beuys with his hare, Cattelan treats animals as important symbols—stand-ins not for the public he wishes to address but for himself. And like the work of Beuys, Cattelan's is hardly comprehensible apart from his biographical tale, which can be as misleading as it is illuminating. Much of his effort has been expended on crafting a persona, and it's the opposite of Beuys's pretense to prophetic and shamanistic charisma, or

his claim to be a teacher above all. Nor is Cattelan's myth rooted in sexual magnetism, like Lord Byron's or Picasso's, or in self-knowledge through suffering, like Antonin Artaud's or Frida Kahlo's. The models for his way of being an artist are silent film comedians. Even his long face—which you'll see a lot at the Guggenheim, and which possibly also accounts for the artist's recurrent use of horses and donkeys as alter egos, though you also won't fail to notice an elephant, a squirrel, and some Beuysian bunnies—recalls that of Buster Keaton.

His story, as it is recounted no more critically than necessary by the exhibition's curator, Nancy Spector, in the oddly sober-looking catalog, is the heartwarming tale of a poor boy who made good—not in the manner of Horatio Alger, all sparkling conduct and good luck, but instead through his insecurity and aversion to work. As Spector notes, Cattelan's father was a truck driver and his mother a cleaner; she was in poor health and deeply religious. Leaving school at seventeen to go to work, Cattelan continued his studies at night. He despised his jobs; at one point, so he claims, he bribed a doctor for diagnoses that would earn him six months of sick leave. Somehow, though, he found his way into industrial design, and while he was "a reluctant participant"—naturally, as enthusiasm is no part of his persona—in the Italian design scene, he found some success. Only at age twenty-five—this would then be in late 1985 or early 1986—did he become interested in art, "after encountering a self-portrait on mirror by Arte Povera artist Michelangelo Pistoletto in a small gallery in Padua." Spector doesn't explain why this piece moved the young man so, but one can imagine that the idea of a work that could communicate a sense of its maker while also reflecting the world around it without mediation by the artist's subjectivity would have a lasting impact on him. In any case, it would not be until a few years later, in 1989, that Cattelan would produce the earliest pieces included in this exhibition.

Among Cattelan's first acknowledged artworks is one that makes an effective bookend to the "Th-th-th-that's all, folks!" spirit of "All." It's a tiny Plexiglas sign, just four-by-twelve centimeters, bearing the legend *Torno subito*—"I'll be right back." Like some of Cattelan's other pieces, it's the relic of a performance, so its meaning is incomplete without its backstory. For what was essentially his first one-man exhibition as an artist, Cattelan had the gallery locked, with the Plexiglas sign displayed on the outside. The hopeful gallery-goer could have had more success waiting for Godot than for the gallerist with the key. As Spector points out, the empty gallery has a by-now venerable history in the annals of art, from Yves Klein onward;

the Centre Pompidou in Paris even devoted a substantial (but, naturally, vacant) exhibition to this history in 2009. Spector's interpretation of Cattelan's restatement of the gesture turns it into the expression of a personal quirk: "the artist's discomfort with the critical attention and public judgment that his exhibition would garner." This sense of dismay, another catalog contributor explains, plunged the artist into "paroxysms of indecision, self-doubt, and crippling performance anxiety." Maybe. Self-doubt is an artist's constant companion, and some artists have been known to panic when it's time to deliver the promised work for a show. But stage fright is an unlikely spur to an action as coolly clever as this. Was Cattelan really "so disappointed with his production" that he had to resort to a ruse in order to avoid exposing it to the public eye? It's more likely that the ruse was the debut Cattelan had planned all along; in order to be seen as a promising young artist, he had found a way to make a promise that could be fulfilled only in the breach.

Cattelan's career is rife with such smooth tricks, with scrapes and shenanigans that somehow turn out to the artist's advantage, at the same time giving inventive twists to gestures familiar from the history of conceptual art, which includes just as many invisible objects as empty galleries. Cattelan once advertised a fake biennial that was nothing more than a Caribbean vacation for himself and some artist pals, and it's said that he once burgled a gallery in order to show the work of another as his own. In 1991, Spector writes, "unable or unwilling to produce a new work for *Briefing*, a group show at Galleria Luciano Inga-Pin, Milan"—again, the unnecessary and probably unverifiable ascription of psychological motivation emphasizes the artist as a sad sack—Cattelan reported the theft (from his girlfriend's unlocked parked car) of the invisible artwork he'd planned to exhibit. The multiply signed and sealed police report of the incident was duly framed and exhibited. The following year, Cattelan established the Oblomov Foundation, canvassing for donations to endow a fellowship that would pay an artist not to exhibit his or her work. The donors' names were engraved on a glass plaque that the artist had affixed (without permission) to the façade of Milan's art academy, the Accademia di Belle Arti di Brera. But because no one accepted the fellowship—was it ever offered?—Cattelan used the money to finance his move to New York in 1993, the same year he sublet his place in the Venice Biennale to an ad agency that erected a billboard advertising perfume. I suggest ignoring the catalog's opinion that Cattelan had "sidestepped the anxiety he felt about having to fill the space with his work for a year." The Venice stunt is Cattelan at his worst, no

longer the trickster who dodges the possibly illusory nature of art itself but the cynic who flatly reiterates a routine denunciation of the compromised scene while also profiting from it.

Cattelan the stuntman, who could make you despair of an art world that seems determined to reward those who would reflect it at its worst, perhaps in the misapprehension that this absolves it of any need to aspire to something better, is certainly present at the Guggenheim. Sometimes his works are just bad jokes, like mine about the horse walking into the bar. But Cattelan keeps repeating them. In the "Zorro Paintings" he remade his versions of Lucio Fontana's slashed monochrome paintings, only in his renditions there are three slashes—horizontal, diagonal, and horizontal—forming a letter Z. Each reiteration is as silly as the others. *Less Than Ten Items* (1997) is a supermarket shopping cart more than seven feet long; installed in a normal exhibition it would suggest that the viewer should be a buyer, and of the biggest works available. How humdrum an insight into the consumerism of the world's big-money collectors—many of whose names (Dakis Joannou, François Pinault, et al.) can be found on the list of the lenders to this exhibition—is that?

At the Guggenheim, to a great extent, the low points in Cattelan's oeuvre are, if not redeemed, at least underplayed by being integrated into a larger exhibition. Even so, it's easy to see that, as a critic of the art world, Cattelan shows how difficult it is to bite the hand that feeds you when the bite is almost inevitably transformed into a kiss. *Stephanie* (2003), for instance, is rather successful considered simply as a sculpture: a life-size wax model of a nude woman cupping her hands over her breasts, with her body cut off just below the waist and bent upward like the figurehead of a sailing ship, but also echoing the silhouette of a hunter's trophy. The woman's hard stare makes the piece creepier than the typical waxwork figure. *Stephanie*, the catalog notes, is a portrait of model Stephanie Seymour commissioned by her husband, publisher and art collector Peter Brant. "In an obvious visual pun," the catalog goes on, "Seymour becomes a literal trophy and the culminating piece of Brant's collection." Is this satire with a feminist edge, or something Brant (and perhaps Seymour, too) simply accepts as the way of the world—their world, anyway? Take your pick, but if "the portrait is most remarkable as a monument to Seymour's and Brant's good humor," as we are told, I don't want to share in that humor; it sounds too much like another name for repressive tolerance. And so I hereby withdraw the joke about the horse.

* * *

The timing of the Guggenheim exhibition, and of Cattelan's purported retirement, could not have been better. Over the past couple of decades, with so much art devoted to the critique of authorship, it seemed as if art had finally been demystified. It was no longer a special calling but simply a kind of job, though not necessarily one just like the others, because the artist is still a peculiar kind of worker, what Jasper Johns once called "the elite of the servant class"—a courtier. Cattelan has been one of the most brilliant and successful artist-courtiers. His success has been the measure of his ambivalence, to be sure. How could it be otherwise? His work seemed to fit the new class structures that were being patiently put into place just around the time he was opening his eyes to art. But with rebellions against those structures sweeping the world, this manner of having it both ways, of being the critical insider, may not look so smart anymore.

Yet I don't think "All" closes the book on Cattelan, whether he makes any more art or not. Certainly parts of his oeuvre can be accused of flattering the plutocrats by playing on their desire to show their capacity for assimilating criticism, but that's not all he does. There are issues that divide the 1 percent from the 99 percent, and art can handle those issues—*nota bene*, from the viewpoint of either side of the divide—but it also addresses issues that concern everyone equally. Among them are death and suffering, through which we may feel our kinship not only with other people but with animals.

At times, while looking at this exhibition, I couldn't help thinking of Robert Bresson's *Au hasard Balthazar*, a strange film in which a long-suffering donkey is finally shown to be a kind of saint through its endurance of work and pain. I know this allusion will seem absurd to those who revere Bresson as a saint of cinema, a paragon of formal and spiritual purity, whereas Cattelan seems to be a mocker, a wiseguy. But when I look at that *Novecento* hanging in the Guggenheim—it was once the hide of a living thing named Tiramisu—I can't persuade myself to believe that Cattelan is kidding, no matter how sophisticated I might be if I could. The same goes for *Not Afraid of Love* (2000), the sculpture of a baby elephant trying to hide under a white sheet with tiny eyeholes and one great big hole for its trunk. Its alarmed little eyes—do artificial eyes really have expression, or is this my illusion?—can only, I imagine, be those of a certain Cattelan in the moment when it occurs to him that his art of evasion, his eternal *Torno subito*, can never disguise him for long. For Spector, the white sheet with the holes conjures up visions of the Ku Klux Klan and their robes. I take her point, but I can't quite see it like that. I think of the similar-looking robes worn by Catholic penitents, most notably by the Nazarenos of the Holy Week processions in Seville.

Cattelan's art is full of the imagery of Catholicism, just as Bresson's was. His mother's piety must have left its mark on him.

In another Bresson film, the main character, a self-righteously rebellious young man, gets into a political conversation with someone on the bus, and passengers nearby chime in with opinions. "It's the masses who determine events," says one. Another asks, "So who is it that makes a mockery of humanity? Who's leading us by the nose?" A third passenger responds, "The devil, probably," as the bus crashes. Cattelan may have stepped off the bus just in time.

2012

6

A Million Little Pictures:
The Pictures Generation

"On Saturday, September 30, 1967," as the artist Robert Smithson was careful to specify, he embarked on the forty-minute trip from the Port Authority Bus Terminal to his hometown. He was about to undertake what in his now famous text—it's not clear whether it should be called an essay or a story; perhaps it's best to call it an artwork made of writing and pictures—he would call "A Tour of the Monuments of Passaic, New Jersey." The monuments in question were things like concrete abutments for a highway under construction or a pumping derrick connected to a long pipe. As he stepped off the bus at his first "monument," a bridge connecting Bergen and Passaic counties across the Passaic River, Smithson writes,

> Noon-day sunshine cinema-ized the site, turning the bridge and the river into an overexposed *picture*. Photographing it with my Instamatic 400 was like photographing a photograph. The sun became a monstrous light-bulb that projected a series of detached "stills" through my Instamatic into my eye. When I walked on the bridge, it was as though I was walking on an enormous photograph that was made of wood and steel, and underneath the river existed as an enormous movie film that showed nothing but a continuous blank.

Writing in a tone derived in part from the deceptive objectivity of the French *nouveau roman* (he quotes from *Mobile*, Michel Butor's collage-travelogue of the United States) and in part from British new-wave science fiction (he entertains himself on the bus ride with the *New York Times* and Brian Aldiss's dystopian sci-fi novel *Earthworks*), Smithson evokes a vacant reality made only of "memory-traces of an abandoned set of futures." Critics fascinated with Smithson's apparently post-Duchampian idea that banal realities become art simply by being looked at a certain way—that

"a great artist can make art simply by casting a glance," as he would write a year later—have often overlooked the way Smithson framed his saturnine view of postindustrial culture through the eye of the camera. His alienation allows him to perceive that things, made or natural, are mere photographs of themselves, and that these photographs are essentially "stills" excerpted from the film that is time. Rereading "The Monuments of Passaic," one begins to wonder whether the grainy snapshots with which Smithson illustrated his text are secretly not photographs of the monuments but in fact the monuments themselves. For Smithson, the image is always of something that was already an image. Artists have perennially had the feeling that they are merely the channel for something that is already art, but Smithson's notion of sunlight pitching images into his eye through the camera is a peculiarly Gnostic or paranoid version of it, with a visceral punch characteristic of a contemporary of William Burroughs, J. G. Ballard, and Philip K. Dick.

Smithson died in a plane crash in 1973 at the age of thirty-five, so he could hardly have been part of the exhibition now at the Metropolitan Museum of Art, "The Pictures Generation 1974–1984," which is devoted to a loose-knit group of artists mostly born around ten to fifteen years after him—the first wave of baby boomers, if you like, the first generation to grow up with (black-and-white) TV. And he is barely even mentioned as an influence on this group in the extensive catalog essay by the exhibition's curator, Douglas Eklund, who imagines Smithson as an artist of "cataclysmic processes and sublime vistas of the natural world," as distinguished from these younger artists who were more immersed in "the media culture of movies and television, popular music, and magazines, which to them constituted a sort of fifth element or prevailing kind of weather." Eklund nominates Smithson's contemporary John Baldessari, a smaller artist but a legendary teacher, as the Pictures group's honorary *chef d'école*. Yet Smithson's ghost lingers everywhere in the show, and as ghosts tend to do, it lingers mostly to reproach. What a work like "The Monuments of Passaic" shows so clearly is that, for Smithson, nature and the image-apparatus were one and the same, and to see is always to see a mediated image. Some of the works in "The Pictures Generation"—most of the best ones—are based on the same premise. But too many of them really do seem to have believed, as Eklund does now, that their work should be concerned with "media culture" as a self-contained area of research, and their work is all the narrower for that.

<p style="text-align:center">* * *</p>

"The Pictures Generation" takes its title from a famous exhibition of 1977—
"famous" in the sense that many more people remember it than ever really
saw it. The original "Pictures" took place at the nonprofit gallery Artists
Space in New York City, and was further publicized by a couple of articles
its curator, the critic Douglas Crimp, published in *Flash Art* and *October* in
1979. Of course, the Met show is far more than a rerun. Crimp exhibited
the work of just five artists (Troy Brauntuch, Jack Goldstein, Sherrie Levine,
Robert Longo, and Phillip Smith) whereas Eklund's "Pictures Generation"
encompasses nearly thirty—among whom Smith, by the way, has gone
missing without the slightest explanation. There's nothing wrong with that
in itself because Smith's work, a more traditional kind of painting, really
does seem to have been on a different track. But it's unfortunate that a
reader of the catalog might easily be left unaware that Smith had ever been
included.

That's just one example of how Eklund, having amassed a vast amount
of information on his artists and their milieu, has organized it haphaz-
ardly. The catalog is a rarity in being blessed with an index, but if you
look up "Pictures" in it you will find, perversely enough, multiple refer-
ences to "artists not included in," but no entry to point you to a page
that says who was included in the 1977 show. Basically, though, Eklund's
loose-knit Pictures generation consists mainly of two distinct groups of
artists. One was made up of former students of Baldessari's at Cal Arts
who had moved east to New York. The other group, less academic in
formation and more working class in origin, had gathered around the
artist-run space Hallwalls in Buffalo before migrating downstate. There,
both groups gravitated to Artists Space and the downtown art and music
scene, and some of them began to show with the commercial gallery
Metro Pictures, co-founded by the former director of Artists Space,
Helene Winer, in 1980. Its opening was immediately and presciently seen
by the critic Robert Pincus-Witten as "definitively" marking "the death
of the '60s" (as though the intervening decade had merely been an
extension of it).

Pincus-Witten's judgment should raise suspicions when we read Eklund's
summation of what constitutes the rough unity of the Pictures group: He
attributes it to their shared indebtedness to the art of the '60s: "They synthe-
sized the lessons of Minimalism and Conceptualism in which they were
educated, with a renewed (though hardly uniform) attention to Pop Art
because it chimed in with the new, media-driven world they had inherited."
Maybe, but if all that was at stake in the work of the Pictures generation

was an effort to tie up a tidy little semiotic package out of the unruly and contradictory impulses of an older generation, it's not likely anyone would be taking the trouble to re-examine their work today. Opening the exhibition up to encompass so many artists was a good decision in that it helps recreate a sense of context, but a more stringent selection focusing on, say, ten central figures—Brauntuch, Goldstein, Levine, and Longo, plus Louise Lawler, Allan McCollum, Richard Prince, Cindy Sherman, and James Welling—would have allowed for more specificity. One might then have said that the Pictures group had gleaned from the Minimalists and Conceptualists a sense that art should assume an incommunicative, pugnaciously neutral stance—that it should throw down the gauntlet of its own incomprehensibility. The public's inability to find anything to see or any evidence of work or meaning in, say, a row of bricks by Carl Andre might be repeated in its encounter with Levine's photograph of a photograph by Walker Evans, or one by James Welling showing some crumpled foil. But this willingness to use recalcitrant inconsequentiality to frustrate the viewer's desire might be all they have in common.

As for Pop, the Pictures group has something in common with that, too: the idea that images are out there for the taking, that art is not necessarily about creating a new image but about seeing existing ones differently. And yet the sense of the image, or of what to look for in it, is different: Pop was more about the signal, Pictures more about the noise; Pop was hi-fi, Pictures low-fi. Above all, the Pop artists found a kind of liberation in the discovery that their art was already out there in the world, hidden in plain sight. To the Pictures artists, intent on cultivating their disillusion, such optimism would have seemed naïve; at most they could hope to "turn the lie back on itself," as Prince once put it. Andy Warhol said, "Just look at the surface of my paintings and films and me, and there I am. There's nothing behind it." For Prince and company, there is something behind the surface, and it's another, creepier and more disquieting surface. Sometimes that other surface can be identified as a form of ideological manipulation, and when it is, the resulting work acts as a form of demythologization, sometimes verging on agitprop or satire. Barbara Kruger ruthlessly pursued this approach, fashioning found images overlaid with blunt slogans, such as YOUR GAZE HITS THE SIDE OF MY FACE, or YOUR MOMENTS OF JOY HAVE THE PRECISION OF MILITARY STRATEGY, that seem to address the (often implicitly male) viewer as an antagonist. But with a kind of implacable scorn, Kruger asserts total control over the interpretation of the image which is meant to be demythologized,

its hidden presuppositions unveiled, which is why I don't place her among the artists central to the Pictures sensibility.

Those artists, for the most part, veer away from this kind of claim to decode the image (Lawler being a partial exception). Typically, the Pictures artists work from the assumption that it may not be possible to offer a clear ideological interpretation of what we see. If "images compose our preconceptions and expectations of the possible, and that sense we are their product," as Welling conjectured in a dialogue with David Salle, then it must be (as the dialogue's title had it) the "images that understand us," rather than vice versa. Like Smithson, Welling and Salle, along with other Pictures artists, are fascinated by their own passivity with respect to the images that willy-nilly flow through them.

Sometimes the line between understanding pictures and being understood by them can be hazy, however. Consider Sarah Charlesworth's *April 21, 1978* (from the series *Modern History*), which reproduces the front pages of European and North American newspapers for that day, but with everything erased except the paper's banner and photos—no text. On April 20, the Italian Red Brigades had released a photograph of Aldo Moro, the kidnapped Christian Democrat politician and former prime minister, holding up a copy of the newspaper *La Repubblica*, thus proving that he was still alive. Each of the April 21 newspapers shows this image, but always differently cropped (sometimes excluding everything but Moro's face, sometimes including the Red Brigades banner behind him), and at a different scale, sometimes (as with the Italian newspapers *Il Messaggero* and, of course, *La Repubblica*) as the only front-page picture, sometimes (as in the Danish *Politiken* or the Canadian *Globe and Mail*) as one of a multitude of small images. Charlesworth's work is undoubtedly intended to reflect, as Eklund says, the semiotic investigations of the early Roland Barthes, but how informative is it really to discover that the Italians give much more weight to the kidnapping of one of their leading politicians than do the Danes? As a demonstration of how an image produced by a revolutionary terrorist group in order to manipulate a precise political situation is manipulated in turn by various news organizations for their own purposes and then manipulated again, presumably for more disinterested ends, by Charlesworth herself, the work is effective but thin. (For Charlesworth, the news organizations become authors of the image in turn, just as an artist like Levine did by rephotographing a classic art photograph.) The work's simple didactic content seems, in retrospect, less like a raison d'être than an alibi. What

gives the piece its real fascination, for anyone who takes the bait of the grim and (as always in Italy) unfathomable story behind the image, is how the seemingly endless multiplication of the Moro photograph, always differ-ent but always the same, takes on its own logic, endlessly relaying the melodrama of the situation while rendering it ever more unreal—and how the artist has allowed herself to become one more relay in this circuit, not its diagnostician.

This fascination with the endless self-propagation of the image reaches its apotheosis, curiously enough, in a work that might seem to have no images in it at all. Allan McCollum's *Plaster Surrogates*, made between 1982 and 1984 and most spectacularly displayed in 1983 at the Marian Goodman Gallery, are hundreds upon hundreds of rectangular objects (there are forty at the Met) made of enamel paint on hydro-stone. They hang on the wall in very dense aggregations—way beyond "salon-style." They resemble matted and framed pictures—the frames here being one or another shade of gray, but also existing in different colors—but with the central framed "image" entirely black. Perhaps for the simple reason that they are painted, or perhaps because they derive from an earlier series by McCollum called *Surrogate Paintings*, I always thought of these works (and this is how they have usually been discussed) as a commentary on painting. The painter and critic Thomas Lawson, whose work is also included in the show, approvingly called them "little model paintings" in an *Artforum* review of McCollum's show at Goodman, "surrogates for painting with little in the way of individuating character." But seeing them here, in the context of an exhibition that is overwhelmingly of photographs and in which painting is quite rare, the impression was rather that these were surrogates for photographs, the whole manner of matting and fram-ing that the pieces mimic being typical of art photography. The black of the central rectangle would then make sense as an exaggeration of that in black-and-white photographs—as if these were radically underexposed. Even more than Charlesworth's front pages, McCollum's installation seems to give itself over to an obsessive desire to encounter the same image over and over again, to see it as always potentially different, always potentially ready to give up its secret—even if it has no secret and can hardly even be thought of as an image, or perhaps all the more so if minimum information equals maximum mystery.

A lot of the work in this show wants to be mysterious, but too much of it depends on having a sovereign, unacknowledged commentator whispering in your ear to point out what's mysterious about it. Among the images

making up Brauntuch's photographic triptych *Untitled (Mercedes)* (1978), is one of a man's head, slumped over as if asleep, in the passenger seat of a car—an image that is a tiny component of a work that is mostly blank, but hieratic and altar-like in its configuration. The work's undeniably creepy overtones are inseparable from its muteness, but what becomes of that muteness when one learns from the catalog that the man in the image is Hitler, the photograph having been taken from Albert Speer's book *Inside the Third Reich*? It suddenly seems like cheap manipulation. Craig Owens— who along with Crimp was the main critical advocate of the Pictures group—observed of similar works that "whether or not we will ever acquire the key necessary to unlock their secret remains a matter of pure chance, and this gives Brauntuch's work its undeniable *pathos*, which is also the source of its strength." But it never was a matter of chance; acquiring the key was always a matter of being deliberately clued in—wink, wink—and this is part of the work's bad faith.

But I don't want to end on that sour note. Cindy Sherman's *Untitled Film Stills* (1977–80), are undoubtedly the best-known images here, and deservedly so, for familiarity has not extinguished their complexity or freshness. In Sherman's pictures it is not the photograph itself so much as its subject— who in turn partakes of the image-reality—who is at once always identical and always different. Sherman reappears in endless, anonymous walk-on roles—the girl waiting for a ride on the lonely roadside, the scuba diver, the sexy babe staring out the window waiting for someone who may never come, and so on. Each of Sherman's reappearances in these photographs seems to be as someone whom we've seen before and whom we will certainly see again, more or less, in some other B-movie. Yet if each is a stereotype, it's one we get too brief a glimpse of to be able to put a definite name to.

"It is important to remember how unassuming and even mysterious they seemed in the beginning," Eklund rightly cautions, and this show succeeds almost too well in putting Sherman's stills back into the context from which they emerged—just a few more gray and grainy photos in an exhibition full of them, each as indifferent as the next to the traditional love of clarity of form and dramatic tonal range as guarantees of photographic art. Yet Sherman's, if you look again, have a power the others lack, because she is neither offering a critique of the image nor simply indulging her fascination with it. Smithson ventured into the postindustrial landscape and discovered that its ontology was that of an image; Sherman broached

the terrain of personal identity and discovered something similar. In doing so, she seems to be showing us something about ourselves, not just about images as a category separate from ourselves. Hers really are "images that understand us."

2009

A Makeshift World: Thomas Demand and Bettina Pousttchi

Just as the act of using a computer comes with an implicit advisement—RTM, read the manual, or, less politely, RTFM—so any serious engagement with contemporary art comes with a like directive, RTC: read the catalog.

For many, I know, that practice is more honored in the breach than the observance. Rumor to the contrary, art catalogs are in general somewhat clearer and better written than computer manuals, even if they are probably a lot less cogent than they should be. Boris Groys has argued that the fact that no one reads most art commentary, as he calls it, should be taken as one of its great attractions for the writer: "For this very reason one can, in principle, write whatever one wants." I hope it's not quite true that no one reads it, for today one can't simply be a *viewer*, as we habitually call the addressee of contemporary art. To see a work without a sense of the commentary around it—its linguistic framing—means blinding oneself to where its edges are, to where the work leaves off and reality begins—to the work's position in the world.

All of which amounts to a circuitous admission that my first view of Thomas Demand's exhibition at the Neue Nationalgalerie in Berlin was constrained by my neglect of an important part of its verbal framing—and this despite the fact that there have been few exhibitions of photographs in which writing is so prominently featured, though never in the photographs themselves. And believe me, I did read the texts so prominently and atypically displayed in the gallery—about which more later. They also constitute an important part of the catalog, so this was one instance in which I really did RTC right there in the gallery as I went along, and as one is meant to do. No, what I forgot to do (the purloined letter syndrome at work, perhaps) was to RTT.

If I had bothered to read the title, or at least to ponder it a bit more deeply, I might have been saved the puzzlement that I experienced when I wandered downstairs looking for the men's room and passed a bulletin

board festooned with local press clippings about the exhibition. Stopping for a quick look, I was bemused by the slant the German papers had given their coverage: it seemed they all saw the show as the artist's meditation on his and their homeland. "Demands Deutschland," read the headline in *Die Welt*. Likewise *Die Zeit* headed its report "Modell Deutschland" and the *Tagesspiegel*, "Deutschland, deine Bühnenbilder" ("Bühnenbilder" means stage scenery, but here it is a play on words: *Bilder* are pictures, images, and Demand's photographs are indeed staged images, albeit without actors). Other publications saved mentioning Germany for the subhead, where it could be conveyed in more than two or three words: "Thomas Demand blickt auf Deutschland" (*Berliner Morgenpost*); "Die Neue Nationalgalerie präsentiert Demands Deutschlandsbilder" (*Berliner Zeitung*). Only as I scanned these articles with my weak German did I cotton on to the fact that Demand's exhibition had a title, cunningly disguised as its location: "Nationalgalerie." This was, I should have understood, Demand's exhibition about or, better yet, of his country.

Demand is sometimes mistaken for a member of the "Becher school," whose best-known figures are Andreas Gursky, Candida Höfer, Thomas Ruff, and Thomas Struth, a group of somewhat older German photographers so called because all of them studied under Bernd and Hilla Becher at the Düsseldorf Art Academy. Demand, who was born in Munich in 1964, left Düsseldorf (where, studying sculpture, he did not work with the Bechers) in 1992, and in the years since he finished his MA at London's Goldsmiths College in 1994 he has become one of the world's leading photographers. "Nationalgalerie" follows big shows of his work in London (Serpentine Gallery, 2006) and New York (Museum of Modern Art, 2005), among others. The monumentally scaled images of the Becher school are typically hyperbolically detailed— their macroscopic dimensions proffering a plethora of microscopic particulars, whether of faces, streetscapes, library interiors, or factories. While it has often been noted that the massive size of Becher-school photographs gives them something like the impact of a painting—whereas traditional photographic prints were indeed prints, demanding the kind of intimate engagement suitable to an etching—large-scale modernist painting, from Matisse through Barnett Newman to Alex Katz, had always favored the elimination of detail. The Becherians, by contrast, multiply details ad infinitum. And though none of them should be taken for mere technicians, the fact remains that, in looking at their work, one can never be unaware of the technical achievement involved in lending the camera a sort of superhuman eyesight. Their work

is often called cold and objective. No wonder, when it seems to lend the human eye the powers of a microscope, even when scanning a distant horizon.

Demand's photographs are nothing like that, despite their equally grand scale. And one would not call him a brilliant photographic technician, which is perhaps not surprising since he came to photography through sculpture. You don't look at his pictures to marvel at his subtle handling of light, incredible control of focus, refined mastery of tone. In fact, he seems deliberately to cultivate the sense that things are ever so slightly over-lit, that just a little bit less of the scene is in perfect focus than might have been possible, that the image could have been rendered with greater crispness and definition. Not that he cultivates the look of the amateur snapshot: nothing seems accidental or haphazard here. But rather than availing himself of the camera's potential for an inhumanly penetrating apprehension of surfaces, he evokes what one might call a normal, technically competent but unfetishized mode of looking. The photographs pretend to be a little less carefully made than they really are.

While the manner of looking appears to be normal, the same cannot be said of what Demand gives us to look at. He shows ordinary things, but not real ones. As is well known by now, all of his photographs are taken in his studio; employing existing photographs, usually from the media but sometimes his own, as his sources, Demand uses paper, cardboard, cellophane, and other flimsy, everyday materials to construct full-scale replicas of actually or formerly existing places. (At least they're said to be full-scale, although there are a few cases where this seems impossible: *Fabrik* ["Factory"] [1994], for example.) These empty stage sets are what we see in the photographs. The reconstructions follow the general lineaments of their originals, but with most detail eliminated. In particular, every trace of language has completely vanished: the papers strewn across the work table and floor in *Büro* ("Office") (1995), have no text on them; the labels next to the doorbells that are the subject of *Hinterhaus* (2005), are variously colored but bear no names. (Even the work's title bears no direct translation; one dictionary explains that it refers to "part of a tenement house accessible only through a courtyard and thus considered inferior.") In general, since everything in the photographs has been newly built, nothing shows any signs of wear, any smudges or defects. Each thing has become a sort of abstraction of itself. In this, Demand shows more affinity with the tradition of grand-scale modernist painting than with other recent German photography.

And yet a few important details are visible in Demand's images—details not of the things depicted, but of how they've been reconstructed. This is the real reason why the pictures must exist at this scale—because if they were the size of classic photographs, it wouldn't be clear enough that they show a world made of paper. Demand has made a small number of more modestly scaled works, mostly still lifes, and they are among his best, but the things in them are shown at the same size they would have in any of his other photographs. Always, things appear as makeshift replicas. These images construct illusions only to deflate them. The image is empty, and eerily disinfected, and Demand makes sure you know it. You see the seams in every wall, the folding of the corners of the furniture. These are two-dimensional pictures of three-dimensional pictures based on other two-dimensional pictures of the real world. And how real is that, anyway? I suddenly feel like I've lost track.

An ambivalent relation to the reality that much photography earnestly aims to record is central to Demand's work. The titles, like the ones I've already mentioned, are clipped, tight-lipped; divulging minimal information, they underline the work's tendency to abstract itself from and generalize the source image, to present an almost platonic idea of, say, a kitchen (*Klause 3* ["Tavern 3"] [2006]), an Olympic diving board (*Springturm* ["Diving Board"] [1996]), an architectural office (*Zeichensaal* ["Drafting Room"] [1996]), or whatever. Nevertheless—and here's where the injunction to RTC comes back to haunt us—Demand has always let it be known that his images represent very particular places. While some of these places may be of merely personal interest, others are historically fraught. Consider *Raum* ("Room") (1994): It depicts a white-walled, low-ceilinged place with blackened windows—but entirely wrecked, the platonic idea of a shambles. For anyone familiar with the history of photography in recent art, it is impossible not to see *Raum* as something of a homage (but perhaps also a retort) to one of the touchstone works of the new large-scale photography typified by the Becher school, Jeff Wall's *The Destroyed Room* (1978), the first of the Canadian artist's "cinematographic" (his own term) lightbox transparencies.

But the textual penumbra around *Raum*—for instance, but not only, as represented by the catalog essay for this show, by the British art historian Mark Godfrey—makes one aware that this is not just any ruined room, and that in making the work Demand had other things on his mind along with his stance toward an important precursor. *Raum*, Godfrey discloses,

* * *

is based on a picture of the bombed-out remains of Adolf Hitler's head-quarters following the failed assassination attempt of July 1944. As much as the picture shows a key event in German history, so, too, it has been associated with the history of the cultural reception of Nazism in post-war Germany: it was published in many school books in the 1970s as it illus-trated (with undue emphasis) that some resistance to Nazism had existed during the war.

Any visible sign that this place has anything to do with the war, with Germany, with Hitler, has been systematically removed. You won't find any telltale swastikas half-hidden amidst the debris, no matter how hard you look. Nothing indicates a temporal location in the 1940s. Walter Benjamin famously observed that Eugène Atget photographed Paris as if it were the scene of a crime; Demand meticulously scrubs away all evidential significance from the scenes he depicts. He utterly defeats the forensic gaze. But that doesn't necessarily mean that no crime has been committed, or if one has, that it can't be solved; just that one can never know simply by looking, no matter how hard. Godfrey informs us that *Spüle* ("Sink") (1997), is based on the basin full of unwashed dishes in a friend's house. Of course, they are the cleanest, shiniest unwashed dishes you've ever seen. This piece is one of the rare exceptions to the generally bland—uncannily, hauntingly bland—affect of Demand's work, maybe because of the acute high angle from which it was taken. Who stares down at a sink full of dishes like that? Myself, I try not to look at them too hard even while I'm washing them. Gawking into the sink's mirrored depths—that is, its mirrored surfaces—one might well be looking for the absent clue to a crime. Terrible things can happen in our friends' houses, too.

The ambivalence toward writing that characterizes Demand's photogra-phy—ostentatiously driven out of the image itself, language hovers portentously around it—is a product of the very delicate balance he is trying to strike between the viewer's knowledge and ignorance of the source of his motifs. For the most part he succeeds. It's not really important that the viewer know in any particular case where the image comes from; but it is important that in the back of one's mind there lurks the possibility that the image might refer to something of historical significance. The secondary status of this knowledge is signaled by the fact that Godfrey's explanatory essay, instead of introducing the catalog as it usually would, is placed at the back of the book, after the images, and is numbered separately as well, and printed on different paper, like an insert. Of course there's

something artificial about putting the text in quarantine this way, but it makes the point.

That's not to say the catalog entirely downplays writing. Demand has added a sort of intermediate layer of text, between his own one- or two-word titles and the art historian's essay: each photograph is now accompanied by "captions" contributed by the prominent playwright and novelist Botho Strauß. The captions modulate fluently between narrative and essayistic registers without ever directly addressing the pictures they accompany; Hitler is mentioned in the caption for *Raum*, but since Strauß does not convey the backstory or mention the image's source, the unprepared (non-German) viewer will be none the wiser. As well as appearing in the catalog, which is designed so that the reader encounters the caption first, only then the image, these texts are presented in the Neue Nationalgalerie on a nearly equal footing with the images, printed in oversized books laid open to the appropriate page in heavy wood-framed vitrines next to each photograph—all enveloped in a simultaneously understated and theatrical exhibition design by the British architectural firm Caruso St. John. Some three miles' worth of gray curtain material has been used to shadow and subdue the museum's classic Mies van der Rohe architecture while nesting the cool artifice of the photographs within a second layer of artifice. The museum itself could almost be the set for a Demand photograph.

On my second take of the exhibition, after sighting the telltale bulletin board, what struck me was how not-wrong I'd nevertheless been in failing to notice the Germanness of Demand's Germany the first time through. Eliminating all that detail from his imagery, and especially eliminating writing, effects a sort of displacement or dislocation; it takes things out of their places, transferring them to a purely mental realm.

Still, the tacit nature of this work's Germanness is striking in itself. Imagine walking through an exhibition by Joseph Beuys devoted to the idea of the German nation without having to notice that this is the theme. Impossible. For Gerhard Richter, even more impossible. With Sigmar Polke, Hanne Darboven, Anselm Kiefer, Isa Genzken, or Martin Kippenberger, for any of the photographers of the Becher school, too, a reflection on Germany and the traces of its history in the present could only be patent, unavoidable. Is this Demand's lesson: that Germany is now no different from any place else, that it is at last a normal, self-confident European nation like any other, unburdened of the memory of its historic tragedies, free of the guilt and resentment that have weighed so heavily on his precursors? Has the

effort of *Vergangenheitsbewältigung*—coming to terms with the past—a process as cumbersome as the word itself, either been completed or simply fizzled out?

It would be tempting to jump to such a conclusion, all the more so because of Strauß's role in the project. Strauß took a blatantly reactionary stance in the debates that raged on this subject around a decade ago, as the culture continued to contend with the repercussions from the *Historikerstreit* ("historians' quarrel") launched by Ernst Nolte in 1986. In a notorious article of 1993, Strauß expressed all too clearly his sympathy for xenophobia, decrying those—supposedly the left—who, he said, "are friendly to foreigners not for the sake of the foreign but because they greet, due to their wrath against what is ours, anything that destroys what is ours."

But what counts as destruction, and what counts as "ours," depends on your viewpoint. In 2003 the German parliament voted to demolish the Palast der Republik, the grandiose seat of the former East German parliament (but also, amazingly enough for us who are accustomed to official buildings being off-limits to the public except under the tightest security controls, a kind of municipal leisure center), which had been closed since 1990, in order to replace it with a replica of the Kaiser's castle that had once occupied the spot. The German parliament sought to efface part of Berlin's living history in favor of a sham historicism. Nothing that belonged to the GDR, according to powerful elements in Germany today, could possibly be "ours." In the meantime, a provisional building sits on the site, Temporäre Kunsthalle Berlin, with a two-year mission to showcase contemporary art—inside and out, for the building's façade as well as its interior is being given over to artists' use. Ah, Germany! Where else would it seem reasonable to use some of the country's most ideologically contested terrain as an artistic proving ground? At present, Bettina Pousttchi, a Berlin-based photographer and sculptor, has turned the building into a sort of three-dimensional billboard, all four sides of it being covered (through February 2010) with a sort of digitally processed abstraction of the façade of the Palast der Republik, which she has titled *Echo*. It's as though the ghost of the old edifice had returned to haunt its former site, strangely transformed but still recognizable—and with the image of a clock substituted for the coat of arms of the GDR.

Usually, when we say a photograph is *of* something, that little word "of" means that some light from the object was reflected through the camera's lens to leave its traces—there is an indexical relation between the thing and the photograph. Demand's *Raum* is not "of" Hitler's headquarters in that sense; nor is *Spüle* "of" his friend's sink. What his work asks is, among other

things, whether and how photographs can be about things that they are not of. Is Demand's work a reflection on the things that his source photographs are of—on Germany, let's say—or is it an effacement of those things, a way to "erase the traces," as Brecht once put it? To choose either position seems equally facile. Pousttchi's *Echo*, on the other hand, really does derive in part from photographs of the Palast der Republik, but the photographs have been so heavily manipulated that initial indexical relation has been reduced to a merely homeopathic quantum. The relation of "ofness" has nearly disappeared. It's the beholder who puts it back.

Like Demand, Pousttchi is concerned with history and memory—or its loss. *Echo* has a representational specificity that Demand usually eschews or effaces, to be sure, and rather than generalizing her source material by eliminating details, Pousttchi has introduced a new element of visual noise into the image by adding horizontal lines to it as if it had been shot off a TV screen. But the two artists seem to be in accord in wanting to convey the feeling that we don't really understand what we're seeing—something is amiss and it's up to us to put our finger on it. That's why I continue to think that, his temporary alliance with Strauß aside, Demand is not attempting to confer a false normality on his country's history. He's availed himself, as Pousttchi has, of an image-maker's right to let the image stand clear of the discourse around it, the discourse that goes into it, and the discourse that comes out of it, and insist on its sibylline reticence. Read the catalog, and certainly read the title, but remember that they only take you so far. Berlin is like any other city, Germany is like any other country, but precisely because they are haunted houses. You know a revenant is near when you feel a chill.

2009

8

Showing, Saying, Whistling: Lorna Simpson and Ahlam Shibli

The old saw that a picture is worth a thousand words may still be true, but it always takes at least a few words to unlock the meaning, to let the picture tell its story. And a different word will make for a different story, a divergent meaning. Artists have been worrying for a long time about the peculiar relationship between pictures and their captions, between showing and saying, and because the relationship is always in flux, the worrying isn't likely to stop.

The American artist Lorna Simpson has been exploring this quandary since the beginning of her career, and an early piece like *Twenty Questions (A Sampler),* from 1986, is typical. Four seemingly identical black-and-white photographs—tondos rather than rectangles—show the back of the head of a young black woman who is wearing a simple white, sleeveless outfit against a black background. It is often assumed that the face turned away from the viewer is Simpson's. It is not. But this may be one of those instances where misidentification—an explicit concern of her work—carries its own kind of truth. If artists like Cindy Sherman can use themselves as models in order to represent other people, who can say for sure that using other people as models is not a way of representing oneself? At the Jeu de Paume in Paris, France's national gallery of photography and media art, where Simpson's work is on view, the title of *Twenty Questions (A Sampler)* is displayed on a white-on-black plaque—the kind you can have made in a hardware store to mount on a door, for instance—on the wall above the photographs. Lined up underneath the four images are five more plaques: IS SHE PRETTY AS A PICTURE / OR CLEAR AS CRYSTAL / OR PURE AS A LILY / OR BLACK AS COAL / OR SHARP AS A RAZOR. The words are big enough to be viewed at a distance.

Twenty Questions (A Sampler) isn't simply a set of photographs in black-and-white. They are, so to speak, emphatically black and white, using photography not only to evoke issues of race but also to explore the relationship between

the black-and-white of the image and that of the text. The words are what's "seen" and the image what's "read"; as Simpson once said of the figure in another of her works from the same year, *Waterbearer*: "I wanted people to see that woman as she sees herself, which is to say, as herself, declarative." In other words, in the form of a statement, a sentence.

The same image can be interpreted through any number of similes, but the fact that there are five captions for four photographs graphically under-scores the lack of a snug fit between text and image. This numerical mismatch between images and captions is a recurring device with Simpson. In a piece from 1988, *Five Day Forecast*, there are five black-and-white images, of presumably the same black woman wearing presumably the same white shift, standing, arms crossed, against a white background. This time she is shown from the front, but only from the neck to the hips. Above each of the five photographs (more or less where the face would be, as if, instead of making identity declarative, the artist is showing how the declarative can take the place of personal identity), a plaque names one of the five days of the work-week. Below the images are ten more plaques, bearing the words MISDESCRIPTION / MISINFORMATION / MISIDENTIFY / MISDIAGNOSE / MISFUNCTION / MISTRANSCRIBE /MISREMEMBER / MISGAUGE / MISCONSTRUE / MISTRANSLATE. Five images might only be one image, but they can generate at least twice as many forms of misrepresentation. A good warning for art critics, that—and for anyone else who thinks it's easy to put words to what one sees.

Simpson is the quintessential studio photographer, an artist who constructs the situations she depicts in order to convey no more information than what she intends the viewer to perceive. Ahlam Shibli, a Palestinian photographer whose exhibition "Phantom Home" is being shown at the Jeu de Paume concurrently with Simpson's, is something else altogether: a documentarian, the kind of photographer who goes out into the world to find her subjects, and therefore starts with the superabundance of things as they are. Her show brims with a visual messiness and pictorial complexity that testify to the messiness and complexity of the world itself. Like Simpson, Shibli regards the words she attaches to her images as integral to her work. But whereas Simpson sometimes uses words as graphic elements whose visual impact is concomitant with that of her images, Shibli's are more conventionally presented on small labels adjacent to the photographs; you have to move in close to find out what the pictures are "of" and then step back again to take in the pictures themselves. Reading

and looking are two separate activities; they cannot be done simultaneously.

But that doesn't mean the words are less significant than the images. A prominent sign in French and English advises viewers, regarding the largest series on view, *Death* (2011–12), that "All of the photographs in this series are accompanied by captions written by the artist that are inseparable from the images." If the management of the Jeu de Paume had hoped that the notice would be sufficient to inoculate Shibli's work from any of the ten varieties of misrepresentation identified in Simpson's *Five Day Forecast*, it must have been quickly disabused of that notion. Although *Death*, along with the rest of "Phantom Home," had already been presented without incident at the Museu d'Art Contemporani de Barcelona (MACBA), in Paris it generated a storm of protest. The umbrella group for French Jewish organizations, CRIF (Conseil Représentatif des Institutions Juives de France), denounced it as "an apology for terrorism," while an Italian writer on a website identified with the Israeli settler movement called for vandalism against the museum, saying: "We must leave this deadly show in the heart of Paris in ruins." As for me, even before seeing the show, having heard that protesters were calling for it to be closed down, I had signed a petition opposing any attempt to censor it and defending "the right to free artistic expression and debate . . . through dialogue and the exchanging of experiences." A notice posted at the museum, added in response to the controversy, specifies that Shibli's work is "neither propaganda nor an apology for terrorism," and goes on to quote the artist: "I am not a militant. My work is to show, not to pronounce or judge."

Death is a series of images about images. It is an almost anthropological investigation of how the pictures of those who are deemed "martyrs"—that is, anyone whose death was a result of the Israeli occupation, including suicide bombers, but also those killed in Israeli attacks, who might have been fighters or bystanders—are deployed in public and at home in the Nablus area (the site of several refugee camps including Balata, the largest in the West Bank). While I am sympathetic to Shibli's desire to let her perceptions speak for themselves without editorializing, what's clear from these photographs is that, at least in the fraught context of the cult of martyrdom, the distinction between what it is "to show" and "to pronounce," between image and discourse, is both thin and unstable.

The images of the dead in the show do not speak for themselves; they are accompanied by innumerable words, the meaning of most of which can only be imagined by those of us who don't read Arabic, because the artist's

captions generally don't translate them. Presumably those that are translated can stand for the rest: "Many carry a weapon, but few bring it to the chest of the enemy," or "Be generous, Brigades, with the blood and bring light to the earth with your martyr heroism." In fact, it is not necessary to translate the bellicose lyricism of these texts, because the images themselves—idealized, sanctified—are imbued with it. The pictures within Shibli's pictures are accompanied by pronouncements, but they are already declarations of a sort themselves: they are rhetorical images meant to promote a cult of martyrdom. As the art historian T. J. Demos writes in the exhibition catalog, they amount to an "aestheticization of death."

When images are declarations, is it possible to make images of them without at least implicitly offering a judgment of one's own? Probably not, but even still, to identify the gist of a judgment may not be easy, all the less if the judgment is complex and nuanced, or even just ambivalent. Knowing of the endless suffering and the thousands of deaths caused by the Israeli occupation since the Second Intifada began in 2000, it is impossible not to sympathize with the Palestinians' effort "to make this daily dose of death not only meaningful but absolutely inevitable," in the words of the poet and novelist Mahmoud Abu Hashhash, as quoted by Demos. The fervor invested in memorialization is its own justification. Yet it is just as difficult not to regard this "aestheticization of death" as a despairing, nihilistic turn in the culture that supports it—an implicit acknowledgment that, despite the calls for victory over the oppressor surrounding these images, victory seems out of reach and self-sacrifice has become an end in itself. What those who decry Shibli's photographs want to censor is not, I suspect, the images within her images, the ones that glorify suicide bombers, but the way her images show the dispiriting effect of Israeli policy on everyday life in Palestine.

 In Shibli's captions, there is no overt evaluation of the cult of martyrdom. The text explains the content of the images entirely from the point of view of the people whose streets, homes, and belongings are pictured. (Only sometimes are the people themselves shown.) Here's one caption:

> The guest room of the family of Osama Bushkar with his brother and his nephew. Bushkar carried out a martyrdom operation on May 19, 2002 in Natanya. He approached different resistance organizations, which refused to equip him for the operation because he was too young. Finally the Abu Ali Mustafa Brigades accepted him. His body is still in

the hands of the Israeli authorities. The army destroyed his family's house as punishment.

The use of the bureaucratic euphemism "martyrdom operation" is striking, in part because of the implication that the ultimate purpose of the operation is martyrdom rather than any particular victory over the oppressor; of course, one imagines that the Israeli authorities must have a whole litany of equivalent bureaucratic phrases to normalize for themselves the practice of bulldozing the houses of people who have committed no crime, just as the United States conceals the practice of delivering kidnapped terrorism suspects to their torturers under the anodyne rubric of "extraordinary rendition." But, far from promoting terrorism, these photographs amount to a clear-eyed look at a society in which death has become a worthy goal because the enjoyment of life in freedom is unattainable.

Despite Shibli's seeming refusal to take a critical stance toward the representation of "martyrs"—unlike her, I can't use the word without scare-quotes because its politico-religious ethos is alien to me—it is not the case that, by re-representing this imagery, she is merely repeating its message and thereby endorsing terrorism. As a resident of the Israeli city of Haifa who has exhibited her work widely throughout the Zionist state, Shibli must know that she is just as likely to be a victim of a "martyrdom operation" as any Jewish citizen of Israel. But her support for resistance to the occupation is equally apparent, as is her endeavor to plumb as deeply as possible its effects on her people.

Rhetorical images like the ones that promote the cult of martyrdom are discursive in a particular way: they tell the viewer what to think and how to feel about what is seen. By placing them in a complex, contradictory frame, Shibli makes images that are discursive in a different way: they ask viewers to question their presuppositions, to compare their interpretations with other possible ones. These images might be called dialectical rather than rhetorical. They are anti-iconic images, and the meaning of each one arises only in relation to others in the series. There are no "decisive moments," simply moments of stasis or transition. And there are no strikingly beautiful or iconic images either; the aesthetic satisfaction of Shibli's work is contained not in the individual frame, but in the multiplicity of linkages between them.

At times, in fact, she is dialectical to a fault, as in her series *Trauma* (2008–09), made in the town of Tulle in central France. The initial inspiration for this work was Shibli's scrutiny of the commemorations of the French resistance to German occupation during World War II. After the killing of

German soldiers by Resistance fighters in June 1944, nearly a hundred male citizens of Tulle were hanged; others were sent to German concentration camps, where many of them died. Just as the Palestinians of Nablus honor their martyrs whatever the cause of death, Shibli noticed that the French commemorated the soldiers who died in Algeria and Indochina—those who fought against the efforts of others to free their countries from colonial rule—along with those who died to liberate France. Irony of this sort is hardly news; anyone who's seen Gillo Pontecorvo's great film *The Battle of Algiers* (1966) remembers the figure of Colonel Mathieu, the former Resistance fighter who encourages his men to use torture in their struggle against the Algerian rebels. But in *Trauma*, Shibli tries to encompass too many elements: the images range, as she says, across such diverse characters as "former members of the Résistance, descendants of the hanged and deported from June 9, former French fighters in the colonial wars, Pieds-Noirs, as well as an Algerian collaborator, a man who was taken to France as a forced laborer from Indochina, a second generation Indochinese, a lady of Algerian descent who considers herself French, and recent immigrants from Algeria." As a result, the thread of the implicit discourse—which concerns the hard-to-identify, easily crossed boundaries between liberator and oppressor, rebel and collaborator—gets lost in a tangle of unrelated details.

Images convey their stories—and, sometimes, fail to convey them—through both the webs of words woven around them and their own capacity to be formed and deployed in wordlike ways. And while every discourse eventually reaches a limit, there remains something beyond words. "What can be shown cannot be said," Wittgenstein famously declared. But what can neither be shown nor said can still be conveyed otherwise, for instance through music. Simpson seems to be just as sensitive to the potential of music as an accompaniment to images as she is of words. In her new three-channel video installation, *Chess* (2013), Simpson herself appears as the two opposing players, male and female, in the game of kings. The accompanying soundtrack is by the pianist Jason Moran; and just as Simpson, in her earlier photo works, treated the text as visually equal to the images, here she has treated the image of Moran making his music as the equal of her fictional chess game. In fact, Moran playing the piano is of far greater visual interest—and so, intentionally or not, the ostensible accompaniment becomes the main act.

"What we cannot talk about we must pass over in silence," Wittgenstein concluded—to which his friend Frank Ramsey added, "And you can't whistle

it either." I wonder why these philosophers were so unmusical. In an earlier video piece, *Cloudscape* (2004), Simpson more concisely evokes what can neither be shown nor said. The setup is simplicity itself: an empty, stagelike space on which a man stands, whistling. The tune sounds familiar, like a hymn. He faces upward, but unseeingly: his eyes are closed. What is in the mind's eye of this man looking upward with closed eyes? Is he one of those of whom Zora Neale Hurston once said, "Their eyes were watching God"? Perhaps, but the comfort to be drawn from a whistled hymn is not necessarily religious. Meanwhile, as the camera gradually closes in on the whistler, the space slowly fills with fog. The beautifully lit black-and-white scene is redolent of the Depression-era romanticism of a film director like Frank Borzage. When the whistler is almost obscured by fog, the footage reverses itself and the cloudscape drifts away. In this whistling of a "melancholic, ascetic, dreamy sort" (to borrow Kafka's description in "Josephine the Singer"), there is some mysterious surplus meaning whose very indefinability may be synonymous with art.

2013

II

Faces out of the Crowd

There are some secrets that do not permit themselves to be told.

—Edgar Allan Poe, "The Man of the Crowd"

Faces out of the Crowd:
The Renaissance Portrait

The voice is that of a court painter, a miniaturist, in the Ottoman world of the sixteenth century. "Two years ago," he says, "I traveled once again to Venice as the Sultan's ambassador," where he studied the portraits made by the Venetian masters. "More than anything," he continues,

> the image was of an individual, somebody like myself. It was an infidel, of course, not one of us. As I stared at him, though, I felt as if I resembled him. Yet he didn't resemble me at all. He had a full round face that seemed to lack cheekbones, and moreover, he had no trace of my marvelous chin. Though he didn't look anything like me, as I gazed upon the picture, for some reason, my heart fluttered as if it were my own portrait.

Describing the painting's setting, and its inclusion of still-life objects associated with both the sitter's way of life and allegorical themes like the passing of time, the miniaturist recalls how his mind seized upon a mystery. "What was the narrative that this representation was meant to embellish and complete? As I regarded the work, I slowly sensed that the underlying tale was the picture itself. The painting wasn't the extension of a story at all, it was something in its own right." Somehow, he seems to believe, this kind of autonomous, self-contained pictorial invention was no longer a thread in a pre-existing narrative but the secret ingredient of communicating individuality in art. "If you'd never seen that man, if they told you to pick him out of a crowd of a thousand others, you'd be able to select the correct man with the help of that portrait. The Venetian masters had discovered painting techniques with which they could distinguish any one man from another," the miniaturist marvels, "without relying on his outfit or medals, just by the distinctive shape of his face. This was the essence of 'portraiture.'"

The author I've been quoting is Orhan Pamuk, and the passage in question falls near the beginning of *My Name Is Red*. Though set in the sixteenth century, the novel and its theme of the seductive and threatening moment of encounter between cultures—or, one might say, a moment of cultural contamination—are urgently contemporary, so much so that it's reasonable to think Pamuk wants his readers to keep several questions in the back of their minds. Could a man of the sixteenth century have articulated the specificity and difference of another culture with such clarity? To what extent could he have recognized himself in the other, or anyway admitted as much to himself with such frankness? Or are we expected to notice the contemporary author throwing his voice, to observe Pamuk's own lips moving as the words tumble out of the mouth of his character Enishte Effendi?

It is possible to hear still other voices in Pamuk's words (or Enishte's, if you will), among them a singular one from the nineteenth century. The idea of the individual as the great discovery of the Italian Renaissance, and of painting as one of the primary mediums of its transmission, inevitably bears the stamp of Jacob Burckhardt, whose *Civilization of the Renaissance in Italy* was published in 1860. Don't for a minute think that this old book is out of date. One can say of it what Burckhardt said of Machiavelli's *Florentine Histories*: "We might find something to say against every line . . . and yet the great and unique value of the whole would remain unaffected." The Swiss historian's thesis that the Italian Renaissance, and especially its occurrence in Florence, was "the most important workshop of the Italian, and indeed of the modern European spirit," evokes the historical process by which "an objective treatment and consideration of the state and of all the things of this world became possible." By the same token, Burckhardt argues that the "subjective side . . . asserted itself with corresponding emphasis; man became a spiritual individual, and recognized himself as such," a belief that presides over our sense of the meaning of "the West." That Pamuk—who hails from Istanbul, where Europe and the Islamic world converge—would be drawn to the theme is hardly a surprise.

But what distinguishes the "individual" whom we meet, fresh-faced and raw, in the Italy of the fifteenth and sixteenth centuries? Is he or she a new incarnation of the human, in whom the un-individuals of the neighboring regions not only to the east but to the north could find their own reflection, though not an identical one? The remarkable exhibition at the

Metropolitan Museum of Art, "The Renaissance Portrait: From Donatello to Bellini," offers some answers, but only part of the story. For one thing, though the Met tells the story as an Italian one, it was not exclusively that. The Renaissance did begin earlier south of the Alps than to their north, but the development of art in this period was also a matter of transalpine communication. The invention of oil painting would prove crucial to the ability of painters to render more profoundly the presence of "all the things of this world," the self-standing human individual among them, and that story starts in Flanders, not Florence. And as great as Giovanni Bellini was, and however one finally wishes to define the Renaissance in art, he represents neither its fulfillment nor its end. The age-old view would be that the culmination of Italian Renaissance art came with Raphael (or, if you prefer Venetian to Florentine painting, Titian), and that its transformation into something else, something stranger and more disturbing that we have learned to call Mannerism, came with Michelangelo or Tintoretto, artists a couple of generations younger than Bellini. A story can't be understood until its ending is known, and for that reason a seemingly comparable exhibition mounted in 2008 at the National Gallery in London, "Renaissance Faces: Van Eyck to Titian," which even included a few of the same key works but within a greater temporal and geographical context, gave a fuller sense of the career of the portrait in the Renaissance.

Vivid communication of the individuality of the portrait subject, the aesthetic specificity of the artwork, and stylistic individuality—a third key concept, though unmentioned by Enishte Effendi—did not come easily to Italian artists at the dawn of the Renaissance. That's apparent in the first room of "The Renaissance Portrait," where three male profiles from Florence, all tempera on panel, hang side by side. Each impassive face, set against a dark and neutral backdrop, looks to the left and wears similar red, turbanlike headgear (called a *mazzocchio*); as the exhibition catalog notes, "the unprepared visitor . . . might think that they formed part of an extended series." Yes, differences in features are evident, most obviously of the nose. Stylistic distinctions can be discerned too, such as the way the body of one has been conceived in a more robust fashion, while in another the body is a sort of unassuming pedestal for the head. In parallel, the *mazzocchio* floats lightly on the head of the latter, while in the former the way the sitter's head bears its millinery burden contributes to his sense of dignity. But nothing of a subjective attitude, little of an inner life, transpires from the paintings. And you couldn't, *pace* Enishte, pick one of these guys out of a crowd. The three

artists who painted their portraits were still working comfortably in the medieval frame of mind, in which "Man was conscious of himself only as a member of a race, people, party, family, or corporation—only through some general category," as Burckhardt claimed. Group identity and social standing still trumped personality.

It may not be surprising that paintings so similar are attributed to three different painters—one with relative confidence to Masaccio (though the English art historian John Pope-Hennessy, for one, disagreed); the other two, with more circumspection, to Paolo Uccello (this one has often been thought to be by Masaccio as well) and Domenico Veneziano. More curious is that scholars have dated the origins of the three paintings over a fairly wide spread of years: the Masaccio is thought to be from ca. 1426–27, the Uccello from ca. 1430–40 (the catalog entry, by Neville Rowley, opens the window even wider, to "between about 1420 to 1445") and the Domenico Veneziano from ca. 1440–42. Domenico's painting is more elegant than the other two, which in turn are more imposing—but only within a very tightly constrained field of differences. Though twenty years may separate the earliest painting from the latest, the artists had no more scope to manifest greater individuality of style.

Further along in the exhibition is another trio of Florentine profiles, again left-facing, but this time of fine and fashionable ladies. (Why are left-facing profiles so much more numerous than those facing right? It's a mystery—and just as much a mystery, to my way of thinking, that it goes unmentioned by any of the scholars I've read on these paintings.) All three portraits are by either Antonio or Piero del Pollaiuolo, and are thought to be from the 1460s or '70s. Two are said to be tempera and oil on panel, the third tempera alone. I'm not sure how the mixing of tempera and oil works, but Stefan Weppelmann, in the catalog, rightly points out "a novel tactile quality" in the treatment of the portraits' surfaces—though one far from the volumetric force soon to be achieved in oil painting. The lines describing the silhouette of each woman's face are of incredible refinement. Yet with their blandly demure, incommunicative expressions, the portraits remain true to type—ravishing insofar as they approach absolute congruence with an idealized image of themselves. Whatever individuality distinguishes one from another is a matter of variations on a theme.

Compare these paintings with a couple of sculptures from around the same time, marble busts of young women, one by Desiderio da Settignano (perhaps of Marietta Strozzi, a renowned beauty) and the other by Andrea

del Verrocchio: both are animated by an inner movement that still, apparently, could not be admitted into the painted portraiture of the day. Francesco Caglioti, the contributor of the catalog entry on the Desiderio, does not exaggerate in calling it "a masterpiece of delicate sensibility, perfectly developed in the definition of volumes and the sense of vibration that marks the surfaces." In the midst of the almost heraldic painted portraits of the time, this object seems to have arrived like a meteor. The descriptive treatment of the face—and all the more so, the supporting shoulders and bodice—is restrained, with the indication of details unerringly reduced to a minimum. Yet the pose and expression are unforgettably vivid. Contrary to the determinedly straight-ahead gaze of the painted profiles, in this sculpture the slightest turn of the neck and head suffices to show this person spontaneously turning to notice something, or more likely someone. One feels that she has been addressed and is about to respond. The slightly asymmetrical hang of her hair, too, adds to the sense of movement as she cocks her head to size up her interlocutor. The ineffably complex expression on her lips—the slightest smile seems ready to break through the barrier of her reserve, though only if she decides to let it—would hardly have been outdone by the far more renowned expression that Leonardo gave to his Gioconda forty or more years later.

But beyond the observational acuity evident here—as well as in the Verrocchio, which Caglioti calls "the most intelligent and sensitive surviving homage to Desiderio da Settignano's portrait"—what should be noticed is the perfect equilibrium obtained between a lifelike sense of inner dynamism and the communication of sheer physical presence that is proper to sculpture, irrespective of any form of naturalism or even any commitment to representation. The most determined modern Minimalist, I should think, could study these works with envy and admiration. Even the fundamental abstraction from reality conveyed by the absence of color reflects not so much an idealization or externalization of the subject as each work's emphasis on an inner movement, a stance—aspects that can be registered, as it were, out of the corner of one's eye—over the details that might be catalogued by a direct visual inspection.

If sculpture was more advanced than painting circa 1470, its advantage did not last. In just a few years, and outside Florence, an extraordinary painting was finally able to bring human presence to the fore just as forcefully as in Desiderio's sculpture. It's a very small portrait of a young man, dated 1478, by Antonello da Messina. Antonello is one of the most fascinating and

mysterious figures in Italian art. A Sicilian, as his name reveals, he established his career in Naples, where, according to Vasari, he encountered a painting by Jan Van Eyck. He thereupon ventured northward, perhaps getting as far as Flanders but more likely not, desiring to learn the secrets of the Netherlandish art of oil painting. Along the way he spent time in Venice, where he was hugely influential—"the first Italian painter," in Pope-Hennessy's view, "for whom the independent portrait was an art form in its own right."

This portrait, Antonello's last, must have been painted in Messina, where the artist had finally returned after his stay in Venice. Yet the sitter's costume, we are told, is Venetian. The sky and landscape in the background don't so much open a space for him to inhabit as lend greater elasticity to the plane that projects him forward, seemingly full-bodied, into our presence; if, as Sabine Hoffmann writes in her catalog entry, the foreground parapet "serves to separate the viewer's space from that of the subject," it must be said that this separation is extraordinarily ineffectual—and probably deliberately so, proving that no mere formal device can restrain this vital force. Shown in three-quarter view, like Desiderio's young lady, the subject seems to be turning to cast an eye on an interlocutor—but more stiffly, with true haughtiness. If you want to know the truth, his attitude pisses me off. What's he got to be so proud about? Maybe he's gloating over the Latin inscription affixed to the stone parapet in the foreground: "Antonello of Messina Painted Me," it reads. Here, the personality of the subject, the originality of the artist, and the autonomy of the artwork achieve the great Renaissance synthesis.

Because its manner of distinguishing its subject would allow you to pick him out of a crowd, such a painting could be thought of as "representational" or even "realist." But such a characterization is ultimately misleading. More than showing you what this person looks like, the painting tells what it would have been like to be with him. The painting conjures up his presence. And we don't have to like it; we just have to deal with it. Here at last we can see what Burckhardt meant by the development of the individual—or what Pope-Hennessy, a little more than a century later, evoked with the somber contemporary phrase: "the cult of personality." Whereas Pamuk's Enishte, experiencing for the first time the force of the individual as conveyed by an Italian portrait, felt above all the pangs of an envy that he could all but sublimate ("I, too, wanted to be portrayed in this manner. But, no, that wasn't appropriate, it was Our Sultan who ought to be thus portrayed!"), Burckhardt was able to see the pictorial

phenomenon of individuality in a disabused way. His account of the birth of individualism in the Renaissance is often misremembered as the paean to a glorious achievement, to one of the bases of Europe's supposed triumph and, if we think of ourselves as Westerners, to ourselves as rightful heirs of that individualism.

But what Burckhardt taught was quite otherwise. The individualism of the Italian Renaissance was the product of a specific historical moment, and was as destructive as it was creative. It was the fruit of the ferment and insecurity of the country's political situation, an insecurity that could only be overcome by quick thinking and bravado, scruples be damned. Burckhardt's view of fifteenth-century Italy curiously resembles Marx's famous description of an incarnation of capitalism in which

> All fixed, fast-frozen relations, with their train of ancient and venerable prejudices and opinions, are swept away, all new-formed ones become antiquated before they can ossify. All that is solid melts into air, all that is holy is profaned, and man is at last compelled to face with sober senses his real condition of life, and his relations with his kind.

Here already, before the birth of industrial capitalism, with legitimate structures of power having been dissolved, in the eyes of the tyrant or condottiere "facts and the actual relations of things, apart from traditional estimates, are alone regarded; talent and audacity win the great prizes." And the artists, poets, and humanists who made their way from court to court seeking patronage were the prince's mirror, for like them he was "incessantly active, and, as son of his own deeds, claimed relationship with all who, like himself, stood on their personal merits."

To think that the modern sense of self is essentially that of a small tyrant is a bleak prospect. But there might be some truth to it. If Burckhardt's picture of the Renaissance ruler and his mirror image—the artist—seems to anticipate contemporary sociologists' chatter about "risk societies" and best-selling hymns to entrepreneurship, it's no accident. Whether the self who is making incessant demands is named Steve Jobs or the Duke of Milan, a sense of emptiness underlies it, masked mostly by an eye for the main chance. And for all the admiration I have for the ways in which the painters and sculptors of fifteenth-century Italy fashioned for the self an aesthetic form that remains so striking today, it's worth remembering that the Renaissance represents a synthesis that did not and perhaps could not sustain itself for long. No one who sees this exhibition—of which I have mentioned only a few

highlights—will soon forget it. Yet one might, in the back of one's mind, wonder if it gives an adequate answer to another of Pamuk's characters, who declares that "where there is true art and genuine virtuosity the artist can paint an incomparable masterpiece without leaving even a trace of his identity"—something like the perfect crime, perhaps. The jury is still out.

2012

Daring Intransigence: Gustave Courbet

It's the early 1840s, and a young painter, having arrived in Paris from Ornans, a town in eastern France, just a few years before, takes his first tentative steps as an artist in a manner unconventional for the day. Yes, he has tried his hand at producing the usual copies of masterpieces in the Louvre, as well as paintings of other subjects, but his real fascination is with self-portraiture—as if he could feel his way toward finding a style for himself only by experimenting with ways to see himself, something the paintings show he's far from settled on.

This painter is not yet Gustave Courbet, for he's still in the process of inventing himself, and very much confused about it. It's as if becoming an artist were something like preparing for a costume party. At times, when the painter lets himself indulge in a flyblown Romanticism, the results are downright ridiculous, as with *Le Sculpteur* (whose swooning, distended anatomy seems half stretched out on an espalier) and *Le Guitarrero*, both from 1845. Oddly, such early Romantic self-portraits seem to be the preferred cover illustrations for books about the realist master—including the catalog for the first full-scale Courbet retrospective in thirty years, which I saw at the Grand Palais in Paris and at the Metropolitan Museum of Art in New York. The exhibition was curated by Laurence des Cars and Dominique de Font-Réaulx of the Musée d'Orsay, and the Met's Gary Tinterow and Michel Hilaire of the Musée Fabre. If Courbet were no more than the ham actor in the corny ghost story we see in *Portrait de l'artist, dit Le Désespéré* ("Self-Portrait, known as The Desperate Man," 1844–45), then he would never have become the subject of a great exhibition such as this one.

When the young artist could bring himself to forget about all the play-acting, things were better, occasionally even very good indeed, as with *L'Homme à la ceinture de cuir* ("The Man With the Leather Belt"), in which pictorial style plays a surprisingly subtle game with historical reference. Some commentators have seen it as modeled on Velázquez, others on Rembrandt, others on Titian; this last reference must have been the one

Courbet had foremost in mind, for in 1855 he exhibited the work under the title *Portrait de l'auteur, étude des Vénitiens*. None of these citations seems quite wrong, or for that matter entirely right; it's a picture so fused with tradition that its varied elements can hardly be disentangled. Still—though the painting is so good one hardly wants to complain—it's somehow not an expression of its own time, nor can we believe it tells us anything of the man it depicts except his profound investment in the history of his art and its many techniques.

In 1848 something changes, and Courbet becomes Courbet—a fateful year, and not just for art. Later Courbet would claim that he'd participated in the uprising against the government of King Louis Philippe (which led to the establishment of the Second Republic), though at the time he was writing letters to his parents assiduously assuring them of the opposite. Commenting on one of these letters, T. J. Clark—whose 1973 book on Courbet, *Image of the People*, remains a cornerstone of the social history of art—attributes the artist's supposed inaction to a "paralysis of will," but I suspect it was just a lie. I wonder how candid Clark's own letters home were when he was mixing it up with the Situationists in the '60s. There are things one's parents should be spared from knowing. Be that as it may, in politics as in painting, Courbet needed time to settle on a role to play. But there's something different about a remarkable self-portrait Courbet painted that year called *L'Homme à la pipe*. Even the relatively understated historicism of *L'Homme à la ceinture de cuir* has here been reined in, and the costume drama of the earlier self-portraits is barely a memory—though this is still the work of a man who has immersed himself in the Venetian, Spanish, and Dutch masters, taking from them above all their grasp of the essential, their compact force. The artist is depicted as though from below, his head tilted back a bit so that his deep-set eyes are shrouded in shadow, black holes under heavy lids. These unseen eyes communicate something nevertheless: a sort of disdain. But that's all; otherwise there is something profoundly incommunicative about this self-portrait.

This refusal to communicate will be the most radical element of Courbet's art, however fitfully it appears. Its first emergence, in *L'Homme à la pipe*, is important because this same taciturn sensibility will preside over the great painting Courbet would commence working on the following year, *Un enterrement à Ornans* (which unfortunately did not make the trip from the Grand Palais to the Met). Today, it is hard to understand the scandal this painting caused when it was exhibited at the Salon of 1850–51, why it was seen as

a shocking political manifesto—this vast, somber frieze of serious, rather ordinary mourners and churchmen packed together in an austere landscape, with the crucifix raised above them and the still-empty grave at their feet while the casket itself is nearly lost in the crowd. What could be more solemn, more reverent, more human? What could be less provocative than a picture of people just standing around waiting, and what could be further from the muckraking melodrama of Géricault's *Raft of the Medusa*, which had been shown in the Salon of 1819, or from the clear confrontation of aggressors and victims in Goya's *Third of May, 1808* (1814)—paintings in which it should be clear that something dramatic enough to have political implications is going on?

Un Enterrement is political in a different way from those earlier paintings—political in a new way, one that makes it modern, as the works of Géricault or even of Goya are not. Its politics are first of all the politics of style, of both its own blunt pictorial style and the unpolished style of the people it depicts. "Here is democracy in art," declared Courbet's supporters; but for the influential critic and poet Théophile Gautier, who had seen much promise in Courbet's earlier efforts, "The resulting impression is difficult to sort out: you don't know whether to cry or laugh. Did the artist mean to make a caricature or a serious painting?" It wasn't just that Courbet was painting an ordinary event and ordinary people on the grand scale that had once been reserved for saints, kings, and heroes; it was that his refusal to idealize them even the least bit made them seem ridiculously ugly to contemporary Parisian eyes. What rankled, perhaps, was that Courbet made it impossible to tell whether he agreed with the taste that found the provincial bourgeoisie ugly or not—a deadpan presentation not unlike that which, a century later, would leave people wondering whether, by painting the American flag, Jasper Johns was being patriotic or cynical. When Max Kozloff asks in 1962, "Are we supposed to regard our popular signboard culture with greater fondness or insight now that we have [James] Rosenquist? Or is he exhorting us to revile it?" he sounds not unlike Gautier wondering if he should cry or laugh over these awful-looking people, and echoes Gautier's bewilderment at why, standing before such a canvas, "the spectator floats in uncertainty."

The puzzlement occasioned by *Un Enterrement*, like that aroused by Pop Art in the 1960s, has long since worn off, leaving universal admiration in its wake; but other paintings of Courbet's early maturity maintain an evergreen strangeness. Prime among these is surely *Les Baigneuses* ("The Bathers," 1853),

with its clashing elements of blunt realism and ostentatious stylization. Painted with incredible force and energy, its central nude, seen from behind, is enormous, the folds of her abundant flesh depicted with ardent attention. To some viewers of the day it must have been simply as if Courbet was shoving a massive ass in the public's face; a cartoon by the famous caricaturist and photographer Nadar, published in *Le Journal pour rire*, shows a bemused viewer asking, "But now that M. Courbet has let us see his moon, what the devil will he be able to show us next year?" Far more enigmatic are the emphatic and highly theatrical gesticulations of the nude and her clothed companion—gestures to all appearances completely alien to the realism that otherwise presides over the painting. And there is something about the placement of the two figures in the landscape, as well, that's disquieting—a sense that they are not quite anchored in the space, that for all their immense physical presence they could easily float away. Few of those who had defended *Un Enterrement* were willing to follow Courbet here. Even Delacroix, the idol of the most advanced younger painters, recording in his diary his amazement at the painting's "vigor and depth," was nonetheless dumbfounded: "What is abominable is the vulgarity and pointlessness of the idea; and anyway, if only that idea, such as it is, were clear!" One hundred fifty years later, this nagging sense of incomprehensibility has not left the painting—and it's what makes *Les Baigneuses* one of the most transfixing and memorable of Courbet's works.

But still today, some might see in a painting such as this the beginning of Courbet's decline—for many art historians believe (though no painter to whom I've ever spoken about it does) that a decline set in at some point. "In the 1860s tradition went dead in his hand," Clark mourned, not without satisfaction. For some, like Swiss scholar Oskar Bätschmann, the turning point might have come in 1857, when Courbet started showing hunting scenes at the Salon, following the notable success in this genre of the English painter Landseer. By offending public morals with a sensational but nearly uncollectible piece like *Les Demoiselles des bords de la Seine (été)* ("The Young Ladies of the Banks of the Seine [Summer]," 1856–57)—showing a couple of hookers cooling off under the shade of a tree—but pleasing the crowd with inoffensive pictures of stags and hounds, he could have both notoriety and sales, but at the price that such Faustian bargains are always said to entail. Yet look beyond the "manifestos," the clamorous masterpieces of the first half of the 1850s, and not only the ones I've mentioned but others just as remarkable and familiar—*Les Demoiselles de village* ("The Young Girls of the Village," 1852), say, or *La Rencontre ou*

Bonjour Monsieur Courbet ("The Meeting, or Good Day, M. Courbet," 1854).
Beyond these you'll find room after room of landscapes, nudes and, yes,
animal and hunting pictures; and the notion that Courbet lost his soul by
painting them is laughable. Take away everything Courbet painted through
1855 and you'd still be faced with one of the greatest artists of the nine-
teenth century—though, as he was earlier, an artist whose extreme
unevenness was the price of his daring.

And he was still one of the most difficult artists, too. Hard as it may be
to see now, during the Second Empire under Napoleon III, when public
commissions and state purchases were the measure of artistic success, culti-
vating a private market was part of Courbet's political intransigence, a way
of maintaining his independence from a government he despised. But in the
paintings Courbet produced for the market, the difficulty is much more
internalized than in the contentious showpieces he made for the salons. Some
of these were undoubtedly mere "potboilers," as Bätschmann calls them. But
if anything, among Courbet's later pictures, it is the ones deliberately made
to court controversy that were the potboilers, like the anticlerical satire *Le
Retour de la conférence* ("The Return from the Conference," 1863)—a painting
that no longer survives but appears to have been an aggrandized cartoon of
the sort that perhaps Goya could have turned into something haunting and
poignant, lending the idiocy of the priesthood a sort of metaphysical intensity.
Courbet's subtlety was not of this sort.

Animalier painting may have been good business, but Courbet was born to
paint animals, and not just because he was an avid huntsman or even because
it enabled him to avoid some of the anatomical eccentricities that always
threatened to undermine his more ambitious figure paintings (and that were
sometimes the making of them), at least when the figures had to do much
more than stand around. Dominique de Font-Réaulx is not wrong in saying
that Courbet's hunting scenes "form the strangest as well as the most original
part of his output." There is a brute energy to Courbet's engagement with
the act of painting, a sense of conflict and a relish in it that finds its truest
expression in his paintings of the hunt, which allowed him to depict a full
range of emotion, both human and animal, from fear, excitement, exhaustion,
and agony to the pensiveness of a breather after the chase. This last is the
subject of a curiously melancholy picture, *La Curée, chasse au chevreuil dans
les forêts du Grand Jura* ("The Quarry, a Deer Hunt in the Forests of the Grand
Jura," 1856), which has something of the enigmatic quality of, dare I say,
Giorgione's *Tempest*; it has been remarked of Courbet's painting that it

contains a "suggestion of allegory," but one that cannot be read, and this is part of what it shares with the Venetian masterpiece. The artist stands at the center of his composition, leaning back against a tree, lost in thought with an elusive, perhaps sardonic smile playing across his face. But he is also lost in the shadow of the tree, and it's almost as if the boy who blows idly on a horn, the two hounds that seem ready for a face-off, and the hanging carcass of a buck whose face is the thing that comes closest to addressing the viewer in this painting—yet without any trace of anthropomorphizing—were nothing but so many apparitions in a dream he's having.

In 1871 Courbet's involvement in politics reached its zenith with his participation in the Paris Commune—a series of events that barely register in his art, for the simple reason that he had more urgent things to do than paint during those dramatic months. But the fall of the commune led to a brief imprisonment (retrospectively depicted in *Portrait de l'artiste à Sainte-Pélagie* [1872–73], in which his wistful gaze out the barred window oddly echoes his expression in *La Curée*, fifteen years earlier) and in 1873 to an unhappy, mostly unproductive exile in Switzerland that lasted until his death in 1877. Shortly before leaving France, in 1872, Courbet made two versions of an almost agonized painting of a trout caught on a hook, paintings that are the ne plus ultra of the identification with the expiring animal that one glimpses in *La Curée*. This identification is just another instance of what seems to have been a special fascination with some instinctive or autonomic animal essence of existence that emerges in its purest form where consciousness slips away, as in sleep or dying, and that can be seen from his recurrent paintings of people asleep or unconscious—mostly women but also himself, as in the early self-portrait, later revised, known as *L'Homme blessé* (The Wounded Man; 1844–54). For Courbet, it seems, this moment of expiration is not only that of ultimate weakness or loss; there also remains an intense life there, but coiled up in itself. Even the distractedness registered by so many of the faces in *Un Enterrement* reflects something like this waning of consciousness that so fascinated him.

Courbet's landscapes, too, more surprisingly, can contain traces of this inwardly turned life—but again, and this is what makes the fact so strange, without any sign of anthropomorphization or idealization. It is impossible to generalize about this part of Courbet's production, for while he limited himself for the most part to scenes of his native region, the Franche-Comté, he painted a greater variety of landscape motifs, and painted them in a greater variety of ways, than any of his immediate precursors or successors. In a more fruitfully indirect way than in his early self-portraits, these

landscapes amount to an insistence on the issue of the artist's identity, for they reassert the image of the artist that paintings like *Un Enterrement* had helped him establish: that of the stubborn provincial who'd conquered Paris without being corrupted by it, a man alert to every topographical as well as social detail of his home territory. The idea of landscape painting clearly meant much to Courbet, for in the great summation of his early maturity, *L'Atelier du peintre, allégorie réelle determinant une phase de sept années de ma vie artistique* ("The Painter's Studio: A Real Allegory Summing Up a Seven-Year Phase of My Artistic Life," 1855)—unfortunately still at home in the Musée d'Orsay rather than at the Met—is precisely a landscape he shows himself painting. Yet there is a certain type of landscape painting that seems most particularly Courbet's own: it is immersive—there is no visible horizon, so that the viewer feels contained within the terrain (indeed, almost pressed into it) rather than able to observe it at a distance—and synecdochical. Above all, it is a landscape in which the most powerful energy comes from something unseen, shrouded in darkness—not unlike the hidden life of the body that's sometimes manifested in Courbet's figure paintings. Works like the various versions of *La Source de la Loue* ("The Source of the Loue"), painted in 1864, or *Le Puits-Noir*, around 1860–65, have a peculiar way of feeling at once absolutely present and completely withdrawn, immediately at hand and yet fugitive and ungraspable. They are densely material, tactile, up-front, and in your face—but they are also built around massively absorptive black holes that seem to contain infinite distance.

Source, origin: the very title of these paintings about the place where water passes from its latency within the earth to visibility recalls that of what is now Courbet's most notorious painting—though then nearly unknown. *L'Origine du monde* ("The Origin of the World," 1866) is another immersive and synecdochical painting. It is a female nude, but one in which, as Flaubert's friend the writer and photographer Maxime du Camp coyly described it, "by some inconceivable forgetfulness, the artist, who copied his model from nature, had neglected to represent the feet, the legs, the thighs, the stomach, the hips, the chest, the hands, the arms, the shoulders, the neck, and the head." Commissioned by a private collector, this is a work that never could have been exhibited in its time and was not seen in public until it was shown at the Brooklyn Museum in 1988, more than 120 years after its making—another sign of the painter's having sold his soul to commerce, some might say. If so, the price was well worth it.

Call it a piece of glorified pornography—but if technique can be transcendent, then the common or garden-variety crotch shot is well and

truly glorified in this painting, in which the rendering of human flesh is of a refinement that Edmond de Goncourt was right in comparing to Correggio's. The pornographic photos of the day, exhibited alongside the painting to contextualize it, serve above all to highlight the vast gulf that separates Courbet's art from its ostensible analogues or sources (and the same is true of the nineteenth-century topographic photographs likewise juxtaposed against his landscapes). The assimilation into painting of a photographic way of seeing would have to wait for Courbet's successor, Manet, to begin in earnest. In any case, that this most extreme example of what would later be called the objectification of women by the male gaze is strangely tied to the way Courbet viewed his native landscape is to some extent confirmed by the title of the painting that was commissioned as a discreet cover-up for *L'Origine* by its last private owner, the psychoanalyst Jacques Lacan: following the same general contours as Courbet's painting but in a much-abstracted manner, André Masson's masking panel was titled *Terre érotique* ("Erotic Earth," 1955).

To notice the connection between *L'Origine du monde* and *La Source de la Loue* is not to forget the vast difference between them, which is not only a difference in subject but above all a difference in manner of painting. The immense if prurient tenderness of the one, its evocation of a surpassing softness, could hardly be mistaken for the vigorous, sometimes raw paint-handling of the other. This is the most remarkable thing about Courbet: he was almost a painter without a style; he had formulas, to be sure, but he never had one formula. There were many painters in him, though he was rarely, after those first clumsy efforts, a *pasticheur*. Tradition came alive under his hand.

2008

Extreme Eccentrics: Modern Art and Its Collectors

"Those who maintain that modern art was started by mental cases would seem to be right," admitted Clement Greenberg in 1946, less than a decade after the Nazis' notorious exhibition of *Entartete Kunst* ("Degenerate Art"). Only "mental impulses so strong and so disconnected from the actual environment" as those that plagued Van Gogh, Cézanne, and Rousseau, he offered, could have allowed them the courage or naïveté to venture so far into the unknown; and only after them could cooler, cannier figures like Matisse and Picasso begin exploring this new terrain in full consciousness of the consequences. Writing just after the war, Greenberg could have had no inkling that such a pursuit might one day at least promise to become a normal profession with a clear career path and, for some, a fat paycheck, pretty much like law or dentistry.

But if in the beginning the pursuit required, at minimum, "an extreme eccentric" who could "shut his eyes with Cézanne's tenacity to the established examples before and around him," how much more maladjustment or nonconformity must it have taken for the early collectors of this art, even coming as they did a generation or more later, to bet their fortunes on its future? It's hard to remember now, when any prudent portfolio of investments includes contemporary art—and the more extreme, the better—that buying the works of avant-garde artists once seemed even madder than making it, and this long after the deaths of pioneers like Van Gogh and Rousseau. Albert Barnes was one of those extreme eccentrics, and he discovered just how naïve he was in 1923 when he exhibited part of his collection—works by Soutine, Modigliani, Matisse, and others—at the Pennsylvania Academy of Fine Arts in Philadelphia. The local papers deemed it a scandal, and medical authorities thought the art worthy of the insane. From then on, Barnes was at war with almost any person or institution that claimed cultural authority in his hometown.

In any case, having already chartered an educational foundation to promote his ideas, Barnes was in the process of creating his own counterinstitution,

and by 1925 it was operating in the Philadelphia suburb of Lower Merion. This wasn't a typical museum: Barnes took seriously the idea that his was a place of instruction, so there was no welcome mat for idle visitors. Barnes's "prime and unwavering contention has been that art is no trivial matter, *no device for the entertainment of dilettantes, or upholstery for the houses of the wealthy*," and the Barnes Foundation's bylaws specifically forbade "any society functions commonly designated receptions, tea parties, dinners, banquets, dances, musicales, or similar affairs." The foundation was to be a place where people came to be taught what art was, according to the philosophy Barnes had developed under the influence of John Dewey, and anyone not enrolled as a student had no reason to be there.

The nearly ninety-year history of the Barnes Foundation has been a tortuous and contentious one. It's easy to ascribe this to Barnes's contrary, self-contradictory personality. A boy from the wrong side of the tracks who made good, he studied medicine but didn't take to its practice. Instead he became wealthy by inventing, with a collaborator, a medication that became widely used as a preventive against gonorrheal blindness in newborns. Barnes was a sharp operator in business, but he was nothing if not high-minded. At his factory, the workday included only six hours of ordinary labor—with the other two hours devoted to seminars on philosophy, often led by the boss himself. When Barnes maintained that his gallery would be for the use of "men and women who gain their livelihood by daily toil in shops, factories, schools, stores, and similar places," he wasn't talking out of his hat. His aim was to wrest the monopoly on the understanding of art, as of philosophy, from the class that he had succeeded in joining, and endow it to the class he had been born into. And overcoming the divisions of class wasn't his only cause. He happily described himself as "an addict to Negro camp-meetings, baptizings, revivals, and to seeking the company of individual Negroes." He was an avid supporter of black artists and, for a time, a committed interlocutor of African-American intellectuals such as Alain Locke.

If Barnes was a progressive idealist, he was also a hard-hearted bastard—litigious, foul-mouthed, the worst kind of control freak. He fell out with everyone he could not dominate, with the exception of Dewey, and demonized anyone who disagreed with him. He became a coprographic crank, and his little institution with its great art collection became increasingly insular—even more so after his death in 1951. The only opening came by way of legal action. In 1960 the State of Pennsylvania finally succeeded in forcing the foundation to post public hours, which it did grudgingly: two days a week, by appointment only. In appearance, nothing else had changed.

But Barnes's will contained a few time bombs. One was a requirement that the foundation's endowment be invested exclusively in government bonds. During his lifetime, Barnes had handled money with an astonishing combination of skill and luck, but a requirement that would have withstood the Depression was no match for postwar inflation. With expenses outrunning income, the endowment steadily dwindled. Second, Barnes stipulated that any successors to his handpicked board must not be affiliated with any of the prominent local educational or cultural institutions, all of which he saw as enemies to the last. Instead, future board members were to be appointed by the trustees of Lincoln University, a historically black institution whose alumni include Thurgood Marshall, Langston Hughes, and Kwame Nkrumah.

Barnes's own chosen board members turned out to be pretty hardy. By 1988, when Lincoln appointees finally became a board majority, the university's great days were past: an increasingly cash-poor gallery was in the control of an equally penurious college (and one that had no real art department). Worse still, the Lincoln trustee who ended up becoming president of the foundation was a man nearly as litigious as Barnes himself (at least according to legal journalist John Anderson in his 2003 book *Art Held Hostage: The Battle Over the Barnes Collection*), and who saw the foundation mainly as the vehicle for his own rise within Pennsylvania Republican politics. When he floated the idea of selling off some of the art to save the foundation, the art world cried horror. But the Barnes was broke.

The solution must have the doctor rolling in his grave. Having reopened this past May in a handsome new building (designed by Tod Williams Billie Tsien Architects) just down the street from the Philadelphia Museum of Art—Barnes's bête noire—the Barnes Foundation is now a museum like any other. Visitors don't even need to make an appointment. Dilettantes may entertain themselves without fear of the doctor's furious invective, and I suspect that tea parties and musicales may eventually transpire. Has Barnes's egalitarian and exclusive vision of art finally been betrayed, or has it been preserved to the extent that history and circumstance allow?

Perhaps preservation and betrayal are one and the same here. As the literary scholar Jeremy Braddock points out in an acute and important book called *Collecting as Modernist Practice*—a wide-ranging study based on the unexpected but revealing parallels between the selection of work for poetry anthologies and the acquisition of art for collections during the modernist era—Barnes's ultimate ambition was "to change fundamentally the entire

field of cultural practice in the United States." (Along with Barnes, Braddock also discusses Duncan Phillips and his collection in Washington, D.C., in tandem with poetry anthologies by Ezra Pound and Amy Lowell as well as Locke's *The New Negro*, among others.) That clearly hasn't happened, and not only because the weight of prejudice stood against such ambition. As fine as Barnes's eye for art may have been, and allied no less to a pedagogical project, his ideas were inadequate. He was too narrowly formalistic in his understanding of art, and his view of its psychological and social implications was too undialectical. Barnes's voluminous writings, though full of apt observations, are never cited by art historians because they are wedded to an intellectual system that resists further development, being so self-enclosed, not to mention one-sided and unjustifiably vehement in judgment. Apparently this branch of the Barnes Foundation's heritage is going to be honored in the breach: in the bookshop I found for sale just three of the founder's half-dozen books (most written in collaboration with Violette de Mazia), in printings dated 1990, 1986, and 1959, as if they had been found in a clean-out of the foundation's storage. Yet Barnes's writings were praised in their time not only by Dewey (as one might have expected) but by Pound (who called *The Art of Painting* "the most intelligent book on painting that has ever appeared in America"), as well as drawing more measured responses from Alfred Barr and Leo Stein. The painter John Sloan's remark that Barnes "knows more about art than any artist needs to know" may have been a backhanded compliment, but who else could have earned it?

In any case, what has been in a literal sense preserved, like flies in amber, are the peculiar arrangements of paintings and objects that Barnes created on the walls of the original foundation building in Merion. These arrangements are surprising because they recall the salon-style manner of hanging in the nineteenth century or, in their intermixing of paintings with all sorts of small craft objects such as andirons and horseshoes, what's been called the "bricobracomania" of that era—everything that the Modernism Barnes loved had in principle opposed. But the association is misleading. Barnes's arrangement had other justifications altogether, and, as Braddock says, they constitute works of art in their own right, aiming "to repeat the operations of the individual painting on the level of the gallery" and become "expressive not only in pedagogical, public ways but in more hermetic, subjective, inward ways as well." The new building preserves the "wall pictures" that Barnes orchestrated so carefully, and can be understood as a museum encasing his original museum, which in turn encases the works within it. Just as any museum necessarily changes the meaning of the art it contains, this new

museum changes the meaning of the old one, in ways that will be revealed only in time.

Whatever you may have thought of the old Barnes Foundation (and even if you never had a chance to see it), you won't be able to stay away from the new one if you have any interest in Impressionist and Modernist painting, which can be viewed here as nowhere else. Matisse, in particular, stands out in all his glory, including aspects easy to overlook in other collections: Wherever did that bizarre yet effectively nebulous lavender background to a 1918 still life of anemones come from, or the surprisingly Lautrec-like reclining figure in another work of the same year—in which, moreover, the artist somehow makes oil paint look more like pastel? And you'll learn as much about Cézanne here as anywhere when you notice in a flower still life of 1896–98 an explosive energy one would not have expected from that quietly furious master.

From another angle, the proof of Barnes's eye can be found in the way his selections by minor artists could almost convince you that they are much better than you imagined. I never gave more than half a thought to Jules Pascin, but suddenly I think I might have been mistaken. Even the normally cloying work of Marie Laurencin looks pretty good. And as for an artist like Alfred Maurer, who I'd always thought was underrated—now I know where to point for the proof.

Instead of curating to illustrate an artist's development, or to showcase his or her most typical works, Barnes concentrated on art that appealed to him most strongly as "plastic form," without reference to biography or history. In so doing, he highlighted features of the artist's aesthetic that may be obscured when other museums—not without good reason—place their works in determinate historical contexts. Barnes allows familiar artists to be seen differently. Since his time, the tide of taste has turned decisively against Renoir, one of his favorite artists, while continuing to reinforce the importance of another favorite, Cézanne. At the Barnes it becomes possible to see the forgotten affinities between them, to perceive something of Renoir's sensual ecstasy in a Cézanne like *The Allée of Chestnut Trees at the Jas de Bouffan* (ca. 1888), and to notice how his *The Large Pear* (1895–98) seems to rock like a boat on a wave of overwhelming feeling; while a Renoir landscape such as *Dovecote at Bellevue* (ca. 1888–89) possesses an intensity of conviction one would have thought was entirely Cézanne's.

Leo Stein, too, was devoted to Renoir with a passion that now seems hard to recover. The qualities Stein said he found so moving—"the shadow of

death has never clouded the art of Renoir and if he has a limitation, it is the very simplicity, the serene graciousness of his pure and noble joy"—may now encapsulate what strikes us as false in it. An excellent exhibition that recently closed at the Metropolitan Museum in New York City, "The Steins Collect: Matisse, Picasso, and the Parisian Avant-Garde"—which was first shown at the San Francisco Museum of Modern Art, and which I was lucky enough to see at its second venue, the Grand Palais in Paris, as well as more recently in New York—tells a story as important to the history of Modernist collecting as Barnes's, and just as ambiguous. Although the name of the youngest of the five Stein siblings, Gertrude, counts for the most these days (thanks less perhaps to her extraordinary writings than to her equally remarkable talent for self-mythologization), the key figure was really her slightly older brother Leo. He was important for Barnes as well, to whom he became, according to Braddock, "a mentor" who encouraged Barnes's acquisition of work by Matisse and the pre-Cubist Picasso.

What unites Barnes and Leo Stein and distinguishes them from Gertrude is their aversion to Cubism, in contrast to her avid embrace of it. There are plenty of Picassos at the Barnes Foundation, but they are early ones, and they pale beside their Matissean neighbors. To Barnes's eye, "the very great majority of cubistic paintings have no more aesthetic significance than the pleasing pattern in an Oriental rug"—a remark that betrays how his faith in the universality of aesthetic values was allied to a definite hierarchy among those values, with the highest achievements being those of representation. Cubism, in this view, had strayed too far into abstraction. Leo likewise saw in Picasso's Cubism mere "diagrams" that "were abstract simplifications and not a whit more real than things with all their complexities," so that "when he became an intellectual at a contemptible level of degradation I couldn't accept it." His dislike of his sister's writing is in part a dislike of the way she used Cubism as a paradigm for prose.

Leo and Barnes shared more than taste: each was incapable of meeting a contrary viewpoint with anything but contempt. Nor were Leo's so vehemently voiced passions necessarily lasting. What Brenda Wineapple has said of the Steins' father—"He was certain of something only until he lost interest in it, and then his loss of interest was complete"—was also true of Leo. Having cultivated a zeal for art in his younger sister and then his elder brother, Michael—their two middle siblings seem always to have been second-class citizens in this family—he eventually lost interest, finally declaring even Cézanne a "squeezed lemon." Needless to say, the desiccation and sourness were entirely Leo's. Yet the years when he and Gertrude together

were amassing art on a heroic scale (considering their relatively limited means) represent the beginning of true avant-garde collecting. Their trove of Matisses was not as various as Barnes's would be, but starting with *Woman With a Hat* (1905), which Leo had to have despite its at first seeming "the nastiest smear of paint I had ever seen," their Matisses remain unremittingly radical. And despite Leo's inability to follow Picasso into Cubism, his and Gertrude's taste in pre-Cubist Picasso seems notably shrewder than that of Barnes.

Like Barnes, Leo expected his contemplation of avant-garde art to culminate in a fully worked-out program of aesthetics. His distillation was a book with the unpromising title *The A-B-C of Aesthetics*, published in 1927 and apparently never since reprinted in full. Fervent opinions constantly revised do not a systematic thinker make. Besides, Leo was already losing interest in the fight. Although he had been the energizing partner of the odd couple he'd formed with his younger sister, a relationship of near incestuous intensity, his passion for art emerged from their breakup with much of its force spent. It's hard to tell whether it was Picasso or Alice B. Toklas whom Leo resented more, but either way, he was as bitter as any spurned lover. To Barnes he would later write, "Gertrude and I are just the contrary. She's basically stupid and I'm basically intelligent." But her "stupidity" ended up being worth more than his intelligence. She continued to be the proponent of Picasso, while the banner of Matisse passed to their brother Michael and his wife, Sarah. Michael, by the way, is the exception who proves the rule that early avant-garde collectors were necessarily eccentrics at the least, if not prey to madness. Responsible for husbanding the family's inheritance so that his younger siblings would never have to work, Michael seems to have been a paragon of equanimity. Never tempted to intellectualize his love of art like Leo, or to play at being a genius like Gertrude, he might have been the quintessential bourgeois relaxing in his armchair evoked in Matisse's famous *Notes of a Painter* of 1908. Sarah was the couple's thinker.

Picasso aside, how did Gertrude's collecting proceed in the postwar years, when her fame grew and she began to resemble, as Picasso had long before predicted, the masklike portrait he'd painted of her in 1905–06? It's better not to look, unless you're willing to countenance that Leo's opinion of Gertrude's mind was correct. There were a few unexpected highlights, like the uncanny 1925 portrait of René Crevel by Pavel Tchelitchew, and a decent Picabia among the various clunkers by him, but most of Gertrude's later discoveries are rubbish. Her taste became as dismaying as her politics. (She once undertook a translation of the speeches of General Pétain into English.)

The exhibition's finale, a massive memorial portrait of Gertrude painted just after her death by one Francis Rose, an English painter from whom she'd purchased many works, is enough to make you weep—and not for joy. The better course might be to turn back and walk out the way you came in, admiring once more along the way the grandeur of the art the Steins collected in the two decades after Leo's discovery of Matisse in 1905, and considering how, while the true avant-garde never loses its radicality, the eye for it can be a passing thing.

2012

Vacant, Limpid, Angelic: Willem de Kooning

Willem de Kooning may or may not have been a bad painter, according to his persistent and vocal detractors, but he was surely a bad influence, giving rise to a "Tenth Street touch" that was a stereotype of spontaneity, anxiety reduced to a mannerism. This opinion has become a truism, one of the few that the likes of Hilton Kramer and Yve-Alain Bois can agree on. For Clement Greenberg, a chief detractor who had once been a supporter, more promising than de Kooning's followers were color-field painters like Helen Frankenthaler and Morris Louis, whose stained canvases retained something of the Abstract Expressionist's spontaneity without the physical trace of the touch. Others preferred the clean lines of hard-edge painting, of Pop Art or Minimalist objects—anything that would eliminate the particularity of the artist's hand.

But a hand like de Kooning's could never have been removed from sight so easily. Robert Rauschenberg proved it with his famous *Erased de Kooning Drawing* of 1953. The twenty-seven-year-old Rauschenberg spent months laboring to efface the traces of the elder artist's ink and crayon. "I wore out a lot of erasers," he later recalled. Yet traces of de Kooning remain, inexpugnable. It's hard to tell from those faint inflections of the paper's whiteness what the work it once was might have looked like (no photograph of it ever existed), but that something was once there remains evident. Given how much time and effort it took Rauschenberg to achieve this distinctly unvirginal, non-Mallarméan whiteness, whatever had been there must have been formidable.

Rauschenberg's effort was like that of a devilish yet secretly devoted student, his erasure an act of copying in reverse that must have taught him all about de Kooning's draftsmanship from the inside out. It's no accident that Rauschenberg's best work emerged in the decade that followed, as he realized that he could move forward only by absorbing and, as it were, metabolizing the work of the man he recognized as "the most important artist of the day." Almost covertly, generations of artists have continued to

find in de Kooning's art something they need to help them make their own, however different. Maybe that's because his aversion to finish—his openness to showing how the route by which he arrived at something satisfactory could be tortuous—makes his work an ongoing lesson in how to do it, and in how doing means always doing it differently. "I paint this way," he once said, "because I can keep putting more and more things in it: drama, anger, pain, a figure, a horse, my ideas about space." I can't think of a single work by de Kooning with a horse in it, but that's why the seemingly arbitrary mention of the animal is important: he had never painted horseflesh, but he never doubted that at some point it might make sense to do so. In his art, nothing he could think of is counted out in advance.

In any case, de Kooning's true subject was never really a figure, or the drama between figures, any more than it was an abstract theme like an idea of space—or never only those things. His art concerns nothing less than how to be and act in the world when it is in flux, how to negotiate the fact that every move you make has unforeseeable consequences that will inevitably change the situation in which your next act takes place. Doing the same thing can mean doing something different from one time to the next. Listen to what one of the best painters of the present has to say about her way of working:

> The painting process is a curious coincidence of thinking and acting. Let's say you start out with one paradigm and while doing the first steps in the painting exactly that paradigm gets extinguished by the newly materialized situation. That triggers off another set of paradigms that will be dropped as a consequence of the work process, and so on and on. It is the continuous flux of visual intelligence constituting reality in every moment. Aggression is the energy that enables you to bear the loss of what has to go. It feeds and sustains that process.

In a suitably gnarly manner, the process Katharina Grosse is articulating is not too different from de Kooning's endlessly self-revising working method. It's a continuous revolution, as the Maoists used to say. De Kooning "could sustain this thing all the time," he once explained, "because it changed all the time."

In the 1930s and early '40s, before the fire that was kindling in some of them burst into flame, de Kooning and his cronies used to hang out at Greenwich Village spots like Romany Marie's and the Waldorf Cafeteria,

capping long days in the studio with long nights of cheap coffee and free talk. A recurring question was: Who was the greatest living artist—Matisse or Picasso? "Bill would always say that Michelangelo was the greatest living artist," the sculptor Philip Pavia later recalled. In something of the same spirit, I can tell you that right now the Museum of Modern Art is showing today's greatest living artist, and that if you have the slightest interest in contemporary art, you should get yourself to West Fifty-third Street to see "de Kooning: A Retrospective," curated by John Elderfield, because the show will not travel. Boasting nearly 200 pieces, comprising paintings, drawings, sculpture, and prints, the show is one of few on this majestic scale that I didn't wish had been more stringently edited. It has an impetuous forward movement that keeps your attention from flagging, and the art is alive because it's still changing. Is that really all?, I found myself thinking as I walked out. Can't there be a little more?

Yes, there could have been more. For my taste, there could have been much more art from the most prolific and controversial part of de Kooning's career: its last phase, from about 1982 to 1989. This was when, depending on your perspective, either de Kooning's growing dementia made him unable to edit his work with a critical eye or the prospect of mortality overrode the inhibitions that were once so strong in him, unleashing a compulsion to finish as much as possible before it got too late. It's widely known that Meyer Schapiro made de Kooning salvage what is now his most famous (or notorious) painting, *Woman I* (1950–52), from a pile of rubbish in the hallway outside his studio when the painter had despaired of ever getting anywhere with it after a year and a half of struggle. Yet one paradox of de Kooning's career is that, for all his periodic inability to finish a picture, he could also be profligate with his gifts, working constantly and profusely. This was a man whose idea of relaxing at night was to sit in front of the TV, drawing. He felt that being distracted from what he was doing enabled him to invent things his focused attention might have censored. Still, I doubt whether we'll ever see a bigger or better de Kooning show than MoMA's. With its plethora of masterpieces, this exhibition should put an end to the carping once and for all.

Not only does it make sense to me, after seeing the show, to call de Kooning the greatest living artist; I am also tempted to call him the most promising young artist, and not only because his oeuvre is full of hints and possibilities that are still ripe for further development in the future. It's also because of his career's Benjamin Button–like shape: his art became ever more youthful as he aged, and its spirit ever more fleet and fluid.

De Kooning's premature artistic old age is apparent in his scrubbily painted, portraitlike studies of male figures of the late 1930s and early '40s. Pallid, isolated men in environments fading away before our eyes, they seem at loose ends, capable of neither leisure nor labor; the eponymous figure in *Seated Man* (ca. 1939) is apparently drumming his fingers with impatience at his never-ending time in Limbo. Moreover, the figures look pieced together out of spare parts; indeed, as Jennifer Field points out in the exhibition's monumental catalog, the artist "recycled anatomical details" among these paintings. Other parts of the body might just fade away into nothingness. The subject of *Seated Figure (Classic Male)* (ca. 1941–43), barely seems to be in any one particular place at all; instead, he is a sum of approximations. There is something terribly poignant about these bald, muscular, petulant Frankensteins, lost in their nondescript rooms. They are people who have been used up by life. The paintings also show the strain of de Kooning's effort to find a modern style while holding on to a recognizable human content—it is the pathos of van Gogh's *The Potato Eaters*—that was fading away, evading his grasp.

It was during this period that de Kooning met Elaine Fried, the art student from Brooklyn whom he would eventually marry. She'd already heard from a previous boyfriend that de Kooning was one of the two best painters in America (the other being his pal Arshile Gorky). Although his work had hardly been seen in public, the intensity of his artistic vocation had become legendary among the downtown artists of the day. Stoking the legend in hindsight, Elaine de Kooning recalled, "I thought he had seaman's eyes that seemed as if they were staring at very wide spaces all day. He had an inhuman look—vacant, limpid, angelic." De Kooning's first painting of a female subject, *SeatedWoman* (ca. 1940), is evidently of Elaine, and with her detachable arms and asymptotic contours, the figure is recognizably a sister to his men—but how his palette has brightened, and how much she radiates life. The sun has found a window into the room where she sits. Unmet longing and quiet desperation may be the lot of his men, but nothing stands in the way of de Kooning's women.

A strange thing happened as de Kooning kept painting. His men remained melancholy and ineffectual, and his manner of painting them emphasized his own sense of doubt and artistic isolation. His women possess a different sense of power, of life, and his style takes on new force to match theirs. Looking at the change, I can't help thinking of Grosse's remark, "Aggression is the energy that enables you to bear the loss of what has to go." It's as if

in painting his men de Kooning had continued regretting all the choices, all the exclusions he'd had to make in order to arrive at a painting; painting women, he suddenly finds a gusto that allows him to override his compunctions and live with his choices. He throws himself into the paintings with a kind of violence, and a love of grotesquerie, that would have seemed unimaginable a few years before. He would continue to paint women, and the series of male figures would peter out. (Although he later drew and sculpted male figures, he never painted them again.)

One of the choices de Kooning did not make was between representation and abstraction. Beginning in the 1930s, and for many decades more, he switched fluently between modes. Just as his figure paintings were informed by abstract methods of construction, his abstract paintings always retained figurative elements. A radicalized version of the same sort of anatomical recycling he'd used in the late '30s to make his men paintings remained part of his way of making abstraction throughout his life. Elements from one painting could be traced, transferred, flipped, and repositioned in another to give them fresh meaning. As long as the paintings could be kept in flux and past ideas could re-emerge and be transmuted, the artist could be "oblivious to time and to any usual understanding of accomplishment and progress," as Richard Shiff explains in his remarkable new book, *Between Sense and de Kooning*, which is essential reading for anyone interested in the artist.

As an abstract painter, de Kooning really came into his own near the end of the 1940s, with a series of mostly black-and-white paintings. The aggression that became an ever more significant factor in his paintings of women—the great uproar might have been over *Woman I*, but similar pictorial onslaughts would have been evident in paintings earlier and later—was just as much a part of his abstraction as of his painting of women. Today, the furiously intricate *Excavation* (1950) hardly disguises its origins as a multifigure composition whose elements seem to have been systematically slashed, diced and compacted, but not so finely that you don't bump into an eye, an elbow, a mouth, a shoulder, every which way you look. In the catalog, Lauren Mahony adduces Picasso's then fairly recent painting *The Charnel House* (1944–45) as a possible model for *Excavation*; but to my eye, de Kooning's painting is far more confrontational, like an update of *Les Demoiselles d'Avignon*. Elderfield's description of "the finely carpentered perfection of *Excavation*" is misleading; yes, the painting is as elaborate and carefully detailed as a fugue, but it's a fugue for slashers.

More than his imagery, it's his paint that de Kooning often treats harshly, especially throughout the '50s, whether in ostensibly figurative works like

Woman VI (1952–53), the "abstract urban landscapes" like *Easter Monday* (1955–56) or the "abstract parkway landscapes" like *Merritt Parkway* (1959). In any case, the boundaries between categories are moot for a painter who remarked, "The landscape is in the Woman and there is Woman in the landscapes." Abstraction in this case is not a separate genre or subject but a name for what this mixing, this impurifying, involves—the breakdown of representational motifs into parts that can be recombined by torquing the space they engender. The gritty, grungy, earthen facture of the paintings keeps things upfront: the painting is always in part an altercation between the space evoked by color and line, a space that necessarily escapes the empirical location of the canvas, and a materiality that holds itself recalcitrantly to the surface. What emerges over the course of this decade is de Kooning's increasing desire to simplify and consolidate, to give the paintings a clearer architecture and a more imposing scale. Figurative forms disappear, yet the sense of human presence remains.

The culmination of this architectural trend in de Kooning's painting is undoubtedly *Door to the River* (1960), where it becomes something else altogether. Like the sun spilling through an unseen window in *Seated Woman*, which startles because de Kooning had been painting all those cooped-up men, a kind of Turneresque blaze has eliminated almost all shadow from the painting. Even the central dark passage that must be the titular door seems to glow. In a way, the painting's all-encompassing radiance overflows the rectilinear structure that underlies it; the painting's architecture seems on the verge of dissolution. And dissolution is all in de Kooning's next major painting, *Rosy-Fingered Dawn at Louse Point* (1963), with the three-year gap between it and *Door to the River* reflecting troubled times in the artist's life; he was not very productive in the early '60s, but when he could pull himself together, my goodness, he was sublime. *Rosy-Fingered Dawn* could almost be a reprise of *Door to the River*, but substituting at its center an illumination that reveals itself nakedly rather in the somewhat veiled manner of the 1960 painting. Moreover, the architecture of the image has begun to melt—to go all wet and goopy toward formlessness—while remaining implicit. The poet J. H. Prynne has written of a meeting in this painting between the "oceanic pathos of the sheer presence of paint and its pearly encouragements" and "a force of character that holds its station."

De Kooning would luxuriate in this near formlessness in the paintings of women, and women in landscapes, that would occupy him for most of the rest of the 1960s, as well as in the landscapelike paintings in which, perhaps,

the figure has dissolved, that he concentrated on in the '70s. Here, it's as if everything is seen through a fluid medium constantly being stirred up, and all shapes are broken up into rippling, resounding echoes of themselves. The artist acknowledges this fluidity in a painting whose title is a tribute to John Keats: . . . *Whose Name Was Writ in Water* (1975). Years before, in Rome with Gregory Corso, he had visited the poet's grave. In the paintings of the '60s and '70s, the violence de Kooning discovered in himself with his first woman paintings did not disappear, but changed form. I am tempted to say it underwent a sea change, because it became a sort of objectless turbulence like the heaving of water in motion, an energy that might be destructive but was without hostility. Unlike de Kooning's work of the late 1940s and '50s, the brilliance of these paintings has still not been sufficiently recognized.

By the end of the 1970s, de Kooning was stranded in another fallow period. He told a friend he "had a dream that the water was turned off." When he started work again in the early '80s, he'd found a new element— not the earthiness of the '50s, or the liquefaction of the '60s and '70s, but a new sense of air. For the first time, his paintings became ethereal, as if he could finally see things as Elaine Fried had first dreamed he did, "vacant, limpid, angelic." Reversing William Blake, who like most of us knew innocence as coming before experience, de Kooning seems to have achieved his innocence at the end of his days. These paintings are governed by a white that is never pure but always flushed with hints of color; through this translucent atmosphere float ribbons of mostly blue and red, sometimes drifting but more often snapping this way and that, as though blown by contrary breezes. That de Kooning was increasingly becoming overtaken by dementia through the decade explains next to nothing about these paintings, which are as complex and imposing as any he'd ever done. If Shiff is right that in painting de Kooning became oblivious to time and progress, then the upshot of the artist's loss of short-term memory was that he could act in the perpetual present of art as never before. Like many artists, de Kooning often felt that he had remained something of a child in the world, and for him this was a source of pride and shame. "I am certain that a real man wouldn't paint any pictures!" he'd once confessed to his sister. Eventually he no longer had to worry about being a grown-up.

2011

13

Evasive Action Painter: Gerhard Richter

Sometimes you go to an exhibition not for pleasure but duty. It might be a little like going to visit an old uncle. You know he needs the company, and your affection for him remains undiminished, but you've heard all his stories and all his complaints too often. I went to Gerhard Richter's recent exhibition at the Marian Goodman Gallery in New York City in something like that spirit.

Partly it's the curse of the big exhibition. Maybe Richter's 2002 retrospective at MoMA exhausted my curiosity, all the more so because it seemed to come a few years too late. Richter had been, arguably, the world's most influential painter from the mid '80s or so—once the tide of Neo-Expressionism had begun to recede—throughout the '90s, but as that decade reached its end, his influence had begun to seem all too pervasive, almost suffocating. His very authority as an artist, along with his immense productivity, made him seem (not unlike Picasso in his day) ubiquitous but increasingly distant from the concerns of younger artists—a museum piece, in the negative sense. And the few exhibitions of his I had seen in the meantime—not to mention the isolated works that dotted the art fairs like so many trophies—had done little to challenge this impression. Certainly his 2008 exhibition at the Serpentine Gallery in London, "4900 Colours: Version II"—an extension of the color chart theme to which Richter has returned periodically since 1966—seemed like a literalization of the idea of painting as marking time, and of artistic production as little more than meaningless saturation of the environment.

How wrong I was. At least the experience of heading unenthusiastically uptown to Marian Goodman will serve me as a good reminder: by all means do your duty, if only because it might turn out to be a greater pleasure than you could ever have expected. The exhibition was breathtaking—but more about that later. After seeing it, I eagerly turned to a couple of new books on the artist, only to learn a different lesson: don't let your enthusiasm run away with you.

The more enlightening of the two books is *Gerhard Richter: Writings 1961–2007*. It replaces an earlier collection, published in 1995 and now out of print, which for a long time was one of the books you were most likely to find in young painters' studios—in part, I suspect, because its title spoke to them so clearly: *The Daily Practice of Painting* was like a promise that the constant pursuit of the art, the everyday doing of it, might be more important than all the theory in the world. This reassurance was all the more important because Richter had become the theorists' favorite painter—and especially among those who barely deigned to acknowledge, otherwise, that painting is still a viable pursuit. I suspect the new book will not have the same impact, not only because of its poker-faced title—which is also misleading, since the book mainly consists of interviews, generally more engaging than the few writings—but because it is now too much of a good thing. Richter has given a great many interviews since 1995, and not all of them are required reading. A more judicious selection might have been useful, especially because Richter is such a slippery character. Nearly any statement he makes can be matched with one that says the opposite. Perhaps this equivocation or deniability is one source of Richter's success, his ability to represent so many different, possibly contradictory things to so many people; it's certainly a characteristic of his art and not just of what he says about it.

One might have hoped that Dietmar Elger's *Gerhard Richter: A Life in Painting* would put the chameleonlike painter into perspective, but no such luck. Anyway, the book isn't so much a biography as a chronicle of Richter's career as an artist. If you're interested in tracing the responses of the German press to Richter's exhibitions, this is the book for you. If you're more interested in tracking the various phases of the art itself—the paintings of black-and-white photos, of color charts, gray monochromes, intensely colored abstractions, photographically derived paintings in color, not to mention *Atlas*, his archive of photographs, which is both a work and a resource—you'll get some important detail from the book, but you still might be better off looking through a couple of the heavily illustrated catalogs of any of Richter's many retrospectives. But if you think a biography means a book that offers insight into the inner life of its subject, forget it. Some day Richter will have his Hilary Spurling or his John Richardson, but he's probably happy to reflect that he won't be around to read it. "Biographical details have limited relevance when it comes to understanding a work of art," he says. There's truth to that, but only some. There are broadly two things one wants to understand about a painting: first of all, how should I

look at it, what should I look for in it? And second, how did someone get to the point of being able, and of needing, to make it? In addressing the first question, biography is perhaps of limited use. For the second, it is essential. But the catch is that, since artworks, unlike the beauties of nature, are always imbued with intention—if only the intention to deflect one's intentionality and allow things to manifest themselves as if naturally—the two questions are really one.

Elger's lack of inquisitiveness weakens even the most biographically substantial parts of his book, such as the opening chapter on Richter's childhood in Dresden during the Nazi era and his young manhood in East Germany. He points out that the artist's parents had an unhappy marriage; Horst Richter was drafted in 1939 and spent the entire war in the army, and then in an American POW camp, returning to a wife who considered him a failure and children who hardly knew him. The painter sees this situation of father-lessness as typical of his generation of Germans, and it has left its traces on his subject matter—think of the doleful pantheon of white (or, rather, gray) European men of his *48 Portraits* (1972)—but more nebulously in the pervasive sense of melancholy that has marked much of his work, as well as in his discomfort with authority. But only in passing in one of the interviews in *Writings*, rather than the biography, does one learn that Horst Richter was not Gerhard's biological father.

Richter has always sought order in his life, and he works in an orderly way. Elger (a former secretary in Richter's studio, and now a curator at the Dresden State Art Collections and director of its Gerhard Richter Archive) mentions that, as a student at the Düsseldorf Art Academy in 1961–64, the young artist arrived at his studio every morning at eight, carrying a suitcase, like a businessman. No matter that the briefcase merely contained his lunch. And he still starts his working day regularly at eight. Yet he seems regularly to have been attracted to those who flout the rules. His closest friendship from the academy was with a remarkable painter who took the name Blinky Palermo, a drug addict who died under mysterious circumstances in 1977 at thirty-three. It's clear from the interviews how much Richter still misses him. One longs to understand this friendship more deeply. Similarly, one would like to know much more about Richter's second marriage, to a remarkable artist a generation younger than himself, the sculptor Isa Genzken. It is well known in the art world that this brilliant woman, who represented Germany at the Venice Biennale in 2007, has struggled with mental illness. Elger makes no mention of it. Yet one former art dealer has published reminiscences like this:

I last saw her in New York in the wee hours on the dance floor of a Chelsea disco. Later she moved to Berlin, and soon had been banned from clubs and bars for her agitated behavior. I heard she was screaming "fascist" at customers and I saw her dead drunk sleeping on the demonstration furniture of a design store in the middle of Wittenberger Platz.

Perhaps knowing this merely satisfies the craving for gossip, as Richter would say; yet I would wager that his attraction to someone who was capable of such behavior (though the time eventually came when he could no longer handle it; he is now married to his third wife) reflects an intensity of his own, held in check only by his blessed rage for order. Richter later recalled Genzken as a "very strict" critic: "'That's ugly, terrible,' she'd say." Wouldn't it have been worth trying to get a deeper sense of those conversations, and of the mark Genzken's strictures might have left on Richter's work afterward?

The impersonality of Elger's presentation echoes Richter's discretion. Yet these days the artist seems less enamored of his former pose of impersonality and removal. In the past he repeatedly let it be known that the imagery in his paintings—mostly derived from news photographs and other such publicly available images—had no personal significance. Notes written in 1964–65 make him sound like Andy Warhol, wanting to disappear into the common consciousness: "I want to be like everyone else, think what everyone else thinks, do what is being done anyway." Using found photographs was the key to this disappearance: the photograph "had no style, no composition, no judgment. It freed me from personal experience." Likewise the choice of subjects was supposed to be neutral:

> Perhaps the choice is a negative one, in that I was trying to avoid everything that touched on well-known issues—or any issues at all, whether painterly, social or aesthetic. I tried to find nothing too explicit, hence all the banal subjects; and then, again, I tried to avoid letting the banal turn into my issue and my trademark. So it's all evasive action, in a way.

Yet, among the paintings made from found photographs, there were always a few taken from family snapshots. How could those, at least, ever have been chosen quite so impersonally? Later Richter would change his story. Asked by Benjamin Buchloh in 1986, "So what were the criteria by which you chose photographs for your iconography?" he answered, "Content,

definitely—though I may have denied this at the time, by saying it had nothing to do with content, because it was supposed to be all about copying a photograph and giving a demonstration of indifference . . . I looked for photographs that showed my present life, the things that related to me."Why did he pretend to indifference? Self-protection, he insists. Again and again, he says that his earlier professions of neutrality were essentially attempts to be left alone, to be able to work in peace.

More likely, Richter's aim was as much to mislead himself as anyone else. We see this in an anecdote from a 2005 interview for *Der Spiegel*, in which he refers to an early painting of his father, *Horst With Dog* (1965). "When I painted it, I thought it was funny . . . But when I saw it displayed in New York thirty years later, I was a little shocked because it seemed to me that the father was portrayed as a predominantly tragic figure." If Richter ever really saw this painting as amusing, his capacity for self-deception is truly impressive. But today, one has to wonder what Richter's new mask of (relative) openness might be hiding. What if his former sense of his father as funny was not unconsciousness but cruelty?

Richter's passionate effort to maintain artistic autonomy at all cost, and to remain free of ideology, has been central to his life and work from the time he crossed over from East Germany to the West in 1961. In notes from November 1989—just days before the Berlin Wall was breached—Richter writes of a "survival strategy" involving "denial of the planning, the opinion and the world-view whereby social projects, and subsequently 'big pictures,' are created."This is the typical postcommunist allergy to utopian projects. But his stance is also more broadly antipolitical: "Politics operates more by faith than by enlightenment, so nothing is going to come of that."

Wherever Richter has faced an ideological demand, he has seen it as a threat. In his notes and interviews he is constantly railing against ideology. When an interviewer contrasts Richter's work with that of a painter who stayed in the East and found success under the communist regime, remarking, "Resistance to any kind of instrumentalization gives your pictures a completely different motivation," he responds, "I certainly did not want to demonstrate resistance because that would have meant countenancing that very instrumentalization. I just wanted to paint pictures."

Richter has certainly been painting pictures. The exhibition at Marian Goodman included fifty-five works, not all entirely abstract despite its title, dated from 2005 through 2009 (along with a single painting from 1976). One of them, a set of forty-nine small diptychs painted behind glass, could

have been a small exhibition in itself. The quantity of work on view, inci-
dentally, evoked another issue unaddressed by Elger's biography: the nuts
and bolts of studio practice. Even for an artist as industrious as Richter, one
has to wonder how he produces so much (and at such a high level). Some
speculate that the abstract paintings, though probably not the now much
rarer figurative ones, may be largely the work of assistants. There'd be nothing
wrong with that. It's common in today's art. Everyone knows that Bridget
Riley, for instance, has not set her hand to one of her canvases since 1961.
It makes sense because the facture of her paintings is entirely impersonal.
Spontaneity and chance have been abolished. That's not so of Richter's
abstract paintings. Each is a compendium of miraculously controlled acci-
dents. One would like to know more about the physical process of their
making, including any division of labor involved.

But back to that set of glass paintings. *Hinterglasmalerei* is an old folk art
tradition that has now and again been taken up by modern artists, Paul Klee
and Wassily Kandinsky among them, as well as, in recent years, the English
artist Simon Periton. Yet there's nothing folksy about Richter's use of the
medium. *Sindbad* (2008) is not the most important work in the show, though
it consumes the most wall space; but it's one that you have to come to terms
with if you really want to understand Richter. That's not easy, because it
represents a side of his work that is hard to warm to—I was tempted to
say impossible, but art lovers are an unfathomable lot. Their colors are brash,
garish and arbitrary, more like those of Richter's abstractions of the late '70s
through the mid '80s than his work of recent years. These aggressively
ingratiating, cheerfully clashing hues are really hard to take. Like his color
charts—represented in this exhibition by the small, square *25 Colors*
(2007)—they represent the perversely antithetical stance toward color that
has periodically been his: to reach the neutrality of gray by forcing bright
colors into a situation where they neutralize each other. But because the
ninety-eight panels that make up the work are each a little bigger than a
sheet of letter-size paper, and because the paint is sealed away behind glass,
their ferocious neutrality is in itself neutralized and contained. Rather than
overwhelming you, as Richter's abstractions of the early '80s might have,
their intensity gets under your skin retroactively, after you thought you were
already thinking about something else.

Most of the abstract paintings Richter has been making of late are not
like that. They use or are dominated by a limited number of colors, and by
moving these colors back and forth across the canvas so that they sometimes
mix and sometimes emerge separately, Richter almost automatically evokes

a specific atmosphere, a mood, a condition of light and space. In that sense they are closer to traditional painting, no matter whether abstract or not, than a work like *Sindbad* is. And yet their very profusion, and the fact that they have been produced by semi-mechanical means, with the paint moved around by a squeegee, suggests that at another level, the same arbitrariness is at work in these paintings as in the color charts, the early abstractions, or *Sindbad*. For works like those, as Richter wrote to Buchloh in 1977, the premise is "that I can communicate nothing, that there is nothing to communicate, that painting can never be communication, that neither hard work, obstinacy, lunacy nor any trick whatever is going to make the absent message emerge of its own accord from the painting process." Consciously or not, Richter is citing Samuel Beckett, who called for an "expression that there is nothing to express, nothing with which to express, nothing from which to express, no power to express, no desire to express, together with the obligation to express." Not surprisingly, Richter soon discovered that a message nonetheless does emerge from the painting process, that something is communicated. In most of his current abstract paintings, which somehow manage to assert themselves as sheer obdurate matter and radiant quanta of space and light at the same time, he allows that message to appear—but washes his hands of it. It's not *his* message but rather something that occurs almost naturally. "Using chance is like painting nature," Richter has written. "No ideology. No religion, no belief, no meaning, no imagination, no invention, no creativity, no hope—but painting like nature, painting as change, becoming, emerging, being-there, thusness."

In one thought Richter goes from nihilism to Romanticism. Likewise in his painting. And if his hope of painting in a way that parallels the processes of nature seems to echo Jackson Pollock's famous boast when asked whether he worked from nature—"I am nature!"—it's no accident. Commentators on Richter's abstract paintings have often emphasized the radical distinction between them and the work of the Abstract Expressionists, with which they might superficially seem to have much in common. After all, the apparent spontaneity of Richter's paintings is not based on the immediacy of the artist's gesture, as with Pollock or Franz Kline, but is highly mediated, not only by his hands-off working methods but by his basic tendency to subsume the space of painting to that of photography rather than of nature. True enough. But in this case, the superficial view contains more truth than the sophisticated one. The most powerful works in the Goodman show were several very large paintings whose surfaces were nearly white, though of a quasi-white highly variegated, with a great deal of color within or beneath

it, surfacing in ghostly demarcations. Contrary to what Buchloh claims in his catalog essay, they bear little or no connection to the Neo-Dada tradition of Robert Rauschenberg's white paintings of 1951 or Piero Manzoni's "achromes" of the late '50s. In these paintings, Richter achieved, as he has rarely if ever done before, an effect of sublimity such as commentators on the Abstract Expressionists often speak of, though the painters achieved it but rarely. Read Richter's notes again with this in mind, and you'll realize that he sounds like a painter of the 1940s more often than you'd imagine. When he speaks of painting as "an almost blind, desperate effort, like that of a person abandoned, helpless, in totally incomprehensible surroundings," it might as well be Willem de Kooning talking about "a desperate view." And it was Harold Rosenberg who declared, "'The artist works in a condition of open possibility . . . To maintain the force to refrain from settling anything, he must exercise in himself a constant No." Richter at his best might surpass any but the greatest works of Abstract Expressionism, but that's not because his project is radically different from theirs. It's because his is theirs in extremis, pursued with a deep-seated suspicion of its impossibility and an even more vigilantly maintained No. It's the drama (and dramatization) of that self-consciousness that's so exhilarating.

2010

The Perpetual Guest: On Warren Niesluchowski

I don't remember exactly when I met Warren, or how. It feels like I've always known him, which is as it should be, because the essence of his temperament is being known, and knowing others. Both pleasure and necessity have prompted him to develop a preternatural skill at networking.

It makes sense that everyone in the art world knows Warren, but how is it that his circle of acquaintance seems so much wider than that? In his case it's as if the six degrees of separation that, according to urban folklore, connect us with all humanity have been reduced to no more than one or two. I remember once, years ago, being with him at an opening in Philadelphia. He had so many goodbyes to say at the end of the evening that we missed the chartered bus back to New York City. There wasn't another train until four in the morning, so off we went looking for the bus station. As we wandered the unfamiliar streets in search of it, we happened to pass a station for the local commuter train, and just at that moment, a woman stepped out and began to ask us for directions. Just as I was going to explain that we were strangers there ourselves and couldn't help her, she turned to my friend and exclaimed, "Warren! Is that you? What are you doing here?" Wherever he goes, it seems, random people—faces in the crowd, passers in the night—recognize Warren.

But not only random people. Later, when I was living in London, Warren would visit periodically. Upon his arrival I would ask him if he had any plans for dinner, and he would usually say something like, "Ah, I might be meeting Nicholas." (Warren is on a strictly first-name-only basis with everyone he knows.) "I'll have to call him first and find out what's going on." It was up to me to divine whether the Nicholas to whom he was referring was Nicholas Serota, director of the Tate, or Nicholas Logsdail, proprietor of the Lisson Gallery, one of London's most distinguished commercial galleries. Sometimes geography gives the clue. In London the Marina he speaks of will be the writer Marina Warner, but in New York he must mean Marina Abramovic. (That Philadelphia opening was hers.)

At least when he mentions Anish or Vito I can tell he's talking about Kapoor and Acconci.

Being on a first-name basis with Warren may owe something to the difficulty people have pronouncing his surname, Niesluchowski. But although everyone knows him, and knows him as Warren, no one knows what he does. Mostly, he seems to drift through Europe and North America, turning up, Zelig-like, wherever something interesting is happening. He always travels by the cheapest means possible; what the bus ride from Warsaw to London is like I can't say, but it doesn't sound comfortable. Warren knows it well. Likewise, he is always turned out with incredible elegance in thrift-shop finds. Even his socks are snazzy. He's welcome worldwide. No great event is complete without his presence. But he has no concrete role. He is not an artist, a critic, or a curator, let alone a collector or dealer. Occasionally he accepts a commission as a translator, and these gigs seem to help him get by. He often mentions a "project" on which he is engaged with this or that artist, but it is usually hard to ascertain its nature, or what his role in it might be. He is, to all appearances, a lily of the field; he neither sows nor reaps.

Warren leads what is in many ways an enviable life, but there is a not inconsiderable drawback. He is, essentially, homeless. And to some extent, his condition seems fated: Warren was born adrift. He came into the world in a displaced persons camp in Germany after World War II, his Polish parents having met in a forced-labor camp in that country, and grew up near Boston (where a strict Catholic education laid the groundwork for his considerable erudition); he lived abroad after becoming an Army deserter in 1968 and returned to the United States in 1975, where he belatedly found himself a Harvard undergraduate. He stayed there as long as he could without taking a degree. Eventually he made his way to New York, where for a while he appeared to have settled. But over the past decade or so, having discovered in himself some inner need for drift that had gone ungratified, he has made his home wherever someone will put him up. Warren is a perpetual guest. His base, to the extent that he has one, is in Warsaw, where he has a sister, but mostly he lives where anyone from his extended network happens to have a spare bedroom or a temporarily empty apartment where he can stay for a while. I once told him that he could solve his financial problems by writing a bestselling book based on his experience; it could be called *How to Make Yourself Welcome*. He hasn't written it yet, unfortunately. And now that he's in his mid 60s, and not as physically sturdy as he once was, I think he's been brooding a lot on the future his nomadic

lifestyle has in store for him, when he becomes less able to move around as easily as he does now.

Living without a permanent home means living with no more possessions than can be packed in a suitcase. Yet, like most of us, Warren accumulates things—and some of them, like books, are too heavy to lug around. He has therefore come up with an original method for accumulating things without being weighed down by them—he leaves things behind at every place he stays, giving his things a stability he denies himself. (Warren: if you're reading this, that brown suitcase you left in my apartment has not come to New York City with me, but it's stored in the basement of the building where I used to live in London. If we're ever both there again at the same time, it can be retrieved.) "A *cynic* should really have no possessions whatever: for a man's possessions, in a certain sense, actually possess him," wrote Friedrich Schlegel in one of his Athenaeum Fragments, referring to the ancient philosophers who, a bit like Warren, made themselves homeless. To Schlegel's *aperçu* his friend Friedrich Schleiermacher added a caveat: "The solution to this problem is to own possessions as if one did own them. But it's even more artistic and cynical not to own possessions as if one owned them." Warren has at times practiced both of these solutions to the problem of ownership.

It wasn't always thus. When I first knew Warren he had a very respectable job. He was working at PS1, the pioneering exhibition space in Queens that was later acquired by MoMA. I don't remember how long that lasted, but after he left PS1 he was a freelance editor for Routledge, and he earned enough money to hold down a small apartment on the Lower East Side. Then, all of a sudden, he wasn't doing the editing job and didn't have the apartment anymore. He had gone into circulation.

One of the mysterious projects that Warren had been mentioning for a long time involved the Hong Kong–born, Los Angeles–based artist Simon Leung. As usual, I never quite understood what it was all about, but one day Warren mentioned in passing that Simon might be getting in touch with me about contributing to the project. Sure, whatever. While admiring the paintings in the Prado one day, I got a call—it was Simon. He was making a video about Warren. Would I be willing to lend my voice to it? Of course, if only out of curiosity. Simon (whom I had never met, and whose work I was nearly as little acquainted with) would be passing through London soon, and we made an appointment.

I imagined he would be interviewing me—asking me some questions about Warren, my impressions of him, our relationship. Not at all, as it

turned out. Instead, he had a text he wanted me to read, an excerpt from Immanuel Kant's essay "Perpetual Peace," a work I'd heard of but never read. Leung explained to me that he had found a couple of passages in it that conveyed his understanding of our mutual friend, and that he was asking some of the people who had extended hospitality to Warren over the years to read one or another of them for the soundtrack of his video.

The passage he handed me was astonishing—not just brilliantly reasoned, as I'd expected, but laced with a sardonic wisdom. Its subject: hospitality as a political notion. The basis of world citizenship is "the right of a stranger not to be treated as an enemy when he arrives in the land of another." It is the right to be, not a long-term guest, but a peaceful visitor. This right, according to Kant, derives not only from the fact that originally no individual had any more claim to a spot on the earth's surface than any other, but also from the finitude of that earth, which means that we "cannot infinitely disperse" and therefore "must finally tolerate the presence of each other." With regard to Warren and his peculiar modus vivendi, Simon's choice of text seemed apt. In a sense, Warren is always testing his hosts' capacity for hospitality. How long can a passing visit be extended before it becomes— before it threatens to become—something more like cohabitation? What are the limits to one's hospitality, one's toleration? You don't just take Warren in; you take him on. He becomes like a temporary (or maybe not so tempo- rary) member of the family—and relations are always a bit more fraught within the family than among mere acquaintances. The limits need to be negotiated and renegotiated; all of Warren's hosts are tacitly aware of this, but no one is as sensitive to the situation as Warren. He sometimes alludes to the diplomacy that his mode of living requires, and points out that his friends are diplomatic toward him too, such as when refraining from asking potentially embarrassing questions. "They don't say, 'Well, why are you calling me . . . Where would you be if I wasn't at home to take this call?'" Hospitality doesn't work like that. "It's either possible or it's not, but it's given on a gift basis."

Leung has been thinking about these issues for a long time, having known Warren even longer than I have. They met in 1992 when Leung was an artist in residence at PS1. While there he made a video installation with the wonderfully Tolstoyan title *Warren Piece (in the '70s)*. I never saw that work, which involved displays of documents and ephemera as well as three videos shown on monitors, but I gather it focused on Warren's experience as a Vietnam-era deserter who ended up in Paris working with the Bread and Puppet Theater. This was the period, I believe, when Warren became

Warren—not his given name but the one on the false passport he'd come by at the time. Bits from that work turn up nested within Leung's new piece about Warren, *War After War*. I saw it, a year and a half after making my little spoken contribution to it, last spring at the CUE Art Foundation in New York.

As the feature-length video begins, we see Warren pulling his carry-on–sized rolling suitcase up to a house—not the Schindler House, as I first guessed it would be, and where Warren was granted a residency last January in order to assist his collaboration on Leung's piece, but a modern suburban house set in a leafy landscape that looks more East Coast than West Coast. He approaches the building in a quizzical way, as if the very notion of a house, or of a home, was slightly unfamiliar—like a word in a foreign language one had learned but had not used in a long time. The camera moves indoors, and it turns out that the house contains a vast library. Then, in a series of brief sequences, we see Warren in a variety of situations: for a while he's at a house party, where he seems an isolated, pensive figure (later he will be seen at other parties, and art openings, in a different guise, the loquacious bon vivant); then he's visiting a multimedia museum exhibition about the Vietnam War (with Jimi Hendrix playing "The Star-Spangled Banner" on the soundtrack). Warren wanders through these early scenes as a silent witness and seeker, a sort of revenant (the coat draped over his shoulders like a cape recalls, at times, the costume often worn onscreen by that other haunting Eastern European figure, Bela Lugosi). There is some-times a voiceover, but the voice is not Warren's, and the text—the excerpts from "Perpetual Peace"—has no overt connection to what we (and Warren) are seeing. Finally, after a long few minutes of this mute spectatorship, Warren makes his voice heard. Standing inside the house looking out, he intones a solemn song in a foreign language—as I later learned, a somewhat garbled version of the once-famous Chinese revolutionary anthem "The East Is Red." (Old revolutionary songs are a recurrent feature of *War After War*. We also hear Warren sing the Internationale and, as he examines some dead flies through a magnifying glass, "Bandiera Rossa.")

Soon enough, Warren's speaking voice is heard. Much of the video consists of straightforward interviews with him, presented talking-head style or used as voiceover with counterpointed visuals. He is not only a witness but one who ruminates over what he has seen. For instance, we see him on the floor doing exercises on a beautiful geometrical rug; like many of us, he is working to cultivate his vital energies, but the sequence of movements ends with a long period of stillness, his eyes closed, arms stretched out, and suddenly

we realize that he is not only preparing for life but for death—just as he had said on the voiceover a few moments before. When we encounter him later in a hospital bed he looks terribly thin, though still natty, sporting a beret along with his hospital gown. There's vague talk of heart problems. In other sequences we see Warren walking down a street of modest brick row houses somewhere in London—he buzzes a door and begins to engage the unseen person inside in a conversation about a set of keys he's trying to hunt down. And there he is tramping through snow-covered New York streets to meet Milo, the cat he must look after while apartment-sitting; its owner compliments him on his tie—"So chic!"—and he responds that a tie is "the perfect Kantian item, something that has no use at all but gives great *Sinn und Sinnlichkeit.*" His segue from Kant's aesthetics to the German rendering of the title of Jane Austen's first published novel is clever, but there's a ruefulness behind it. Is he also thinking of his own "useless" (that is, nonpro-ductive) existence, and the hope, which would certainly be affirmed by those who know him, that he contributes to the lives of others in his own way, which might well be summed up in Austen's notion of "sense and sensibility"? What Warren would not ever say, I think, though it is an idea that his invo-cation of Kant could justify, is that he is therefore a kind of artist—or even that his life is art.

I couldn't help being touched by Leung's portrait of my friend. He and I view Warren a little differently, though. For Leung, the Vietnam era is the time that has most strongly marked the course of Warren's life; to my mind, World War II and its aftermath dominate the story. But thematically, the portrait is very rich. Although not all its themes are developed as thoroughly as they might have been, their multiplicity, and Leung's skill at creating a reflexive structure that allows him to move fluidly among them, is testimony to a life lived, though in the shadow of two wars, with originality and verve. Leung calls Warren a "cosmopolitan nomad," but Warren wonders which one he really is: a cosmopolitan or a nomad—that is, by his own definitions, one who is at home everywhere or one who is at home nowhere?

For me, and I think for Leung, too, Warren is a romantic figure. Yet one of the attractive things about Warren is that he never romanticizes himself. At one point in *War After War*, the famous lines from "The Love Song of J. Alfred Prufrock" are heard, and their relevance is patent: "No! I am not Prince Hamlet, nor was meant to be; / Am an attendant lord, one that will do / To swell a progress, start a scene or two, / Advise the prince"—though Warren is never, as Prufrock thought himself, "Almost, at times, the Fool."

In another era, Warren really could have been an excellent courtier, "full of high sentence." And how curious it is that our society doesn't easily accommodate people with undefined roles. Yet we need such people, to add *Sinn und Sinnlichkeit* to life rather than to produce. I suppose that's why I've never questioned my impulse to offer my home to Warren when I could—on account of a sympathy that blossomed into friendship, yes, but also because of an obscure sense of principle. I think there should be space for those who neither sow nor reap but through their example show us something about how to live our life as art. In *War After War* there's a funny detail that Leung's camera homes in on more than once: the many extra buttons scattered on a sleeve of Warren's coat. I've noticed them before, but only after seeing the sleeve onscreen did it occur to me to wonder whether it was the work of some fabulous deconstructive designer, a Margiela or Yamamoto, that Warren has lucked upon in one of his thrift shop trawls, or just his way of keeping replacement buttons on hand so that his coat will stand him in good stead no matter what happens.

Style or necessity? Art, and Warren, remind me they can be one and the same.

2011

15

Love by a Thousand Cuts: Kara Walker

History, said Stephen Dedalus, was a nightmare from which he was trying to wake. For Kara Walker, history seems to be a nightmare she's trying to enjoy, perhaps in the sense that Slavoj Žižek urges his readers to "enjoy your symptom." Whether or not Walker succeeds in attaining this enjoyment through her work (I'll wager she does), lots of other people certainly do. Even in this era of immense and sudden success for certain young artists, it's hard to think of any who have come so far so fast. A 1994 MFA graduate of the Rhode Island School of Design, Walker began to garner attention as soon as her work appeared in the "Selections 1994" show at the Drawing Center in New York; the next year she produced three one-person shows, two of them in public spaces, and by 1997 the artist, then all of twenty-seven years old, had been given a MacArthur fellowship. Her work is in the most important American museums, and the European ones that own or have exhibited her art are nothing to sneeze at either. In New York alone, she's exhibited in the past four years at the Studio Museum in Harlem, the Met, and the New School, not to mention Sikkema Jenkins, the commercial gallery in Chelsea that handles her work. And the art world shows no sign of Walker Fatigue: a traveling retrospective of her work, *My Complement, My Enemy, My Oppressor, My Love*, which originated earlier this year at the Walker Art Center in Minneapolis, recently closed at ARC/Museé d'Art Moderne de la Ville de Paris, where I saw it, and where it was called *Mon Ennemi, Mon Frère, Mon Bourreau, Mon Amour*. The retrospective, which includes three films, a dozen large-scale wall works, and hundreds of drawings, watercolors, and small paintings, has now arrived at the Whitney, after which it will finish its tour at the UCLA Hammer Museum in Los Angeles. Why is it that museums can't get enough of Walker's work? Early on, Walker found the art world's holy grail, an instantly recognizable amalgamation of technique and content not previously associated with any other artist—the aesthetic equivalent of what the marketing gurus call a unique selling proposition. What struck the eye from the first were Walker's grand-scale

figurative compositions made with cut-out black silhouettes affixed directly to the wall, and the neat way this folksy, traditional, and domestic technique, expanded to the scale of a public mural and executed with a breathtaking precision and elegance, meshed with the subject matter it was used to convey: the violence of American black slavery recast as a perverse sexual fantasy. Here was *Uncle Tom's Cabin* as it might have been envisaged by a disciple of the Marquis de Sade, or *Mandingo* remade as a Matisse cutout, if Matisse had been a student of Aubrey Beardsley rather than of Gustave Moreau. The ironies thus generated are endless, delectably so: the use of a graphic technique that ruthlessly reduces everything to the polarity of black-and-white to evoke moral and psychological ambiguity and doubt, for instance, and favoring a mode of representation that makes it impossible to represent skin color in addressing questions of race.

The intensity of Walker's ambivalence about identity is evident even in one of the simplest of these mural silhouettes: a work from 1998 called *Cut* functions as a portrait of the artist, the "emancipated negress" we encounter in the archly elaborate titles of some of her other works. Here, the gesture of cutting that's the basis of Walker's silhouettes is given a surprising twist. With a pair of girlish braids and wearing a big flowing skirt, the figure in *Cut* seems to be rising into the air, kicking her heels together like Dorothy in *The Wizard of Oz* using her ruby slippers to go home. One outstretched hand clutches a straight razor, which has slit the other wrist so deeply that the hand, with its daintily spread fingers, is hanging on to the forearm by just a thread. Blood gushes up like a feathery geyser from the wrist, and a couple of puddles of it have gathered on the ground beneath her. Then one notices that the hand that holds the razor has somehow been slashed too—blood plumes from it as well, though less profusely—and for that matter the razor blade is hanging from its handle in the same way, as if it had even cut itself. This is an image of self-laceration as ecstasy beyond the dreams of your average paraphiliac. What's important, though, is that the blade that's used to make the art is equated with the blade that draws the artist's own blood. *Cut* is an expressionist melodrama such as Edvard Munch or Oskar Kokoschka would have understood, though in their day the creative artist could not be her own *femme fatale*. Yet its execution (the word suddenly becomes a strange sort of pun) is the opposite of expressionist style as we normally conceive it—not disordered but precise, not turbulent but cool, not messy but clean, not demonstrative but formal, even downright prim. Walker

draws blood, but her art is dry. She presents her work as concerning self-control in emotional extremity—where self-control does not necessarily mean keeping quiet but rather the opposite, being capable of a stylized gesture so extreme that it can only freak out its witness with its sublime indifference to self-sacrifice. The most extreme gesture in Walker's art, however, is one that is shown in this allegory of her self-conception as an artist, though it is nearly everywhere else in her oeuvre: the insistent equation of polymorphous carnal pleasure with the perverse power structure of slave society.

Maybe our delight in this copious phantasmagoria amounts to a sort of enlightened masochism. Although *Cut* implies that is a form of self-wounding, Walker means to draw blood from her public as well, and not just through pictures of master-slave orgies and the like. Thanks to Francis Picabia and Barbara Kruger, among others, there may be nothing new about an artwork taking a verbally aggressive stance toward its public, but it's hard to remember any before that addresses its viewer as "Dear you hypocritical fucking Twerp," as Walker's does in *Letter From a Black Girl* (1998), a text displayed prominently on a wall in the retrospective, not to mention on the cover of its catalog. That charming salutation pretty well sums up the mixed feelings that Walker cultivates with such feverish tenacity, and while her work can make you feel kind of beat up on, there's nothing quite like the jolt of being told "I hate you" by someone who really seems to mean "I love you"—the emotional up-and-down can be addictive.

It's easy to take a single figure like *Cut* as paradigmatic of Walker's vast, multi-figured murals, starting with *Gone, An Historical Romance of a Civil War as It Occurred Between the Dusky Thighs of One Young Negress and Her Heart* (1994), because those works, eschewing traditional hierarchical composition, are spread across the wall as concatenations of isolated figures or, more typically, tight little groups of two or three, cut from the same sheet. The most complicated of them, if not quite the largest, also gets the longest title: *Slavery! Slavery! Presenting a GRAND and LIFE LIKE Panoramic Journey into Picturesque Southern Slavery or 'Life at "Ol'Virginny's Hole" (sketches from Plantation Life)' See the Peculiar Institution as never before! All cut from black paper by the able hand of Kara Elizabeth Walker, an Emancipated Negress and leader in her Cause* (1997). But the scenes it shows are comparatively tame by Walker's standards. Sure, there's a bit of farting and pissing going on, and a couple screwing on a rooftop—but nothing like the sadomasochism and child abuse that turn up with such regularity elsewhere in her work. For that matter, most of

these pieces—unlike her later film works—may actually be a good bit less obscene in reality than they become in one's retrospective imagination of them. In part that's because "her characters"—as one of Walker's savviest supporters, Hamza Walker (no relation), director of education at the Renaissance Society of the University of Chicago, put it—"shamelessly engage in the most shameless acts." They are without shame because the silhouette technique empties Walker's figures of all inner life—the better to stir that of its viewers. Equally, the figures are disconnected from one another. In all these pieces, there is little or no narrative connection among these figures and small groups, just a freewheeling Brueghelesque concurrence between them.

As early as 1998, Walker admitted that she was "sort of" getting tired of doing the cutouts. Around 2000 she began experimenting with abstract colored projections on the walls to which the cut-paper silhouettes were affixed. The results were not successful, on the whole: in works like *Darkytown Rebellion* (2001) the figures seem a bit lost amid a garish multiplicity of colors to which they have no relation. Walker once said that, in her student work, "I used to avoid the face issue by just kind of mashing up different colors," and here, likewise, the use of color seems a distraction.

Since 2004 she has been exhibiting animated films, which represent a more decisive broadening of her aesthetic—precisely because her work in the medium is formally so much rougher, less refined, than her paper cutouts, though in retrospect the multiplicity of vignettes in her murals leads naturally to the sequence of scenes in a film. The first of them, *Testimony: Narrative of a Negress Burdened by Good Intentions*, takes off from the premise that white men have become slaves to black women. *8 Possible Beginnings or: The Creation of African-America, a Moving Picture by Kara E. Walker* (2005) is a more episodic fantasia on the fate of blacks under slavery. In these films the story, such as it is, is played out by hand-manipulated shadow puppets—not unlike those used by the South African artist William Kentridge in some of his films (for instance, *Shadow Procession*, from 1999), except that Walker handles hers in an ostentatiously crude way that makes the work feel like something produced by a brilliant but emotionally disturbed child who's been given her first camera as a birthday present.

Above all, the imaginary world of the shadow puppets is never allowed to occupy the viewer's attention completely. Instead, one is constantly made aware of the arbitrary manipulation (in both senses of the word) of these

hapless figures by the even more shadowy figure of the person who moves them about—her hands are often visible, and in one segment of *8 Possible Beginnings*, we see a young woman, presumably the artist herself or in any case her stand-in, earnestly cutting a silhouette—her model is a white man in a hat—after which an intertitle congratulates her: "Good job, Bess!" In *Testimony*, we even get to see a milky, viscous fluid spatter over the image, in case we didn't get the masturbatory gist. Childish in a different sort of way is the specific form of fantasy *8 Possible Beginnings* engages at one point, where the distinction between the sexes has no meaning. In one episode, a rather frail-looking master engages his handsome male slave, first in a bout of fellatio, then in anal sex—which results in the young man's pregnancy and then the birth of their not-exactly-human offspring.

Walker, according to a leaflet at ARC, "accounts for the relationships between black and white people, master and slave, segregation and its inherent contradictions," and "counterbalances the American official history as propagated by cinema and literature"—an essentially realist rationale for her art that's not uncommon in commentary on her work. Such deadening verbiage strains to find edifying significance in the fraught and unruly fantasies Walker throws in our faces. All of her work makes clear, *8 Possible Beginnings* just a bit more blatantly than the rest, that any basis it may have in historical or even in biological reality is completely circumstantial. Slavery becomes a metaphor for sex—and, why not, for love—as much as sex becomes a trope for slavery. Not that this lets anyone off the hook. There's no writing off Walker's inventions as the byproducts of a deranged imagination—as if she were some sort of black, female, art-world-insider counterpart to Henry Darger.

But this is just where interpretation gets tricky. "None of this is about her own fantasies," insists the exhibition's curator, Philippe Vergne, deputy director and chief curator at the Walker Art Center; "it is about the codes of representation and their power." Yet any such intellectual impersonality is constantly belied by the incandescent tone of all of Walker's work. And after all, how powerful could those codes be if they weren't able to generate some pretty urgent fantasies? Likewise, another contributor to the exhibition catalog, cultural historian Sander Gilman, works overtime to establish that attacks on Walker as pandering to racism and sexism—and it's not surprising that they've come up—must be misguided because art cannot be "a mimetic mirror of the inner life of the artist," cannot be unambiguously traced back to "the character of the artist." But while the causal connections may be interestingly oblique and tenuous, still, the art comes

from precisely what the painter and occasional critic Carroll Dunham, writing in *Artforum*, has called "the hostile, raunchy, ironic consciousness driving Walker's art."

Some of Walker's most fascinating work consists of writing, whether embodied in vinyl lettering on a wall, as with *Letter From a Black Girl*, or scribbled on paper to be presented as a form of drawing either with or without any pictorial accompaniment. It would be a mistake to rely too heavily on these texts to interpret her other works—they are artworks, too, posing their own hermeneutical challenges, not explanatory commentaries—but they help underscore what may be slightly more obliquely indicated by the murals, films, and other pieces: that all this is intensely personal to Walker, and that precisely for this reason, it reflects her hyperawareness of context—above all the art-world context that, as the daughter of an artist, she must have been at least tangentially aware of since childhood. "I knew that the only way to gain an audience in the art world was to cloak my work in the guise of blackness," we read on one sheet from the sometimes almost embarrassingly diaristic 1997 drawing series *Do You Like Creme in Your Coffee and Chocolate in Your Milk?* "I would have to make work that was so directly racial that no one could help but notice." Since she could hardly pass as white, she would have to pass as black.

This paradoxical strategy undoubtedly explains the angry reaction Walker's work—or rather its quick success—aroused early on among a number of prominent older black women artists: in her they see a black putting on blackface. Walker's ruminations, however, convey an almost excruciating sincerity at odds with the canny trickster we imagine behind the insolent films and murals. But if they also suggest a calculated bid to manipulate the white, liberal art world in the interest of success, what about the fantasy, recounted elsewhere in the sequence, of seducing none other than David Duke, "to 'bring down' . . . the former Klansman and almost Louisiana Senator in SCANDAL!" Well, more surprising things than that have happened.

Still, as for scandals, Walker may have caused a few, but they've been small change compared with the honors heaped on her. Does that mean she's doing something so right it's wrong? I don't think so. Whoever her public is—and they're not all white men like me—she does "bring us down" to dwell amidst appalling desires and admit they might be or become one's own. "But that I would fuck an avowed RACIST—not at all unusual," writes Walker in *Do You Like Creme*. "Since all I want is to be loved by you And to

share all that deep contradictory love I possess. Make myself your slave girl so you will make myself your equal—if only for a minute." Walker turns out to be a closet utopian, and it's not her scathing humor or her obscenity that's made her loved—it's her perverse optimism.

2007

"You're So Pretty": Laurel Nakadate

Laurel Nakadate describes her 2009 feature-length film *Stay the Same Never Change* as "both visual fact and narrative fiction." She's referring to how she shot the film in the Midwestern milieu of the amateur actors she'd recruited to flesh out her invented, scripted tale. Maybe "visual fact and narrative fiction"—which could sum up most of Nakadate's work in video and photography, as well as *Stay the Same* and her more recent feature, *The Wolf Knife* (2010)—is just another way of describing realism: the creation of verisimilitude through the use of observed detail. But there's something more to Nakadate's aesthetic, or anyway, something other than putting real toads in imaginary gardens. Realism implies a seamless transition between the real and the imagined. Nakadate troubles the relation between them. She grew up in the Midwest and studied first at the School of the Museum of Fine Arts in Boston and then at Yale, where she took an MFA in photography in 2001. From the beginning, her work was clearly influenced by a somewhat older group of photographers who'd come out of Yale in the late '90s—artists like Dana Hoey and Malerie Marder, whose staged, girl-centric images came to wide notice through the 1999 exhibition "Another Girl, Another Planet," curated by their teacher Gregory Crewdson. But it also had a performative dimension that recalled the aggressively sexual self-presentation of '70s artists like Hannah Wilke and Lynda Benglis, with their parodic reenactments of gender stereotypes.

It didn't take long for Nakadate's work to get noticed, and a visit to MoMA PS1 in Queens, where her exhibition "Only the Lonely" is on view, immediately shows you why. The work is not self-effacing; it deliberately pushes your buttons. It would be tempting to dismiss Nakadate as a sensationalist, a young woman artist who exploits her own body to stage soft-porn reality-TV scenarios with pathetic middle-aged men. Even critics writing enthusiastically about this art can't help discussing it in terms that, when taken out of context, sound harshly critical. Writing in the *Village Voice* in 2005, Jerry Saltz called attention to what he saw as Nakadate's "slutty,

back-alley exoticism," saying, "If a young male artist preyed on women this way he'd risk being kicked out of the art world." As for those turned off by such a spectacle, they are well represented by the critic/blogger Carol Diehl, who has suggested that Nakadate's admirers, such as *New York Times* reviewer Ken Johnson and MoMA PS1 director Klaus Biesenbach, who curated "Only the Lonely," are simply men who become "unhinged at the sight of a young woman in her underwear."

Given that *Out* magazine once named Biesenbach one of its "100 Most Eligible Gay Bachelors," Diehl's analysis may not be entirely watertight. Still, since I'm not on that list, it behooves me to examine my response to Nakadate's work to see whether, as Diehl proposes, it radiates from something other than my brain. I'd be surprised if any man could spend much time with "Only the Lonely" without questioning his response. Consider one of the earliest of the videos at PS1, *Happy Birthday* (2000). In each of the work's three channels, the artist lights the candles on a birthday cake in the presence of a different middle-aged white man; we can imagine that these are the men's apartments: cheaply furnished, unappealing, a bit sad-looking, like their occupants. Once the candles are lit, the man sings "Happy Birthday" to Laurel, who then blows out the candles, cuts the cake and serves it. Except for the singing, the four minutes or so of each segment are mostly filled with awkward silence; occasionally one of the men makes a casual remark or a little joke—"I'll have to throw my scale out"—to which Nakadate replies with a polite acknowledgment, but no more. Throughout, her ingenuous facial expression, neatly pulled-back hair and demure dress suggest someone considerably younger than twenty-five, as she was at the time.

The Nakadate I see in *Happy Birthday* is certainly pretty, though not enough to unhinge me. But maybe I'm being too easy on myself with that example. A lot of skin gets flashed in her other videos. In *Lessons 1–10* (2002), Nakadate models in various (but never total) states of undress and strikes provocative, sometimes absurd poses for a balding guy who assiduously draws her with charcoal pencils, all to the accompaniment of the yearning voice of Patsy Cline singing "You Belong to Me." Then there's *Love Hotel* (2005), in which Nakadate—this time without any male partners—engages in what can only be described as air sex in a Tokyo hotel room. Showing consistent form in her taste for tear-jerking musical Americana, she has set *Love Hotel* to Merilee Rush's pop hit of 1968, "Angel of the Morning."

Let's say one was inclined to let the presence of the more or less unclad body in a work like *Lessons* go to one's head. There'd still be a snag—the

male presence in the scenario. Here one has to keep in mind the question of something like a class or status politics alongside the more evident gender issues. Think of the kind of person likely to be a visitor of art galleries, someone who means to cultivate an aesthetic sensibility, who probably has a considerable degree of education and also, if there not as a disinterested viewer but a potential collector, of income. For such a person, the men in Nakadate's videos—her muses, her collaborators—are likely to be objects of scorn: guys stuck in dead-end jobs who have never seen the inside of a health club and lack the savoir-faire to arrange an unpaid date. They seem weak, unmasculine. If you find yourself appreciating Nakadate for her body, you've inevitably got to ask yourself, "Am I like those guys? Is that me?" And the answer is likely to be, "I sure hope not." As a result, it's hard (at least if you're male) to look at some of these pieces without a queasy feeling. You're not so much looking at the female figure as at male desire, and, much as in certain works by Vito Acconci, suddenly the latter doesn't look very pretty. You might want to disavow your reaction, but Nakadate doesn't make it easy.

At the same time, it's impossible not to consider, in viewing these encounters, that while they are obviously to some extent staged, one has no idea how far down the staging goes. What if the men are actors who specialize in playing these kinds of roles? Or if that doesn't seem too likely, to what extent has Nakadate directed them to play sad losers, members of what Saltz called "the race of men who lack the ability to seduce women and whom women never attempt to seduce"? When fact meets fiction, only the devil can untangle the result. In any case, because of the strict neutrality with which these situations are presented—the visual blankness of the still-camera *mise-en-scènes*, the lack of contextualizing setups, voice-overs, or titles—we should always be ready to come to terms with the fact that most of what we think we are seeing in these works is our own projection. We can't take the artist's word for it because she is not explicitly telling. Why do I think the guy drawing Nakadate as she poses in underwear and roller skates in *Lessons* is not a "proper" artist but just a dirty old man who's discovered life drawing as a socially acceptable way to leer at naked young women? Just prejudice, really, albeit conditioned by the overall context of Nakadate's work—but prejudice nonetheless. The man drawing Nakadate looks as serious as can be. He's not ogling her; he's just looking, as any artist might, and he doesn't seem to be having a particularly good time. Then, too, I have to wonder why I think it's possible to distinguish between someone drawing the model for valid artistic reasons and someone

drawing with ulterior motives. Picasso was not the only artist to have had affairs with his models.

The art of looking, and of thinking about looking, keeps getting more complicated. All my responses seem to turn back on themselves and end up somewhere quite different from my first visceral reaction. My disinterested aesthetic gaze might really be compromised, prurient—and that other guy's prurient gaze might be much more innocent than I imagine. But what about a piece like *Love Hotel*? Doesn't the absence of the alienating figure of the pathetic man turn this into something more like simple voyeurism? Maybe, but it doesn't take any particularly acute sense of the absurd to see the ridiculousness inherent in all these postures, the fakery of these solitary writhings and come-ons to no one in particular. As pathetic as all those men may seem, Nakadate makes herself appear no less so. In her case, admittedly, pathos might be endearing in a way that the men's pathos is not. A fit young body is innately alluring. But even so, the simple enjoyment one might feel in the display of the female body is complicated by a sense of emotional disconnection, of a displacement that feels troubling. Empathy and alienation are constantly embroiled in Nakadate's art, just as are desire and compunction.

It's all about self-consciousness, really, in both senses of the word—being self-aware and being ill at ease. You watch Nakadate—and you watch her watching herself, because she often indulges in the tic of breaking character and looking at the camera as if checking herself in a mirror. Or you watch someone watching Nakadate, and then you watch yourself watching someone watch her as she watches herself—and all those different viewpoints start to blur together. This *mise-en-abyme* might make you want to be more alert about understanding what's going on, in the work and in yourself.

All this self-consciousness is no guarantee that Nakadate's art will always act as a good, respectably self-disciplined essay in which critical reason triumphs over irrational impulse. The feeling of uneasiness provoked by the work is not always edifying or pleasurable. Sometimes things feel too creepy. Every viewer will have different limits, but for me they appeared in *Good Morning Sunshine*, from 2009, in which a given scenario is repeated three times with different subjects. "We"—that is, the camera—enter a young teenage girl's bedroom. She's asleep. A woman's voice, that of the artist (who remains unseen throughout), coaxes the girl awake—"Hey morning! Wake up, Sleepy . . . Did you sleep OK?" But then the voice starts coaxing the girl into undressing. "That's a pretty shirt . . . Let me see your bra strap.

Why don't you take your shirt off? . . . Stand up and let me look at you. You know you're the prettiest girl, right? Let's see your panties." The voice takes each girl through the same routine. "You're so pretty . . . Let me see a little more."

The girls, who act shy but mostly go along with what's requested, hardly speak. They respond more with expressions and gestures: they come across as infantile, as incapable of speech. And Nakadate speaks to them as if they were even younger than they look: one girl wears a Snoopy T-shirt, so instead of "Take off your shirt," the voice says, "Make Snoopy go bye-bye." With this combination of flattery and pressure, Nakadate has taken on the voice of the child abuser. We know it's all play-acting, as is the ceremony of the birthday cake in *Happy Birthday* and all the rest, but the performance is convincing enough to be excruciating. And besides, when has sex not had something to do with play-acting? I can't resolve my aesthetic pleasure in many aspects of this piece (including the sensitive attention to these, yes, pretty young girls by Nakadate's camera, which for once mimes the artist's viewpoint rather than remaining stoically neutral) with the acute discomfort it causes.

Good Morning Sunshine, with its mobile camera in place of the Andy Warhol–style fixed viewpoint of the earlier pieces, as well as its more evident fictiveness, was made after Nakadate had gamely set one foot into the world of cinema with *Stay the Same Never Change*, on which she was credited as writer, director, editor, and cinematographer. Made with amateur actors on a budget of $19,955 (according to IMDB), it became a special selection at Sundance and part of the New Directors/New Films series in New York in 2009, and earned her fans like the novelist Rick Moody and the playwright Neil LaBute. Its teenage heroines drift through their hometown of Kansas City, observed by men who always seem to be looking for an opening (and who are sometimes shown with black bars over their faces). The color photography is at times achingly beautiful—one thinks of William Eggleston—and so are the two girls: being pretty is a *promesse de bonheur* but also a source of vulnerability, of danger. Their doings may be banal and arbitrary, but the film, essentially a sequence of loosely linked tableaus, is never boring to watch, in part because of its eerie atmosphere. There always seems to be an unspoken threat in the air. It's a film that sticks with you, not just for its rare pictorial intensity but also for its empathy with a place that it nonetheless cannot depict as anything but lost.

Nakadate's second feature, *The Wolf Knife*, follows a similar formula, but somewhat less successfully. It tracks the wanderings of a pair of teenage

girls, this time as a sort of road movie starting in Florida and leading to Nashville. The girls drift among men who seem predatory; the film begins with the mother of one of the girls warning them about a rapist on the loose in the area, though it's the mother's boyfriend who seems the more immediate problem. But the relationship between the girls seems more fraught than in *Stay the Same*. There is a palpable sexual tension between them at times. *The Wolf Knife* is a darker film, but also a less coherently organized one. Watching *Stay the Same*, I felt sure Nakadate is a natural for the cinema; with *The Wolf Knife*, I was less sure. Besides, there's also the question of whether in the long run she'd be able to accommodate sufficiently the conventions of mainstream cinema without fatally compromising her deliciously raw style. Any low-budget indie flick you can name would look downright slick in comparison with Nakadate's films, whose ramshackle quality gives them a reckless poetry.

Another recent work likewise shows Nakadate less sure of foot: *365 Days: A Catalogue of Tears* (2010) is a sequence of large color photographs, one for every day of the year, based on the conceit that once a day she would photograph herself in a weepy state. It's a cross between Tehching Hsieh's meticulously documented yearlong performances of the late 1970s and '80s and Sam Taylor-Wood's 2004 photographic series *Crying Men*, in which the British artist photographed famous actors exercising their métier by turning on the tears. Individually, the images are striking, but the idea just doesn't carry enough weight to justify their quantity. A month of crying would have made the point well enough.

The photographic series *Lucky Tiger* (2009) is stronger through its evocation of intimacy, both in the scale of the pictures, four by six inches, and their more informal, snapshot-like style. But again, there is a conceptual conceit that falls flat: these images of the artist in pinup-style poses were passed around to men whose hands had first been covered with fingerprinting ink, so they are filled with black smudges. They are literally dirty pictures. It's a clever, resonant idea, and yet the forensic overtones are exaggerated.

In any case, one feels that Nakadate is trying to close the book on the video work she's been doing since 2000. "I made the majority of this work at a very specific time of my life, when, if an artist is lucky, they're very naïve and brave," she told R. C. Baker of the *Village Voice*. "I'm very proud of having been naïve and brave, because it's authentic." That kind of naïveté doesn't last very long. It eventually cancels itself out. Nor, of course, does prettiness last forever. It's specific to youth, and more than ten years after *Happy Birthday*, Nakadate might feel that her fascination with the pretty—an

underexamined aesthetic category in comparison with its big sisters, the beautiful and the sublime—is best served through observing its embodiment in others, as she does in the two features as well as in *Good Morning Sunshine*. In this light, perhaps *Lucky Tiger* is a farewell to the video work, a last souvenir of that time, a deteriorating and partly obscured memory.

When a young artist is given a show of this scale, it's always tempting to ask, "Is she really ready?"—all the more so when the exhibition is in New York, where Nakadate is based, and where so much of the work has already been seen. In this case, though, the question seems irrelevant. Familiarity certainly hasn't dulled the work's edge: it's as disturbing as ever. In retrospect, Nakadate's oeuvre of the decade beginning in 2000 has an undeniable power and completeness. Now the burden is on her to understand what comes next. It seems clear that she still hasn't settled on a project that can take her through the next decade, perhaps through the rest of her life. Sometimes artists lose their way at this point of transition. A critic is not meant to be a clairvoyant, but if any artist has the nerve and intelligence to negotiate this crucial shift, it's this one.

2011

The Complete History of Every One: Zoe Strauss

If, like me, you traveled from out of town to see Zoe Strauss's exhibition at the Philadelphia Museum of Art, you might have encountered it well before reaching the museum. Near Thirtieth Street Station stand two billboards side by side. One is a straight-on view of a weathered plywood board nailed to a telephone pole in the middle of anywhere, surrounded by nothing but sky. Spray-painted in red on the makeshift sign is the phrase DON'T FORGET US. The other billboard shows the dilapidated façades of a block of three-story row houses; some of their windows are boarded up, and shreds of a strange white material hang from the window frames. Only after passing the billboards did I realize that I had already stepped into "Ten Years," on view in the streets of Philadelphia as much as within the temple of art on the hill in Fairmount Park. Even the most cosmopolitan of local residents seeking out the fifty-four images Strauss has situated throughout the city will end up roaming across unknown territory.

The billboards are not ads for the show. Uncaptioned, without any indication of their purpose or sponsor, they demand to be experienced on their own terms, visually and semiotically, if they are to be understood at all. They owe their meaning mostly to the response of each viewer. Even the pairing of the two near Thirtieth Street Station, which encourages one to find an implicit connection between them, is unusual, because most of Strauss's other billboard photographs are isolated, unmoored from their artistic context—seemingly urgent messages crying out to be decoded, but without a key.

Some of the images on the billboards are also among the nearly 150 on view at the museum (along with three slide projection pieces that include still more images), but their meaning is altered by the indoor context, and not only because of the extreme difference in scale. (Strauss is not one of the size queens of contemporary photography; a billboard, a standard photograph, a projected slide, a reproduction in a zine, or a jpeg on her blog are all equally valid ways of conveying different aspects of her project.) In the

densely hung galleries the photographs are forever forming new constella-
tions of meaning: the museum creates the possibility for the images to
coalesce into something like a discourse. As writers like Boris Groys and
David Carrier have reminded us, the museum *is* the context for art; yet
artists are often uneasy with this condition, and rightly so. While it may be
true that art's home is the museum, art often looks homeless there, stranded,
isolated from its living sources. Like an unhappy adolescent, museum-bound
art is in perpetual conflict with itself, and its deep desire may be to run
away from home—to find its other contexts, its other homes or
homes-away-from-home.

Strauss's work was a runaway from birth, and by putting her photo-
graphs on billboards she is returning them to the streets from which
they sprang. Many of the photos were shot on the street, and with an
eye mindful of the now-venerable tradition of street photography whose
earlier protagonists include Henri Cartier-Bresson, Helen Levitt, and
Garry Winogrand, image-makers determined to record the random and
unruly essence of modern urban life by catching on the fly those odd,
almost unnoticeable moments when reality seems to have let its guard
down. But more than that, Strauss's images are not only about but for
the urban rough-and-tumble. The streets of Philadelphia have become
her museum: no admission, no coat-check, no guards, and a true public
space for all that.

While the most interesting thing about Strauss is her pictures, the second
most interesting thing is how the end run she's made around the art world
has led her pretty much to its center. The story starts, at least as told by
Peter Barberie, the curator of "Ten Years," on the Sunday after Thanksgiving
2001, when Strauss, who had been eking out a living mostly as a babysitter
and had been involved as a social activist in organizations like ACT UP,
"pasted around thirty color photographs onto concrete columns beneath an
elevated section of Interstate Highway 95 in Philadelphia." Some of the
images were of places in the immediate vicinity; others were taken farther
afield. Strauss has explained that, having little previous experience of
photography or formal training in any art, and not even owning a camera,
"I decided I wanted to work on a large-scale public art project comprised
of photographs that were to be placed outside . . . I had cooked up the idea
for the big installation first, and the individual photos were going to be made
with the intent of being a part of this installation." Strauss sat with her
installation for the day and then went home, leaving the pictures to the

mercy of passersby and the elements. She was determined to make the installation an annual event for ten years, but ended up organizing two similar exhibitions the next year and another in 2003 before moving on to what Barberie describes as "a similar but much larger space, still under the highway" in a different part of the city, where she exhibited her photographs annually from 2004 through 2010.

Strauss's first outdoor exhibition drew only a few visitors, most of whom already knew her. But the recurring exhibitions brought more notice, and she eventually received a grant from a local organization that supports women and transgender artists. More grants followed, enabling her not only to keep working but to travel beyond Philadelphia in search of material—and eventually to quit babysitting. In 2006 Strauss gained national recognition through her inclusion in the Whitney Biennial, in New York City, where she displayed her images as a sequence of projected slides. Up through the most recent and final outdoor exhibition under I-95, she sold and signed photocopy prints of her images for $5. One imagines her photographs have fetched higher prices at the relatively few exhibitions she's had in commercial galleries (most notably two shows at the Bruce Silverstein Gallery in New York); but many of her exhibitions, other than those she has organized herself, have been in museums and other nonprofit spaces. The art blogger Tyler Green has rightly pointed out that a family of four would have to pay $56 to see the museum component of "Ten Years"—more than many of Strauss's subjects would feel they could afford.

Within ten years Strauss has gone from being a babysitter whose ideas and ambitions were being acted out mainly in her imagination to becoming, as the present exhibition confirms, one of her hometown's most prominent artists. Given that history, it is tempting to see Strauss as a sort of outsider artist, transfixed by an inner vision that transcends the need for a style shaped by tradition. Nothing could be further from the truth. Looking at her images at the museum or on the billboards, one can't help noticing overt references to the history of photography. Barberie, in his catalog essay, points to traces of imagery by a wide range of photographers, from Lewis Baltz to William Eggleston, Walker Evans to Allan Sekula, among others. He quotes Strauss's acknowledgment that she owes her interest in the slide-show format to Nan Goldin's *Ballad of Sexual Dependency* (1979/2004) and notes that her ambivalence toward Andres Serrano's *Nomads* (1990)—ravishing, arguably glamorized studio portraits of homeless people, which Strauss saw in 1994 at Philadelphia's ICA—"prompted her to think critically about photography." And that's only scratching the surface. I could point to images that suggest

a close acquaintance with the works of Alfred Stieglitz, Richard Avedon, and Mark Morrisroe as well.

What to make of this wealth of references to an extremely eclectic bunch of precursors? Does Strauss, far from being the maverick she seems, simply lack originality? Is her eclectic talent limited to sampling bits and pieces of existing styles without fashioning one of her own? The concentrated dose of her work on view at the Philadelphia Museum should eliminate any such suspicions. Everything here adds up. Strauss is an artist of strong sensibility, and for this reason she has no need to avoid trying out an aspect of techniques defined by others; if anything, she is self-consciously testing how far she can expand her reach and challenge her aesthetic preconceptions. From the beginning, as someone new to the practice of photography but nervy enough to exhibit her work in public without seeking the validation of a curator or gallerist, she has taken the stance not of a master but of a student conducting her ongoing education in the open. What she has gleaned from her precursors is mostly a confirmation of the choices she'd already made.

Strauss may be at ease with her artistic forebears, but at times I wish she were just as nonchalant toward the subjects of her photographic portraits, which represent about a third of her portfolio. Strauss has said that when she's doing a portrait, "the person I'm making the portrait of is an active participant. They can choose however they want to pose, and the most I usually ask is for someone to move in or out of a shadow." If only she were sometimes pushier. While Strauss has made some searing, unforgettable portraits, portraiture is the most conventional feature of her oeuvre—which is strange, because it seems that her humanistic approach would put the accent on human presence. As it turns out, absence can be more eloquent, and the billboards near Thirtieth Street Station are testament to that.

In portraiture, Strauss often resorts to a minimalist approach, a foursquare presentation of a subject looking straight at the camera, framed by an urban environment that is likewise "facing" the camera but generally not examined in any great detail. I'm thinking of her pictures like *Tonya, Chicago* (2007), *Wench With Cigarette, Philadelphia* (2010), *Whopper, Philadelphia* (2009), and *Woman With Red Hair and Green Bag, Madrid* (2009). Each has striking features—in the case of the last, not so much the shocking scarlet dye job of an otherwise ordinary housewife out grocery shopping as the way her coiffure, and the jazzy graphic pattern of her housedress, call as much attention to the pale, nearly effaced graffiti on the gray wall behind

her as they do to themselves. As *Woman With Red Hair and Green Bag* shows, even at her most straightforward, Strauss always finds much of visual interest when she makes a photograph. But that may not reveal much about the person whose presence is the photograph's occasion or about that person's place in his or her urban milieu. Honorable though it may be, Strauss's noninvasive approach to her subjects, her willingness to accept at face value the image they want to present to the world, can make for a gallery of idiosyncratic neighborhood characters one observes with fascination but who leave little mark on one's memory.

When the subject is willing to offer more to the camera—or perhaps does so inadvertently—the results can be remarkable. Once you have seen *Daddy Tattoo, Philadelphia* (2004), you won't be able to get it out of your head. Again, the subject is centered in the frame, facing the camera, backed by a wall slightly off-parallel to the picture plane; in the upper left corner is a heavily scratched window in which one sees both glinting reflections of the outdoors and a cheap neon light fixture glowing within. But there's a little bit of a twist to the figure; she's holding an odd, unbalanced pose that's slightly disguised by the plastic shopping bag slung over her shoulder—as if she had been walking forward but suddenly stopped and, leaning back, had turned her head to face the photographer. What's really facing us is the tattoo of the title. The woman is made up in an Amy Winehouse manner—grotesque but spellbinding—and her hair is brushed across her face, nearly hiding the eye that's slightly closer to the camera. Yet her eyes (the one we can see and even the one we can't quite see) are seething—somehow both deep-dark and incandescent, armored and melting at once. Whatever passed between subject and photographer in that moment, it was no simple encounter; this gaze is as vulnerable as it is riveting, and burning with questions.

Another photograph that's hard to forget, for different reasons, is *Monique Showing Black Eye, Philadelphia* (2006). Here, unlike in most of Strauss's portraits, there's hardly any background—just some unidentifiable blue, not the sky, in one corner. The camera has pulled in tight to show how horribly this girl has been beaten—even if you knew her likeness, you might not recognize her in this bruised, swollen mess. (You might think of Nan Goldin's 1984 self-portrait *Nan One Month After Being Battered*—but this is even worse.) Together Strauss and Monique are showing just how vulnerable a human being can be, but at the same time, the frankness of Monique's self-presentation implies an inner strength unscarred by her physical wounds. By showing herself this way Monique is making her protest, one might say. The sight of her face is so disturbing that one might not notice the tattoo on her

arm as it intersects the bottom left corner of the photograph. It looks familiar, and suddenly it's clear that we've seen that broken, no longer recognizable face before: it's the Daddy tattoo from the photograph taken two years before.

Thankfully, sights as rough as Monique's face are rare in Strauss's oeuvre. There's much beauty in her work, but little that's pretty, and Monique's sense of protest is always lurking somewhere beneath the surface of Strauss's images. Consider the two billboards by the train station. Between them they represent the two other most common kinds of motifs in Strauss's photographs: landscapes (especially but not exclusively cityscapes) and what might be broadly called signs. The latter includes all the manifestations of the written word in our visual environment, from graffiti to billboards to shop signs, and all manner of ways things get labeled with writing, including the tattoos with which people brand more or less overt or ambiguous messages onto themselves, from Monique's "Daddy" to the odd glyphs on the face of the young man in *Whopper, Philadelphia*—gang markings?—to the tiny ones I didn't want to inspect too closely, as they're sported by a couple of mummers in *Tattooed Penises, Philadelphia* (2008). DON'T FORGET US could be the unwritten motto for all these images, those with people and, even more so, those in which we see only what people have made, what they have done, what they are responsible for.

Gertrude Stein wrote, in her novel *The Making of Americans*, "perhaps no one will ever know the complete history of every one. This is a sad thing. Perhaps no one will ever have as a complete thing the history of any one. This is a very sad thing." Such a sadness imbues Strauss's work—the melancholy of knowing that every image contains stories, and stories behind stories, that will never be fully conveyed. Of course, although a single photograph can illustrate a story, it can never tell one by itself. Sometimes, by putting two or more images together, a story can be implied, as happens when one notices that *Daddy Tattoo* and *Monique* show the same person two years apart, or when one imagines that the billboards showing the homemade sign and the row houses, though evidently not taken in the same place, suggest a larger, broader story nonetheless. In the case of the billboards, it would help to know the circumstances in which the images were made. On a press tour of some of the billboards before the opening of her show at the Philadelphia Museum, Strauss explained that she had found the DON'T FORGET US sign in Grand Isle, Louisiana, near the Gulf Coast, not long after the BP oil spill; the houses with the tattered white material, she said, were substandard ones

built to replace the sixty homes destroyed when the Philadelphia Police bombed the headquarters of MOVE in 1985.

How to point visually to things without surrendering all the advantages of being able to speak about them is a recurrent problem for photographers. Strauss handles this problem better than most, and she handles it best when she's concentrating not on people directly but on the story-traces they have left on their environment, whether through words or otherwise. The images offer the information needed to understand the force of their broad message; the backstory provides some particulars to hang the message on. Strauss is more interested in the desire to know one another's stories, and to make them known, than in the stories themselves. And yet people, places, and signs, the three big categories in which Strauss goes fishing for imagery, can sometimes turn out to be almost indistinguishable. Another of her billboards shows I LOVE YOU rendered in what looks like blue spray paint on an oddly mottled surface. It's not easy to tell if the words are in the photograph or on it. After a minute it dawned on me that I was looking at an extreme close-up of a tattooed arm. At billboard scale, body and landscape become nearly identical, sharing language equally between them. Thinking big works well for Strauss.

2012

Heroism, Hidden: Ian Wallace

There's a subtle but crucial difference between showing photographs *as* art and showing photographs *in* art. No one has ever been able to elicit quite as much feeling from that difference as the Canadian artist Ian Wallace, whose work is surprisingly little known in the United States. Vancouver (where Wallace has lived most of his life) became, in the 1970s, one of the most generative art scenes anywhere, and in the following decade, as a result, a number of artists from there became prominent figures internationally, above all Jeff Wall, now one of the world's most successful and influential artists; his work is generally accounted one of the main reasons—to borrow the title of the book Michael Fried published four years ago—"why photography matters as art as never before." But for Wall, writing in 1992, it was Wallace who was the key transformative figure there: "I think it can be said that the streams of tradition and counter-tradition in Vancouver divide with the appearance of his work." Now the Vancouver Art Gallery has mounted a retrospective encompassing some 200 pieces, "Ian Wallace: At the Intersection of Painting and Photography."

For Wall, Wallace was important not only as an example of how to bypass the heritage of romantic, lyrical evocation of the natural landscape that had been the dominant strain in the art of western Canada, but also because at the same time he showed a way out of what Wall calls "the impasse of conceptual and antiformal art" as it had established itself in the 1970s. What was that impasse? Wall doesn't explicitly define it, but reading between the lines it is clear that he is thinking of the tendency of conceptual art to take up a position at the margins of the culture—a tendency that as it happens is on full display just upstairs from Wallace in a traveling exhibition, "Traffic: Conceptual Art in Canada, 1965–1980." What Wall took from Wallace was an aspiration "to find a legitimate way . . . to occupy the kinds of spaces in architecture and culture reserved for painting," that is, for the great art of the past. The point was not to dismantle the museum but to renew it, with a critical edge.

That Wallace had fully assimilated the most important lesson of conceptual art—that art is not in the first instance a category of objects but rather a way of thinking, or as he put it at the time, "a principle of semiotic order"—is evident in his early work *Magazine Piece* (1969), which originated as a sequence of right-hand pages from a recent issue of the American magazine *Look* taped to a wall in a straight line. In that work, one of the typical "picture magazines" of the time, the perpetual number two to *Life*, became a fragmented panorama of "The Mood of America," as the first headline on the left would have it, a synoptic meta-picture, a no longer quite readable but rather visible image of a cultural moment. Subsequent iterations of the piece used, for instance, an issue of *Life*—this was 1970 and the issue featured the killings at Kent State University—and *Seventeen*. The work now exists in the form of a drawn "schema" calling for "the cover and facing pages of a mass-circulation magazine attached to the wall in a given arrangement until exhausted by the format" and showing them arrayed in a grid rather than a line, the choice of magazine being pointedly unspecified. Whatever the magazine chosen, it will appear at once whole (shown from beginning to end) and fragmented (only every other page will be visible, breaking the continuity of texts, pictures, and ads). At the same time, the colored tape that runs across the top of each row of pages—the only truly continuous element of the piece—becomes an abstract pictorial element, a horizontal Newmanesque "zip." Here in Vancouver, the curator, Daina Augaitis, selected an issue of *Bomb*, the New York quarterly that focuses on "the artist's voice" through interviews with writers, musicians, painters, and so on. This being not exactly the "mass-circulation" periodical Wallace's schema calls for, Augaitis's realization of the piece turns it from a wide-screen snapshot of a moment's cultural consensus to a cross-section of a more restricted cultural setting, one in which Wallace himself might easily figure (although in fact he never has appeared in *Bomb*). Christine Poggi, writing in the exhibition catalog, sees *Magazine Piece* as an early embodiment of Wallace's ambition "to think the world through the image of the world," but here it becomes something smaller, though perhaps no less necessary—a way of thinking the art world through the image of the art world.

That a "concept piece" like this is so permeable to the world that its very character can change so much from one instance to the next is its strength but also its limitation. In its radical openness to contingency, such a work gives up on any notion of composing a determinate response to (and out of) the contemporaneity it reflects so clearly. That Wallace was not prepared

to make this sort of effacement of his own authorship a central tenet of his aesthetic is something that was probably already clear from things he had been doing just before the first version of *Magazine Piece*. Among the earliest works in the exhibition are a number of vertical paintings in which an opaque, uninflected field of a single color is bordered by a band of a second color—thus they are self-explanatorily titled, for instance, *Untitled (White Monochrome with Red)*, *Untitled (Black Monochrome with Yellow)*, and so on. It's worth noting that, whereas the gesture that was *Magazine Piece* preceded its schematization, in the case of these monochromes (or, more accurately, I guess, *monochromes-with*) the schema came first: the color choices for these paintings were not based on subjective judgments of taste, but rather on the idea of exhausting the thirty possible combinations of the three canonical primary colors (red, yellow, blue) plus white, black, and gray. These paintings may not be terribly unusual for their period, but as a group they embody more vividly than most similar works the feeling, which must have been widespread at the time, that (as Wallace later put it) "anything was possible in a painting, but not much was possible as a painting." They testify to their own simple presence but also to their refusal to represent anything else but this presence—as opposed to *Magazine Piece* with its readiness to represent whatever.

If abstract painting represented, for Wallace, the aspiration to an artistic absolute, and the use of readymade pages from a mass-circulation magazine represented an opening to radical contingency and the inaesthetic, the synthesis he arrived at in the 1970s was to put the photograph in the place of painting. This was, of course, the idea that lit a fire under Wall, who had stopped making art around the beginning of the decade and started doing so again in 1977, clearly in cognizance of what Wallace had been doing in the meanwhile: sequences of very large-scale hand-colored black-and-white photographs, here exhibited under the rubric of "The Cinematic" (one of five thematic categories into which the exhibition has been organized, along with "The Text," "The Street," "The Museum," and "The Studio"). The label makes sense insofar as these sequences conjure explicit or implicit narratives and because, departing from the traditions of "straight" or documentary photography, they are engaged in what, around this time, the critic A. D. Coleman (who probably did not yet know Wallace's work) dubbed the directorial mode—that is, in which the photographer has staged the scene before his or her camera in order to photograph it, ironically turning the camera's capacity to veridically record the appearance of things and events away from realism and toward fiction. When Coleman named the directorial

mode in 1976, he seemed to be pointing to an underground current in the history of photography, yet one that was traceable straight through from its beginnings to what was then the present, in which practitioners calling themselves photographers and ones calling themselves conceptual artists more or less unknowingly shared a common ancestry. What distinguishes Wallace's work of the 1970s from that of contemporaneous practitioners of directorial photography is that, unlike anyone but Richard Avedon, who had made several grand-scale group portraits around 1969–71, other photographers at the time were not thinking in terms of mural scale. By translating the succession of shots that would make up a cinematic sequence into a string of stills covering a wall, Wallace had set himself the problem of composing a visual rhythm out of repetition and variation—and this is where he excelled. As a quasi-cinematic sequence, *An Attack on Literature* (1975)—in which a man and a woman in a featureless black space are seen (across a dozen panels amounting to more than thirty-five feet across) seemingly trying to elicit some text from a blank sheet of paper in a typewriter but producing instead a sort of storm of blank pages—can seem a bit hokey, but as a rhythmic pattern of black-and-white shapes with a kind of visual crescendo, it is impressive.

More properly cinematic is a work from 1979, *Colours of the Afternoon*, whose six panels show a woman roaming alone amidst a rocky seaside landscape. The six images are actually stills from a 16mm film; their enlargement lends them a grainy texture that contributes to the work's pensive mood. One thinks of the harsh, empty landscapes in which the characters of Michelangelo Antonioni's films wander; Stan Douglas, in a conversation with Wallace in the catalog, likens it to "a missing part of *L'Avventura*," though Wallace himself points out a connection to an earlier Italian film, Rosselini's *Stromboli*. The black-and-white images are each tinted a different pale monochrome shade; these create the sense of metrical sequencing (along with the recurrent figure, who is always however seen from a different viewpoint and therefore provides only a very weak visual connection) that ties together the six otherwise very distinct images and gives the piece its rather somnolent, melancholy atmosphere. Here, something of the lyrical, feeling-laden approach to landscape that Wallace had rejected in the 1960s returns, but in a new form, based not on communion with nature but on alienation from it.

The pinnacle of Wallace's work of the 1970s is another piece from 1979, *Lookout*. Again, what's at stake is a specifically urban way of being in or with the countryside, in this case Hornby Island, British Columbia; you might

think of this as an update of the fêtes galantes painted by French rococo artists such as Watteau and Lancret, but at Cinemascope scale (its twelve panels are together about forty-eight feet long). Unlike *An Attack on Literature*, in which a single scene is repeatedly shown from slightly varying viewpoints, or *Colours of the Afternoon*, in which each frame shows a different location, in *Lookout* one vast panorama is composed out of contiguous slices. As with *Colours*, the black-and-white imagery has been hand-colored, but not this time in monochrome rectangles encompassing each frame; instead, as in an old postcard, the sky has been tinted blue, the trees green, some items of clothing red, and so on. This is nature with the color drained out and then reconstituted artificially. The casually dressed young people who populate this scene seem to mill around aimlessly, alone or in small groups, sometimes looking off into the distance but never making eye contact with each other. One has the feeling that they are something like *staffage*, those anonymous secondary figures, dressed perhaps as plowmen or shepherds, who populate old paintings for reasons more decorative than narrative—but here, the center of interest which these accessory figures might have noticed in passing is missing altogether. The panorama seems to present a view encompassing 180° or more; the viewer therefore feels like one of these characters in the picture, looking around from side to side in search of what to look at. The implication is that the main spectacle here is one's own estrangement from the landscape, which is reflected in that of the figures shown in it—who for that matter, it's pretty clear, were never really in it anyway: they were photographed in the studio and montaged onto landscape shots that were shot separately. As Wall remarked, this "experimental pastoral" expresses our detachment from our favorite places.

In all these works, Wallace is working through ways to bring together what another of the catalog essayists, William Wood, calls "the sensuous (and sensual) qualities of painting and the mechanical, pictorial quality of photography," though it might be better to emphasize the tension between the determinate intentionality of painting and the openness to contingency characteristic of photography. "I would describe myself as a very passive photographer," Wallace says in the interview with Douglas. "I accept the subject as it presents itself to me." In the work he developed in the 1980s, and still continues today, Wallace found a different way to bring these dichotomies to the fore, a downright obvious way, though not so obvious that anyone else had tried it before in just the same way: literally "bonding . . . the discourses of painting and photography into a single program," at first by silkscreening the photographs (*à la* Warhol), but starting in the middle of

the decade by laminating large-scale photographic prints onto the surface of the canvas in juxtaposition to areas of monochromatic painting (or, in recent works, with hard-edged geometrical abstraction using multiple colors). It's interesting that some commentators on these works refer to them as photographs and some call them paintings, while others, perhaps more scrupulous, seek more precise but roundabout descriptions—Wallace himself sometimes calls them "works on canvas." They are both/and/neither/nor photographs and/or paintings. Although the photograph, with its richness of detail and its "human interest," is invariably the part of the work that any viewer will focus on first—and of course it's what gives the piece its subject matter—the photographs might not be artistically self-sufficient if seen in isolation from the painted portions of the piece. However full of interest the images may be, there is also always, in them, the implication that something is missing, that the image is somehow incomplete. Likewise, the simple uninflected fields of color, if seen on their own, would hardly function as autonomous art; if it's true that, as Donald Judd once put it, a work of art need only be interesting, these areas of color without depth or suggestiveness could be said to have (if seen in themselves) successfully resisted any attempt to find interest in them. And yet the simple juxtaposition of these two "inadequate systems" yields, thanks to the precise choices Wallace makes in bringing them together, something much more than the sum of the parts.

Among the earliest and still most moving of Wallace's works of this kind is the series *My Heroes in the Street* (1986), in which images of individuals on the streets of Vancouver—friends of the artist, all of them apparently easily recognizable to denizens of the tight-knit local art world—are shown as if glimpsed from a distance, in passing, and very small in comparison to the structures around them. They are on their way somewhere, purposefully, yet they seem isolated and somewhat lost amidst the impersonal geometry of the city. And just as they are dwarfed by their environment, the images in which they are wandering seem small in relation to the large areas of white paint that surround them. And yet somehow these areas of white paint seem to give a kind of answer to the question of what is missing from the image and of where these people are heading. When I first got to know these works, I used to wonder about the title—*My Heroes in the Street*. What did Wallace mean by that word "heroes"—since these people look so average, so unheroic? Was he being ironic? Or is it just that to exist at all in the modern city, to his mind, takes a heroic effort? Now I think it's neither one of those things. It seems to me, rather, that according to these works, the

heroism of modern life—to borrow Baudelaire's phrase, which Wallace surely had in mind—is necessarily a hidden thing, and that though the environment through which each of us proceeds from day to day is that of the contingent, the alien, the massed geometries and random minutiae of daily life, to the extent that we have in mind some idea, some thought that abstracts us from the quotidian, we are also surrounding ourselves with the absolute which is our goal—not the heaven of the scriptures, to be sure, but an entirely human transcendence of the present; and this is why it can also be true that, as Baudelaire said, "We are enveloped and steeped as though in an atmosphere of the marvelous; but we do not notice it."

If there is a heroism specific to the modern artist, it lies, first, in the effort—usually less effectual than we think—to forge out of the common materials of the culture a language that is adequate to the time, and then to convey something through (and at the same time about) that language that resonates with the feeling of that time. I am conscious of the fact that in this review I have traced some of the steps by which Wallace forged his language but am about to stop short of delving into all that has been said in that language since it came together. One reason for this is simply that the early part of his career is substantially new to me—and the same is probably true for most non-Canadian viewers, since his first solo exhibition outside the country took place only in 1987 (in Munich). In trying briefly to catch you up with the last twenty-five years of Wallace's art, which are conveyed beautifully and in detail at the Vancouver Art Gallery, I can only say that through his hybrid of photographic imagery and painting he has continued to think deeply about the place of art and the artist in our time, a witness to and participant in both its political conflicts, as in *Clayoquot Protests (August 9, 1993) I–IX* (1993–95), and the solitary ruminations of the isolated individual whose only powers are those of thought and perception, as in the hotel room still lifes he has made periodically through the years. It's a rich oeuvre we will surely get to know better in years to come.

2012

Hotel Artists: Henri Matisse and Ian Wallace

Christmas, 1917: Elsewhere in France, war was raging, but not in Nice, where Henri Matisse had checked into the Hôtel Beau-Rivage. A few years earlier the painter had been turned down for military service on the grounds of poor health. Safe in Paris, he'd been haunted by guilt at how little he could contribute to the war effort, and he struggled—fruitfully—with some of the most severe, ascetic paintings of his career. They were "displays of force," one fellow painter declared at the time. Now Matisse wanted a little less reality. Leaving his wife and younger children behind in Paris, he'd gone south, stopping along the way to visit his eldest son Jean, who'd been called up and was stationed west of Marseilles. At the Beau-Rivage, on New Year's Day, 1918, the day after his forty-eighth birthday, Matisse began painting what would be his last self-portrait—a chilly depiction of the suited, bespectacled, reserved bourgeois-with-a-brush that we have come to accept as the quintessential image of this artist. It's "a powerful, anti-heroic, oddly provisional image for a man approaching fifty with an international reputation," writes his biographer Hilary Spurling. Although masquerading as the solid citizen (the anti-bohemian, the functionary of art), the painter shows himself with a suitcase at his feet. He was a nomad.

Matisse stayed on at the Beau-Rivage until mid-April 1918. Over the next few years he would head south each winter, staying in various hotels around Nice, mainly the Hôtel de la Mediterranée, and would eventually find a place of his own in the town. Years later he reminisced about the Mediterranée with Francis Carco, the arch-bohemian poet and novelist who also happened to be staying in Nice at the same time:

"A good old hotel, I must say!" he murmured. "And what lovely Italian-style ceilings! What tiles! . . . I stayed there four years for the pleasure of painting nudes and figures in an old rococo salon. Do you remember the way the light came through the shutters? It came from below like footlights in a theater. Everything was fake, absurd, terrific, delicious . . ."

The impassive figure we see in Matisse's 1918 self-portrait does not look like the kind of man who would have a camp sensibility, a "love of the unnatural" and "of artifice and exaggeration," as Susan Sontag famously defined it. The man in the picture is still the one who spent many years battling with his *Bathers by the River*, started in 1909 and only completed (or, as Paul Valéry would have said, abandoned) in 1917. Or he is the man who—to take an example from the fine exhibition now at the Metropolitan Museum of Art, "Matisse: In Search of True Painting"—had painted the darkly luminous, bluntly geometricized still life *Apples* (1916). The fruit it shows is beautiful, but not in a way that would have tempted Eve to bite.

The journey to Nice led Matisse to a different manner of painting. His was to become an "often decorative art, emphasizing texture, sensuous surface, and style at the expense of content"—again, the words are Sontag's, and though written without reference to Matisse they are apt. The art of Matisse's Nice period is often associated with the "return to order" proclaimed by Jean Cocteau as the watchword for the 1920s, but this seems mistaken. The neo-classicism and archaism of some of Picasso's work, or of the Novecento Italiano, are real manifestations of a desire for order. (With the Italians, the political implications were clear enough; their great promoter was Mussolini's mistress, Margherita Sarfatti.) In Matisse's case, the work of the war years is more deeply permeated with a search for order than what he produced in the decade that followed. In Nice he rediscovered light's intoxicating purity, but he also rediscovered—through Auguste Renoir, whom he went to visit almost immediately in nearby Cagnes-sur-Mer—a specifically Impressionist treatment of light, using it to dissolve hard boundaries between forms in his paintings.

But, unlike most of the Impressionists, Matisse would not be preeminently a landscapist, a *plein-air* painter. He would not be a painter of nature, perhaps because "to be natural," per Sontag and Oscar Wilde, "is such a very difficult pose to keep up." In "fake, absurd, terrific, delicious" hotel rooms, which turned natural light into theatrical lighting, he found that "the richness and the silver clarity of the light in Nice" had been trapped and condensed, intensified even when gathered in shade, and bounced from wall to wall and ceiling to floor in a kind of dizzying ebullience: always changing, always in motion. The exhibition at the Met, the theme of which is how Matisse "used his completed canvases as tools, repeating compositions in order to compare effects, gauge his progress, and, as he put it, 'push further and deeper into true painting,'" is perfectly pitched to his Nice period. His newfound fascination with theatricality, combined with his immersion in the mercurial

nature of light and its incessant intersuffusions, enabled him to show the same motifs again within the compass of the same room, which can never be as neutral a background as a proper artist's studio can be, and never the same way twice.

At the Met there is a pair of remarkable and, at first glance, very similar paintings of the same room, with nearly the same view; they are *The Open Window (Room at the Hôtel Beau-Rivage)* (1917–18), and *Interior at Nice (Room at the Hôtel Beau-Rivage)* (1918). In a way, they are both paintings of nothing. This could be the room, in Roy Lichtenstein's celebrated 1961 painting, in which ace reporter Steve Roper is seen looking through a hole in the door and exclaiming, "I can see the whole room . . . and there's nobody in it!" The absence of the figure in these paintings is palpable—it's as if the armchair in which the model should have been seated has been pushed aside to make room for her absence, and for the view of sea and sky out the window that seems to wear its lace curtains as the model would have worn her artfully revealing deshabille. The second version, a tad larger, shows a bit more of the room and puts the window at a greater distance. Perhaps in part for this reason, and also because the sky is whiter in the second version and its reflection in the open window correspondingly paler, whereas in the first it has been painted nearly the same deep blue as the sea, the most notable difference between these two paintings is that in the first the room is dominated by the sky and sea at its center, which amount to a single dominant entity, while in the second painting, as Dorthe Aagesen writes in the exhibition catalog, "the focus shifts to the decor," above all the green armchair on the left. The earlier painting uses light to collapse the room's space nearly into a single intransigent plane; the second version opens it up, softening the painting's impact but letting in more air. It's a sunnier picture, with a different sense of looseness and spontaneity.

For Matisse, there could never be only one way to interpret a scene. He always recognized that it could have been painted otherwise. "I do not repudiate any of my paintings," he famously declared, "but there is not one of them I would not redo differently if I had it to redo. My destination is always the same, but I work out a different route to get there." Earlier on, he would have been more likely to start with a somewhat more conventional, easygoing approach, working his way toward something stark and unyielding; at the Met, for example, there is the sweet, almost anecdotal 1914 view of Notre-Dame from the collection of the Kunstmuseum Solothurn in

Switzerland, hung alongside the far more famous, nearly abstract one he painted a little later the same year, which belongs to New York's MoMA. Or observe, likewise, the pairing of *Interior with Goldfish* and the slightly later *Goldfish and Palette*, also from 1914. The difference between the two 1918 views of the room at the Hôtel Beau-Rivage is far subtler, but what's more telling is that the development from one to the next runs in the opposite direction; having learned to be so obdurate, Matisse was teaching himself again how to be more yielding. Earlier, Matisse had been determined, as he said, "to risk losing charm in order to obtain greater stability." Now he'd become fascinated by charm, and the way it put stability—something like classical order—in doubt, redirecting the viewer's attention from the compositional center to its "decor."

But the story doesn't end there, because there is a third painting of the same room, also from 1918—the same room, but not the same view. It's a bigger painting and an altogether bigger statement. *Interior with a Violin (Room at the Hôtel Beau-Rivage)* shows the same room—the same window, chair on the left (now with an open violin case resting on it, revealing its treasure), dresser on the right. But despite the change of scale, it shows less of the room. The focus is tighter. The vantage point is higher—we can see a bit of beach out the window, which wasn't visible in the other two paintings, but the ceiling's been cut out of the frame, making the room feel much less boxy but also somehow smaller, almost constricted, and the frou-frou of the curtains has been reduced to a minimum. The great change is in color, or rather, in tone: this is a dark picture. One of the blinds has been closed, the other, half-closed, and the space is bathed in shadows. Yet miraculously, this darkness is somehow luminous. "In that painting," Matisse said, "I painted light in black."

As different as *Interior with a Violin* may be from its two precursors, Matisse couldn't have painted it without having first painted them. If you look at the two earlier paintings, you'll notice a detail that might not have registered before: the dark bar around the top of the curtains. When Matisse showed Renoir his paintings, the master was thunderstruck by the bar. "How do you do that?" Renoir exclaimed. "If I used a black like that in a painting, it would jump out at you." In fact the Impressionists had more or less banished black from their palette; for them it was not a color, and its use would have destroyed the unity of painting whose basis was color. Matisse realized that he could take whatever he wanted from the Impressionists because the foundations of his art were different, and more capacious. *Interior with a Violin* is his proclamation of that discovery. Impressionism, though Matisse's

idol Renoir would have been horrified to hear this, was for Matisse at one with the "fake, absurd, terrific, delicious" charm of a hotel in Nice, which he could enjoy or abstain from as he pleased.

Checking into the Beau-Rivage, Matisse deliberately uprooted himself from his settled existence in Paris—checking out of everyday life. A successful artist these days hardly has what Matisse would have recognized as a settled life. Consider the Canadian artist Ian Wallace, whose remarkable retrospective at the Vancouver Art Gallery, "At the Intersection of Painting and Photography," continues to preoccupy me. In 2008, for instance, Wallace had solo gallery shows in London, Brussels, and New York, not to mention a museum show in Zurich, Rotterdam, and Dusseldorf. Naturally he'll have traveled to all those cities, and I wouldn't be surprised if he also attended the group shows in Ottawa and Vienna that featured his work. And of course there are artists who are even more in demand than Wallace. How does one keep making work under such conditions?

Wallace has long been interested in making his activity as an artist a subject of his work: "documenting my workspace," as he says, is "a self-consciously modernist strategy" for self-reflection. One of the five thematic sections of the Vancouver exhibition is accordingly devoted to The Studio. But "studio," it becomes clear, is a highly elastic term as it applies to Wallace's artistic practice. Yes, the white-walled, cement-floored ex-industrial space where Wallace habitually works in Vancouver appears in various pieces; it's charming, too, to catch sight—in *Work in Progress (June 28, 2010)* (2010)—of the drum kit he keeps there: his equivalent, perhaps, to the violin Matisse liked to play as a break from his painting, and which was perhaps a stand-in for himself in *Interior with a Violin*. But many of Wallace's studio pictures (like most of his work since the late 1980s, they juxtapose photographic images and monochromatic or geometrically abstract painting) are really hotel pictures. Among them are four in whose collective title I like to think Matisse would have found a pleasing irony: *Abstract Drawing (Hotel de Nice, Paris, February 2, 2010)* (2010). As "fake, absurd, terrific, delicious" as a Nice hotel might have been, wouldn't a Parisian hotel pretending to represent Nice be even more so? In these works, as in many of Wallace's other hotel pictures, and unlike Matisse's paintings from the Hôtel Beau-Rivage, one can hardly sense the room as a whole, though there's still that open window; these are really still life paintings, where the focus is on a tabletop and the things it holds. In the *Hotel de Nice* suite, there are the sheets of paper on which the artist has been making some geometrical abstract drawings, his

supply of colored pencils, a zipper pouch of who knows what small items (a pair of scissors seems to be sticking out—that can't have been in his carry-on bag), and the ashtray filled, not with old cigarette butts, but with the delicately curled shavings from the artist's pencils.

One trait that Wallace's *Hotel de Nice* pictures—and for that matter nearly all his other hotel pieces—have in common with Matisse's paintings from the Hôtel Beau-Rivage is their concern with light. And as with the Matisse of *Interior with a Violin*, the inclusion of an open window in a generally dark picture, and therefore of the gamut of tones between brightness and shadow, is crucial. These hotel still lifes are a reminder of just what a good photographer Wallace is. "I accept the subject as it presents itself to me," he has said, but his avowal is misleading. His street pictures certainly give such an impression, but the hotel still lifes are extremely studied. The light is recorded, not passively, but with great attentiveness, tenderness, and warmth, and one feels the artist's affection for these familiar tools, just as one feels the light in one's fingers, in the palms of one's hands, as one looks at the images. We see them from above, probably at the same angle as the artist himself would, contemplating the piece of work he is about to continue. The objects are placed with a deceptively casual-looking geometrical rigor that would have brought a smile of recognition to Matisse's face. Wallace likes to emphasize that the artist is not only a maker but also a thinker. In other hotel pictures of his—as in his studio pictures more broadly—the accoutrements shown are ones that might belong to the poet he once thought of becoming: books, notebooks, pens. Or they might belong to an art historian, traveling to some symposium. But light touches his things with a delicacy akin to that with which his colored pencils have touched his sheets of paper: a delicacy that thought alone—so much clumsier than light—rarely achieves.

2013

III

Old Vagabond

Old Vagabond: Paul Gauguin

The Italian conceptual artist Alighiero Boetti, as his onetime protégé Francesco Clemente recalled, "considered that there was a big difference between people who moved north towards power, order, and control, and people who moved south, away from them." Boetti himself had moved from Turin, in Italy's industrial north, down to Rome, and then, for a while, to Kabul, Afghanistan. But, historically, this southward vector has rarely been the one chosen by artists, whose profession magnetically draws them toward courts and capitals, patrons and potentates. Paul Gauguin was one of the first to take the opposite route, and he remains the most emblematic and radical of those who've tried to flee the world's metropolitan centers, submitting without resistance to what Charles Baudelaire had once diagnosed in his poem "Le Voyage" as the "Singulière fortune où le but se déplace, Et n'étant nulle part, peut être n'importe où," or, to turn French verse into English prose, the "singular fate of having a goal that keeps shifting, and being nowhere, might be anywhere."

The story is well enough known: Gauguin, grandson of a pioneer of socialist feminism, Flora Tristan, was born in Paris in the revolutionary year of 1848; he spent part of his childhood in Peru (where his grandmother had roots) and part in France, before spending much of his young manhood at sea as a merchant marine and then a naval sailor. He liked to think of his Peruvian forebears as Indians. "As you can see," he would later explain, "my life has always been very restless and uneven. In me, a great many mixtures. Coarse sailor. So be it. But there is also blue blood, or, to put it better, two kinds of blood, two races." Eventually, back in Paris, he became a stockbroker—and a successful one—but also a Sunday painter who was soon accomplished enough for his works to be accepted by the Salon; during this period he also began buying works by the most advanced painters of the time, among them Camille Pissarro, Paul Cézanne, and Edgar Degas.

The crash of 1882 brought matters to a head. Gauguin abandoned the world of finance, now in tatters, for the full-time pursuit of art. His Danish

wife, Mette, who hadn't bargained on having an artist for a husband, collected their five children and returned to Copenhagen. After a few months Gauguin followed her there, attempting to re-establish himself in business; but it took less than a year of that life to persuade him to return to France without Mette, though he kept in touch with her as a confidante for many years thereafter, addressing her, as he admitted, with "an adoration often full of bitterness." Finding Paris too expensive, he moved to Pont-Aven in Brittany, where his magnetic personality and pursuit of artistic independence helped make him *chef-d'école* to a group of young experimental painters. He became enamored of the landscape, saying, "I find a certain wildness and primitiveness here. When my clogs resound on this granite soil, I hear the dull, matte, powerful tone I am looking for in my painting." Likewise in the people of rural Brittany he found a primitive quality that appealed to him. "I try to put into these desolate figures the savageness I see in them," he wrote, "and that is also in me." But further travels were in the offing: wanting to reinvigorate himself "far from the company of men," he set off for Martinique and Panama. When his funds ran out, he went to work on the digging of the new canal.

Returning to France, Gauguin was invited by Vincent van Gogh to Arles for the purpose of establishing a "Studio of the South." Their intense but intensely conflicted friendship brought them to the verge of violence; Gauguin fled to Paris, whereupon van Gogh severed his own ear. Increasingly seeing himself as a "savage" discontented with the civilization that had formed him, Gauguin began dreaming up new travels and a "Studio of the Tropics," still in collaboration with van Gogh: the Far East? Madagascar? Eventually, after the Dutchman's suicide, Gauguin settled on Tahiti, where from 1891 to 1893 and again from 1895 to 1901 he made many of his most famous works but found himself even more at odds with the French colonial authorities than he had ever been with the customs of bourgeois life in Europe. Feeling that "there are landscapes still to be discovered—in short, completely new and wilder elements," he set sail for an even more isolated spot, Hiva Oa in the Marquesas Islands, where he remained until his death in 1903.

If Gauguin's fate was, in Baudelaire's word, *singulière*, all the more so is the tension between the incessant, restless movement of his life and the steadiness characteristic of his art. Yes, of course, as you move from painting to painting, from sculpture to woodcut, in the Tate Modern exhibition "Gauguin: Maker of Myth," you see his travels reflected in his imagery; you'll find depictions of Brittany, Martinique, Tahiti, and the Marquesas in turn. But look at the

paintings one by one and search out depictions of motion: you'll find few. More typical is a kind of uncanny stasis—not necessarily an equilibrium but a suspension of time, a caesura.

Consider even an early, still residually naturalistic painting whose subject would have lent itself to a sense of inner dynamism, *Breton Girls Dancing, Pont-Aven* (1888). What gives this work its atmosphere is the way the three girls embody an inexplicable stillness, like children playing at statues rather than enjoying "a Breton *gavotte* at haymaking time," as Gauguin explained the picture to Theo van Gogh, his dealer at the time. Or it's as if they were not taking the next step in the dance but waiting for it to happen to them. What seems strange—though for all I know this may be typical of Breton folk dancing—is that as they form a semicircle, hand in hand, the girls face not toward the center of the circle, and therefore toward one another, but outward, away from one another and, as it were, away from the dance. The choreography contributes powerfully to the painting's paradoxical feeling of stillness. Even as the girls engage in their joint recreation, each seems caught up in herself, almost unaware of the others, and therefore unmoved by the common rhythm that the dance, we imagine, ought to signify.

Actually, though, *Breton Girls Dancing, Pont-Aven* does not entirely freeze the motion it pretends to depict. There's one small detail that contradicts this suspension of movement. Look at the little dog to the right of the three girls; it's not scampering or chasing anything but just sniffing around, as dogs do, and yet the peculiar twist to its body lends it an air of carefree liveliness, of impulsive energy, that counterpoints the girls' calm solemnity. Once you've noticed this, you can't help seeing how often in his paintings Gauguin has invited the animals to wander in—deliciously observed dogs, chickens, horses, goats, and pigs, not to mention the sly-faced symbolic fox of *The Loss of Virginity* (1890–91). They liven up the scenes in which human protagonists strike their hieratic poses. Even when the animals are shown as still, you feel they could move at any minute; whereas even when the humans are shown in motion, they seem fixed in place. In the upper-left corner of the masterpiece of Gauguin's time in Brittany, *The Vision After the Sermon* (1888), there's a bull whose form so curiously echoes that of the fused wrestlers in the upper-right corner, Jacob and his angel, whom the peasant women of the painting see in their collective mind's eye. Here again, the two wrestlers locked in their struggle seem caught at a standstill, while the unconscious beast ambles by with an unaccountable vivacity. The reality/unreality of the women's vision of Jacob and the angel is like that of Degas's

ballerinas in those paintings of his where we see the dancers over the heads
of the audience or even the orchestra musicians. Gauguin had collected the
elder artist's work when he was a successful stockbroker rather than a
penniless painter—later Degas would return the compliment—and it was
from him that Gauguin learned how to create off-angle compositions with
seemingly arbitrary juxtapositions that nevertheless allow for a sense of
classical solidity and poise.

Gauguin's propensity for compositional stasis, even when his subject
matter seems to lend itself to the evocation of change and movement,
reflects his urge to perceive something eternal within the momentary. If
you want a more direct glimpse of the inner tumult that impelled him
ceaselessly to seek ever more distant shores—"le cerveau plein de flamme,
Le coeur gros de rancune et de désirs amers," in Baudelaire's words; that
is, the brain aflame, the heart fat with rancor and bitter desires—you must
look for his comparatively rare paintings of the sea, such as *Ondine/In the
Waves* (1889) and *The Bark (La Barque)*, from 1896. Not only the swirling
waters themselves but the off-balance figure, neither standing nor reclining,
and the boat seen at an angle that makes it seem to be spinning in the
storm—all declare the disequilibrium that drove Gauguin on, seeking
primeval sources of grave and joyous harmonies. Unlike the wandering
protagonists of Baudelaire's poem, Gauguin never truly traveled "pour
trouver du nouveau," to find something new, but rather in search of the
traces of something ancient and perhaps close to vanishing. His incessant
journeying was finally not in search of a more pristine, remote, incompletely
colonized corner of the earth; rather, as he'd already told his fellow painter
Émile Bernard in 1889, well before his first visit to Tahiti, "What I desire
is a corner of myself that is still unknown."

Whatever hidden corners remained obscure to Gauguin by the time he
died of syphilitic heart failure in 1903—and there must have been many,
for one of his greatest talents had always been for the sort of happy self-
deception that allows a man to persist in the hope of a breakthrough just
around the corner (or in Gauguin's case, just on the next island a thousand
miles away)—it is possible to feel one knows him too well, and better than
he knew himself. He required the greatest possible distance from the civi-
lization to which, after all, his paintings were addressed, but that civilization
desired him to maintain his distance even more. A mythic being, he was
already posthumous in his lifetime. In 1902, when he wrote to his great
friend Daniel de Monfreid of a desire to return to France, he received a
sobering but prophetic reply:

It is to be feared that your return would only derange the growing and slowly conceived ideas with which public opinion has surrounded you. Now you are that legendary artist, who, from out of the depths of Polynesia, sends forth his disconcerting and inimitable work—the definitive work of a man who has disappeared from the world . . . You must not return. Now you are as the great dead. You have passed into the history of art.

Into the history of art, but also of literature, mass culture, and various points in between. Surely I wasn't the only college student whose dorm room featured a poster of *Two Tahitian Women* (1899), the perfect pinup for moodily alienated intellectuals in bloom. Little as I knew about painting back then, I was right to have taped the poster up next to one of a work by Mark Rothko, a painter whose sometimes almost implausibly blended hues are direct descendants of Gauguin's. Still, is there any way to picture Gauguin to oneself except as played by Anthony Quinn? And for that matter, isn't the artist partly to blame for his rather embarrassing mythologization?

In the past, art historians often treated Gauguin's legend with disdain, as something essentially irrelevant to the art, suitable for treatment only by popularizers and novelists. Thus, for a long time the crux of historical research was the breakthrough year 1888, and especially the months in which Gauguin worked alongside van Gogh in Arles. Although their time together offers plenty of material for melodrama, one could focus chastely on the all-consuming question of art-historical development and the transition from Impressionism to Post-Impressionism, not to mention the pleasures of disentangling the threads of mutual influence and (on a strictly technical level, please) conflict, in the hope of offering a more solid account of just how Modernism came about. As a bonus, although Gauguin was already at this time explaining his differences with van Gogh as attributable to the fact that "he is romantic, whereas I, I am more inclined to a primitive state," his self-mythologization as a "savage" had not yet entirely solidified.

By the 1980s the focus of attention had shifted to Gauguin's later career and his two voyages to Oceania. Now, instead of evading the legend, it was time to wrestle it down. Historians set formalism aside, and Gauguin's work and character were interrogated (as the appropriately juridical terminology would have it) from the double perspective of anticolonialism and feminism, and found it deeply wanting. Far from being the critic of European civilization he claimed to be, Gauguin was just one more adventurer who'd abandoned

wife and children to indulge his passion for exotica, his illusions of lost paradises where the living would be easy and cheap, and a sleazy thirst for sex with dark-skinned, underage women.

The tide began to turn back in Gauguin's favor, I think, with the publication of Stephen Eisenman's *Gauguin's Skirt* in 1997. Examining the evidence closely, Eisenman presented the artist's journeys as a gradual process of shedding many of the illusions he'd carried with him from France to the colonies. Moreover, Eisenman concluded, "Gauguin combined European and Polynesian ideas into a hybrid art that mirrored his own liminal stance on the contested border of sexual and colonial identity." In other words, he continually challenged his sense of self in his only very partially successful effort to learn from the people among whom he chose to live—natives and half-caste colonials, as opposed to the officials and gendarmes who were the constituted powers on the islands. The result is an art that fulfills in ways Gauguin could never have imagined the injunction he carved into a lime wood relief of 1890: *Soyez Mystérieuses* ("Be Mysterious").

In "Gauguin: Maker of Myth," curator Belinda Thomson tries to show the artist's story, not as a regrettable excrescence on his art, nor as the hidden shame at its core, but simply as the intertwining of life and art through "narrative strategies." She uses the phrase "to encompass not only the deliberate, conscious ways Gauguin had of conveying meaning through picture-making and written commentary, but also the whole apparatus through which he projected himself into public consciousness, engaged with contemporary debates and generated critical discourse around his work." Thomson sees in Gauguin the artist as operator, albeit perhaps a sincere or at least self-convinced one. It's a fairly standard approach these days, and hardly surprising in the age of Jeff Koons and Takashi Murakami. Creating a public profile has long been part of an artist's job description, but there is a real risk of historical distortion in overemphasizing the deliberateness with which such a profile is formed and the artist's control over its contours.

In the case of Gauguin, the decision to investigate the work under the rubric of "narrative" as a way of articulating the bonds between life and art seems particularly misleading. Like so many artists before him and since, Gauguin liked to rail at the critics; but in his case the reason, over and over again, was precisely their penchant for turning paintings into literature. For him, the limitation of a painter like Gustave Moreau was that "he can speak only a language written by men of letters: the illustration, as it were, of old stories." True, Gauguin had been inspired to choose Tahiti as his destination

in part by his reading of a trashy novel of exotic sensuality in the tropics, Pierre Loti's *Le Mariage de Loti*. But speaking of the figure in one of the paintings he made there, he insisted, "She is not some pretty little Rarahu, listening to a pretty ballad by Pierre Loti played on the guitar." The bodies and faces of the Polynesian women Gauguin incessantly painted were not simply offered up for delectation and the projection of fantasies. They possess their own intelligence and keep their own counsel; their slyness and self-possession make them resistant to interpretation, almost indecipherable. Gauguin identified with them precisely because he could not entirely "read" them. Something in them remained as mysterious to him as he was to himself.

To fixate on the idea of narrative as the key to Gauguin's art, as Thomson does, is practically a betrayal. The paintings are literary only in the most literal sense—the paintings' titles are written on them, though often in Tahitian, which Gauguin didn't know as well as he thought and could assume his audience wouldn't know at all: *Aha oe feii?* ("What! Are You Jealous?", 1892), *Manao tupapau* ("The Spirit of the Dead Keeps Watch," 1892), *Eu haere ia oe* ("Where Are You Going?," 1893) and so on. They establish a mood or suggest a situation but never inaugurate a story. Why not listen to the artist himself, who from the beginning insisted that in painting, "color becomes essentially musical": that is, structured and evocative but not specifically discursive. In the paintings I've named and others, Gauguin conjures up rich cadences of dissonance and harmony out of color and line, the likes of which had no more been seen before in painting than had his Polynesian subjects. His colors are not often ruthlessly clear and crisp, as those of Henri Matisse would later be; they are suave, smoldering, somewhat distant— colors that don't declare themselves but slowly unfold in stepwise progressions. It is for the sake of their unprecedented cadences that we still remember his story, which also still has much to teach us.

"I find *everything* poetic," he once wrote to Vincent van Gogh, "and it is in the deepest recesses of my heart, that are sometimes mysterious, that I glimpse poetry." But despite his aversion to illustration in painting, his life often seems like a series of illustrations to an old poem by Baudelaire. In it, "le vieux vagabond, piétinant dans la boue, Rêve, le nez en l'air, de brillants paradis": the old vagabond, his feet trampling in the mud, his nose in the air, dreams of bright paradises. Toward the end of the 1890s, and especially after his move to the Marquesas in 1901, the character of Gauguin's painting begins to change. His health was declining. The paintings of his last years have a ragged, unfinished look, with drawing that sometimes seems maladroit even by the standards of an artist who'd always insisted that the greatness

of an artist could never be measured by an absence of "mistakes." At times there is a sense of distraction: the stillness and calm Gauguin had always sought seem more beyond his reach than ever. Yet some of the paintings of this period, among them *Contes Barbares* ("Primitive Tales"), from 1902, present his art in its most powerfully concentrated form.

In a self-portrait Gauguin painted the year of his death, the proud masculine ego that shone through his many earlier ones has subsided. He betrays no sign of illness but looks far older than his fifty-four years. Happiness would never have agreed with him. It's not so much Gauguin's search for an earthly paradise that remains interesting but his continued inability to convince himself that he'd ever found one. Gauguin died dissatisfied, and in that dissatisfaction lies the aesthetic and political value of his art and his life.

2010

No Images of Man: Nancy Spero

"The limits of my language," Ludwig Wittgenstein famously declared, "are the limits of my world." One of the most notorious limits of our language, and one that has done much to limit our world, is "man" being the embodiment of humanity. That the pronoun "he" can represent indifferently "he" or "she," that "man" represents "man" or "woman": these are grammatical traces of the phenomenon that Simone de Beauvoir made the starting point of *The Second Sex* more than sixty years ago: "humanity is male and defines woman not in herself but relative to him."

Seen in this light, when Nancy Spero began using only the female figure in her paintings in 1976—paintings that by this time were more like what most people would call drawings—she was doing more than simply adjusting her pictorial style or focusing her subject matter. As Spero explained a few years later, "I decided to view women and men by representing women, not just to reverse conventional history, but to see what it means to view the world through the depiction of women." That is, she was trying, in the way that was open to her as an artist, to change language, to pictographically use "she" or "woman" as her universal term. Her goal was not to overturn the hierarchy and put women on top, because she knew from experience that the effort to make a particular term play the part of the universal could lead only to violent contradiction; rather, she was doing it speculatively, as a thought experiment, in order to see differently, to push back the limits of her world.

The idea of eliminating "man" from painting was not new; what was original was Spero's realization that this could be done by interpreting "man" to mean "male." In 1959 New York's Museum of Modern Art mounted an exhibition called "New Images of Man," focusing on the figurative expressionism that was an important part of the postwar scene, thanks in part to the work of Francis Bacon, Jean Dubuffet, and Alberto Giacometti. For Paul Tillich, writing in the catalog of that exhibition, the assumption was that when, "in abstract or non-objective painting and

sculpture, the figure disappears completely," the reason is that man is "losing his humanity and becoming a thing amongst the things he produces." The new figurative artists, he suggested, acknowledge this danger and protest against it. Among the younger artists included in the MoMA show was Spero's husband, Leon Golub; her work would have fit just as well.

For the most influential tastemakers in New York, the exhibition was a fiasco, the ideas behind it indefensible; abstraction was the only way forward. As Christopher Lyon writes in *Nancy Spero: The Work*, a comprehensive study of the artist, "The event was attacked by critics as a retrograde exercise and was a professional disaster for Golub, who was ferociously criticized by William Rubin, then a professor at Sarah Lawrence College and later the powerful director of the museum's Department of Painting and Sculpture." Rubin, the champion of such contemporaries as Jasper Johns and Frank Stella, singled out Golub's work as "inflated, archaizing, phonily expressive, badly painted."

As hard as this must have hit Golub, it could have affected Spero no less acutely. In interviews Spero never hesitated to admit that much of the anger that fueled her early work was caused by the feeling that her art was being ignored, that she was being silenced by an unsympathetic art world—a "very painful, personal experience." At this point, not only an artist but also a wife and mother in a world not yet shaken by *The Feminine Mystique*, she might have stifled whatever resentment she must have felt that her husband had been chosen for the prestigious museum show and not herself. But seeing the high price Golub had to pay for this recognition would have been doubly painful, adding guilt to her other hard-to-acknowledge feelings. Perhaps it was then that Spero began to question the language according to which, as Tillich's almost comically gendered language would have it, "Whenever a new period is conceived in the womb of the preceding period, a new image of man pushes towards the surface and finally breaks through to find its artists and philosophers." Whatever the case, Spero would later show that it was possible to make important paintings, not with new images of man, but with no images of man.

On the face of it, Spero's sacrifice of the male figure was hardly as radical a restraint on her pictorial language as that achieved by some abstractionists, but in her hands the artistic consequences of this reduction were enormous. Ironically, some women had a harder time with her work than men did. In the 1980s young feminist critics enamored of the new photographically based art of Cindy Sherman and Barbara Kruger dismissed Spero's

hand-rendered, historically grounded, woman-centered imagery as promot-
ing essentialism, a charge the artist hotly denied: "I try to indicate the range
of differences as coded in a variety of female images," she maintained. "I
try to emphasize this diversity, sometimes with shocking contrast and
disjunctions." Although Spero rightly thought of herself as bucking most of
the artistic trends of her time—above all abstraction, in the 1950s, when
she was a young artist finding her way, and later, in the '70s, conceptual
art—her wager that she could expand her art by reducing it to an essence
was the consummate Modernist move. Piet Mondrian, for instance, never
felt that by eliminating representation, by eliminating lines other than
horizontal or vertical, and colors other than the three primaries plus black
and white, he was narrowing his art. On the contrary, through this "elemen-
tarization" he hoped to make his art as universal as possible, and in such a
way that he could practice it with complete freedom and spontaneity. Spero's
gamble in sacrificing the image of man was much the same, and like
Mondrian's it paid off.

Unfortunately, the exhibition of Spero's work at the Centre Pompidou in
Paris (curated by Jonas Storsve) showcases only part of her achievement.
Though billed as a retrospective, it's not. One's first reaction might be
disappointment at the show's scale: there are just four rooms with sixty-
two works, all on paper. But for such a small show, it's very big. The
more attention you give it, the more its density and breadth become
apparent.
 The restriction to works on paper is not the problem. It reflects a turn
in Spero's career nearly as important as her decision to eschew the male
figure. In 1966 she stopped working on canvas and started working on
paper—though she continued to refer to her works as paintings. For two
decades paper was her exclusive medium, until she began making site-
specific wall paintings in the late '80s. Lyon calls these latter works
"peripheral monuments," evoking "images glimpsed at the edge of vision,
fragments that seem to be remnants of a vast ruined fresco, of which just
a few figures survive." Usually they were temporary, painted over at the
end of an exhibition. Planning for the exhibition at the Centre Pompidou
began while Spero, who died in 2009, at eighty-three, was still alive;
perhaps if she were still with us she would have supervised the installation
of one or more such wall works. I can't help wondering whether they can
be remade without her—or will they be known henceforth only through
period photographs?

More surprising, especially for viewers looking for an overview of Spero's work, is the show's near-exclusive focus on the early and late phases of her career and its neglect of what came in between. As if to illustrate the truism that there are no second acts in American lives, Storsve stages only the first and third acts of Spero's career. There are fifty works dated between 1956 and 1974 and ten finished between 1997 and 2002, with just one each from 1978 and 1986 to fill in the gap. In sum, fifty of the sixty-two works on display date from before the period when women became the universal protagonists of Spero's art.

However questionable this may be from the standpoint of illustrating Spero's development, it dramatizes the enormous change her work under-went over the years. In the first three rooms, covering the period through the 1980s, color and imagery are sparse; in many of the works through 1960 the figures—pairs of lovers, a mother and child—almost disintegrate into a brownish-gray haze. Of the paintings from these years, Spero recalled, "The figures would become obscure and they would merge with the back-ground." But it seems more accurate to say that, at least in some of them, the figures are so buried in the surrounding murk that they become its background. By the mid '60s, this gloomy haze had lifted. The works of this period, with few exceptions, are dominated by the white of the paper. The imagery and inscriptions that were becoming more important compo-nents of the works seem to sit uneasily on these sheets in a frail and transitory state. The images are like discrete, punctual cuts or holes in the continuity of space.

In the fourth room—which is dominated by the vast, thirty-nine-part (some 280 feet long) cycle *Azur* (2002)—there is a new density of imagery, and with it the grandeur evoked by a rich sense of color. By this time, Spero was working with an alphabet of hundreds of female hieroglyphs, some of her own invention, many drawn from the furthest reaches of cultural history. No longer reactive to a text, cut free from any narrative, the figures mingle in uninhibited visual converse. The work illuminates the actual space of the room, taking on "the fragile, naked radiance of what is newly born and utterly alone." The words are those of Pierre Schneider, speaking of the late cutouts of Henri Matisse. I'm not evoking a comparison with Matisse simply in order to lend Spero some of the reflected luster of a great name—she hardly needs it—but because her effort to unmoor painting from the Western tradition finally did converge with Matisse's earlier one. It's a surprising connection. When MoMA mounted a Matisse retrospective in 1993, Spero was scathing about the way, at a certain point, "Matisse seems to disengage

from experimentation and assume the position of the maître," resulting in an art in which the "world is extraordinarily unreal, sealed, everything is under control." Spero complained as well that "in many works the model appears to be featureless," assuming this featurelessness entailed disposability. Matisse explained it differently. "The face is anonymous," he said, "because the expression is carried by the whole picture." Spero, too, often sought such anonymity in her work. "I am not interested in individual physiognomies or personifications," she wrote. "The work deals with the rhythms, styliza- tions, often distorted or exaggerated variations or contrasts of body types from disparate cultures." Expressive anonymity was part and parcel of both Matisse's and Spero's efforts to liberate painting from the constraints of the easel picture and allow it to interact more freely with architecture; it also grew from the concerted effort each of them made to inform their work with a kind of total art history in which the European classical tradition would be only one strand.

And isn't Spero, after Matisse, the great painter of the dance? She depicts two sides of female experience—torment and victimization, on the one hand, but also activity, untrammeled movement, the celebration of one's own energies, on the other. Although her work never forgot the victims, not for a minute, with time the celebratory, even utopian side of the equa- tion took precedence. Still, the solemnity of the luxuriant color of late works like *Azur* suggests that even the celebration of sensuality can be mindful of all that has to be overcome in order for that celebration to be justified. But there is lightness, too, albeit less than in Spero's late wall paintings, with their more transparent colors amidst expanses of white that remain unbounded. (In this they are nearly the antithesis of the long scroll- like forms Spero made in the 1970s, which are works dominated by the white of the paper, where the extendibility of the format mainly evokes the possibility of elaborating more numerously and in greater detail the crimes being protested.) Matisse, speaking of his chapel in Vence, explained, "This lightness arouses feelings of release, of obstacles cleared, so that my chapel is not 'Brothers, we must die.' It is rather 'Brothers, we must live!'" Spero's late work embodies this same sense of release. "Sisters, we must live!" could be its motto.

A more complete exhibition than the one at the Centre Pompidou would undoubtedly give a better-articulated sense of how protest and celebration intertwined in Spero's work through the decades, of how the antagonistic fury of the '60s and '70s was subsumed (but not subdued) into the Dionysian

art of the new millennium. "Woman in Motion," a smaller show in Paris, at Galerie Lelong, with a dozen or so works, offers at least a few glimpses of Spero's direction in the '80s and '90s. But the Pompidou show, with its emphasis on her early work, draws more attention to the protest. It's as muted as possible in the unspecified existential gloom of the work from the late '50s. There is something tragic about these faceless lovers, as if they are surmounted by a destiny that surrounds them like a cloud of poison. Spero's discovery of a political reason for tragedy, in her antiwar drawings of the mid '60s, brought new clarity. New energy, too: the difference between the two bodies of work is the difference between a postcatastrophic state from which escape is no longer possible and a situation in which a shrill warning still might help make a difference.

In 1969 Spero found a new focus for her imagination: the figure of the French writer and director Antonin Artaud. He was the inspiration for two works: the "Artaud Paintings" (on paper, of course) of 1969–70, a series of ninety pieces from which Storsve has selected fifteen; and the "Codex Artaud" (1971–72), a series of thirty-seven collages of which seven are on view. Spero saw Artaud as "having uttered the most extreme expressions of dislocation and alienation in the 20th century. He represents himself as the victim par excellence. While violent in gesture and language, he is masochistic and passive. Nevertheless, he plays the part of the female victim." Spero's identification with Artaud was aggressive, even vengeful, in the sense that she understood that he would have seen it as a violation; a misogynist, he "would have hated a woman re-using his language and shifting his implications."

Lyon rightly calls the Artaud works "the pivot" of Spero's career. The "Artaud Paintings" look back at the anguished protest of the "War Series" and the anomie of the work of the '50s, in some measure combining them, but still within the confines of work entirely painted (and also written) by hand. "Codex Artaud" looks forward to Spero's later work. Its scroll-like accumulations of sheets show her chafing at the limits of the pictorial rectangle and reaching toward a different conception of pictorial space that is scattered and nonhierarchical. Also, the hand of the artist is put at a remove. The texts are not handwritten but typed, usually on a "bulletin typewriter" meant for preparing notices to be read at a distance, and the images are not painted directly onto the paper but collaged onto it; the images are also often repeated with small variations, anticipating the use of printing in her later works.

A codex is quite simply a book (as distinguished from earlier textual forms), but the word is usually used to refer to handwritten books such as

those of the Middle Ages. The name "Codex Artaud" calls attention to the booklike status of the works as carriers of text and image on multiple pages, but their display on the wall contradicts this. A scroll, unlike a bound book, can be displayed at once in its entirety. It exists somewhere in between the distinct forms of the book and the self-contained picture. Of Spero's work in this new format, the *Nation*'s art critic at the time, Lawrence Alloway, wrote, "It expresses ideas no less ambitious than painting and on a scale comparable to sculpture. There has been a dilation of drawing to room size, as in the wall drawings of Sol LeWitt . . . Spero expands collage to environmental scale without losing that subtle fragmentation of diverse parts central to the tradition of collage."

There is something a little bit perverse about packing such an expansive work back into the delimiting form of a book, but it's hard to be too critical of another recent publication that does just that. *Torture of Women* reproduces one of Spero's most important works of the 1970s, along with several texts including an interpretive essay by Diana Nemiroff, the curator who acquired *Torture of Women* for the National Gallery of Canada. In book form, spread out over some 100 pages of reproductions, the fourteen panels become far more readerly than they must be when displayed on walls; the exquisite balance between image and text is upset. By the same token, the unavoidable reaction of averting one's eyes, and skipping over some of the horrifying stories of political torture taken from a 1975 report by Amnesty International, becomes harder to maintain. I won't quote any of the stories here, but I instead reproduce Spero's citation of the Babylonian tale of the god Marduk and his defeat of the female monster Tiamat—a text also used in part in her 1986 work *Marduk*:

> marduk caught tiamat in his net and drove the winds which he had with
> him into her body and whilst her belly was thus distended he thrust his
> spear into her and stabbed her to the heart and cut through her bowels
> and crushed her skull with his club. On her body he took his stand and
> with his knife he split it like a flat fish into two halves and of one of these
> he made a covering for the heavens.

As Spero juxtaposes ancient myth with contemporary crimes of the state in Vietnam, Chile, Uruguay, Iran, and elsewhere, one might be tempted to imagine that she is pointing to the grim notion that hatred of women, a recurrent male need to take his stand on her body in order to create the glorious mantle of the sky, is an unchangeable archetypal pattern destined

to be reproduced in different forms. Nothing could be further from the truth. The accusatory vehemence of Spero's testimony, and the subdued visual presence of the goddesses and other female figures who serve as witnesses, remind us that judgment has yet to be rendered, and suggests that one day it will.

2010

22

Dimensions of the Abyss:
"Afro Modern" and Chris Ofili

In October 1699 a ship called the Liverpool Merchant set sail for Africa, proceeding thence to Barbados with a cargo of 220 slaves. Among the ship's owners was Sir Thomas Johnson, who that same year was largely responsible for the Act of Parliament making Liverpool an independent parish. And so the port city in what was then still part of Lancashire was initiated into the Triangular Trade. By 1799 the number of slaves reaching the New World in ships setting out from Liverpool hit an annual peak of 45,000. Controlling 40 percent of the European slave trade, Liverpool rivaled London in terms of wealth.

The grandiose architectural offspring of the city's former shipping might are still visible on its waterfront. One of the more recent is the Cunard Building, completed in 1917 in ornate Italian Renaissance style. The Canadian-born Samuel Cunard had parlayed a contract for transatlantic mail shipment into the world's most prestigious passenger cruise line; he represents an era in which Liverpool's maritime industry had sloughed off the shame of the slave trade. His great-granddaughter Nancy Cunard became an energetic promoter of literary and artistic Modernism who also edited the 1934 collection *Negro: An Anthology*, a landmark of the Harlem Renaissance era.

If there is any doubt that coming to terms with this history remains painful, consider what happened in 2006 when the Liverpool city council decided that street names linked to the slave trade should be changed to honor abolitionists. When it emerged that Penny Lane, the subject of the famous Beatles song, was named for an eighteenth-century owner of slave ships who testified in favor of the slave trade before parliament, and that it therefore would be one of those renamed, there were howls of rage. "Few songs are lodged in the national psyche like Penny Lane," the *Guardian* conceded. "Penny Lane should keep its name, but its fame should be used to make people aware of its shameful history." (In a letter to the editor, one

of the paper's Australian readers took sweet reason to even greater lengths: "The solution to the Penny Lane problem is obvious: commemorate the song instead and rename it Penny Lane Lane.") For now, the street remains Penny Lane, and tourists still go there looking for the shelter in the middle of a roundabout.

Tate Liverpool is located in a considerably less flamboyant structure than the Cunard Building, a former warehouse in the Albert Dock, but given the city's history it is hard to think of a more apt setting for its current exhibition, "Afro Modern: Journeys Through the Black Atlantic." As the subtitle discloses, the exhibition takes its inspiration from British sociologist Paul Gilroy's groundbreaking 1993 book, *The Black Atlantic: Modernity and Double Consciousness*. Thanks to its international reach, Gilroy's notion of the Black Atlantic offered one of the most suggestive distillations to date of an idea that was broadly articulated by Alain Locke nearly seventy years earlier, that "to be 'Negro' in the cultural sense" is "to be distinctively composite." It's peculiar, then, that Gilroy is not among the contributors to the exhibition catalog. (Music and the written word, rather than the visual arts, have been Gilroy's primary cultural sources, as reaffirmed by his provocative new book *Darker Than Blue: On the Moral Economies of Black Atlantic Culture*, with its more somber view of the cultural scene that Gilroy evoked in 1993.) By the same token, as Courtney Martin points out in her contribution to the catalog, even before Gilroy, Robert Farris Thompson had written of a "black Atlantic visual tradition"—though Thompson is not a contributor either.

While it seems evident that the violent yet galvanizing conjuncture of European and African elements in, mostly, the Americas has produced a world-historical transformation of musical culture, and an unprecedented politics of liberation as well, its effects on visual art have been more difficult to measure. The profound effect that African tribal sculpture had on Matisse, Picasso, and European and then international Modernism in general is well known. But to what extent was this the beginning of a broader transformation, one with consequences not only for white European artists but for artists in Africa and in the African diaspora in Europe and the Americas? To what extent, that is, can we speak not simply of a Euro-American encounter with African art but of a mutually transformative encounter of European, African, and diasporic cultures? These are the kinds of questions at stake in "Afro Modern," and while the exhibition can only begin to pose, not answer, them, the very fact that they are being asked is already a considerable achievement.

* * *

The exhibition's first section, "Black Atlantic Avant-Gardes," juxtaposes works of very different sorts. Paintings, drawings, and sculpture by Picasso, Brancusi, Léger, and Karl Schmidt-Rottluff illustrate the astonished Western discovery of African art, as do Walker Evans's photographs of tribal masks. There is also evidence of the social response to the increasing black presence in Europe: a print of Josephine Baker performing in her famous banana skirt; a caricature of an interracial couple dressed to the nines. (The drawing, in the collection of the National Portrait Gallery in London, is identified as "probably" Nancy Cunard and her lover, the black musician Henry Crowder; but Crowder's biographer, Anthony Barnett, assures me is not them.)

This is already a very mixed bag. Picasso, most notably, was inspired by African art to foment a thoroughgoing revision of the very syntax of representation—a revision that the others, Brancusi perhaps most of all, seized on with relish for its potential to be subjected to their highly personal reinterpretations. Paul Colin's lithe, stylish impression of La Baker has no such ambitions. Also in this section are works from the 1920s by white South American artists who employ Modernist stylization—the Brazilian Tarsila do Amaral had studied with Léger in Paris—and the awkward rhythms of folk art to observe the black cultures around them, and above all works by black artists of the Harlem Renaissance, who, to one degree or another, were productively reacting to both Modernist and African art. Naturally, these artists appreciated the latter with a "double consciousness," to borrow W. E. B. Du Bois's famous phrase: as the heritage they were eager to reclaim and as a source of the Modernist syntax, which at least some of them viewed as the means to effect that reclamation, or in any case as a stylistic badge of the contemporaneity of their artistic quest. Here I was particularly taken with two sculptures by Ronald Moody, a Jamaican-born British sculptor whose work I had not known before. His *Midonz* (1937) is a massive female head of carved elm that persuasively demonstrates that Modernist reduction could reveal a timeless serenity not unlike that of archaic Greek sculpture. Moody's works were shown alongside those of his American colleagues at the Baltimore Museum of Art in 1939 in an exhibition of "Contemporary Negro Art," but his works in "Afro Modern" have a stylistic authority that the Americans' lack.

The next stage in the evolution traced by the exhibition is titled "Black Orpheus: Negritude, Creolization, Natural Synthesis." The term "negritude" was coined, of course, by Aimé Césaire in the mid 1930s, but the period covered at the Tate is roughly the mid '40s through the mid '60s—essentially the era in which Europe's former colonies in Africa were gaining

independence and black consciousness was manifesting renewed élan. This was the beginning of what later would be called Afrocentric thinking. It's at this juncture in the exhibition that modern African artists (rather than the anonymous makers of tribal artifacts) appear for the first time. By the same token, Maya Deren's film *Divine Horsemen: The Living Gods of Haiti*, assembled after her death from footage shot in 1947–51, exemplifies a new turn in the white avant-garde's involvement with "exotic" black cultures. It was no longer a matter of connoisseurial rummaging in Parisian flea markets but of a pilgrimage to the source, and a concomitantly heightened sense of the embeddedness of masks and other objects in ritual.

The "Natural Synthesis" of the section title refers to the ideas of Nigerian artist and theorist Uche Okeke, whose take on negritude emphasized contemporaneity and heterogeneity over tradition and authenticity. Cuban, Brazilian, and American artists held similar goals, but as hopeful as such a synthesis of old and new African and European influences may sound, the results often seem strangely bloodless—something that could hardly be said of the succeeding section, "Dissident Identities: Radicalism, Resistance and Marginality," which features works reflecting the civil rights and black power movements of the '60s. The polemics here hardly seem dated, and are not limited to black artists; Andy Warhol's 1964 silkscreen print *Birmingham Race Riot* is right at home with Adrian Piper's 1975 drawing *I Embody Everything You Most Hate and Fear*. But within this countercultural uproar, another theme begins to emerge in counterpoint to overtly racial concerns: gender politics. Art historian Judith Wilson is quoted to explain that Romare Bearden's extraordinary collages—which have been looking more and more relevant again of late—"recuperate the black female body, wresting it from the clutches of white purveyors of erotic fantasies about exotic Others, and reposition it in relation to black vernacular culture." No doubt, but this still leaves open the issues of inequality within that culture.

A different view of the black female body emerges in a work by a woman artist—Piper's *Food for the Spirit* (1971). This sequence of murky black-and-white images showing Piper photographing herself in a mirror evokes a self-confrontation that involves opacity more than clarity, unknowing as much as enlightenment. The artist/philosopher's gaze, seemingly troubled and doubtful, is toward and for herself; she looks forward but not outward, and the viewer becomes marginal—not a voyeur, yet neither welcomed nor challenged. Her nakedness seems to speak less about sexuality or gender than of a reduced and isolated sense of self.

The exhibition's last three sections, "Reconstructing the Middle Passage: Diaspora and Memory," "Exhibiting Bodies: Racism, Rationalism and Pseudo-Science," and "From Post-Modern to Post-Black: Appropriation, Black Humour and Double Negatives," bring the story of the Black Atlantic up to the present with works dating mostly from the past two decades. The multiplication of categories suggests that the present and immediate past are harder to encapsulate than previous eras—which is always the case—but also reminds us that the complexities of history, and the strategies for dealing with them, are essentially the same as forty years ago: mourning, protest, and humor are still of the essence. In retrospect, "post-black"—a term coined by curator Thelma Golden of the Studio Museum in Harlem and artist Glenn Ligon—represents a depth and complexity of ambivalence that exceeds any merely double consciousness, and typically characterizes much of the strongest black art. That's why I say Bearden is a central figure. It is hard not to have mixed feelings about his formally and semiotically dense and raw concatenations of imagery, and those mixed feelings amplify rather than dissipate the work's appeal. His influence on an artist like Wangechi Mutu is most patent, but it's not hard to find in many of the other relatively younger artists here (few are under forty), such as Ellen Gallagher, Kara Walker, and Chris Ofili. The collage-based conflation of the pornographic and the sacred, suspending judgment, critique, and satire, in Ofili's *The Holy Virgin Mary* (1996)—the painting (now on view at Tate Britain in London) that caused such a foolish ruckus when the "Sensation" exhibition came to the Brooklyn Museum in 1999—is as raucously Beardenesque as you could want.

By contrast, Judith Wilson's desire to offer a politically righteous alibi for Bearden's unresolvable little pictorial desire machines seems like a turn away from the risk and exposure of the post-black position that was already implicitly his. To some extent, this is true of the exhibition as a whole. The downside of its laudable ambition is the need to thematize everything and to seek out what has already been thematized at the expense of what resists explication. In the "Afro Modern" catalog, the great Martinican writer Édouard Glissant explains in an interview that "a person has the right to be opaque," and that this is because "a racist is someone who refuses what he doesn't understand." Glissant's insight is profound but painfully hard to act on. An exhibition like "Afro Modern" tends to refuse what is opaque. Another way to put it would be to remember Stuart Hall's plea in an essay published in 1996: "I ask you to note how, within the black repertoire, *style*—which mainstream cultural critics often believe to be the mere husk, the wrapping,

the sugar-coating on the pill—has become *itself* the subject of what is going on." What Glissant calls opacity is inseparable from what Hall calls style. The need to find clearly marked subject matter tends to deflect attention from the importance of style as such.

One way that this inattention manifests itself in the exhibition is through the near suppression of abstract art. Rubem Valentim's paintings are didactic illustrations of how abstraction might absorb forms redolent of Afro-Brazilian culture but feel like a compromise more than a real synthesis. "Afro Modern" includes other artists who painted abstractly, such as Norman Lewis and Frank Bowling, but with works in which abstract motifs are allegorically overlaid with more overt topical content. Their abstract works, not to mention those of artists like Alma Thomas, Beauford Delaney, Sam Gilliam, Martin Puryear, Leonardo Drew, and Mark Bradford, are essential to any visual survey of the Black Atlantic. I also wonder about missing figures such as William H. Johnson, Robert Colescott (another of Léger's students, by the way), Barkley Hendricks, and Kerry James Marshall, whose works are far from abstract but which exemplify stylistic peaks that I felt as sore absences in this context. I mention American examples because that is the context I know best, but the examples could multiply internationally. Moreover, the focus on subject matter over style means that some artists are represented by weaker work than they should be. A prime example is Jacob Lawrence, here with an African street scene from 1964, which serves to illustrate the growing ties between black American artists and the mother continent at the time. But Lawrence's greatest paintings are his early ones, from the late '30s and early '40s, and those are the ones that helped make a future for Black Atlantic style. Wifredo Lam is rightly presented in the catalog as the premier artist of negritude, but you'd never know it from the minor examples of his work in the exhibition. Likewise, from the single photograph exhibited here, the viewer has no way to understand what has made Isaac Julien such a significant artist and filmmaker over the past two decades; his idiosyncratic compound of extreme aestheticism and moral intensity cuts across all invidious dualisms.

Few artists today exemplify style—and its opacity—as acutely as Chris Ofili. His current retrospective at Tate Britain underlines the fearlessness it takes to let your work go that far. It's also a good reminder of how in-your-face blatancy can be just as good a vehicle for opacity and style as ambiguity and nuance are. Ofili knows it. As he tells interviewer Ekow Eshun in his solo catalog, "Sometimes though, I'm just blindingly obvious, an example being

Afrodizzia (Second version), from 1996. Like, bang, there it is. Afro head—celebration of Afrocentricity." You can be that obvious with style, of course, if you've got a lot more going on than just what you're being so obvious about. *Afrodizzia (Second version)* belongs to the first phase of Ofili's work, or anyway the earliest phase shown here, in which imagery is subsumed to pattern and the play of materials. Collaged to its surface are, indeed, a plethora of heads with Afro haircuts—dozens of them, maybe hundreds. You can never lose sight of them, not for a minute, but there is so much more going on in the painting: the collaged heads are just one layer in a dense commotion of optical, linguistic and tactile elements (including the famous varnished balls of elephant dung) that manage to create a coherent visual field only by the skin of their teeth. The thrill of the painting is that, miraculously, the elements do cohere.

Painted in the same year, *The Holy Virgin Mary* is part of the next phase of Ofili's development. Figurative drawing—flat and posterlike but with great bravura and proffering a single, centralized, iconic image—rather than pattern dominates, and to a great extent visual coherence comes more easily. But in compensation, the paintings become more complex emotionally. Mixed feelings about women come to the fore. *The Holy Virgin Mary* could have been a simple illustration of the age-old virgin/whore dichotomy—except, where's the dichotomy? Carnality and the spirit simply coexist, with no resolution of their potential contradictions, and none sought. By 1999 Ofili seems to have become interested in synthesizing his new figurative content with his earlier emphasis on abstract pattern. This doesn't always succeed—*The Upper Room* (1999–2002), a chapel-like installation of thirteen paintings (on the model of Christ surrounded by the Twelve Apostles, but here substituted by rhesus macaques), is grandiose rather than raucous when it probably should have been both. But what's intriguing about Ofili's best paintings of this period—from *Prince Amongst Thieves* (1999) to *Afro Sunrise* (2002–03)—is how they start to feel like their own camouflage. Their visual density heightens one's awareness that they contain more than one can easily make out, but it also suggests that density itself might be the main thing to see, to accept. There is much hidden in these paintings, and you always feel as though there's something inside them that might be looking out at you, spying, as much as you're looking at the paintings.

Then, between 2003 and 2006, comes a break from painting, though not from drawing. In 2005 Ofili moved from England to Port of Spain, Trinidad, a place where he had no roots, although his friend and fellow painter Peter Doig, who had spent his childhood there, had returned a few years earlier.

166 OLD VAGABOND

There are curious parallels in the effect that moving to the island has had on the painters. Doig and Ofili paint very differently, but one thing their paintings have had in common is that they were built from the micro level up, their images like condensations of innumerable small marks, swarms of punctual sensations. Slowly, after Doig moved to Trinidad, his paintings began to clear out, to become broader and more open, and at the same time more mysterious. Something similar has happened with Ofili, but more suddenly. Starting in 2006, there is a sequence of close-valued, dark-blue paintings whose imagery, stylized in a way that recalls German Expressionism, can be very difficult to make out. Perhaps the most legible is *Iscariot Blues* (2006). Judas, the Gospel of Matthew tells us, ended his shame by hanging himself. Here the gaunt, naked body hangs broken-necked as he is serenaded, or so it seems, by a pair of musicians. It's an eerie and terrible image that to some extent makes one grateful for the deeper opacity of some of the other blue paintings.

Other recent Ofili paintings use a wider range of hues with more contrast, but still with these expressionistic distortions of the figure. Not only has Ofili transformed his technique, and the surface quality of his paintings, but the nature of his drawn line has changed as well. Before it was rounded, voluptuous, seductive; now it is tense and elongated. Ofili speaks of "a very particular mystery" that he derives from the Trinidadian landscape, adding, "Essentially there's a joy I feed off." And yet the paintings are not joyous, at least not in the way so many of his earlier, more insouciantly bad-boyish ones were. At best, perhaps, one can speak of an *amor fati*. There is something haunted in these paintings, a sense of fatality that was not there before. And with that, a sense of existential weight. The imagery in these paintings is not iconic, as in earlier works like *The Holy Virgin Mary*. Instead it conjures up narratives, though of unclear purport. There is a sense of hidden dramas, of fables with secrets. This affinity with the riddling quality of legend or parable recalls the art of Bob Thompson, the American painter of the '60s—another of those figures who might have been worth including in "Afro Modern" but wasn't. The paintings evoke, whether Ofili realizes it or not, a thought that Glissant has explained in this way: "The Africans in the New World—African-Americans, but also the Antilleans, Brazilians, etc.—escaped the abyss and carry within them the abyss's dimensions." Ofili's heritage is otherwise—his family having come to England from Nigeria, they are not part of the diaspora that endured the middle passage and slavery—yet in the Caribbean he seems to have glimpsed and been affected by the dimensions of that abyss.

2010

An Art of Time: Rafael Ferrer
and Christian Marclay

Shows by the peripatetic Puerto Rican–born artist Rafael Ferrer have been curiously sparse on the exhibition calendar in recent years, so his recent retrospective—or, as its title would have it, "Retro/Active"—at El Museo del Barrio in New York City was a welcome reminder of the powerful, protean oeuvre he has fashioned in more than half a century of artmaking. Forty years ago his work would have been hard to miss. In 1969 he participated in three of the signal exhibitions of the new wave of conceptual, postminimal, process-oriented and "antiform" art that would dominate the scene for much of the next decade: "Live in Your Head: When Attitudes Become Form" at the Kunsthalle Bern; "Op Losse Schroeven (Square Pegs in Round Holes)" at the Stedelijk Museum, Amsterdam; and "Anti-Illusion: Procedures/Materials" at the Whitney Museum of American Art. The following year Ferrer had a one-man show at New York's leading gallery, Leo Castelli, and took part in another now-legendary group show, "Information," at the Museum of Modern Art.

Ferrer's work from those days was not very prominently displayed at El Museo; much of it consisted of highly ephemeral installations of unconventional materials—piles of dead leaves and massive blocks of ice were particular favorites. In "Retro/Active" these were represented by means of a wall of small photographs that had been banished to a side room, although it would have been worth the trouble—a lot of trouble, admittedly—to re-create a couple of these ventures into what Carter Ratcliff has called "a medium that was part sculpture, part theater, part guerilla action on the aesthetic front." By contrast, the more conventional paintings and sculptures Ferrer made in the 1950s and early '60s, when he was still finding his way as an artist, were fully integrated into curator Deborah Cullen's thematic (rather than chronological) traversal of Ferrer's career, giving a possibly misleading sense of its overall shape.

Since the '70s, Ferrer's work has been strikingly polymorphous, ranging from sculpture and painting to drawing, collage, and books. Just as he was

associated with process art at the end of the '60s, around 1980 he started making figurative paintings that seemed to be right in step with the Neo-Expressionism just then on the horizon. Journalists saw this style of painting as a rejection of the avant-garde of the '70s; but in its crudity, the new painting was yet another attempt to start again from scratch, just as much of the art of the '70s had been. More than a few of its protagonists, notably Francesco Clemente and David Salle, had, like Ferrer, first essayed the more conceptual aesthetics of the previous decade. I doubt, though, that their paintings would hold up anywhere near as well as Ferrer's do today. For all the variousness of his efforts, it would be wrong to see Ferrer as an eclectic artist, one whose work lacks coherence or commitment—at least after his years of youthful experimentation, which admittedly lasted longer than is common these days. Born in 1933, he was already in his late thirties by the time he began making the process-oriented installations that can be considered his first mature works.

Along with several new texts, the catalog for "Retro/Active" reprints a long and searching essay by Ratcliff published in the catalog for an exhibition at the Contemporary Arts Center in Cincinnati in 1973. What's remarkable about "Rafael Ferrer in the Tropical Sublime" is how descriptive it still seems today of the thinking behind Ferrer's work, even of the work made over the subsequent thirty-seven years, much of which bears very little overt resemblance to anything the artist was doing back then. This is testimony, of course, to a critical perspicuity on Ratcliff's part that practically amounts to prescience, but also to the fact that the multifariousness of Ferrer's art nonetheless manifests a dogged insistence. He has simply taken as many approaches as possible to a few recurrent themes—or perhaps it would be better to say a few recurrent obsessions.

Ratcliff shows, too, that Ferrer's work was always in fundamental tension with the context it appeared to be part of, in the first instance the new forms of art that developed in New York in the wake of minimalism. Think of Robert Morris, with whom Ferrer was closely linked at this time, or Richard Serra, whose works were only the residue of simple physical manipulations of materials as exemplified in his famous "Verb List Compilation": "to roll, to crease, to fold . . . to bundle, to heap, to gather, to scatter." Ferrer was undoubtedly concerned with the physical character of the materials he was using and with the visible changes one could see them undergo; but at the same time, as Ratcliff insists, he was always a Romantic with an ingrained faith in the power of symbol, myth, and metaphor to give

meaningful direction to life through art. In Ratcliff's view, Ferrer's use of autumn leaves was an invocation of Johnny Mercer's sentimental standard of that name and Shakespeare's Sonnet 73—literary and emotional references that were supposed to be taboo for sophisticated artists of the day, who were fundamentally empiricists, intent (as Ratcliff says) on "the construction of non-symbolic objects with no admitted reference to humanity or the natural world." Ferrer used natural materials with blatant symbolic implications, though with a bluntness that headed off any possibility of sentimentality or overly effusive lyricism.

Other early installations by Ferrer juxtaposed similarly transient materials with more solid, evidently sculptural ones, among them steel, tree trunks, and neon lights. He also made self-contained sculptures, often in the form of kayaks and other kinds of boats, and began drawing, in crayon, maps of imaginary places. He was summoning the Romantic myth of the journey, the dream of exploration—which, of course, echoed his own real life, moving between Puerto Rico and the American mainland, not to mention Europe, where he had spent an important period as a young man in the 1950s, rubbing shoulders with the Surrealists and engaging in deep dialogue with Wifredo Lam, the Cuban-born painter whose work attempted to synthesize a formal syntax derived from Cubism and Surrealism with an iconography reflecting his culture's African and Indian roots. Ferrer's use of crayons shows his attraction to the pictorial expressiveness of children, the untutored, people on the margins—another Romantic theme—and he also used them to design masklike forms on paper bags, something he still does today. This multitude of faces constitutes a marvelous vocabulary of legible forms in which observation and invention become indistinguishable.

What separates Ferrer's paintings of the 1980s and '90s from the Neo-Expressionism with which they might have been confused (and which they might have influenced) is a predominance of observation. If the art of the 1960s and '70s, for all the brilliance of its innovations, was rendered too narrow (and, ultimately, academic) by its extreme empiricism, which ruled out of bounds so much of art's potential material, then the besetting sin of the art that in the '80s emerged in reaction against it would have to be an excessive subjectivism, an overindulgence in the cultivation of what Harald Szeemann dubbed "individual mythologies" unchecked by any significant external reality. In an interview with Alex Katz, Ferrer says, "I know that I am attracted to German Expressionism, Neue Sachlichkeit, Dix,

Beckmann," which might seem to underline an affinity for the later Neo-Expressionists as well, but like the early-twentieth-century Expressionists and unlike the Neo-Expressionists of the '80s, he was finding his symbols in an encounter with reality, and one with an immediate political dimension at that: the subaltern.

In 1975, after nearly a decade spent mostly in Philadelphia, Ferrer again began spending much of his time in Puerto Rico; in 1985 he gave up his home there for one in the Dominican Republic. It was in Puerto Rico that Ferrer seriously took up painting, after a visit from Katz suddenly convinced him that painting from observation still had a future; and the subject matter of nearly all his best painting has come from his experience of the islands. This has led to misunderstandings. When a critic referred to his style as "faux primitivism," Ferrer objected that the characterization was based on a prejudice about the people he depicted rather than on his way of painting them. "They can call the people in the paintings natives or they can call them inhabitants of this place or the other, *but I call them neighbors.*"

Actually, some of the first paintings Ferrer made after his return to the medium do betray a certain primitivism. I'm thinking of works like *El Cuarteto* ("The Quartet") or *Melida la Reina* ("Melida the Queen"), both from 1981, which almost seem like elaborations of his paper-bag mask fantasies. But by mid-decade his style had become distinctly more sophisticated, settling into a sturdy Modernism that would not have looked outrageous to any of Ferrer's early-twentieth-century heroes, but with a personal inflection that could never be confused with anyone else's. Ferrer's brush is tough, unsentimental; he prefers to show things bluntly rather than suavely coaxing them into visibility. His pictorial space can seem almost hammered into place—as if an imprint of his work as a sculptor. His use of the word "neighbors" to describe his subjects is quite precise. In painting the people who lived near him in the Dominican Republic, he was painting neither familiars—it is telling that although Ferrer has done self-portraits, he has rarely painted his family or close friends—nor complete strangers. Wariness and curiosity register in the faces of many of Ferrer's subjects, although others appear more ingenuous. There is no false familiarity here, but rather a distance to be negotiated. And it can be negotiated.

A curious light is shed on Ferrer's art by learning that for a long time he was as deeply involved in music as in painting and sculpture, playing drums professionally in Latin bands until 1966. One of the exhibition's thematic sections is devoted to representations of music and musicians, making it clear that his fascination with sound never abated. The relation between

music and the other arts was one of the great themes of Modernism; in the European tradition, where the musical reference was always to the great tradition of classical concert music, this usually pointed toward the possibility of abstraction. Just as a string quartet needs no literary program, neither does a painting. For Ferrer, the implications are different because the music he has in mind comes from a different tradition. "My instrument is the drum," he explained in 1971:

> It minimizes all the other assets that music has, like harmony and tone, and concentrates on the fundamental point of time and the ability to split time in ways that are intricate and inventive, and to do that under pressure, which comes from the fact that musical decisions are made at a high rate of speed—they are literally split-second decisions. So they require intuition and the ability to take chances within a structure which has time as a critical element.

Ferrer's understanding of the significance of music is hardly opposed to its potential for abstractness, but neither is that the main point. Instead, Ferrer calls for an aesthetic of spontaneous responsiveness irrespective of subject (or lack thereof)—an aesthetic just as applicable to the figurative painting he would take up a decade later and the seemingly abstract yet symbolically resonant installations he was making at the time. For that matter, his most inventive and intricate elaborations of the structure of time will undoubtedly turn out to have been his paintings. It's a pleasure to see them again after so long.

Ferrer's quasi-manifesto for music as the fundamental aesthetic is worth keeping in mind when visiting "Christian Marclay: Festival," at the Whitney. The Swiss-American artist, born in 1955, might seem to have very little in common with his Puerto Rican elder, yet Marclay is just as insistent as Ferrer that music, as an art of time, can be a model for visual art—if anything, he is even more so. Unlike Ferrer, Marclay has no musical training. But as an art student in Boston in 1979, inspired like many of his generation by punk rock, which "had freed people from the idea that you had to be skilled to play music," he began performing, or as he puts it, "inventing ways to make music when not a musician." Since he couldn't play an instrument, he began working with musical readymades, using vinyl records and turntables as instruments, not unlike the breakbeat DJs who'd started working with the same equipment to revolutionary effect in the Bronx just a few years before,

albeit to very different ends. Soon he started treating his records as sculptural material, cutting them up and recombining the pieces to create visual collages that were also bearers of sound collages.

By now, Marclay has become something of a virtuoso of the turntable; the correlate of the punk notion that you don't need to be skilled to make music is that if you keep making music you will become skilled, though possibly in unusual ways. Increasingly, he has collaborated with trained musicians; and although he still calls himself an artist, he is highly respected as a composer of the avant-garde, even though he does not read or write conventional notation. At the same time, he has continued to use music, records, record covers, musical instruments, and images of music and music-making as material for sculpture, collage and video as well as performance.

Not all of this work is at the Whitney; "Festival" is not a full-dress retrospective. Instead, in keeping a fairly tight focus on the notion of the "visual score," curators David Kiehl and Limor Tomer give a concise cross-section of his oeuvre that shows it to advantage, despite the absence of some of his best work. Among these I should at least mention two: the astonishing *Video Quartet* (2002), a four-channel projection that conjures up a new, fourteen-minute-long piece of music out of more than 700 brief clips taken mostly from Hollywood movies—scenes in which people are shown making music or at least making sounds; and *Tape Fall* (1989), a sculpture consisting of a reel-to-reel tape recorder mounted high up above one's head, playing a tape of the sound of trickling water that, instead of being taken up by a second reel, falls in elegant coils to form an ever-rising pile on the floor. One misses such pieces but not the relatively large quantity of facile, one-liner-ish works for which Marclay has also been responsible—for instance, assemblages of record covers that create grotesque figures out of, say, a solemnly gesturing orchestra conductor from the waist up matched with a ballerina *en pointe* from the waist down. In fact, the very notion of the visual score works against the one-liner. It means there always has to be at least a double-take—one's perception of the graphic form should be followed by an effort to understand how it might be understood as a series of cues for making music.

The idea of the visual score—or graphic notation, as it is often called—is hardly a new one, originating with the composers of the New York School of the 1950s: Earle Brown, John Cage, Morton Feldman, and Christian Wolff. But Marclay not only pursues the idea to unheard-of extremes; he turns it on its ear. When a composer presents the performer with a graphic score

that may allow far more interpretive leeway than a conventional score would, he still has some basic sonic parameters in mind—and in any case, the score was produced with the idea of making music. That's not always the case with Marclay, for whom the visual takes precedence. And he sometimes asks performers to use as scores things that were never intended to have anything to do with music.

Shuffle (2007) is a deck of seventy-five cards with photographs taken by Marclay. Each shows an image of musical notation found in "real life"—that is to say, on billboards, candy boxes, T-shirts, cars, cakes, umbrellas, teacups—anywhere that a musical note might serve a decorative purpose, but not where it would have been meant to be read as a basis for making music. Yet this is what Marclay proposes: using this deck of cards as a recombinant score. What any given performer might make of, say, a single quaver crossed out, no particular tone specified, or a bunch of notes splashed across a staff with only two rather than five lines is entirely unpredictable; someone who went to hear pianist Anthony Coleman perform *Shuffle* on August 4 will undoubtedly have heard something with no discernible resemblance to either the version created by the duo of Robin Holcomb and Wayne Horvitz on August 26 or what the great Canadian artist and musician Michael Snow will come up with on September 26. But even for those of us who could never make music out of these paltry and absurd signs, the effort to imagine doing so makes us see the images differently.

Another photographic piece with a somewhat more complicated genesis is *Graffiti Composition* (1996–2002). In 1996 Marclay had posters of blank staff paper printed and posted all over Berlin. Soon enough, the posters were torn and marked up by passersby, half covered with other postings, written over—sometimes even with music. The results were photographed, and now these, too, constitute a score, also being performed several times during the course of the exhibition. From poster installation to photograph to score for an unpredictable sound event: "I like these evolving structures," Marclay says, "where I eventually lose control."

Not only graphic signs have a capacity to score the unforeseeable. Marclay conceives even some of his video works as scores, while *Mixed Reviews* (1999–2010) is a wall text made from excerpts spliced together from all kinds of music reviews, taking only the parts where the writer was trying to describe a specific sound or sound quality. The performer's task is to produce this sequence of sounds—a task perhaps made even more challenging by a twist: the piece has been displayed and performed in various countries; each time it is re-presented, it is translated into the language of

the host country, and the subsequent version is translated in turn from that, not from the original English. This means that the text shown now at the Whitney is several generations removed from its first version—and presumably the sound sequences it might evoke are different as well.

As much as the sonic matter of music, Marclay takes much of his material from what might be called music's mythologies—in Roland Barthes's sense of that word. Unlike Ferrer, who would rather create symbols, Marclay prefers to deconstruct them. He cites conceptual artist Douglas Huebler's motto, so typical of the 1960s: "The world is full of objects, more or less interesting; I do not wish to add any more." But by reusing existing images, existing records, existing video footage, he comes closer to refraining from adding more meanings than more objects. Yet his work conceals a certain unresolved irony. It is possible to devise out of the banality of our visual environment a score that does not commit the composer—if that is still the right word—to any particular musical statement. Doing so has the desirable effect, at least momentarily, of scrubbing some elements of that environment clean of those heavily stereotyped meanings that constitute its banality, allowing one to see it as also rather wonderful. But the performer who interprets this score, who might also be its composer, has no choice but to choose this sound rather than that, this structure rather than that, this myth rather than that. Deconstructing the old mythologies only clears the way for developing new ones. "Absence," as Marclay says, "is a void to be filled with one's own stories."

2010

Hubbub and Stillness: The 2009 Venice Biennale

Biennials are the exhibitions all art-lovers love to hate, and the Venice Biennale is the one we wouldn't miss for the world. The reason? Take your pick of clichés: *Timing is everything*, but don't forget *location, location, location*. Born in 1895, the Biennale was the first of the great recurrent international exhibitions, but even if the Carnegie Museum of Art had been a bit quicker in kicking off the first edition of what is now the Carnegie International (DOB, 1896), it's hard to imagine the prospect of another trip to Pittsburgh setting the aesthete's heart aflutter quite like that of a visit to la Serenissima. Venice is preeminently the city of art, meaning not just that it houses a great many works of the highest order—like many another city, including its old rival Florence—but that the city as a whole is a superlative embodiment of art. Precisely because our time is so deeply marked by an anti-aesthetic spirit, a suspicion of every quality that has already been certified as a guarantor of artistic value, seeing contemporary art in Venice—this "jeweled bathtub for cosmopolitan courtesans, *cloaca maxima* of passéism," as it was denounced by Marinetti in 1910—is a perfect way of testing its ability to go against its own grain. As the Biennale spreads its tentacles ever more thoroughly into every part of Venice, we begin to experience contemporary art as a city in itself, overlaid on the existing one with which it is deeply in tension, as in some lost fable by Calvino.

Then what's the problem? Clearly, the form of the mega-exhibition itself. The complaints are legion, and all in their way justified. The exhibitions have become too big, too crowded, too hectic; instead of qualitatively sifting the masses of art being produced, they simply follow a more or less arbitrary selection schema and toss the results back at the public to sort through. For many, the *ne plus ultra* of this tendency was Documenta 11 in Kassel, Germany, in 2002, curated by Okwui Enwezor. Thanks to its emphasis on video, the "650,000 visitors [who] came to appraise around 450 artworks on a surface area of 13,000 square metres" (according to the Documenta website) often left wondering if they could have sat through all that footage even if they'd

stayed the whole hundred days of the exhibition. Of course, these complaints have been common since before the big exhibitions became as big as they are now, and well before the advent of "time-based art" (or, as I have been tempted to rename it, time-consuming art).

Venice differs from most other such extravaganzas, not so much in scale as in comprising a multitude of more or less self-contained parts that can be considered independently of the others, and some of which are more central than others. The central parts are found in the Giardini del Biennale, where the exhibition has been taking place since its inception, and in the nearby Arsenale. The Giardini houses thirty pavilions, twenty-eight of them belonging to the nations whose participation has been longest-established—primarily European, as one might imagine, along with the United States and Canada, but also including several Latin American countries plus Japan, Korea, and Egypt. Each country chooses its own exhibition program, usually a one-person show of a prominent artist or a small group exhibition. The twenty-ninth is the Venice Pavilion, while the thirtieth and largest of the pavilions, once called the Italian Pavilion, is now devoted to a large, curated international group show, in recognition of which its name has been changed this year to Palazzo delle Esposizioni. (In exchange, Italy has been given its own pavilion at the Arsenale; a shaky start has been made of it, with a group show that completely ignores the Italian artists who are actually making any impact internationally.) This group show is the component of the Biennale that is comparable, but on a global rather than a national scale, to exhibitions like the Whitney Biennial. But in Venice it is only one piece of the puzzle. As this curated part of the Biennale has grown more important, it has been given more space. In recent years it has been expanded beyond the original pavilion and taken over the Corderie of the Arsenale, a long, almost tunnel-like building about a fifteen-minute walk from the Giardini, in which the ropes for the Venetian navy were once made. This year, the curator is the Swedish-born critic Daniel Birnbaum, rector of the prestigious Städelschule in Frankfurt, Germany. Upholding the tradition of giving the shows vague but grand-sounding titles that have the aroma of a theme without actually committing the curator to including or leaving out anything in particular, his exhibition is called "Fare Mondi"—Making Worlds.

The reach of contemporary art has grown enormously of late. Nearly every country wants a pavilion in Venice, but the Giardini having been filled to capacity, the newer arrivals have to find temporary accommodation elsewhere in Venice. There are plenty of stray palazzi for rent around the lagoon, so

this year there were more than sixty national pavilions, with the offsite presentations showcasing work from nations ranging in scale from the Republic of San Marino to the People's Republic of China. The national presentations beyond the Giardini represent the Biennale's second circle: scattered and sometimes hard to find, most visitors make their way only to a few of them. A third circle consists of "collateral events"—exhibitions (forty-four this year) organized independently of the Biennale but recognized by it and included in its catalog. Finally, at the greatest distance from the center, are a multitude of events timed to coincide with the Biennale but without any official link to it whatever. As far as the curated exhibition goes, the tendency toward gargantuanism probably reached its peak six years ago, when Francesco Bonami's "Dreams and Conflicts: The Dictatorship of the Viewer" was merely an umbrella for no less than eleven sub-exhibitions, most of them subcontracted out to other curators (Bonami himself curated just two sections and co-curated a third together with Birnbaum). One section alone, "Utopia Station," curated by Molly Nesbit, Hans Ulrich Obrist, and Rirkrit Tiravanija, included over 200 artists and collectives in an outdoor setting that felt like a more expansive version of a high school Earth Day fair, all earnestness and good intentions, however ineffectual. By contrast, "Fare Mondi" includes the work of only about ninety artists.

Even allowing for a curated portion that has been much scaled back since 2003, one could not see the entirety of the Biennale without devoting a couple of weeks to the task. Whether anyone ever actually does so, I doubt. To say this is not merely to make a point about the practicalities of the visit. Because each county chooses the art in its pavilion internally, the differences among them amount to a practical demonstration of the multiplicity of perspectives in the burgeoning international art world. This doesn't mean, of course, that a given country represents a particular perspective on art, or that there is a particular international perspective— art is contentious everywhere, but the ideas under contention vary sufficiently that even well-informed viewers are liable to misunderstand (and to dismiss as naïve and outdated, or as slick and facile) work that emerges from unfamiliar contexts. From within the contemporary inter- national art world, one can have the impression that everything is converging into a sort of aesthetic *pensée unique*. But to wander among the national pavilions in Venice is to be forcibly reminded that if such a conver- gence is occurring, it is happening very unevenly. While many of the smaller countries make every effort to present up-to-date forms of installation art, video, and whatnot, others choose to ignore these forms altogether.

As an example, Ahmed Askalany's stylized figurative sculptures made of woven palm leaves—Askalany is one of two artists in the Egyptian pavilion this year—would probably have been considered too close to handicrafts to feature in the pavilion of any western nation, let alone in the curated show. And yet, for all their propensity toward a too-generalized humanist sentiment, his sculptures are artistically stronger than most of the more contemporary-seeming work in other pavilions.

For Lawrence Alloway, writing in 1969, the capaciousness of the Venice Biennale already showed that the quantity of works and artists and possible styles meant that it was no longer possible to hope to arrive at the "uniform validated standards" to which art critics once aspired; forty years later, given the Biennale's exponential growth, that is even more the case. Paradoxically, that same growth has made it easier to ignore the consequences that Alloway saw clearly. Then, when the Biennale took place only within the confines of the Giardini, each visitor was likely to enter every pavilion, and was sure to come upon something that challenged his or her aesthetic assumptions— whether by being too radical, too conservative, or simply too unexpected. Today, when the viewer must pick and choose what to see because the whole is too big to take in, one is more likely to see just those presentations featuring art one already knows, or at least knows enough to be curious about. And of course, the more of an art world insider you are, the more likely this is to be the case. One goes to the Biennale in order to encounter something new, to have one's assumptions challenged, but the very scale of it makes that ever less likely.

 Another paradox: as Alloway acknowledged, far from flattening and standardizing responses, the diversification and multiplication of artists, works, and experiences means that "first-person awareness is more singular than ever, as art is encountered in changing contexts." For Birnbaum, the same idea holds for the curator: "The chaos on my table," he writes, "is probably as close as one gets to a master plan for this exhibition." The very first sentence in his catalog essay, for that matter, is a single word standing there like a totem: "Bricolage." It's a simple, everyday French word that means something like "DIY" or "patching up," but has enjoyed enormous intellectual success since Claude Lévi-Strauss employed it to describe the way mythic thinking is constructed, not systematically, but through tinkering with pre-existing ideas from various sources, bending and hammering them into shape, as it were, to make them fit together. Jacques Derrida and Gilles Deleuze are just two of the thinkers who took up the term and widened its

application, but few artists have needed any theoretical justification for recognizing something of their own practice in the term.

Birnbaum's choice of artists, and above all his installation of their work, demonstrates an appealing empathy for all that is intelligently fluid and spontaneous in the contemporary art mainstream. This is especially notable at the Corderie, which has always seemed a deeply unsympathetic venue because of its long, narrow structure. Walking through the exhibitions here has felt a bit like strolling through a pedestrian shopping street, glancing at the wares to one's right and left. There was never any sense of flow between one artist's work and the next. But by reducing the number of artists, Birnbaum has not only been able to give more space to each; he has managed to carve out spaces of different dimensions for each one, more intimate or more expansive as their art demands, and in such a way as to create a path for the viewer that feels not strictly rectilinear but serpentine and organic. And while the art that Birnbaum has chosen is quite various—within the limits of what is currently presentable as sophisticated contemporary art— the predominant aesthetic recalls that of the New Museum's 2007–08 exhibition "Unmonumental," which favored assemblage-based work that is (as the New Museum curators had it) "materially provisional and structurally precarious." In the Corderie, painting, photography, and even self-contained sculpture are not entirely absent, but they are overshadowed by makeshift arrangements of objects. Grids and straight lines are out; scatter and unpredictability are in. At the New Museum, the choice of works and their installation in its cramped confines had the unfortunate effect of undermining one's sense of the distinctions among the various artists' projects. Birnbaum succeeds in sharpening the distinctions, even if the accompanying rhetoric is cramped and confining. "For Pascale Marthine Tayou," one reads, "the ceaseless movement between places and contexts, forms and media, has become a permanent condition," but the same might have been said of most of them as easily as of the Ghent-based Cameroonian Tayou.

But, ultimately, the rhetoric isn't a big problem. More so is that, subsumed into the artwork, the "ceaseless movement" of its context becomes an artifice, a fiction, even a mannerism, because as soon as the random matter of daily life gets put together into an artwork, it takes on a kind of permanence or at least longevity, albeit one that costs more effort to maintain. In any case, it is easier to note that many artists today want their work to acknowledge impermanence, flux, and multiplicity than it is to put words to the visual evidence of their distinct and characteristic ways of doing so. But what the rhetoric doesn't acknowledge is that this art is not so much about the

"permanent conditions" within which today's artists find themselves working as about the sensitivity, spontaneity, and idiosyncratic élan with which they react to them—about the artist's "genius," though the word is taboo. Just as much as with the Neo-Expressionist painting of the '80s, the assemblage sculpture of the present decade has been about the power of artistic subjectivity. If Rachel Harrison is in many ways the midcareer artist of the moment—and her appearance in "Fare Mondi" is merely one more reminder of that—it is because of her uncanny ability to put images and materials together in a way that not only always seems to have a hidden logic but also outstrips the viewer's ability to explain it. That viscerally experienced distance between the artist's awareness of the possibilities inherent in her material and one's own gives the work its sense of surprise, but also marks its exemplary status. And the funky, offhand look Harrison cultivates is a permanent reminder that she didn't have to sweat over creating her work's oblique logic; when intuition and intelligence are one and the same, it all comes naturally.

Still, if the test of genius today comes in the encounter with the condition of multiplicity, what's apparent in Venice is that the attempt to counter multiplicity with more multiplicity is at best merely an inspired stopgap. The opposite strategy, facing multiplicity with singularity and blankness, flux with stillness, is just as valid. Among the best works in "Fare Mondi" are a group of large-scale paintings on paper, made in the early '70s by Tony Conrad, who is better known for his Structuralist films and Minimalist music (he was a member of Dream Syndicate with LaMonte Young, John Cale, and others). All titled *Yellow Movie*, their imagery of a white or yellow rectangle framed by a roughly painted black border in turn surrounded by yet another color suggests a blank movie screen in a dimly lit space. The artist's conceit was that, painted with inexpensive, unstable paint, the rectangles would gradually yellow, and this imperceptible change would make them the slowest motion pictures ever made. Conrad mixes mediums in the mind, not in the gallery space. But just as he renders the distinction between movement and stillness moot, so does his minimalism undo the distinction between multiplicity and singularity, since the simplest differences of color, proportion, and touch are sufficient to give these works all the complexity they need to linger in the mind, not as generalizations, but as concrete particulars.

This is not to say that Conrad's reaction to the condition of art is inherently superior to that of Harrison, or Tayou, or of many other good artists whom Birnbaum has included. It's only to say that it stands out by standing against the exhibition's presiding aesthetic; because art teaches us to value

the anomalous, a dominant aesthetic always undermines itself. If there's one thing you can depend on, it's that assemblage will not be the main event at the next Venice Biennale, because it will be felt to be too familiar, too easy.

In a Biennale in which the national pavilions seemed extraordinarily flat, the best of them was the one that the Biennale itself rightly awarded its Golden Lion, the mini-retrospective of Bruce Nauman in the American pavilion (with two offsite supplements), curated by Carlos Basualdo and Michael R. Taylor of the Philadelphia Museum. I say that with some regret, as I believe that a survey of such a well-known artist is not necessarily the best use of a pavilion; I'd have been happier if a chance had been taken on a younger, unconsecrated figure such as Harrison. Or at least if the Nauman show had consisted entirely of recent work. For Venice, Nauman produced a new sound installation in two versions, Italian and English—*Giorni* and *Days*. Each is a space filled with a hubbub of words that soon turn out to be a variety of voices enunciating the names of the days of the week, but not in order. There is a logic to the sequences but, unlike the logic behind Harrison's works, it's not beyond one's grasp; it just takes a little time and concentration to catch on to it. That logic is of no particular interest in itself; it simply serves, I think, as a way to introduce a certain sense of irregularity into the texture of the words. A close contemporary of Conrad's—both artists are nearing seventy—Nauman shares his intuition that stillness is always already in movement, minimalism already dense with detail. In *Days*, clamor and multiplicity resolve into clarity and simplicity and then fall back again: according to Nauman, this is the structure of time.

2009

Post-White?: "Blues for Smoke"

If you walked up the stairs to the third floor, rather than taking the elevator, to get to "Blues for Smoke," the recent exhibition at the Whitney Museum of American Art, organized by Bennett Simpson, associate curator at the Museum of Contemporary Art in Los Angeles (where the show originated), you'll have heard it before you saw it: the roiling, joyful noise of John Coltrane's music incorporated into David Hammons's installation *Chasing the Blue Train* (1989). But then, too, you might have eventually noticed that you'd begun seeing the show before you even realized you were seeing it: reflections on the lower part of the wall along the stairs and on the third floor landing, flickering from the sheets of silver Mylar that are the main ingredient in Kira Lynn Harris's installation *Blues for Breuer* (2013). "Blues for Smoke" was the kind of exhibition that sneaks up on you, and that wasn't so much about the things you saw as about the resonances and reflections those things emitted.

But how deep are those resonances, how illuminating the reflections? After two visits to the exhibition and considerable thought, I'm still not sure. Harris's piece is probably a little too twee and insubstantial for its own good, and besides, its title rings false: Does the piece really plumb the experiential depths that we associate with the blues? As for Hammons, his piece—in which a toy train runs at intervals along a meandering track among scattered piano lids and through a tunnel under a pile of coal—can't be accused of lacking substantial content; here the problem is that the content seems too weighty for the artist's linguistic scaffolding of puns and free associations to support. Okay, we get it, coal plus train equals Coltrane, and then it's up to you what further mental connections you make with, say, the underground railroad by which blacks were delivered from slavery in the era before the Civil War, or perhaps the A train that Billy Strayhorn advised taking "the go to Sugar Hill way up in Harlem"— commentators have cited both, and sometimes both at once, which seems pretty incoherent. And then there've been a lot more trains than that in

the world—why not the 5:22 to Ronkonkoma? It's true that Freud, in recommending free association as method, specified that none should be excluded, not even on the grounds that it might be "too *unimportant* or *irrelevant*, or that it is *nonsensical* and need not be said"—but the analyst's, the interpreter's free associations were not for all that allowed the same liberty as the analysand's.

Among the virtues of "Blues for Smoke" is that it torques the reading of a piece like *Chasing the Blue Train* away from speculation about references toward the contemplation of form—in a way, toward abstraction. The next room on the right from Hammons's installation is hung with an array of mostly abstract paintings, about which more in a moment, but in the center of the room sat Kori Newkirk's sculpture *Yall* (2012), a shopping cart sparsely bedecked with a few random items—a water bottle, for instance—whose wheels were aligned with a ring of blue glitter on the floor. Here the journey implied by Hammons's train track had been rationalized into a perfect circle, and any implication of onward movement flattened into the banality of a daily round, always self-identical: "same shit, different day," as the saying goes. And for that matter most of the rooms in the exhibition had at their center either some variation on the repetitive closure of the loop (Dave McKenzie's *Fear and Trembling* [2009], a conveyor belt of the kind you've seen at the dry cleaner's from which dangle a single hanger whose paper cover reads LOVE ME JESUS; the conveyor mostly stands motionless but occasionally makes a full turn; Liz Larner's *No M, No D, Only S & B* [1990], with its lumpy leather forms enclosing a rough circle of floor), or else on the contrasting image of the straight line going nowhere (Zoe Leonard's *1961* [2002-ongoing], a procession of old blue suitcases—empty or full? Who knows? Which made me wonder why one of Carl Andre's similarly modular lines of railroad ties hadn't been included in the show; John Outterbridge's goofy assemblage sculpture of a racing car, *California Crosswalk* [1979]).

Taken together, these pieces seem to pose questions about recurrence and progress, movement and stasis; and those questions become something like a vamp or ground bass that keeps turning back on itself to accompany and provide a coherent framework for the other works in the show, which range widely, though at first one might not realize it. On the walls surrounding *Yall* are a selection of paintings that might lead you to think "Blues for Smoke" will essentially be an exhibition about black artists, many of them abstractionists, who've been inspired by music. There are a couple of superb

paintings by Jack Whitten, one of them dedicated to Duke Ellington; an intricate geometrical composition of great energy by William T. Williams is titled *Trane* (1969), while a less successful painting, Jeff Donaldson's *Jampact and Jelly Tite (for Jamila)* (1988), combines abstract patterning with representational fragments to create a lively but rather clichéd representation of a jazz combo at play. In this context, we can fill whatever musical analogies we like in contemplating the room's other contributions by veteran abstractionists, Edward Clark's *The Big Egg (Vetheuil Series)* (1969), and Alma Thomas's *Late Night Reflections* (1972)—both artists are lavish yet subtle colorists—or even in the dizzying numerical sequences of Charles Gaines's conceptual drawings on gridded paper in *Untitled (Regression Series: Group 3)* (1973–74). And the elegant juxtaposition of these works from the '60s through the '80s, with a 2006 collage painting by Mark Bradford (*Weather* [2006]) shows that this bent toward abstraction remains strong among midcareer and younger black artists today, not just a bygone cultural phase. At the same time, the raw, scarred quality of the surface of Bradford's painting—distantly redolent of the torn poster works of the French affichistes of the 1960s, it evokes the remnants of an old, torn-away billboard, a thing of the streets and not of the drawing room—relates it to the blunt everydayness of Newkirk's sculpture, while helping us see the abstract qualities in that work, which might otherwise seem an almost documentary transfer into the gallery of an object that might have come from the life of one of those homeless people we sometimes see pushing around a shopping cart with all their worldly goods, here reduced to a last few shreds.

But that's to imagine another show that "Blues for Smoke" might have been but wasn't, a show about music and abstraction in the work of black American artists since the 1960s. It's an important show that someone ought to do, and for at least two reasons. One is that it would redress the lack of recognition that has been accorded to black artists in general, and black abstractionists in particular, by the mainstream (i.e. white) art world, at least until very recently. As the works by Thomas, Whitten, Clark, and Williams remind us, some of the best abstract painting of the '60s and '70s was being done by black artists, yet they are hardly known to the museum-going public (and presumably the prices of their works reflect this relative obscurity). But such an exhibition, if properly done, would not only provoke a revaluation of individual reputations; it would have to prompt a broader revision of our understanding of what abstract art is all about. Because while the analogy with music has always been important to the way abstract artists

think about their work, from Kandinsky onward—and the recent MoMA exhibition "Inventing Abstraction 1910–1925" underscored this—music has been important to black American artists in a different way and to a different degree than it has been for whites; and this difference has allowed them, at times, a deeper understanding of the unity of the arts. But what white painter has ever made a declaration comparable to Whitten's when he proclaims, "My cosmic guides are: John Coltrane, Thelonious Monk, Charlie Parker, Miles Davis, Charles Mingus, Kenny Dorham, Bud Powell, Ron Carter, Fats Navarro, Dexter Gordon, Cecil Taylor, Ornette Coleman, Sonny Rollins, Coleman Hawkins, Eric Dolphy, Albert Ayler, Sun Ra, Clifford Brown . . . I am so blessed."

The difference, of course, has to do with the centrality of music to black American culture, and to the near-universal acknowledgment of the validity of that music—the way its call seems never to fail of a response. Whitten allegorizes it this way:

> When my white slave masters discovered that my drum was a subversive instrument they took it from me . . . The only instrument available was my body, so I used my skin. I clapped my hands, slapped my thighs, and stomped my feet in dynamic rhythms. I stretched my mouth wide open and allowed my vocal chords to strike a primal cry. I forced the world to listen. I discovered that my pain was a universal pain.

In other words, Whitten locates the sources of his culture in a kind of minimalism or reductivism—but not the kind that has animated European modernism. It's certainly not a search for purity, for the limits of each artistic discipline, as Clement Greenberg thought, or for an irreducible definition of art, as Arthur Danto might have it. It's an existential minimalism, in which to be reduced to nothing but one's own resources is to know oneself and to discover this knowledge as one that compels recognition, a bridge between isolation and universality. Here lies the grounding for Amiri Baraka's seemingly counterintuitive observation that "the notes of a jazz solo, as they are coming into existence, exist as they do for reasons that are only concomitantly musical." The seeming paradox inherent in Baraka's insight is not so far removed from that reflected in Harold Rosenberg's contention that, for the Abstract Expressionists, "what was to go on the canvas was not a picture but an event." "You cannot hang an event on a wall," scoffed Mary McCarthy. If so, then no more can you hang the sound of a drum—its rhythm, its resonance, its message. And yet it has been done, because the marks a painter

makes may exist for reasons that are only concomitantly—not purely and immediately, as Greenberg believed—pictorial.

For a developed and elaborate culture to keep faith with this primal cry may seem a fragile project. But as Whitten says, "Time is a memory book," and I think when he says this he is in agreement with Walter Benjamin, for whom "the past carries with it a secret index by which it is referred to redemption" and "there is a secret agreement between past generations and the present one," though the urgent task involves "appropriating a memory as it flashes up in a moment of danger"—I am quoting, of course, from the last words (aside from some letters) that Benjamin committed to paper before his death, and therefore (wittingly or not) his testament, the theses "On the Concept of History." For Whitten, the lesson of the past is encompassed in the word "freedom," which always calls for its own expansion. Benjamin implicitly glosses this word for the arts in speaking of the effort "to wrest tradition away from the conformism that is working to overpower it." A different rendition of "Blues for Smoke" might have included Benjamin's emblem, Paul Klee's *Angelus Novus*. But did Benjamin ever find redemption in music? Whitten has. "I found my stolen drum. I found it while experimenting with the formal elements of space. Evidently, Rashied Ali, Alvin Jones, Philly Jo Jones, Art Blakey, Max Roach, Roy Haynes, Arthur Taylor, and others had retrieved it and stashed it in deep space."

"Blues for Smoke" is not and does not claim to be the exhibition that would explicate the connections between the subversive drum of blues and jazz and the "formal elements of space" explored by the black artists of the past fifty years, though its seeds can be found there. That exhibition would have to include many artists who are missing here, of several generations. I can call out the names of Sam Gilliam, Simon Gouverneur, Howardena Pindell, Stanley Whitney, and Leonardo Drew as a few examples. And it would explicate music as a model for painting and sculpture and the other plastic arts not only as an art of pure form and pure sensation, as Greenberg maintained, but as an essential bid for freedom.

That "Blues for Smoke" even allows for a glimpse of this possibility is a testament to its curator's adventurous sensibility. That it swerves away from that possibility may reflect the limits of that sensibility, although it also represents the curator's own stand for freedom. He is pushing awkwardly, not quite successfully, against the conventions of what a museum art exhibition should be. The invocation of repetition and variation

in the sequence of sculptures involving lines and loops, and the telling juxtapositions of these assemblages of readymade objects with abstraction and representational imagery evince a genuine musicality, an independence from merely didactic or discursive reasoning. There's a mind at play here, not just at work. And yet the curator of a museum exhibition does after all have certain didactic and discursive responsibilities to shoulder; if he wants to operate as a free artist he must do so through the overtones of his work as a historian and educator. And this is where I feel that Simpson has let me down.

Simpson apparently did not want to make an exhibition on the importance of black musical culture for black artists, nor even about its influence on American artists in general. Boldly, he wants to invent a new meaning for the word "blues": "I'm not entirely invested in telling a story of the blues as it has existed." But if he is not going to "lend definition to an established aesthetic," then what is his counterproposal? Neither discursively, in his catalog essay, nor through plastic invention, in the (mostly excellent) artworks he has brought together and juxtaposed, has he succeeded in establishing some new, more extended sense of what might be understood by the blues. In fact, the show is filled with works, primarily by artists who are not black—not even "black by persuasion," as the late Johnny Otis so beautifully defined himself. Everybody loves Martin Kippenberger's sculpture *Martin, Into the Corner, You Should Be Ashamed of Yourself* (1992), but was there really a compelling reason to drag it uptown from its home at the Museum of Modern Art for this exhibition? The wall label explains, "Operating at a remove from the historical and cultural roots of blues music, Kippenberger nonetheless relates to the blues through his freedom with found materials, his improvisatory attitude, and his canny explorations of identity." Well, that's the relation to the blues that nearly every good artist has; if that's your criterion, this exhibition could have taken its title, not from Jaki Byard's great solo piano record of 1960, but rather from John Coltrane's quartet outing of the following year, or the surprise hit single that came from it, "My Favorite Things."

The Kippenberger wasn't the only one of my favorite things I was happy to see at the Whitney but puzzled about why. Jeff Preiss's remarkable two-hour-long film *STOP* (1995–2012)—here smartly presented across four side-by-side video monitors—is an incredibly moving work: a tour de force of montage, it has been pieced together from hundreds of brief clips taken from seventeen years of home movies (but the home movies of a

professional filmmaker; Preiss is probably best known as the cinematographer for *Let's Get Lost*, Bruce Weber's 1988 documentary on Chet Baker) that inadvertently trace his child's transition from female to male. Again, the wall label uses phrases like "lyrical flow" and "almost improvisational"— but that's a big "almost," and I remain unconvinced that this work has any special connection to blues or jazz. Equally arbitrary seem the decisions— but were they even decisions, rather than simple oversight?—not to include various artists whose work would seem on the face of it to have a more concrete relation to the idea of the blues. I've already mentioned a number of black artists who might have been included in a show on black music and abstraction; those names are only the tip of an iceberg. There are also white artists who have responded deeply to black music. I particularly missed Archie Rand's "Letter Paintings" of 1968–71, a remarkable suite of tributes to jazz, blues, and Motown musicians made through the simple— and yet in these works, not so simple—act of inscribing names so that (as Roberta Smith wrote about them in 1991) "the look and sound of the names and the music they conjure mingles with rich textures and tones of paint" while "the relatively private act of looking at a singular handmade painting is animated by the more collective, widely accessible experience of music, its memories and associations."

The problem with "Blues for Smoke," for all the pleasures the show affords, goes deeper than who's in and who's out. That's just symptomatic. It really has to do with the difficulty of knowing how to use concepts derived from black culture in a period that ostensibly allows for identities that are—to use Thelma Golden's famous phrase, as Simpson himself does—"post-black." As Simpson quotes her, "Post-black artists are adamant about not being labeled 'black' artists, though their work [is] steeped, in fact deeply interested, in redefining complex notions of blackness." More than a decade after Golden introduced the term, it's still intriguingly unclear how and to what extent an artist can function as post-black. But what "Blues for Smoke" tells me is that—for a curator, an artist, a critic, any interested party—it is not yet possible for a white person to be post-black, because we don't yet know how to be post-white. And that seems a much harder task. Nearly thirty years ago, in his now-classic essay "Repetition as a Figure of Black Culture," James A. Snead observed, "The outstanding fact of late twentieth-century European culture is its ongoing reconciliation with black culture." In this still-early stretch of the twenty-first century, that still seems like a very incomplete project. But the important thing to emphasize is that it's

European (Euro-American) culture that must complete and transcend itself through reconciliation with black culture, and not the other way round. In its very failure, "Blues for Smoke" is a timely reminder of the work to be done.

2013

Monumental, Imperial, Historical: Ai Weiwei

Ai Weiwei's sculpture *Wenchuan Steel Rebar* (2008–12) has a bluntly descriptive title and restrained lyrical form, and contains an allusion that places the viewer at a remove from both. The work amounts to a polemic against appearances. I encountered it in the traveling exhibition "Ai Weiwei: According to What," which recently closed at the Art Gallery of Ontario in Toronto. What I saw was a mass of rebar, the steel rods used to reinforce concrete and masonry, that had been gathered into a perfect rectangle of about twenty by forty feet, amounting to some forty tons of metal, according to the exhibition catalog. The thousands upon thousands of rods are as straight as the specs for any construction project would require, but they don't look entirely new. They bear a patina of use. Varying in length, they've been heaped together in such a way that they form a carpet of rusty metal, gently rising and falling in wavelike patterns that are at most about a foot high. This lightly undulating form lends the sculpture a lyricism at odds with the muted material in which that form has been embodied.

The title's allusion to Wenchuan adds human weight to that sense of embodiment. You may recall that Wenchuan is the name of a county in the province of Sichuan in southwest China that was the epicenter of a massive earthquake in 2008. According to official figures, some 90,000 people were killed and millions left homeless. One of the most shocking consequences of the quake was the collapse of many school buildings, even when other nearby buildings remained standing. At least 5,000 of the dead were school-children. In the quake's aftermath it emerged that the schools had been shoddily built owing to corruption among government officials and contractors. Demands that the construction of these "tofu dregs schools" be investigated and those responsible prosecuted were repressed. The names of the dead were never publicly released. Children, scandals, secrets—they all remained buried in the rubble.

Ai was not in Wenchuan when the earthquake occurred; it's not his part of China at all. But it changed his life as an artist. For a decade, art from China

had been a growing subject of fascination for Western curators and collec-
tors—a trend that first became broadly visible when the celebrated Swiss
curator Harald Szeemann included a significant number of artists from China,
Ai among them, in his 1999 Venice Biennale. By 2008, when the "Bird's Nest,"
the Beijing National Stadium for that year's Olympics, was unveiled, Ai, who
had collaborated with the Swiss architects Herzog and de Meuron on its design,
was the country's best-known artist internationally. He was also a wild card,
an artist who was not afraid of proclaiming that "an artwork unable to make
people feel uncomfortable or to feel different is not one worth creating." One
notorious early work bore the self-explanatory title *Dropping a Han Dynasty
Urn*, 1995—two thousand years of history smashed to bits. The same year, he
began a series of photographs called *Study of Perspective*, each of which shows
his outstretched arm and an extended middle finger before such monuments
as the Eiffel Tower, the White House, Tiananmen Square. But more important,
he seemed to think that the artist—and not just the artwork—ought to be
causing discomfort, by taking critical public stances not just within the relative
safety of art galleries, most of them abroad, but also in public, which Ai did
in a widely read blog launched in 2005. (A selection of entries from it, in
English translation, was published by MIT Press in 2011.) The trophy project
was supposed to show the world the new modern face of China and its ruling
Communist Party; at that point Ai was willing to test the degree to which he
could accommodate the ruling powers even as he continued looking for ways
to give them the finger.

That uneasy accommodation came to an end when Ai threw himself into
the "citizen's investigation" of what had happened in Sichuan. Soon his blog
was shut down, and later he was beaten by police while attempting to testify
on behalf of a fellow investigator who had been charged with defaming the
Communist Party of China; as a result, he had to undergo emergency brain
surgery in Germany. In April 2011 he was arrested and held for nearly three
months; he discusses his imprisonment in detail in the lengthy interview at
the heart of the recently published *Hanging Man: The Arrest of Ai Weiwei*, by
the British journalist Barnaby Martin. It's hard to imagine the situation of a
man being held incommunicado, in fear for his life, endlessly browbeaten
by interrogators essentially demanding that he justify his art to them:

> The accusations are ridiculous and it is much more frightening because
> you've been thrown into the hands of people who will never understand
> what you are trying to say. I cannot explain to them about what I do. And
> on the other side, they are very frustrated. They don't know anything

about art and they have never even touched political crimes before. I said, "Please, get on the internet to see how people discuss my art."

If nothing else, Martin's book convinced me of the unseemliness of the long-standing fashion among art critics for talking about "interrogating" works of art, or of artworks "interrogating" their subject matter. Let's stop modeling art criticism on the cross-examinations meted out to political prisoners. That doesn't mean we can't be critical.

If Ai's prison guards ever took his suggestion and looked him up on the internet, they might have found an eighteen-minute video that is an essential pendant to the sculpture *Wenchuan Steel Rebar* and a companion work, *Forge* (2008–12), which was not included in "According to What" but was exhibited at the Mary Boone Gallery in New York in late 2012. In this "making of" video, which was shown in Toronto and can be found on YouTube, Ai explains that *Wenchuan Steel Rebar* was produced by taking twisted rebar salvaged from the earthquake wreckage and deposited in waste collection plants and having it hammered back, little by little, into straight lines. (According to the video, its title is, simply, *Straight*.) I can't help but think of Immanuel Kant's famous adage: out of the crooked timber of humanity, nothing entirely straight can ever be made. Needless to say, steel has greater plasticity than timber, and if the sculpture is a vision of how lives twisted by history can somehow be healed, that only goes to show the optimism behind Ai's incessant activism. Or perhaps the work's lesson is about memory and forgetting—with the way the steel remembers its new form and forgets the catastrophe that deformed it, though we humans remember. At the same time, the piece is about the relation between sculptural work and the Duchampian readymade. With the art that conceals art, an incredible amount of labor has been expended in order to create a quantity of material that looks like it just came from the warehouse, "returned to a near-mint condition" as Ai says in the video. *Forge* does the same thing by the opposite route: It was made from new rebar carefully hand-sculpted to reproduce the misshapen pieces found amidst the debris.

The two works are complementary, presenting the same theme from contrary perspectives. Why then do I find *Wenchuan Steel Rebar*—or rather, despite the label in Toronto, *Straight*, which is more fitting—so much more moving than *Forge*? Maybe it represents an unexamined inclination toward reticence over pathos—for the wounded person concealing pain over the person who exhibits more pain than he might actually feel in order to

dramatize a point. It's a preference, one might say, for minimalism over expressionism. Or maybe my response has to do with the way the elements that make up *Forge* are scattered across the floor in a manner that strikes me as arty and arbitrary while those in *Straight* are presented in a manner that seems straightforward and natural despite the evident care that has been taken, for instance, to create a perfect rectangle on the floor and give a kind of lambent rhythm to the ups and downs of the surface of the field of bars.

Which brings me to why I am of two minds about Ai as an artist, despite my admiration of him as a valiant activist and even despite his ability to create a subtle, multilayered work like *Straight*. For every piece as finely judged as that, he's made as many or more that are subtly or blatantly out of tune with themselves, works in which aesthetic missteps trip him up. "That's irrelevant!" is what Ai would probably say if he heard my objections. "I don't see art as a highly aesthetic practice," he told the Hirschhorn's chief curator Kerry Brougher. But it's dangerous for an artist to be so cavalier about aesthetics. Most of Ai's works are quite beautiful, or at least highly finished, but their beauty often seems a mere quotation of a beauty one has seen elsewhere. This wink should not be mistaken for a challenge to existing conventions of beauty. Ai tries to do this, for sure—exhibiting a field of twisted-up rebar is undoubtedly meant to be a challenge to the viewer's sense of art. And yet as anti-art the work is pat and mundane, as if Ai had been mimicking not the results of the terrible forces of an earthquake acting on inadequate building materials, but the routine pictorial gestures of the meandering brushstrokes of a second-rate Abstract Expressionist painting and immortalizing them in metal.

In *Hanging Man*, Ai regales Martin with a telling anecdote about his time as a student at the Parsons School of Art (Ai lived in New York from 1981 through 1993). He recalls a drawing class where he flaunted his technique by making "a very nice figure drawing with ink and brush, which requires a lot of control." His fellow students were intimidated by his abilities, as he recalls: "'Wow! If this guy can draw like this what can we do? We can never get to this point,'" they thought. But his teacher, the painter Sean Scully, dismissed it as the worst thing he had ever seen:

The whole class was shocked by what he said and also I was shocked because in that moment I immediately understood. The other students had put a lot of effort into trying to just draw a little bit, maybe a hand or foot or something, but it never really worked. They tried to erase it.

Then they tried again. Their effort was so strong, so sincere and their actions were so much more important than someone who is so skilful producing so-called beautiful work just using a convention. So that moment I changed and I knew in a second that I had to give up all those skills I had learnt in China.

As so often with artists, even the story Ai tells against himself, the story in which he gets his comeuppance, redounds to his favor: he started out with great chops, the envy of his peers—and then immediately got the point that art is so much more than technique. But I have to wonder if he ever really took Scully's point to heart. He hasn't really abandoned conventional skills so much as farmed them out to his employees. Ai sees himself as a conceptual artist, an heir of Marcel Duchamp (and of Duchamp's American disciple, Jasper Johns, from one of whose paintings the title "According to What" is borrowed), but too often—and he is far from the only one of whom this is true—the conceptual artist seems more like an art director, because the underlying idea is overwhelmed by its high-finish realization.

One example is *China Log* (2005), a quasi-cylindrical horizontal sculpture made of gorgeous wood salvaged from the pillars of old temples and assembled, we are told, by "using traditional Chinese joinery techniques." Through the center of this artificial log runs a cavity whose contours are those of the map of China. The exhibition catalog helpfully spells out the work's intended meaning: "that the present Chinese nation has been put together from a variety of cultural and historical elements." Usually I roll my eyes when I read such bromides in catalogs or on the wall texts of museums, wondering why it is thought necessary to oversimplify artists' ideas in this manner, but in this case I have to admit that Ai's notion might have been just as banal as that. If you were looking for a nation of which it wasn't true, you'd probably have to find a mighty small country—the Republic of San Marino maybe? Compare the biting sarcasm of Ai's blog when discussing rebellions in Guizhou province, in China's southwest, as well as in Tibet: "Today's harmonious society was not easy to come by. As long as we follow in the firm leadership of the Communist Party of China, any unlawful attempts to fragment the motherland . . . will ultimately come to a bad end." He is all too familiar with the imperial nature of the "joinery" through which his country, like our own, has been cobbled together, but whatever his intention, the beautiful piece of useless furniture that is *China Log* makes it all seem worthwhile. Here, aesthetics—in the sense of beautiful appearance—trumps concept, to the work's detriment.

Like finish, scale and quantity too often trump concept in Ai's work. The most obvious example is probably his most famous piece, the installation of 100 million porcelain sunflower seeds at Tate Modern in 2010–11. This is surely another of Ai's representations of China, not by way of its map but as a metaphor for its vast population. But the same meaning would have been communicated by one hundredth or even a thousandth of the seeds; in fact, there is something self-defeating about a work which it is too easy to imagine as a bid for a kind of Guinness Book of World Records notoriety—the artwork with more individual elements than any other in world history—but which ends up presenting a vast prospect of dreary sameness. Nothing in "According to What" has been made on that scale, but Ai is always willing to try and overwhelm the viewer with manyness. There's *He Xie* (2010), an installation of 3,000 porcelain crabs, or the innumerable inkjet prints of Ai's snapshots with which a wall is papered to make his *Provisional Landscapes* (2002–08). Ai also dabbles in muchness: how much tea had to be used to make the nearly six-foot-tall sculpture *Teahouse* (2009), which is— yes, a basic geometrical house form made entirely from bricks of delicious-smelling tea. Somehow I often remain underwhelmed.

The book *Hanging Man* takes its title from one of Ai's earliest works, a 1983 sculpture made from a clothes hanger bent into the shape of Marcel Duchamp's profile. But in the end, Ai's insistence that he is a Duchampian artist may be misleading. An essential characteristic of Duchamp's readymades is being visually unimpressive, which is precisely what makes them into tools for thinking about what art is or might be. Duchamp liked to emphasize that in choosing his objects, "This choice was based on a reaction of visual indifference with at the same time a total absence of good or bad taste . . . in fact a complete anesthesia." As Boris Groys recently explained, Duchamp

> wanted to reduce all levels of expressivity and introduce into the valorized cultural context an object that, situated as it was outside the artistic tradition, did not belong to the complex system of cultural associations, meanings, and references. This strategy typified the classic avant-garde approach, which preferred to make use of non-traditional, profane, "insignificant" objects to get rid of the ballast of traditional cultural symbolism.

For Duchamp, the readymade was thus a kind of abstraction.

In our now-globalized art world, this neutrality is always something of an illusion. Only people who share the same background or context can

view the same things with indifference. To someone from a tropical climate, Duchamp's snow shovel might be an object of intense exoticism, evoking all kinds of "associations, meanings, and references" about the cultures of the north, while his urinal can hardly be so easily detached from the French artist's feeling about his adopted country, as summed up in his lover Beatrice Wood's quip on his behalf that "the only works of art America has given are her plumbing and her bridges." Like so many artists today, Ai has taken Duchamp as his starting point in order to do just the opposite of what Duchamp was trying to do—to create an essentially literary and moralizing art replete with beauty and spectacle. It's through the backstories of his materials, which connect them to specific histories, that Ai gives his work its subject matter without having to resort to traditional representation. For Groys, the irony is that the Duchampian readymade has become the basis for an updated version of the salon art of the nineteenth century—what used to be called "grand machines." The only difference, Groys says, "is that the goals of subjective expression and relevant content are now attained by way of a particular strategy for selecting objects from the profane world, not by their representation on canvas or in stone."

To this academic formula, Ai has succeeded in adding something specifically Chinese—or so it seems if one accepts the view of Victor Segalen, the French writer and pioneering Sinologist, who declared that Chinese sculpture shared four key features: "It is monumental, it is funerary (but profane), it is imperial, and it is historical." The imperial part comes with a twist, for Ai is a scathing critic of the empire under which he lives—and yet his viewpoint is not that of an individual at odds with the mainstream. Instead, he sees himself as a spokesman for the whole. Maybe that's why he feels the need to make works that are vast—not simply to symbolize the vastness and multiplicity that is China but to establish an overview on it, albeit an oppositional overview. But still, it's a position from which random differences among the millions of individual sunflower seeds are neither very perceptible nor very significant.

2013

IV

Unfinished Tradition

. . . that non-finito is the medium not only of synthesis but of a scattering or disruptive force that will lend itself to effects that mirror those of flood-water or of lightning.

—Adrian Stokes, *Michelangelo: A Study in the Nature of Art*

Unfinished Tradition: Édouard Manet

"You must live like a bourgeois and save all your violence for your art"—
has anyone ever fulfilled more completely Gustave Flaubert's directive than
his younger contemporary, Édouard Manet? And has any artist ever been,
as a result, more of an enigma? Even those rare few spirits of his time who
valued his art at its true worth nonetheless often misunderstood it. Manet's
contemporaries saw him as above all else a realist, the heir of Gustave
Courbet. Had any of them been sufficiently realistic to take Émile Zola as
an investment advisor, they would have done well indeed: "So sure am I
that Manet will be one of the masters of tomorrow," the critic and novel-
ist wrote in 1866, "that I should believe I had made a good bargain, had I
the money, in buying all his canvases today. In fifty years they will sell for
fifteen or twenty times more . . . It is not even necessary to have very much
intelligence to prophesy such things." As the art historian George Heard
Hamilton remarked, Zola's guess as to the rise in value in Manet's prices
was stunningly accurate—and this, some five years before Manet had
managed to sell, as far as we know, even a single picture. Although Zola
grasped many of the subtleties of his friend's art, he could yet imagine that
Manet "came to understand, quite naturally, one fine day, that it only
remained to him to see Nature as it really is," and that he thus "made an
effort to forget everything he had learned in museums" in order to tran-
scribe what he saw with unexampled freshness.

Today, it is hard to see Manet as a realist. Not that he neglects to picture
the life around him, far from it—but he so often does so in such skewed,
confounding, contradictory ways. He made his style modern by quoting the
art of the past—not to use it as a model in the approved academic manner,
but to cite it in an alienated way, at times reminiscent (retroactively remi-
niscent, one might say) of what would later be dubbed "appropriation":
Manet seems to use a painting by Velázquez or Goya, Titian or Raphael, in
much the same oblique and riddling way that Jeff Wall, for instance, would
use Manet's *Bar at the Folies-Bergère* (1882) as a source for his own *Picture for*

Women (1979). For Manet as for Wall, tradition is unfinished and therefore open to reinvention.

Needless to say, Zola eventually came to realize that Manet was not a realist after his own heart. In 1879 he wrote on the artist again, this time regretting that "he is satisfied with unfinished work; he does not study nature with the passion of the truly creative." Just as the ordinary run of critics were finally getting, not yet to like Manet, certainly, but at least used to him, Zola was starting to sound like them. That Manet's paintings looked unfinished had always been their complaint. He seemed to violate a sort of artistic ethic, as if he could not be bothered to bring his work to a conclusion. The subjects of Manet's many portraits, at least, knew that the unfinished look of his paintings was not the result of laziness. They had to sit through the incessant sessions in which he would attempt again and again, sparing neither their time nor his own, to satisfy the artistic scruples that he could never quite put words to but which are so evident now on his canvases. But this lack of finish was not the only objection that Manet faced. There was something else, something less specific, a more inchoate feeling: these paintings were just incomprehensible. "*Olympia* can be understood from no point of view, even if you take it for what it is, a puny model stretched out on a sheet," insisted Théophile Gautier. He was the leading critic of the day, a man who had earlier considered Manet promising, and might have been expected to have some sympathy for him thanks to their shared friendship with Charles Baudelaire. One Louis Etienne confessed, "I search in vain for the meaning of this unbecoming rebus"—meaning *Le Déjeuner sur l'herbe*.

The meaning that was missing, in the eyes of Manet's contemporaries, was what would tie together the people and things depicted in his paintings into a legible story—and that's precisely what Manet wouldn't give them. There's always a sense of the arbitrary in the relationships in his paintings. No "realistic" narrative can hold things together. The solution of modernist critics was to say that what unifies Manet's paintings is form—that the imagery is incidental. Yet his recurrent resort to topical, politically provocative subject matter—*The Execution of Maximilian* in the late 1860s, *The Escape of Rochefort* in 1881–82—should undermine that notion, which now seems no more plausible as an explanation for Manet's painting than was Zola's realism. Instead of seeing Manet as an exponent of realism, or as an implicit abstractionist, it might be better to think of him as a precursor of Surrealism, whose inspiration was Lautréamont's image of a boy "as beautiful as the chance meeting on a dissecting-table of a sewing-machine and an umbrella."

If *Le Déjeuner* is beautiful, it's beautiful like that—in the spark it generates by short-circuiting meaning. As entwined as each of the three foreground figures seem to be, they are also strangely disconnected from each other. Yes, the man on the left, the one with the fez-like headgear, seems to be gesturing toward the man on the right—but the latter seems to be in some other space entirely, both physically and psychologically, as does the nude woman, who seems quite unaware of either of her male companions, looking out in the direction of the viewer. And then their relation to the landscape background is ambiguous. Don't the trees seem small in relation to the size of the figures? And what about the fourth figure, the woman in the background? It's impossible to judge her distance from the other three; it's almost as if she is part of a painted backdrop, a painting within the painting. Altogether, *Le Déjeuner* recalls more than anything Max Ernst's definition of a Surrealist collage, as a coupling of apparently irreconcilable realities, on a plane that would apparently not suit them. It is this incipient Surrealism that made the painting so detestable in 1863 and that accounts for its tremendous popularity today, a popularity that can be measured in part by the fact that it is one of the most parodied and pastiched images in Western art—coming in third, by my estimate, after the *Mona Lisa* and *The Scream*.

That Manet is a tremendously popular painter today—and the crowds you will have to contend with if you visit the exhibition "Manet: The Man Who Invented Modernity" at the Musée d'Orsay in Paris are proof enough of that—is a curious fact, because he is also a difficult and unpredictable painter. Moments of resolution in his oeuvre are few; sometimes it seems like his paintings are most interesting for their problems, for their quiet sense of unease with their own devices. Manet's paintings rarely have the calm, soothing quality of so many of the landscapes by his younger friends, the Impressionists; he doesn't glam up the people he paints as a bravura brushman like John Singer Sargent (who followed his lead in looking to Velázquez for inspiration) would do; and, aside from *Le Dejeuner*, his paintings are rarely very sexy—his other famous nude, *Olympia*, is distinctly tough, without a hint of come-hither, which is one reason why the painting kicked up such a storm when it was first exhibited. Besides, there's no sensational or pitiable backstory *à la* Caravaggio or Van Gogh; Manet's early death at the age of fifty-one is apparently not early enough to wring many tears. Could it be the inner quality of his work that accounts for his popularity, along with the fascination of his historical position as "the painter of modern life"? It would seem the general like their caviar after all.

A word is in order about that phrase, "the painter of modern life." Baudelaire coined it, of course, before he knew Manet's art—he applied it to the illustrator Constantin Guys, a few of whose drawings are included in this exhibition. But it has long been understood to apply best to Manet. The real poignancy of it, in retrospect, is that Manet really turned out to be *the* painter of modern life and not simply *a* painter of modern life, since for his successors modern painting became increasingly divorced from anything resembling those "sketches of manners" or the "portrayal of bourgeois life and the fashion scene" that Baudelaire saw as essential to the depiction of modern life; painting was giving up whatever journalistic function it had. The critic Michael Fried, who would go on to write a monumental study of Manet, famously spoke of a "history of painting from Manet through Synthetic Cubism and Henri Matisse . . . characterized in terms of the gradual withdrawal of painting from the task of representing reality—or reality from the power of painting to represent it." What was lost, in truth, was a common sense of what would count as a reality worth representing; what was gained was a feeling for the means of representation as realities in themselves. Henceforth ambitious painting was not going to reflect modernity primarily through its subject matter but through its technique: Picasso and Matisse—let alone abstractionists like Malevich and Mondrian—were modern painters, but not painters of modern life; in their own way the German Expressionists strove to be painters of modern life, it's true, but their exacerbated sense of the clash between inner experience and objective reality made it impossible for them to be clear-eyed chroniclers. Only in the 1960s, a full century after Manet appeared on the scene, did a few photorealists on the one hand and Alex Katz on the other find more or less credibly modern ways of painting modern life again.

Stéphane Guégan, the curator of the Orsay's Manet exhibition, would like to divorce the artist's "modern" from the Modernism that found its beginnings in his work. Guégan would rather speak, pugnaciously, of "the dead ends of modernism." And he's not entirely bereft of evidence. Wasn't Manet committed to the official Salons as a vehicle for his career, despite the repeated snubs he received there—paintings refused, prizes withheld—and didn't he decline to exhibit with the Impressionists, who were his friends and widely considered his followers? Degas, who like Manet was a little older than the Impressionists and not entirely at one with their sensibility, nonetheless grumbled that Manet's refusal to unite with them showed him "more vain than intelligent." And yes, the young Manet had spent no less than six years studying under Thomas Couture, today best known as the

author of a spectacularly monumental piece of kitsch, *The Romans of the Decadence*, which won a prize at the Salon of 1847 and now hangs elsewhere in the Orsay. The exhibition begins by placing Manet firmly in Couture's orbit, showing his early works among those of his master. Among the latter are studies whose lack of finish may remind us of the loose facture of those paintings of Manet that his contemporaries slated as uncompleted—but those works of Manet's *were* finished. (Incidentally, you can always tell a finished Manet, however loosely painted, from a study or sketch: proof, if it's needed, of how wrong his critics were in their taunts that Manet was too indolent to see his projects through.) More telling, however, is a group of Couture's informal portraits, which show a facile touch but also, occasionally, real penetration. Yet here, too, the seeming resemblance between master and student is misleading; Couture has nothing of Manet's force. His influence is more clearly seen in the relative conservatism of Manet's friend (and fellow Couture student) Henri Fantin-Latour, whose *Homage to Delacroix*, an 1864 group portrait that includes Manet and Baudelaire among its subjects, is also included here. Guégan does not quote Manet's despairing remark on Couture's studio, quoted by his fellow student and lifelong friend Antonin Proust (and possibly the subject of one of Couture's portraits here), "I don't know why I'm here. Everything we see around us is ridiculous. The light is false. The shadows are false. When I come to the studio, it seems to me that I'm entering a tomb." Proust was writing long after the fact and not without prejudice, but his testimony cannot be discounted, all the more so since, contrary to Guégan, Manet's mature work owes little to Couture in either technique or attitude.

As Couture dominates the exhibition's beginning, Baudelaire is the presiding figure over its second section. Manet's acquaintance with the poet, ten years his elder, developed rapidly after his first Salon appearance in 1861. (He had been rejected two years earlier.) But he had already been a reader of *Les Fleurs du Mal* and certain of his paintings already had Baudelairian overtones. An 1862 portrait of Jeanne Duval, Baudelaire's mistress, shows her in a vision that is at once hallucinatory and hilarious: reclining on a sofa, with harsh features and a pose that might remind you more of a vampire raising herself from her coffin than of a conventional odalisque, her voluminous white skirts have swollen to immense proportions, like clouds that are about to envelop her. Nothing quite like *Baudelaire's Mistress, Reclining* would be painted again until Matisse or Beckmann. It's good to keep this strange painting in mind as one recalls Baudelaire's famous words in an 1865 letter to Manet: "You are only the first in the decadence of your art." What keeps

those words ringing in our ears is their ambiguity. What did the poet really mean? Was it, "Alas, in our day painting has fallen into its decadence, but at least in this bad time you are the best there is—that is, the least decadent?" This is essentially the position taken by the novelist Philippe Sollers in the exhibition catalog, when he asserts that those who laughed at *Olympia* were the true moderns, "totally ignorant *petits bourgeois*," while Manet was the true classicist. Or did Baudelaire mean, rather, "Painting is heading into decadence and you are the captain leading the charge—you are the avant-garde of decadence, that is, the most decadent of all?" This is the perennial cultural pessimism that will never be refuted or proven, but which is as integral to Baudelaire as his Modernism. Perhaps that's where the poet and the painter parted ways, intellectually.

If Guégan is on thin ice in overemphasizing Couture, he goes completely off the rails in using Manet's few paintings on Christian themes, done in 1864–65, as evidence of what he calls Manet's genuine "attachment to the God of Scripture." It's not just that there is no supporting textual evidence for this. Look at the paintings: the best of these is *The Dead Christ with Angels* (1864). Its Christ is no God, and the death it depicts is an utterly irrevocable one. One believes in the former life of this man to the same extent that one sees that there can be no hope in his resurrection. As for the angels, they appear rather as lovely young actresses in angel costumes; they represent the artifice that sets off the veracity of the scene which arouses our pity, just as the light that caresses the face of the girl on the right, the one supporting Christ, sets off the shadow that bathes his unseeing eyes and separates him from us definitively. The miracle of this painting—to borrow the religious terminology—is that it can be at once an urbane pastiche of art history and a plea for human empathy. Artifice and realism reinforce each other in a direct challenge to the Salon's conception of history painting, not in expression of piety.

I don't mean to imply that Guégan is wrong at every turn. His skepticism toward the idea that Manet became an Impressionist in the 1870s, for instance, is well taken. Not that Manet couldn't have learned in turn from the younger painters who'd learned much from him. There's no denying that his palette became more brilliant and the weave of his brush marks looser as he became more drawn to daylight, even indoors—see how the sun pours in on *Lady with Fans (Portrait of Nina de Callias)* (1873–74). Yet where painters like Monet or Renoir gave a rhythmic regularity to their brushstrokes—it is this that gives their works that sensation of restfulness that has allowed

them to be mistaken for a sort of visual easy listening—a painting like Manet's *Croquet Party* (1873) is imbued with a sense of agitation that belies its ostensibly bland subject, especially with the overhead foliage that covers the sky like threatening storm clouds. One might be tempted to read some social or psychological drama into this—to see the male figure in the background as somehow alienated from the foreground group involved in the match—but I don't think you can get very far that way. Manet was simply more interested in the multitude of ways he could apply his paint so as to describe the true visual complexity of all the detail we normally overlook in a seemingly simple outdoor scene—a task he seems to have experienced as a harassing struggle.

Something remains unsatisfactory about a painting like *The Croquet Party*, but the paintings of café life that began to occupy Manet toward the end of the 1870s would have been inconceivable without such experiments. These culminated, of course, in *The Bar at the Folies-Bergère* (1882), which ought to be the climax of any big show of Manet but has remained in London at the Courtauld Institute. Actually this loss might have turned out to be a gain if it had allowed the exhibition to end on an unexpected note, with the still lifes that Manet painted at the very end of his life. Curiously, Guégan downplays them, reminding his readers that Manet never abandoned the old idea of an artistic hierarchy in which "paintings with multiple figures and an indirect narrative . . . are an accomplishment of an altogether taller order than the seascapes and still lifes." And it's true, Manet wanted to challenge the conventional sense of what history painting could be, not abolish it. For Guégan, "the end of the story" lies with the political Manet and a "return to rhetoric and action." This might well be the direction Manet would have taken, had time allowed. We'll never know. But what could be less rhetorical than either version of Manet's last political painting? The escape from imprisonment on the South Pacific island of New Caledonia by the radical political agitator Henri Rochefort in 1874 must have been a dramatic event, or at least a desperate one; but not as Manet shows it. Instead, these are paintings of uncertainty, of waiting—men stuck in a frail craft on rough waters, with a goal nowhere in sight.

Since 1879 Manet's health had been deteriorating; he was infected with syphilis. In the circumstances, it's astonishing that he was able to complete *The Bar at the Folies-Bergère*, which is not only his masterpiece but his testament, a painting full of paradox and irresolvable mystery. And yet another painting of 1882, the fiercely attentive still life *Flowers in a Glass Vase*, could just as easily be that testament, such are the perceptual complexities Manet

has discovered in this everyday sight and the grace with which he's mastered them. It's one of a series of some twenty flower paintings that Manet painted between the summer of 1882 and his last day in his studio, March 1, 1883. Even Manet's detractors had often had kind words for the still lifes that were always worked into his grand compositions from *Le Dejeuner* to *The Bar*, but this had been but the other side of a repeated complaint, that he painted the human figure with no more soul than a still life object. Here he finally gives his rejoinder: Who paints the human form with more life than I paint these flowers? For Manet, that's the end of the story. Even behind the back of a misconceived exhibition, great painting tells its own tale.

2011

For and Against Method:
Edgar Degas and Merlin James

My friend waved his hand dismissively when I mentioned I'd recently seen an outstanding exhibition about Edgar Degas. "How can you go wrong with Degas?" he asked. True enough. But what I saw wasn't another guided tour of the artist's greatest hits. Instead, the show at the Ny Carlsberg Glyptotek in Copenhagen, "Degas's Method," is an intellectually challenging one that promises not just familiar pleasures but a deeper understanding. Instead of organizing Degas's oeuvre around its subject matter (ballet dancers, horses, landscapes) or the diverse media he employed (oil painting, pastels, sculpture) or even chronology, it focuses on his aesthetic premises and representational strategies as they cut across medium, motif, and his lifetime. The exhibition's curator, Line Clausen Pedersen, has articulated this approach by singling out Degas's relation to Impressionism—as ambivalent as it was essential—and his ideas of process, draftsmanship, and artifice. Pedersen's kind of daring ought to be more widespread in museums but somehow isn't, maybe because it requires curators who are capable of thinking more like artists and less like collectors or product managers.

But there is an irony in the title "Degas's Method." As Pedersen points out, when a fellow painter proudly boasted of having "found his method," Degas replied, "Fortunately I myself have not found my method; that would bore me." In his once-famous and appropriately titled essay *Against Method*, Paul Feyerabend wrote, speaking of revolution, and implicitly of science, that "*participation* in a process of this kind is possible only for a ruthless opportunist who is not tied to any particular philosophy and who adopts whatever procedure seems to fit the occasion." Degas, who was born in 1834 in Paris and died there in 1917, would have said the same of art. As Pedersen writes, he "is faithful to no one and nothing, at most to himself and the idea that his art makes a difference—to art." Such self-absorption is as modest as it is arrogant: "You must have an elevated idea," Degas believed, "not of what you do, but of what you can one day do; without this it is not worth the trouble working."

And yet, allergic as he was to the idea of method, to the notion that an artist should invent a formula and then unfailingly apply it, Degas was nothing if not methodical, working with great diligence and intense application. He disavowed impulse and extemporization as much as he did method. "I assure you," he liked to say, "no art was ever less spontaneous than mine. What I do is the result of reflection and study of the great masters; of inspiration, spontaneity, temperament . . . I know nothing." The key is repetition: "It is necessary to execute a motif ten times, a hundred times. Nothing in art must look accidental."

Knowingly or not, Degas kept violating his canon: his works often appear casual and immediate, deceptive as that impression may be. That he would contradict himself is hardly surprising. The English painter Walter Sickert, in his memoir of Degas, reports various opinions of the master's—that one should use oil paint as if it were pastel, say, or that "the art of painting was so to surround a patch of, say, Venetian red, that it appeared to be a patch of vermilion." (Josef Albers would have agreed!) But Sickert also specifies, "It must be remembered that I am only recording what he said at a given date, and to a given person. It in no wise follows that, by advising a certain course, he was stating that he himself had ever refrained from taking another."

In painting as in conversation, Degas knew how to take a transitory observation and generalize it—to lend a percept the solidity of a precept. Yet he never lost sight of things being perpetually in transition. In his depictions of dancers at the bar, jockeys on their mounts, or women bathing, he catches his subjects in an "off" moment. He is less likely to show the performance or the race than he is the moment before or after when nothing much is happening, and he excels in capturing these interludes without imposing any ulterior formality on them by training a too obviously intent gaze on his subjects or depicting them in such a way as to subliminally convey just how much study he's invested in them. The fact is that Degas's sense of organization and accident is eccentric. His studio, as the gallerist Ambroise Vollard recalled, was "always in complete disorder," yet when Vollard accidentally dropped a scrap of paper, the painter immediately scooped it up and threw it in the stove, saying, "I do not care for untidiness." His works are like that, too. Unfussy and teeming with the random stuff of life, they cohere around a hidden sense of order that lies just beyond one's grasp, yet is no less palpable for that.

Degas's propensity for saying one thing and doing another is undoubtedly linked to his inveterate experimentalism (or opportunism, as Feyerabend

would put it), his propensity to try anything that might lead to new ways of reinterpreting and revising his established subjects and compositions. Consequently, for all their pungency and quotability, his quips—which I certainly don't intend to stop quoting—cannot be taken as entirely descriptive of his practice. Pedersen and her colleagues are not as careful about this as they should be. They take at face value the artist's repeated assertions that, contrary to his fellow Impressionists, he had upheld the classical tradition of draftsmanship as transmitted through Ingres: "I have always tried to urge my colleagues to seek for new combinations along the path of draftsmanship, which I consider a more fruitful field than that of color. But they wouldn't listen to me and have gone the other way."

Degas's drawings are marvelous, and the early ones, cool and linear, show Ingres's unmistakable influence. But for Degas the practice of drawing was utterly different than for Ingres and the academic tradition of which Ingres represents the apotheosis. This neoclassical drawing was never a matter of simply inscribing a beautiful line. Its function was always teleological; no matter how much observation it involved, no matter how much trial and error, it was always oriented toward composition and the idea of a completed picture. This composition, in turn, was to be based on an analysis of the narrative to be conveyed; it had to present coherently what would later, in a completely different context, be called *the decisive moment*, the moment in which the truth of an action reveals itself. This kind of drawing is essentially a sort of coding.

Degas seizes upon moments that Ingres would have found utterly insignificant. In his images of dancers, for instance, he rarely shows a performance; what interests him is the rehearsal, or even the warm-up for the rehearsal. Likewise, he will sometimes paint a horserace, but more often shows the period before the race has started, or after it's over. As Pedersen says, "Degas chooses unstable moments and situations that are not long-lasting, but not instantaneous either," ones in which "the figure is preparing for something else—something that lies further out in the future or is perhaps over."

The allure of ambiguous moments led Degas to reconceive the purpose of drawing. Instead of crystallizing a moment, it liquefies a momentary order. A fascination with instability is especially evident in the many small wax or clay figure studies that Degas kept in his studio. The only sculpture he ever exhibited was the famous *Little Dancer Aged Fourteen*, but after his death seventy-four others that he had made were cast in bronze. (The Ny Carlsberg Glyptotek is one of the few institutions to own a complete set of them, and they form a prominent part of the exhibition.) Not only do they often

represent unbalanced poses, but the sculptures are also in themselves unbalanced: their original wax or clay forms required external as well as internal armatures to keep them upright. These were sculptures not meant to bear their own weight.

Degas's conception of drawing led him in the direction of a second master who has always been considered Ingres's dialectical opposite, Eugène Delacroix. But Degas understood that the polarity between Ingres and Delacroix was never, as it is so often supposed, between an art of line and one of color; it encompasses two different ideas of drawing, two different ideas of color. With Degas, the mark is smudged, blurred—an area that looks like a pure transition of color appears on closer examination to be composed of innumerable little crisscrossing lines of different hues that have been blotted and interfused. The lines are always quantities of substances, not bounded singularities. The matter of which the image is made becomes porous to itself and therefore begins to make indistinct what it is an image of. For Degas, any dichotomy between drawing and color is meaningless, and drawing loses any specific identity; it is no more the essence of a painting than an armature is the essence of a sculpture.

The exhibition may overemphasize Degas the draftsman, but no viewer can walk away from it without having been amazed by his radical use of color. If his approach to drawing tends to undo its ability to function as a code, his use of color does the opposite: because he restricts his palette to few colors, and ones that have little to do with the "natural" hues of the things he's painting, color ends up having an independent impact of its own. It was undoubtedly his palette that gave rise to the mutual admiration between Degas and his younger colleague, Paul Gauguin, whose strange and disquieting clouds of color might well have floated out of a Degas painting like *The Milliners* (1882–1905). Likewise I am almost reconciled to the mawkishness of Picasso's blue period now that I can see its cooler, drier precedents in a Degas pastel like *Portrait of a Woman in a Green Blouse* (ca. 1884). Degas is normally cast as a realist, but his incessant transformations of the real lead his art in the direction of Symbolism. When he told the Irish writer George Moore that "la danseuse n'est qu'une prétexte pour le dessin," he's wasn't emphasizing once more the centrality of drawing; rather, he was intimating that the dancer is transformed into something else. As his friend Stéphane Mallarmé put it,

> the dancer is not a woman who dances, for the juxtaposed reasons that she is not a woman, but a metaphor summing up one of the elementary

aspects of our form, sword, cup, flower, etc., and that she doesn't dance, suggesting, by miraculous short-cuts or élans, with a corporeal writing, what it would take paragraphs of prose with dialogues as well as descriptions to express in the text: a poem freed from all the apparatus of the scribe.

And yet Degas's art is too complex and multifarious to be reduced to Symbolism. "Degas's Method" reminds us that, after Ingres and Delacroix, Degas took on a third great influence, an artist only a little older than himself, namely Honoré Daumier—another great draftsman but one who worked for the popular press and who showed that great art could be bent to the service of journalism without losing its integrity or its aesthetic force. In his own way, Degas was no less intent than Daumier on being an observer of his time. He once told Sickert that he hated taking cabs because "You don't see anyone." He preferred the bus. "On est fait pour se regarder les uns les autres, quoi?" ("We're made for looking at each other, you know?") His search for what Mallarmé called the elementary aspects of form was intense, but it was inextricable from the endless pleasure taken in looking at people. And Degas saw things that had never been noticed before, little gestures that are insignificant but that are touching in a strangely anonymous way because they are simply human: a woman's arm stretched out as she towels her hair dry, a dancer's leg lifted up to the bar as she rehearses.

If Degas painted dancers more than any other subject, it was because he identified with them—not as performers but as workers, and above all because they are not only artists but also, in themselves, art. Their training endows them with bodies that are already in themselves imbued with artifice. Similarly, if Degas had to repeat the same motif "ten times, a hundred times," this was not only in order to remake and revise the motif but to remake and revise himself in his developing capacity to reveal the motif. He explained it this way, with an extraordinary metaphor: "Art does not expand, it repeats itself. And if you want comparisons at all costs, I may tell you that in order to produce good fruit one must line up on an espalier. One remains thus all one's life, arms extended, mouth open, so as to assimilate what is happening, what is around one and alive." The horizontal beam on which the espaliered fruit tree is trained resembles, more than anything else, the dancer's bar.

Degas's art was inimitable, but it survived him in its reinterpretation by Gauguin and, at times, Picasso, as well as in the work of Matisse and Bonnard

and, later, de Kooning. But it was Degas's rival Claude Monet who succeeded in imposing his idea of Impressionism on history: an analysis of natural perception, an art at home in the outdoors, rather than Degas's distillation in the studio of memory into symbol through repetition. More important in the long run is that Monet's commitment to serial production (which was very different, as Pedersen points out, from Degas's own practice of making independent variants without sequence) leads to the systemic abstraction of the 1960s, not to mention Andy Warhol's reiterations of mass-produced imagery and Sol LeWitt's definition of conceptualism as an art where "the idea is the machine that makes the work." It's Monet and not Degas whose work points toward the origins of most of what today is called contemporary art. Does that mean Degas is now a historical relic, or does he still have living artistic progeny?

Degas's children may be a distinct minority among contemporary artists, but they're out there if you look hard enough. If you happen to be in London this summer, one of the most engaging of them has a substantial show on view at Parasol Unit, a nonprofit exhibition space. Merlin James is a painter of Welsh origin, presently living in Glasgow, who has been exhibiting to increasing critical interest since the early 1990s. Like Degas, he emphasizes his attachment to tradition—and not only in his paintings; he's a critic, too, but instead of publishing in a slick contemporary art journal, he's found a home at the dowdy old *Burlington Magazine*, where Moore and Sickert published their memoirs of Degas back in the day. And yet, for all his supposed traditionalism, he takes no aspect of painting for granted. He has made some of his works by stretching sheer polyester over an elaborate frame and touching the translucent surface with just ghostly splotches of color. Others, painted on canvas, have holes gouged in them or objects of various sorts collaged on top. The paint itself sometimes seems to be mixed up with some nameless schmutz—it could be hair or who knows what studio muck. This approach puts me in mind of nothing less than Degas's remark that "with a bowl of soup and three old brushes you can make the finest landscape ever painted!" James is not a stuntman aiming at sheer novelty; he seems to want to avoid following any formula and, per Feyerabend, to "adopt whatever procedure seems to fit the occasion." This means, above all, that James uses representation or abstraction as he sees fit, and always methodically.

Also like Degas, he keeps works in the studio for ages, tinkering with them endlessly. The nocturnal landscape *Dark (Trees)*, for instance, bears the dates 1989–2012; it is one of the simplest-seeming paintings in the

show, so we have to assume that what happened to it over twenty-three years was a gradual editing out or paring down. Another long-lived effort, *Black* (1984–2008), is a more elaborately composed abstraction, but in this case the painting's surface seems to indicate that what is visible was painted on top of another sort of work entirely, so that it's not so much that a painting has been revised over time as that one painting has been entirely replaced by another.

When James discusses painting he often speaks of "plasticity," and when in his work he uses paint to form a determinate image, what seems to interest him most is manipulating it as a malleable material, something to be pushed and pulled, pressed and dragged to create endlessly different sorts of marks. He tries to handle the surface he paints on and the structure that keeps the surface taut and on the wall with the same freedom. He likes to quote old paintings—*Sower* (2001) derives from Millet, while *Large Sea* (2005) conjures memories of Courbet—but the aim is less to commemorate the past than to see how much a familiar image can be transformed. James often paints buildings, but as the critic John Yau has pointed out, the construction of a building seems to stand in, in his art, for the construction of a painting; I'd add that you can make a building or a painting out of the remains of existing ones and achieve something habitable.

Like all good painters, James suffuses his work with a very personal intuition of the qualities and capacities of light; it is through the medium of light that the emotional quality of his art materializes. Yet light is also the favored medium of his quest for plasticity: he wants it to be something he can grasp, mold, make an impression on—rather than something ethereal, immaterial, that enters the eyes from some great distance. It is hard to tell whether he fulfills this desire or not, yet the results are equally poignant either way.

2013

Margins of Modernism:
Silke Otto-Knapp and Lynette Yiadom-Boakye

Modernism, if we need a quick and dirty encapsulation of it, can be summed up by Ezra Pound's imperative: "Make it new!" which at its most extreme leads, insofar as visual art goes, to the feeling that one could only begin, "as it were, from scratch, as if painting were not only dead but had never existed"—so Barnett Newman described his aspiration in 1967. Whereas postmodernism, as we came to know and love or hate it in the 1980s, seemed to say that nothing of the sort was possible or even, really, very interesting—and to prove it, artists began to devote themselves to appropriation and pastiche. These strategies are still very much with us today, as can be seen from the recent court case over Richard Prince's reuse of imagery taken from a book by the photographer Patrick Cariou, exemplifying the persistence of appropriation, and the resurgence of George Condo, widely lauded for his slick, jokey twists on familiar modernist styles, as an illustration of the art of pastiche. And there are plenty of younger artists following in their footsteps.

But there are also other possibilities in the air. Just as the idea that art could make a fresh start, unencumbered by the conventions of the past, eventually came to seem in itself a tired and conventional idea, so did the idea of the end of history, condemning the artist to what Fredric Jameson, in his celebrated 1984 essay on postmodernism, described as "the imitation of dead styles, speech through all the masks and voices stored up in the imaginary museum of a now global culture." In retrospect, both the modernist and postmodernist positions (at least in their most intransigent forms) seem like evasions of the historicity of the present. In reality, there are no absolute beginnings or endings, just a continuing entanglement between present and past, so that we can only continue to recognize the truth of William Faulkner's famous admonition, "The past is never dead. It's not even past." Faulkner's warning means that there are always unacknowledged histories at work in the present; the now may not be what it seems. For new art, which we hope

will tell us something about our present and, perhaps more to the point, show us something of the look of the present, that means things may be more complicated, more ambiguous than they used to seem. It's harder than it used to be to distinguish an art that's truly of the present from one that is more backward-looking. And when art starts to go delving into its past, it can be hard to tell whether it's doing so in the spirit of postmodernist pastiche—which has come to seem a bit old-fashioned though it's still widely practiced—or with the sense of a present that's infused with history, a spirit that has not yet been named and is still emerging. Somewhat reluctantly, I'll borrow a phrase from literary studies and call this a new historicism in art.

That such a thing exists—not a movement but a tendency of the time— has only gradually become clear to me, and most recently thanks to recent exhibitions in London by two of my favorite younger painters, Silke Otto-Knapp and Lynette Yiadom-Boakye. It helped that their shows happened to be in the same building, at the galleries greengrassi and Corvi-Mora respectively; perhaps it was their propinquity that allowed me to see past the fact that the two bodies of work don't visually resemble each other in any overt way and recognize their curious inner congruence. The two artists' backgrounds are different enough. Otto-Knapp was born in Osnabruck, Germany, in 1970. She came to London in 1995 to study at the Chelsea College of Art, and has been living and working here since then. Yiadom-Boakye is a native Londoner, born in 1977, of Ghanaian heritage. That they both work in London doesn't seem crucial; their roots are elsewhere: I'd be surprised if Otto-Knapp hadn't been crucially influenced by Karen Kilimnick, for example, though she hasn't emulated Kilimnick's fannishness and whimsy, and Yiadom-Boakye has clearly been marked by John Currin's work, though he is still a pasticheur in a way that she's not. Even the fact that they are both painters may not be that important. I could point out similar qualities in artists working in other media—for instance the sculptor Daniel Silver, who was raised in Israel, or the American-born filmmaker Daria Martin, to name a couple of other London-based artists who've made a strong impression on me in recent years.

The first thing one saw in Otto-Knapp's exhibition, "Voyage Out," was *Tableau 1 (braiding)* (2011), a largish, near-square painting in richly toned grisaille depicting a group of dancers, clad in white robes like dervishes, performing in front of a large openwork construction, somewhat taller than the dancers, of indeterminate use or significance; behind it, one sees their accompanists, playing four grand pianos and a range of percussion. The

scene is represented in a highly stylized manner that might have come from some unidentified no-man's-land between the Modernism of a Georgia O'Keeffe and Art Deco, with detail reduced to a minimum—the figures are faceless, for instance—and the space tipped forward so that the background figures appear to be above those in the foreground rather than behind them. The musicians look stiff, doll-like; the dancers appear not to have been captured in mid-movement but to be holding their extravagant poses indefinitely. In contrast to the austerity of the work's palette and composition, its smoky half-tones of seemingly infinite gradation, the intangible flickering lights and shadows in which the scene has been rendered are incredibly seductive, as is the painting's delicate texture, at once sheer and velvetlike, all due to Otto-Knapp's use of watercolor and gouache (rather than, say, oil or acrylic) on canvas. Writing about an exhibition in Cologne three years ago, the German critic Catrin Lorch shrewdly attributed Otto-Knapp's restricted palette to the influence of "the dusty-grey medium of photocopy reproductions of old images from ballets." No doubt, but who'd ever have thought the grainy detritus of hours spent in the library would yield such an emotional tug? Otto-Knapp's paintings are permeated by nostalgia, but is it for the lost artistry of dances we will never be able to see or for the archive that beguiles us with the incommunicative traces of what was or might have been?

Presumably *Tableau 1* represents an actual performance—in the past, Otto-Knapp has derived paintings from documents of performances by Diaghilev's Ballets Russes and Ninette de Valois; at Sadler's Wells, she's been exhibiting a series of etchings based on the ballet *Lilac Garden*, choreographed by Antony Tudor, which was performed there in 1936. There's no written clue as the source of *Tableau 1*, but the unusual instrumentation is that of Stravinsky's *Les Noces* (1923), which was originally choreographed by Bronislava Nijinska. So maybe those dancers are meant to be, not Sufi mystics, but Russian peasants. In any case, some of the other paintings in "Voyage Out" return to a subject that occupied Otto-Knapp a few years ago, before she began focusing on dance performance: landscape—or rather, more specifically, gardens: not wild nature, but the artifice of a cultivated theater of nature. In *Garden (moonlit)* (2011), the luminous disc hardly seems the source of the pale radiance that permeates everything, for it seems as if the areas of deepest foliage are somehow the least hidden in shadow. And despite the muzzy atmosphere, the painting is incredibly detailed. Perhaps this is what it's like to see a garden through the shining eye of a cat prowling through the night.

But is a painted landscape really the likeness of a terrain through which animals may stalk or merely the image of an image? As Otto-Knapp reminds us, it's hard to know. The darkest and most mysterious of the paintings she showed here was another one seen in lunar light—or so one might have thought. But its title tells us otherwise. *Stage (moonlit)* (2011), with its bare, scattered trees, depicts, not a real forest, but a theatrical backdrop. Its painted moon has only this in common with the real one: that it gives reflected light and not its own.

The idea would seem to be that painting detaches an image from any definite connection to its source. Reference to nature and reference to art become indistinguishable. And yet art is not entirely removed from reality; there's a connection, however attenuated, that Otto-Knapp seems to want to hold on to. Perhaps the most affecting work in her exhibition was an image of another artist, *Painter (Marianne North)* (2011). It shows a woman sitting before an easel in a clearing before dense woods. Although as usual with Otto-Knapp, details have been reduced to a minimum, the woman's costume seems vaguely nineteenth-century. Who is she? The name Marianne North meant nothing to me, but thanks to the magic of Google I now know that she was an English naturalist and botanical artist who lived between 1830 and 1890. The Royal Gardens at Kew maintain a gallery devoted solely to her paintings—said to be "the only permanent solo exhibition by a female artist in Britain." Nothing could be further from Otto-Knapp's own dreamy, aesthetically and conceptually distanced mode of painting than the hard-headed realism practiced by this doughty Victorian maverick who traveled the world to document its flora in minute detail and intense color. North wanted to show things in the most direct manner possible; Otto-Knapp reminds us obliquely of what may be beyond our grasp. And Otto-Knapp's evident empathy for her subject has not tempted her to imitate North's manner of painting—anyway, she couldn't, without changing everything, right down to her very materials, since North painted in oils at a time when ladies were expected to use watercolor, and Otto-Knapp uses watercolor, perhaps partly in solidarity with the generations of female amateurs who might indeed have had the gifts to be something more if only the times had permitted it. What North wanted to paint was nature; Otto-Knapp wants to paint North's aspiration.

Otto-Knapp's paintings often probe around the edges of Modernism, both in their subjects—dance performances that are only familiar to specialists because they can only be reconstructed from documents, an artist who

ignored the burgeoning innovations of contemporaries like Manet and Whistler to pursue her own (perhaps inadvertently) visionary take on the vegetable realm—and in their style, which often evokes provincial variants of metropolitan modes, often imbued with symbolist overtones. Yiadom-Boakye's paintings, portraits of imaginary people, invoke an even longer historical memory, but they're also concerned with art history's margins. Commentators on her work invariably cite a very specific pictorial heritage: Velázquez, Goya, Manet, Sargent—and rightly so, though we'd do well to remember the less renowned figures who also share some of the same artistic DNA: the likes of Robert Henri or William Nicholson. But speaking of Velázquez and Manet, what if Juan de Pareja were not the only black man the Spaniard had painted? And what if not just Olympia's maid but her mistress too had had dark skin? The people Yiadom-Boakye paints are almost always black—people who were marginal to the European tradition of portraiture until the advent of Modernism made the portrait itself a marginal pursuit.

Not that these imaginary figures ever look like they've been marginalized. "I don't like to paint victims," the artist insists in the press release for her recent exhibition, "Notes and Letters." Her people are proud and tough, for all their vulnerability. They have nothing to prove. Okwui Enwezor, in an essay for the catalog of Yiadom-Boakye's recent show at the Studio Museum in Harlem, borrowed from the art historian Richard J. Powell the notion of "cutting a figure"—"an incisive, slashing action or a spectacle created by an all-too-visible person"—as a way of understanding her imaginary portraits. But this kind of compensatory self-representation strikes me as exactly what Yiadom-Boakye's subjects rarely if ever resort to. It's as if they've never been made to feel that their race could count against them, that they are too visible or invisible; in that sense they may be "post-black," to use the term coined a decade ago by Thelma Golden, the Studio Museum's director.

But there's something else to be noticed about these figures: the absence of markers of class in their depiction. Most portraits show their subjects in the midst of their possessions—props that define their stations in life: sometimes their profession, more often their wealth and status. And even in the absence of other such articles, clothing is usually enough to show who you're dealing with. Think of the sumptuous gowns worn by the women painted by Sargent or Ingres. With Yiadom-Boakye's people, you'd be hard put to say if they're rich or poor; it might be tempting to assume they're middle class, but even that would be unwarranted. Their costume, often close to styleless—see for contrast the flamboyantly mannerist gear sported by the

portrait subjects of Barkley Hendricks—is strictly unidentifiable as anything but vaguely modern: plain brown sweaters, casual slacks, at best a little black dress. Nothing flash.

There's something else to be said about this tropism toward plainness. It has to do with Yiadom-Boakye's extreme reserve with regard to the use of color. There's a strong use of red (for the figures' garments) in one work in "Notes and Letters"; green provides the background for two others. But otherwise, the paintings are mostly brown with a bit of white: brown skin, brown clothing, brown backgrounds, the whites of their eyes. In the most literal sense, most of these figures are at one with their world, which is nothing other than that of painting, or rather—since the substance of paint is everywhere in evidence here—of paint: its physicality, its uncanny life. These faces are nothing other than the paintings themselves insofar as it takes on legible features.

At the same time, there is something knowingly generic about these imaginary portraits. Not that each subject doesn't have his or her own quirks of pose or expression; even knowing that they are invented, it's easy to imagine that they represent people we might have seen or met. They evoke empathy. But at the same time, the paintings always also present themselves as examples of portraiture, as "tokens" (to use C. S. Peirce's nomenclature) of a type of representation. We see the people they represent as individuals, but the people do not trouble to exteriorize or dramatize their individuality, and something similar could be said of the paintings themselves. Maybe we should think of them as portraits of portraiture—which they could probably not be if they depicted real people.

A few of Yiadom-Boakye's recent paintings, however, seem to represent a withdrawal from the notion of portraiture. This show included a pair of full-length figures in which the subject's face is turned away—a young man in *Aftersong* (2011) and a middle-aged woman in *11 am Monday* (2011)—figures with "lost profiles." Yet these characters seem hardly less knowable than those who face us directly in some of the other paintings. The woman is seen amidst the nebulous light-grayish atmosphere of what could well be an overcast morning; however the day might turn out, her wide-brimmed hat would provide protection from either sun or rain. Little more than a few darker horizontal brushstrokes at the bottom of the canvas establish a reflection: she seems to be standing in shallow water, one foot resting on a rock, perhaps gazing out at the ocean. Though we barely see her face, her contemplative mood comes through vividly enough. Whatever we can know about the subjects of these paintings is to be known indirectly, yet we feel

we do know something, and in relation to this something, everything we don't know contributes a sense of untold depth.

Of course that depth is in the eye of the beholder. Contemporary painting is "conceptual" in just this sense, that the effects it aims to create take place in the viewer's mind and not on the canvas. That's not to say that some curious and difficult things don't have to happen on the canvas to produce the desired effect. The viewer completes the work, as Marcel Duchamp famously said—but he or she doesn't complete it in just any old way; the artist cannily, inexplicitly shows you how. The painters Yiadom-Boakye admires, the likes of Velázquez and Manet, were masters of the unfinished who knew how to use the eye and mind of the viewer to animate the raw physicality of paint by breathing life into it through gaps they'd left for just that purpose. She's been going to the right school.

At the same time, she's learning how to give the viewer more information while still keeping things open—and to remind the viewer, as well, that the way one completes a picture through perception is always open to revision. The largest painting in "Notes and Letters," strangely titled *Curses* (2011), is, unusually for Yiadom-Boakye, more of a genre painting than a portrait. Two girls, robed in red, are seen crossing a river by striding from stone to stone. The background is not depicted in any great detail, but is nonetheless much more concrete than her usual nebulous fields of colorless color. The careful energy invested in each of their steps is beautifully evoked. So is the concentration on their faces. And this despite the fact that, in the midst of all the seemingly effortless lyrical painting by which she has adumbrated the girls' environment, she has rendered their faces with blunt, awkward, at time almost harsh gestures. These features that read so naturally from a certain distance come to seem masklike, arbitrary, even grotesque if you get too close—and yet gorgeously so.

Yiadom-Boakye's art, like Otto-Knapp's, is pervaded by an exquisite historical consciousness, no doubt about it—yet their work never comes close to seeming academic. I suppose it's the wise incompletion of their paintings that makes this possible. Go back to Otto-Knapp's portrait of Marianne North: notice how the painting she's shown making is nothing but a rectangle filled with a few liquid strokes of watercolor. Everything around it tells us what the picture might be. But we have to fill it in for ourselves, now and always in the present, knowing whatever we might of the past.

2011

Black Is Also a Light: Henri Matisse, 1913–1917

In October 1908, when Henri Matisse exhibited in Paris thirty paintings, sculptures, and drawings representing his work of the past eight years, a disgruntled critic complained of the artist's "unhealthy state of mind, over-worked by search and ambition." If only he'd realized what was coming. Just three years earlier Matisse had burst into notoriety as the most radical of the Fauves, or "wild beasts," of painting; the 1908 exhibition showed that the thirty-eight-year-old artist was ready to take stock of his work without false modesty, the better to push forward into new terrain. His sense of accomplishment and his restlessness could hardly be disentangled. "I do not repudiate any of my paintings," Matisse declared in his "Notes of a Painter," published a few months later, "but there is not one of them that I would not redo differently, if I had it to redo."

Where most observers saw madness and aggression in Matisse's work, his one great early defender among the critics, Guillaume Apollinaire, saw a "Cartesian master." "We are not here in the presence of an extravagant or extremist undertaking," Apollinaire argued. "Matisse's art is eminently reasonable." The poet was being sly, knowing as he did that to be reasonable, or rather to put one's reason into practice, can be a most extreme under-taking. And Matisse himself was being just as crafty when he claimed, in implicit contradiction to Apollinaire, to disdain intellect as a guide to paint-ing: "I believe only in Instinct." True, Matisse is the most intuitive of painters, yet to express his instinct cost him immense intellectual as well as physical labor. "Often behind one of these works," he explained to a Catalan journalist, "a dozen more have been undergoing evolution, or, if you wish, involution, from objective vision to the sensationalist idea that engendered it." Matisse's insight, if it has been precisely transcribed, is extraordinary. It would have been more conventional to assume that art begins with sensation and is gradually elaborated to construct an "objective vision," but Matissean vision is just the opposite, moving from objectivity to sensation, or rather (and here comes a curious oxymoron) to a "sensationalist idea," apparently a sort

of intellectualized sensation. It's as if, in Blakean terms, one were to start from experience to achieve innocence.

Matisse's paintings can appear to have taken form effortlessly. Their time-lessness is akin to that of the icons which stunned the painter when he visited Russia in 1911—"the true source of all creative search," he declared. Of course the frank evidence of multiple revisions observable on the surfaces of most of them tells us that this sense of ease is deceptive. Readers of Hilary Spurling's biography of the painter can easily come away from it thinking of the artist as an absolute kvetch: high-strung and anxious, a reckless worka-holic on the verge of a nervous breakdown. Of the 1906 painting *The Gypsy*, he later observed that it "shows the energy of a drowning man whose pathetic cries for help are uttered in a fine voice," while the mural *Music* (1910), he described as "an immense effort which has exhausted me." Of the glorious 1912 still life *Basket of Oranges*, later purchased by Picasso and now on view in Chicago, he told François Gilot, "It was born of misery." When a painting happened to achieve an unexpected success he took little pleasure in it, seeing the work as just "the beginning of a very painful effort." A confirmed atheist—except "when I work"—he would use the Lord's Prayer as a mantra to calm himself down. And yet as his friend the writer and socialist politician Marcel Sembat observed, "He has no wish to offer other people anything other than calm."

The war years made Matisse's anxieties even more acute. He volunteered for military service, and even bought combat boots, but failed the medical exam; he appealed his refusal and was turned away again. His mother was caught in the German-occupied northeast; painter friends were in the trenches. Contributing prints to fundraising efforts on behalf of civilian prisoners of war did a little to assuage his feelings of guilt, "sickened by all the upheaval to which I am not contributing." His living had been dependent on a market composed mostly of foreign buyers, now dispersed; there were no more commissions from Russia. But in his art, Matisse never thought of seeking safer ground; away from the front, his own struggles became all the more acute. Alfred H. Barr, in his pioneering 1951 monograph on the artist—still the first stop for anyone wanting to look further into his work—defined the years 1913–17 as Matisse's period of "austerity and architectonics." The perceptual puzzles of the Cubists having stolen the Fauves' thunder as the last word in artistic radicalism, and with the fate of France in doubt, the *luxe, calme et volupté*, the *bonheur de vivre* that had given names to some of Matisse's most ambitious canvases of the previous decade yielded, at least

for a while, to a new sobriety of color and emphasis on geometric structure. "Matisse: Radical Invention 1913–1917," at the Art Institute of Chicago, puts the artist's work of this period under a microscope—sometimes literally so.

Some works of this period verge on abstraction and, significantly, some of the most important among them were not exhibited until much later, as if the artist feared that the public would not comprehend them. When the 1914 *View of Notre Dame*—with its rough and hesitant approaches to an architectural volume that might have been unidentifiable without the title— was finally shown thirty-five years later, it was still seen by some as "an unfinished sketch to which Matisse had unaccountably signed his name." Another famous near-abstraction from the same year, *French Window at Collioure*, really might be unfinished—or perhaps it would be better to say that Matisse may never have stopped wondering whether he was done with it or not; in any case, it was only first exhibited after his death. The black rectangle that occupies most of the canvas is not simply a negation—the "black future" that the poet Louis Aragon later saw there—but a latency rich with possibility. A finely balanced uncertainty toward itself makes *French Window at Collioure* the quintessential Matisse painting—if there is one.

During these years Matisse produced some of his greatest works, and some of the best known. The exhibition's climactic next-to-last room includes three of his most monumental and mysterious paintings, *The Piano Lesson* and *The Moroccans*, both works of 1916 in MoMA's collection, and the masterpiece from the following year, *Bathers by a River* (from the Art Institute). Not that Matisse's relentless self-criticism always stood him in good stead; his attempt to get the better of Cubism in an oversized 1915 pastiche of Dutch still life from the Louvre is a thing of fits and starts. But a visitor who'd walked into the exhibition (or picked up the catalog) without reading its subtitle would never imagine that it simply covers the years 1913–17. Really, the exhibition chronology starts in 1907 (and there are even a few works dated earlier than that); you go through several rooms (or 140 pages of text) before reaching 1913. Why the discrepancy between the actual scope of the show and the more modest claim of the title? The reason, I'll guess, was the unavailability of many of Matisse's most important works from the half-dozen years before the war. Because his greatest collector in the prewar period was the Russian textile manufacturer Sergei Shchukin—wasn't he the tired businessman whom Matisse so notoriously invoked as a potential receiver of his art in "Notes of a Painter"?—paintings like *Harmony in Red* (1908–09), *Nymph and Satyr* (1908–09), *The Conversation* (1909), *The Dance* (1910), *Music* (1910), *The Painter's Family* (1911), *Moorish*

Café (1912–13), *Mme Matisse* (1913), and many more hang today in the State Hermitage Museum in St. Petersburg. None is in this exhibition. There are wonderful paintings from these years in Western museums too, not to mention some of the artist's best sculpture, but while they are sufficient to illustrate Matisse's development away from Fauvism, they can't convey the whole story, so the curators were wise to refrain from appearing to claim any full accounting of the period.

But when Stephanie D'Alessandro of the Art Institute writes of Matisse having "radically changed direction" around 1913 (and in this she reflects the prevailing wisdom), I'm not convinced. In what sense could his paintings of 1913–17 be considered significantly more "austere" or "architectonic" than *Bathers with a Turtle* (1907–08)? Here the three nudes, starkly rendered, pensive, are isolated against an environment reduced to three imposing, horizontal blue bands—an abstraction closer to the minimalism of Brice Marden's *Grove Group* of the mid 1970s, or to the geometricized backgrounds of some of Matisse's later works such as the still life *Gourds* (1916), than to the luxuriant foliage echoing the figure's sensuousness in a somewhat earlier painting like *Blue Nude (Memory of Biskra)* (1907). And the severity of *Bathers with a Turtle* is hardly a rarity in Matisse's work before 1913. What about the 1911 *Portrait of Olga Merson*, in which the primly seated figure is hemmed in by a pair of blunt, almost brutal concentric black arcs—a painting in which geometry seems to be used less to "construct" a figure than to deface it with what Barr called a "scimitar-like stroke?" Even the works Matisse produced in 1912, a year spent mostly in Morocco—works that explore, as D'Alessandro well puts it, "the power of North African light to dissolve form and to reconstruct space into vaporous, mutable, interwoven layers of ethereal color"—are not as sensuous or exuberant as she seems to imply. Reflecting the strictness of Muslim mores as well as the intensity of North African light, the figures are hieratically static, self-contained, distant. Although the paintings include passages of delicious detail (for instance, the pointillist shorthand fantasy of dots and dashes at the center of the sash worn by *Fatma, the Mulatto Woman* [1913]), they generally use a mode of representation based on the principle of the adequacy of the least possible indication.

None of the paintings I've mentioned can be called typical. In fact what's amazing about Matisse's production throughout this whole period is how restlessly experimental he was. Seemingly a natural dialectician, he was provoked by his every pictorial choice to wonder what would happen if he did the opposite. His inclination was not to balance out alternatives but to

pursue each to its contradictory extreme: architectonics and arabesque, severity and sensuality, psychology and decoration. But if any single painting seems best to support the idea of a new sobriety entering into Matisse's work in 1913, it would be *Woman on a High Stool*, whose subject is Germaine Raynal, the wife of an art critic associated with the Cubists—although I can never look at the painting without thinking, instead, of Virginia Woolf. The painting is mostly a gray that mutates into chromatic highlights here and there—flashes of pink on the woman's face and left forearm, blue and green in her skirt—while the heavy black outlines of the various forms at times become entirely schematic, for instance in the leg of the rusty red table behind her.

This seeming suppression of color was something new for a painter whose calling card since 1904 had been the fearless use of color. Again, though, it can hardly be called typical, but that Matisse did recurrently experiment with what he could do with gray and black after 1913 is inarguable. Along with *French Window at Collioure*, another painting of 1914, *Portrait of Yvonne Landsberg*, may be the most extreme example here, but paintings like *Head, White and Rose* (1914–15), *Goldfish and Palette* (1914–15), *Apples* (1916), *The Rose Marble Table* (1916), *Portrait of Auguste Pellerin (II)* (1917), and *Shafts of Sunlight, the Woods of Trivaux* (1917)—not to mention *The Piano Lesson*, *The Moroccans*, and *Bathers by a River*—are all ones that Matisse could not have made earlier because he would not have used black or gray so emphatically except to mark a contour.

In 1917 Matisse began to frequent the aged Pierre-Auguste Renoir; they were close until the Impressionist's death in 1919. Years later Matisse passed on to his younger colleague André Masson the story of the first time he brought one of his canvases for the patriarch to see. "Renoir exclaimed, 'You must understand very well that I could never like such a thing! All the same you've put there a pure black that doesn't disturb the light of your painting; if we'd done that it would have created a hole!'" Matisse felt himself vindicated. "I'd won my point all the same," he told Masson. "The Impressionists had banished black from their palette; I put it back—and prominently—and a painter as in love with color and light as Renoir had the honesty to confirm it: Black is not only a color but also a light." Years later, after Matisse's death, his son-in-law Georges Duthuit would recall that "Giacometti saw black everywhere in Matisse," adding, drily, "He was exaggerating." And yet a paragraph later, Duthuit found himself in agreement with the Swiss sculptor: "And most often, there is black there, breaking up the most luminous colors. Calm, yes, luxury, if you please, but

voluptuousness? Maybe Giacometti was right: Look for black, in the work of Matisse, if you want the truth."

The conquest of a color that's not a color and a light that's not a light is the inner story of Matisse's art in the war years. His sudden intense production in 1913 of monotypes in which fiercely elegant white lines pierce voluptuous black fields—the two elements perfectly matched so that the delicate line is as substantial as the massive field, the black as luminous as the white—must have convinced him that something similar had to be possible in painting.

It was Gertrude Stein who best captured Matisse's involutedly self-critical way of working:

> One was quite certain that for a long part of his being . . . he had been trying to be certain that he was wrong in doing was he was doing and then when he could not come to be certain that he was wrong in doing what he was doing when he had completely convinced himself that he would not come to be certain that he was wrong in doing what he had been doing he was really certain he was a great one.

If reading that gives you a headache, you've got the idea, and those who think of Matisse only as the artist who claimed to offer "a soothing, calming influence on the mind, something like a good armchair that provides relaxation from fatigue" should be warned that Stein's words give a better idea than the master's own of what's in store at the Art Institute. To see the show properly demands effort, and rewards it; the catalog can be even more taxing. In both exhibition and catalog, the curators—D'Alessandro of the Art Institute and John Elderfield of MoMA—ask us to follow Matisse's working methods more closely, by becoming aware of that "evolution, or, if you wish, involution" of which he spoke, both within each painting (through his process of revision) and from one painting to the next.

But there's a danger to the method. Two dangers, rather: either losing sight of the painting being scrutinized to the welter of modifications and reconsiderations that the painter thought he'd subsumed into it, or, on the contrary, mistaking the painter's revisions for so many moves in a chess game whose outcome he'd decided in advance. It's worth quoting the catalog at some length to get an idea of just how minutely the curators have enquired into Matisse's process. Here is what D'Alessandro reports of a painting from 1909:

An X-radiograph of *Bather* shows how deeply Matisse scratched into the paint as he adjusted the figure's form. Examination with infrared reflectography makes the artist's adjustments in pencil and dark blue and black paint even more clear. Here we can see at least five variations of the right leg, as the bather initially had a wider stance; the left leg grew heavier and then slimmer as Matisse worked toward its final tapered form; and her hunched back was reshaped at least four times.

Furthermore, she continues, "An image of the work viewed under ultraviolet light emphasizes the successive layers of paint that Matisse applied over the initial figure as he reduced the torso and limbs on one side and built up the other."

The curators' examination of the paintings includes close ocular examination; the use of technical means to make more visible aspects that are already visible to the naked eye but otherwise easy to overlook or difficult to see clearly enough to describe properly; and then what might be called the third degree, the use of technical means to see things that are entirely hidden from view in the finished painting. In what may be their most ingenious effort, they have used a series of photographs of Matisse in his studio in 1913, with an early version of *Bathers by a River* in the background; as they explain it, "software was developed to reregister these images so that the details of the painting, which were documented at oblique angles or otherwise distorted, could be flattened and aligned into the same plane; these were then stitched into a never-before-seen composite of the canvas at this critical stage." One might say that they have tried to use the tools of the conservator for the purposes of aesthetic analysis. But to what extent is this valid? At times the desire to draw back the curtain and reveal the hidden workings of the painter's art seems downright prurient. After all, the surfaces of Matisse's paintings already tell so much about his methods—and precisely *all* that he wished to tell. In 1946 the artist allowed himself to be filmed at work, drawing; in the finished documentary, the footage was shown in slow motion. The film amazed the philosopher Maurice Merleau-Ponty. "That same brush that, seen with the naked eye, leaped from one act to another," he wrote, "to try ten possible movements, dance in front of the canvas, brush it lightly several times, and crash down finally like a lightning stroke upon the one line necessary." You can see this film in the exhibition, and it's everything Merleau-Ponty says, but it pays to remember Matisse's reaction: "My hand made a strange journey of its own. I never realized before that I did this. I suddenly felt as if I were shown naked—that everyone could see

this—it made me deeply ashamed." All those X-rays and infrared and ultra-violet lights would likely have mortified him as well.

Matisse said that, while painting, only then did he believe in God. Merleau-Ponty put it a little differently: "The painter, any painter, *while he is painting*, practices a magical theory of vision." And Walter Benjamin: "Magician is to surgeon as painter is to cinematographer." But not everyone agrees. Jean Genet could not resist poking fun at Matisse when he wrote of Rembrandt, "Whether he believes in God? Not when he paints." As art historians, D'Alessandro and Elderfield are committed to an analytic inquiry that tends to dissolve pictorial magic, to abolish God; they approach the paintings like film editors trying to see their development frame by frame, like surgeons trying to see structure by cutting into the skin; and yet their fascination with the minutiae of Matisse's process, like the obsessiveness of an unrequited lover, also tends to affirm the paintings' aura. It sounds like a contradiction, but if anyone can teach us the innocence that succeeds "objective vision," it's Matisse. D'Alessandro and Elderfield's findings will surely be mined by their colleagues for years to come. For the rest of us, they've succeeded in making some of modernism's most familiar works seem, if not quite as maddeningly intractable as they could be to their maker, then unresolved and difficult again.

2010

Empty and Full: Stanley Whitney
and Jacqueline Humphries

Remember the old Leiber and Stoller number "Is That All There Is?" It was a hit for Peggy Lee in 1969 and has since been covered often; crate diggers may prefer the notorious 1980 version produced by August Darnell for no wave/mutant disco chanteuse Cristina. Well, that song of disappointment has been playing in the background of abstract art right from the beginning. What? A black square surrounded by white? Is that all? A bunch of colored brush marks? That's it? A grid of faint pencil marks on a bare canvas, some ordinary bricks lined up on the floor, a square segment cut out and removed from a wall? Is that all there is? Actually, this pinched refrain was voiced in the art world long before abstraction or Peggy Lee. Henri Matisse once reported the perplexity of Gustave Moreau upon seeing his work; Moreau, then his teacher, exclaimed, "You are not going to simplify painting to that degree, reduce it to that! Painting will cease to exist." Moreau was right. In the eyes of many, painting did eventually cease to exist. Once the process of reduction was taken far enough, there was little left of painting but the idea of it, and the next logical step was conceptual art.

But nature abhors a vacuum, and so into the void from which painting had been vacated rushed all the subject matter that abstraction had put at a distance. Art became referential again. For artists who continued to avail themselves of canvas and paint, colors and lines and matter, a direct appeal to the senses but without images, without a secure referent, "Is That All There Is?" was a charge hurled from both sides. Those scattered marks and patches of color continued to give the layman (and the layman who persists in the back of the mind of the practitioner) what the song called "the feeling that something was missing." At the same time, the abstractionist heard the voices of a certain colleague, asking with an ironic tone: Why so timid? You can't unburden your art any more than that? While the tyro cried out, "My kid could do that!" the virtuosi of the concept sneered at works in which

the great historical task of deskilling had not been pursued with sufficient radicalism or rigor.

For a long time, in other words, the abstract painter had to negotiate the anxiety that he might be doing or showing too little; more recently he has also had to worry about doing too much. Yet between the two extremes there has always been a sweet spot where a little and a lot, austerity and sensuality, have coalesced. One painter who has found the sweet spot pretty consistently is Stanley Whitney. Although he is hardly a young artist—he was born in 1946—his work has come into focus only in the past ten or fifteen years. Last year Whitney was awarded the first Robert De Niro Sr. Prize for painting, endowed by the actor in memory of his father, a notable New York School painter. (Along with curators Robert Storr and Thelma Golden and patron Agnes Gund, I was a member of the jury that made the award.) In a recent interview, Whitney reminisced about arriving in New York City in the late 1960s, when the Abstract Expressionists were still thriving but were not the only draw. There were the Pop artists, Minimalists and color field painters, among others. "I watched all of it, but I wasn't about to act on it. I was in the studio, struggling and struggling . . . There was never any one thing I could say, 'this is it.' I was sort of in between everything." Part of his difficulty in finding a method of working may have had to do with being African American, having to face the question of "how the art answers the call to race." Whitney seems to have realized that, in abstraction, race would manifest itself the way most issues do: indirectly and willy-nilly. There is a particular way of articulating color and rhythm in painting that might be the outcome of specifically black experience, but to the extent that's true, it need not be insisted on; it just emerges. In any case, social and economic pressures have made it harder for younger artists to follow Whitney's example and bide their time. But for him, persistence has paid off. By his own estimate, it wasn't until 1994, when a visit to Egypt convinced him that ancient architecture showed a way to combine structural simplicity with visual grandeur, that he found a way of working he was certain was for himself—his "piece of the puzzle."

"Il maçonnait comme un romain," said Cézanne in admiration of Courbet. He built like a Roman—to last—and Whitney, inspired by the Egyptians (but also by Rome, a city he knows well), takes the idea of building a painting very seriously. Each painting—usually a square, as were the three big ones recently on display at Team Gallery in New York City—is constructed of rectangular color areas, loosely painted, laid one next to the other like blocks

of stone; the horizontal line of each color block is separated from those above and below it (and from the top and, usually, the bottom edges of the canvas) by a continuous or broken line of colored "mortar." Colors are placed next to one another, so that each speaks for itself as a single complex entity while also combining with others to form a synthesis that is the visual equivalent of musical chords.

Though these juxtaposed masses of color function like chords, they do not necessarily harmonize. There is dissonance, which keeps each color note standing separate instead of forming a blend in which the identity of each would be subsumed. Something of an exception is *This Side of Blue* (2011); as the title indicates, it is on the cool end of the spectrum, and is accordingly moodier or more guarded in feeling than the other paintings at Team. Yet one of the rectangles along the bottom row is a bright yellow that, almost single-handedly, manages to rouse all those blues (and some earth colors) into ebullience. Neither of the other two canvases, *Insideout* (2012) and *Left to Right* (2011), is dominated by a single hue; rather, one color after another seems to elbow its way to the fore in succession. I think this is the secret to the pungency and presence of these paintings. Although some colors are naturally more recessive while others project, in these paintings of Whitney's all the colors seem to be coaxing one another to take the spotlight, even those expressed in the thin horizontal lines that at first appear simply to hold the others in place.

Whitney is above all a colorist, and his paintings are often compared to those of Josef Albers (whose work he finds, however, "too institutional," meaning, I suppose, too didactic or theoretical—a perception I don't share) or Mark Rothko. But Whitney also needed an "architecture" for his paintings that would allow his color to function as it does, and the loosely repetitive structure he's found so accommodating points toward another predecessor who, as far I know, is never mentioned by Whitney's critics. The use of a square support has been the practice of a great many postwar painters— Albers, Ad Reinhardt, and Robert Ryman are only the first to come to mind. It is the most neutral, unnatural, and abstract of forms. And the use of a grid, strictly or loosely maintained, has been even more constant; again Reinhardt could be cited, but so, too, an artist as different from him as Chuck Close. Among the four or five most cited texts in contemporary art criticism is Rosalind Krauss's 1978 essay "Grids," which starts from the premise that "flattened, geometricized, ordered, it is antinatural, antimimetic, antireal. It is what art looks like when it turns its back on nature." One might expect that with a square support the components of the grid would be squares also, forming a Cartesian grid in which the two symbolic

structures of Modernist formal rigor would reinforce each other, as they do in Reinhardt's black paintings.

But Whitney's grids are irregular, and instead of being made from squares echoing the shape of the canvas, they are composed of rectangles cast against the canvas square. If Whitney has a predecessor in this, it's Agnes Martin, that most ascetic of painters, who eschewed color or limited it to almost the whitest shades of pale. She worked always with this paradox: her faint inflections of the painting's surface continually dissolve what they indicate; she re-marks the surface and disperses it in the same gesture. The play between square and rectangle was essential to this effect: "When I cover the square surface with rectangles, it lightens the weight of the square, destroys its power," she once observed. Much later she said, "The rectangle is pleasant, whereas the square is not," which I take to mean that the rectangle, despite its rectilinearity, allows the artist to compose in accord with natural perception (we experience our visual field as roughly rectangular), which the square works against. Whitney's paintings, too, avail themselves of this unexpected imbalance between square and rectangle, but instead of using it to dissolve the surface, as Martin does, he uses it to multiply the surface. It's as if each of the colored rectangles within the painting was itself already a complete painting, and each in turn could become the focal point for one's perception of the others. Martin's paintings look from unity toward nothingness, while Whitney's look from one toward multiplicity.

Whitney's deliberate manner of coming to terms with how to paint is echoed in his manner of making each painting. "I paint them," he muses, "but then I hate them. I never get what I want. It takes me a long time to relax and see what I have, as opposed to what I wanted. It takes me a while to see it." In a sense, allowing a lot of time for coming to terms with what one sees is essential. Art is not instantaneous. A painting sometimes gives the illusion that it can be taken in all at once, that it is simply there, present, in the instant. Perhaps, but that instant keeps unfolding. And just as the present tense is undone in art, so is the past. As Whitney says, "Painting reinvents time . . . Today or tomorrow doesn't exist in a painting. You look at Caravaggio, and it's really contemporary. Time doesn't exist. That's the good thing about painting."

But still, although Whitney's are certifiably slow paintings, they also have an immediate impact. They're not quiet or unassuming. It's hard to imagine anyone walking past the ground floor space of Team Gallery without having to stop and stand in front of the window and wonder—or

better yet, walk in to see what the fuss is all about. What do these foghorn blasts of rich, deep color mean to announce? That this is all there is—and that's enough.

Another painter who has been consistently finding the needle's eye where seemingly too little becomes enough is Jacqueline Humphries, who recently exhibited at Greene Naftali in Chelsea. A generation younger than Whitney—she was born in 1960—like him she has long been drawn to the square as a format for painting. But she's not, in his sense, a colorist; she can use color with eloquence, but it is not the main concern. Whitney subsumes even touch to color: "Color for me is all about touch. Whether it's thicker or thinner—how you touch the canvas is different." The proof may lie in certain drawings I have seen in Whitney's studio that use the same motif of stacked colors as in his paintings but, incredibly, with the color left out—its weight and character communicated solely by the gestural quality of black line. For Humphries, on the other hand, the relation between color and touch might be just the opposite: what her painting communicates is above all a haptic sensation of space—you don't so much see into it as feel your way through it—to which a canny employment of color may contribute. And in the past few years color has become ever sparser in her work.

The paintings at Greene Naftali, like most of those that have occupied Humphries since about 2006, were dominated by the metallic sheen of silver paint, with a dense, sludgy black—pitch black, you might say—as its main complement. Humphries' silver is a non-color—one might almost say an anti-color—and it sends light bouncing around crazily in all directions, creating a sort of blur around the canvas that has approximately the same relation to the nebulous visual hum emitted by Agnes Martin's paintings as a chemically zippy drug-induced euphoria does to the putative clarity of serenity and insight in meditation. That comparison may sound weighted in favor of Martin, but I prefer Humphries; the impurity and nervous energy of her paintings seem truer to my own experience of things—which I understand may be simply to say that with Humphries I share similar existential limitations, ones that Martin, in her paintings, transcends. So be it. Maybe it's a generational tic, shared by those whose childhood was spent in the vicinity of the television set. (Humphries sometimes speaks of the screen as a visual metaphor in painting, "the presiding model of perception," but always with reference to cinema; to me, though, the experience seems closer to the staticky flicker of the cathode ray tube.)

In these paintings, there is a gestural energy that distantly recalls Abstract Expressionism, but the gesture may just as well be that of wiping away as of laying down paint. Making and unmaking, appearance and disappearance fuse. The distribution of marks across the surface can seem almost random, and yet at the edges of the paintings you are likely to find, threading in and out of their tangled skein, elegantly graphic decorative patterns. These remind us that the painting is a shape, not just a space. But what shape? As I mentioned before, Humphries has often preferred the square, like Whitney, and looking at these new paintings, I thought at first they were squares, too. After a little time I realized they are slightly off-square: at eight feet by seven and a half feet, they are just a few inches longer than high. I suspect that a 6.25 percent difference is about the smallest that can be readily perceived. Just like Whitney, and like Martin before him, Humphries seems to want to play square and rectangle against each other, to keep in tension power and lightness, pleasure and recalcitrance. But she's found a different way of sustaining the tension, not by populating the square with grids of rectangles but by finding the format where the perception of squareness and non-squareness flickers in and out. By marking the edges of the paintings, she calls attention to their shape as significant, while the nebulous contents of the pictorial field—lacking the order and legibility of the grid—offer few clues to its inner structure, and encourage the viewer to lose sight of place.

Looking at some of Humphries' recent paintings, you might be tempted to complain that there's nothing there, or anyway not enough. Or you might feel that there had been something there, but that the artist had lost faith in what she'd put down and wiped it off in preparation for another attempt that she abandoned. Yet these seemingly vacated canvases command the room. A lot of effacement may have gone into their making, but the result is the opposite of self-effacing. As Humphries puts it, "There are ways of expressing fullness and emptiness other than with objects." Her paintings may seem objectless, but their emptiness conveys an almost overwhelming sense of fullness.

In recent years, more than a few critics have argued that painting might be palatable again if only it would adjust to a period of lowered expectations. Forget about the grand ambition and scale (and macho posturing) that supposedly characterized Abstract Expressionism. Painting should walk softly, stay humble, expose its vulnerability, and keep a tentative look about it. I'm not so sure. Minor virtues are all very well, but they're still minor. Humphries and Whitney want their work to feel urgent, to stop you in your

tracks. They aspire to grandeur—with a pictorial vocabulary that to some may seem painfully narrow. The tension between squareness and rectangularity: Is that all there is? Yes, and when a painter does so much with so little, it's called virtuosity.

2012

32

Breaking and Entering: Gordon Matta-Clark

The artist and musician Laurie Anderson, ostensibly reminiscing about her friend Gordon Matta-Clark's style as a conversationalist, handily summarized his work as an artist: "He really liked fragments . . . He was a deconstructionist; his approach was to pull things apart. And I think when you pull things apart you can really see what's there." You'll find lots of fragments in the big Matta-Clark exhibition at the Whitney Museum of American Art, sometimes in the bluntest, most literal way—for instance, pieces of walls and floors sliced out of their architectural contexts and quite simply standing there in all their raw vulnerability—but often pieced together into new and complex wholes.

More important than the fragments, though, are the spaces left behind by their removal. Matta-Clark is the artist who is most famous for having carved a house in half from top to bottom so that the two halves split apart, opening a gap between them through which, if you'd been there to peek in, you could "really see what's there." Just as Robert Smithson, the subject of a fine retrospective that also appeared recently at the Whitney, left a single iconic work that everyone knows, the *Spiral Jetty* (1970), along with a mass of equally fascinating works for the cognoscenti to immerse themselves in, so did his slightly younger, equally meteoric colleague. In Matta-Clark's case, the iconic work was *Splitting* (1974), an early example of the sculptures he made by cutting through existing (though usually about-to-be demolished) buildings: over a period of about three months, he made two parallel vertical cuts straight through the middle of a nondescript two-story suburban house in Englewood, New Jersey, removing the material left between the cuts as well some of the foundation blocks on which the house stood, so that one half slightly tilted away from the other, creating a wedge-shaped aperture between them. He also cut away the four upper corners of the house, subsequently exhibiting them as freestanding objects.

As with the spiral-shaped earthwork Smithson built in the Great Salt Lake, Matta-Clark's gesture is simple to describe, hard to execute, and larger than

life—crazy, almost hallucinatory. In contrast to Smithson's piece, it was not about adding something to existing place, but about taking something away; not imposing a new reality but exposing more of the reality that is already there. In this, his work turns out to be a surprising extension of an old sculptural idea, one that would have been familiar to Michelangelo: that "carving is an articulation of something that already exists in the block," as Adrian Stokes put it in his book *The Stones of Rimini*, back in 1935. For Stokes, an emphasis on carving over modeling was the hallmark of modern sculpture, and he even maintained that "a carving approach to the canvas . . . underlay the modern movement in painting" even more than in sculpture—though of course in his day no painter had ever literally taken a blade to his canvas for any other reason than to rid the world and his own reputation of a botched effort. That wouldn't happen until the '50s, when the Argentine-Italian artist Lucio Fontana began slashing and gouging holes in canvases that were sometimes elegantly monochromatic, sometimes gaudily encrusted with bits of glass—always with the intention of opening the virtual space of the picture up to the reality of the surrounding space, including the wall, the architectural support that pictures normally hide.

A different way of articulating reality by cutting through material was soon seen in Yoko Ono's *Cut Piece*, performed several times beginning in 1964, in which an audience was invited to cut away at the artist's clothing, an act with social and psychological overtones one can well imagine. That Ono had the sculptural tradition of carving in mind is confirmed by something she wrote about *Cut Piece* several years later: "People went on cutting the parts they do not like of me. Finally there was only the stone remained of me that was in me but they were still not satisfied and wanted to know what it's like in the stone." The melodrama is partly about the reversal of roles: the artist has challenged the audience to act as artists—with all the freedom to express aggressive impulses, among others, that this implies— while she becomes the mere material; but because she is the artist, because the proposition and the situation belong to her, there must have been a tacit struggle for control over the event, its result, and its meaning.

Such gestures of cutting or piercing are extreme and discomfiting; the same is true of Matta-Clark's. *Splitting*, the painter Susan Rothenberg remembered, "invited you into some very macabre participation." Not surprisingly, he has been described by another fellow artist, John Baldessari, as "both a Minimalist and a Surrealist." A Minimalist is supposed to work in an impersonal manner but a Surrealist works with dreams and desires; and insofar as he is sort of Surrealist, there is no escaping the importance of Matta-Clark's

family romance. His father was the Chilean-born Surrealist painter Roberto
Matta Sebastián Antonio Matta Echaurren, who usually went by the single
name of Matta. But the father was mostly absent, having separated from his
American wife, Anne Clark, four months after the birth of their twin sons.
A high school friend recalled repeated visits with Matta-Clark to MoMA,
"to look at the pictures and the girls. Surrealism was our least favorite."
Matta had studied architecture before finding his way as an artist whose
work was always concerned to imaginatively disassemble the "Euclidean
world" of everyday life; his son would do the same, leaving Cornell with an
ingrained disdain for architects and the practice of architecture but an insa-
tiable fascination with buildings.

You'd think showing an artist whose best-known works no longer exist would
be a trying exercise for a museum, and seeing it a dry chore for viewers.
That this exhibition is so involving is thanks in part to the Whitney's pres-
entation—dense but always lucid—but mainly to the fact that Matta-Clark
was nearly incapable of letting anything he touched become visually inert.
How to exhibit "dematerialized" conceptual works, ephemeral performances,
and geographically inaccessible earthworks was a problem that had been
confronting artists well before Matta-Clark. "Documentation is fragmentary,
incomplete, and an inadequate surrogate for the reality of the work, leaving
the viewer unequipped to do more than barely comprehend the experience,"
a critic complained in *Art News* in 1973. One feels this, too, with many of
Matta-Clark's earliest works. And a relic may not be much better than a
document. A charred Polaroid from *Photo Fry*, a performance from 1969,
the year Matta-Clark moved to New York from Ithaca, doesn't really do
much more than say, "You had to be there." The metaphor of cooking is
recurrent in Matta-Clark's early work; it represents the idea of a sort of
alchemical transformation of materials, but the results were rarely palatable.
For instance, he cooked up pots of agar which he would mix with all sorts
of organic and nonorganic materials and then ferment and dry in flat trays;
he hung the moldy, rumpled results like paintings, and at least one of them
has survived to take its place at the Whitney.
 The culmination of Matta-Clark's fascination with cooking was Food,
which was both an art project and a functioning restaurant—the first in
SoHo—which in 1971 he opened together with a number of artist and
dancer friends. No loner, he was always part of a network, a community—
well reflected in the catalog to his first big posthumous exhibition, in Chicago
in 1985, whose text (the source of many of my quotes here) is composed

largely of interviews with some forty friends and associates, mostly artists. Food was also the beginning of Matta-Clark's architectural cuts; while refurbishing the space, one of the team remembers, "Gordon decided to cut himself a wall-sandwich: he cut a horizontal section through the wall and the door and fell in love with it." Also around this time he cut a piece from the wall of his studio and displayed the extract as a sculpture. After this, he began scouting out abandoned buildings, not hard to find in New York in those days, which he would illegally enter and cut pieces from to retrieve for display. The building fragments shown here, such as those from the 1973 *Bronx Floors* series, are surprisingly effective as sculpture, not so much a cross between Minimalism and Surrealism as between Minimalism and kitchen-sink realism—extracted layers of time as well as of materials. With their multiple layers of wood, linoleum, plaster, and so on, they are fragments composed of fragments. Yet the breakthrough (in this context the word almost becomes a pun) would be the realization that the void left by the cutting could be even more powerful than the removed material.

But how to show the void? Again, the problem of documentation loomed. For many artists of this time, the solution was to present things in the bluntest, most deadpan way, employing a zero degree of style, with photographs, diagrams, and texts deliberately fixed in a bureaucrat's neutrality. Determined to avoid the "aestheticism" they associated with an outmoded form of modernism, they forgot one of the crucial lessons of modern art: that no medium can ever be transparent; today, paradoxically, their work displays a distinct period style that can overwhelm its content. Matta-Clark remembered that style and content are inseparable, even in works whose presentation might at first seem to exemplify a pure form of conceptual documentation. For one of his most enigmatic projects, *Reality Properties: Fake Estates*, Matta-Clark purchased at city auctions in 1973 fifteen tiny parcels of land in Queens—leftover spaces between other pieces of land, what he might have thought of as "cuts" in the property system that had been produced by anomalies of the system itself. "The description of them that always excited me the most," the artist told an interviewer, "was 'inaccessible.'" Apparently he never arrived at a definitive arrangement of the material from this project, though it was exhibited in 1974. Still, we can imagine that the simple framed juxtapositions of deeds of sale, maps, and black-and-white photographs shown here are much like what Matta-Clark had in mind. They are indices of next-to-nothing. Whatever one sees merely stands in for the gap the artist is trying to point to. As the critic Frances Richard once wrote of an entirely different work of Matta-Clark's, he "enters a glitch that he did

not cause but which, in a sense, he creates by noticing." (Later, he stopped noticing, and the city repossessed the lots for nonpayment of taxes—"me-tabolizing" them, as the artist might have put it.) The documents do not merely record what they show; to some extent they produce it, and this is how they differ from works that might otherwise be seen as their immediate precursors, such as another conceptual investigation of New York real estate, Hans Haacke's famous *Shapolsky et al. Manhattan Real Estate Holdings, a Real-Time Social System, as of 1 May 1971*, which documented a slum empire in the Lower East Side and Harlem. Haacke, more an investigative journalist than a poet, was interested in revealing the hidden connections of capital, not, as Matta-Clark was, in an imaginative exploration of its gaps.

With *Splitting* and then with the other, increasingly elaborate and playful sculptural interventions into buildings that followed, most notably in New York, Paris, Antwerp, and Chicago, however, Matta-Clark jettisoned the idea of objective documentation. Instead, the actions became subjects for films, videos, and photo-montages that eschewed the deadpan look of the *Reality Properties* byproducts in favor of lyrical, baroque, and elaborate aggregates of imagery that have little to do with the visual prose typical of conceptual art. Instead of simply recording the fact that a sculpture was done, these works are intended to offer, on a smaller scale, a visual equivalent for the bodily experience of exploring the dramatic and disorienting spatial effects that resulted from the building cuts. Few people ever had the full experience of not only peering at these from the outside, but actually entering and exploring them. There was risk to life and limb involved; a sometime assistant recalled that Matta-Clark "would start out being very whimsical and then he would get reckless. I was constantly worried about killing people or ourselves." The artist Lawrence Weiner really did fall through one of the works. Only those who did risk it can now judge how accurately the expe-riences offered by the photomontages correspond to what they saw and felt inside the sculptures. Still, the photographs have an intensity and bravura of their own that can't be gainsaid. They are dizzying, and you do feel like you could fall through them. In the Cibachromes of his last big projects, *Office Baroque*, in Antwerp (1977), and *Circus or The Caribbean Orange*, in Chicago (1978), the perspectives become hypnotic, Piranesian. Circular cuts in vari-ous directions seem to reveal unexpected layers, not only of space, but of time. The depicted cuts through floors and walls are doubled by the literal cuts to the constituent bits of film that Matta-Clark has sliced, spliced, and

blown up. And yet the conceptualists were extremely suspicious. Weiner saw Matta-Clark's photography as "one of his weaknesses," while Joseph Kosuth considered that there was a schizophrenic relationship between the two stages of his work, the buildings and the photos, and that the problem was only compounded by the fact that "the photographs are good."

In the meantime, that division has resolved itself: the buildings have disappeared. *Office Baroque* stood for several years, and after Matta-Clark's death a foundation was formed with the aim of forming a new museum of contemporary art around it, but the municipality of Antwerp had it torn down. This loss only makes the remaining traces of it on paper and film the more poignant—yet poignancy was there in all the building cuts from the beginning. "A collapsed room displays many more facets than a room intact," Stokes observed in an essay of 1961, comparing the mingling of inside and outside in the ruined buildings he had observed in the London of the Blitz with the multiplication of aspects displayed by Cubist paintings. The rooms Matta-Clark shows us are neither collapsed nor whole; broken up but holding together, they offer no sense of security but rather of risk and exposure. They evoke anxiety, yet transform it into exhilaration. They turn space inside out.

In 1978, at the age of thirty-five, Matta-Clark was suddenly overtaken by pancreatic cancer. An artist's early death can't help but provoke ponderings about what might have come next, but with great artists, the question, perhaps surprisingly, becomes less urgent than with those careers that never quite fulfilled themselves. Who laments Mozart's unwritten forty-second symphony? Matta-Clark, artist of fragments, left an oeuvre that feels whole.

2007

Beyond Exhaustion: Dan Graham and X Initiative

Over the last several years the Whitney Museum has co-organized with the Museum of Contemporary Art, Los Angeles, a sequence of important retrospectives of artists who, born within a few years of 1940, emerged in New York City around the mid to late 1960s, just after the Minimalists. Robert Smithson was the subject of the first exhibition in 2005, then Gordon Matta-Clark and Lawrence Weiner had shows in 2007. Each was in its own way a triumph. Arguably, this generation of artists (and of course they flourished not only in New York) represents at once the culmination but also the exhaustion of the Modernist project as it had played out over the preceding century. In their work, formal reflexivity and self-critique reached degree zero; language and action were revealed as ultimate abstractions of the art object.

Now it's the turn of another of their cohort, Dan Graham. The choice must have seemed a no-brainer. After all, Graham is something of a cult figure, especially among younger artists, perhaps because he's dabbled in many of the major artistic issues of the time, above all the relation of the artwork to its social context. And he seems to have garnered an ineffable aura of cool, in part because of his association with rock music—writing and making videos about it but also palling around with musicians (the catalog includes an interview with Graham by Kim Gordon, bassist with Sonic Youth and herself widely recognized as one of the coolest people in the universe). Graham is, as the exhibition's co-curator Bennett Simpson writes (in an essay focusing precisely on Graham and music), something of an artist's artist.

So I can't help but feel that I'm about to blackball myself from some invisible club when I say that, in contrast to the three shows I mentioned before, each of which I walked out of thinking that I'd discovered an even richer and deeper oeuvre than the one I already admired, "Dan Graham: Beyond" (curated by Simpson and Chrissie Iles) left me disillusioned. Graham's work turns out to be mostly a period piece—the product of a

brilliant dilettante who was, at least for a while, so in step with the zeit-geist that he sometimes appeared to be a stride or two ahead of it, an illusion that lent his work the appearance of an originality or strength it lacked. If you read the interviews with Graham in the exhibition catalog, it's fascinating how often he still speaks, not on behalf of himself, but of the group to which he felt he belonged, articulating a shared sensibility expressed as a series of likes and dislikes: "We hated Duchamp." "We loved Speer at that time"—referring to the Nazi architect. "We were all very influenced by Jean-Luc Godard." "We were very influenced by the French new novel, and the idea was not to use metaphor." Much of the exhibition feels like an anthology of illustrations of what a certain "we" found inter-esting in the late '60s.

Graham started out, not as an artist, but as a twenty-two-year-old wunderkind gallerist who sold nothing but latched onto some of the best new work of the moment in less than a year in business. The downside of his curatorial flair may be reflected in the fact that every issue he took up was developed more lucidly and with greater intensity by one or another of his contemporaries. His earliest efforts, formally self-reflexive work with language verging on concrete poetry, are all too successfully featureless and nondescript—arid and dutiful compared to text pieces by artists such as Carl Andre or Vito Acconci. His use of magazine pages as a medium—the great calling card for his first phase as an artist, thanks to the fame of his 1966 work *Homes for America*—is neither as coherent nor as surprising as that of Mel Bochner or Robert Smithson, whose collaboration *The Domain of the Great Bear*, which inaugurated this genre, was published shortly before *Homes for America*. And for that matter his fascination with suburban American housing, not only in *Homes for America* but in a work like *Alteration to a Suburban House* (1978/92), seems half-hearted when compared with Matta-Clark's furious engagement.

Graham's use of performance as recorded, at first on film, then on video, to examine embodied phenomenology recalls a host of artists at the time, among them Acconci, Joan Jonas, and Bruce Nauman. Starting at the end of the '70s, and increasingly in the following decade, Graham's interest in the feedback between body and environment, behavior and context, led to a form of art that seems halfway between sculpture and architecture—"pa-vilions," as he calls them, metal constructions with walls of glass and in particular of two-way mirror glass. "It's about spectators observing them-selves as they're observed by other people," Graham says. The notion is seductive, but in practice nothing much ever seems to come of it in Graham's

observation pavilions. People catch the idea of it and just move on. Graham's switch into architecture or something resembling it recalls, again, the trajectory of Vito Acconci—but Acconci's endeavors in this field have been far more playful, various, and challenging.

From the beginning, Graham's core concept has been that the artist's task is to construct, not a singularity, but an empty structure—or "schema" as he calls it—that can be indifferently filled by whatever content. In its first instance, this took the form of a procedure for describing "a set of pages" of any kind whatsoever—generating a text with no other discernable content than "[Number of] adjectives, [Number of] adverbs, [Percentage of] area not occupied by type, [Percentage of] area occupied by type," and so on alphabetically through "[Number of] words capitalized, [Number of] words italicized, [Number of] words not capitalized, [Number of] words not italicized." It's a kind of hyper-formalism—semiotic analysis as a Martian might perform it. If you believe that reading need not be pleasurable or enlightening, this text's for you.

What was brilliant about *Homes for America* was that Graham had found a schema that repeated itself at various levels, but with specific content as a structural lynchpin. His photos of boxy tract houses in serried ranks, "designed," in the artist's word, "to fill in 'dead' land areas" with "no organic unity connecting the land site and the home" since they were simply "separate parts in a larger, predetermined, synthetic order," were echoed by the boxy, mechanical style of his layout—"insistently squared away," as Carter Ratcliff once described it—and then in turn by the blank, listlike structure of the texts. These in turn echoed both the rectangular schemata of the underlying page design (which most designers try to overlay with something more organic and fluid rather than emphasize) and the blunt, uningratiating aesthetic of minimalist structure. Here, Graham's schematic approach operates at a multitude of levels rather than reducing everything to zero.

Graham's performance-based work is a set of schemata, too. The works have no predetermined content. They are open-ended structures meant to set up feedback loops between different people's behavior. Thus, as Graham says, "In *Past Future Split Attention* (1972), one person is describing the past of another person and that person is simultaneously talking about the future of the other person who's describing them." Watching the video record of one of these performances can be fascinating or boring or anything in between—it depends, not so much on Graham's concept, but on how "on"

the particular performers happen to be in the moment. Graham's schemata in such pieces are rather like the improv exercises actors use to loosen up their approach to character; the interest of the result depends more on the actors than on the designer of the exercise. Or to put it a different way: such works seem designed to elicit unforeseen psychological or proprioceptive material from their performers—yet Graham never shows any particular interest in working with the material that arises, developing it from one piece to the next. It's there simply to "fill in 'dead' areas" in his schema.

Graham's pavilions can be seen as a form of display architecture in which the audience itself is what's put on display. He is attempting to get the public to do what, earlier, he had depended on performers (among them, sometimes, himself) to do. "I thought the people themselves, the spectators, should be inside a showcase situation looking at themselves perceiving each other"— that was the thought behind *Public Space/Two Audiences*, which Graham presented at the 1976 Venice Biennale. It is simply a room divided in half by glass so that the people in each side function as moving images of each other. With the pavilions he developed this thought in freestanding constructions rather than adaptations of existing rooms—but likewise using the interplay of opacity, reflection, and transparency to turn people into dreamlike apparitions for each other.

By now, Graham has made some fifty pavilions, some of them adapted for particular uses (*Skateboard Pavilion* [1989]; *New Space for Showing Videos* [1995]; *Girls' Make-Up Room* [1998–2000]), but all essentially running through minor variations on the same scheme. Architectural historian Beatriz Colomina suggests seeing this "global army" of pavilions as "a single artwork, a single experiment," but the experiment has long since petered out. If Graham's earlier work was characterized by a nervous energy that impelled him to leave things half-developed in order to try something new, the last quarter-century of his career has been devoted to dogged repetition. The fox has turned into a hedgehog. But in neither case has he deepened and explored his ideas; he merely recycles them. That's probably another great source of his appeal to younger artists: his ideas are still available for their elaboration. And precisely because he realizes his ideas in such an offhand way ("I basically do fast sketches, fax them to my architects, we do a site visit, and then they bring one or two possibilities for glass") he makes it all seem easy. But Graham's is not the deceptive simplicity that opens up to ever more unexpected implications. It's just facile thinking, and a formula for perpetuating a franchise.

<p style="text-align:center">✻ ✻ ✻</p>

I'll bet that if you asked any of the three up-and-coming artists currently showing at X Initiative what they think of Dan Graham, they'd tell you without giving it a moment's thought that he's a great artist. And yet at this moment, anyway, I think any one of them is more interesting—even the one whose work is the least developed, the youngest of them, Tris Vonna-Michell, an English artist born in 1982. At first glance, his exhibition consists mainly of a sparse array of tables with various objects on them, along with a couple of slide projectors; but at each station there's a set of headphones, and that's where the real action is, because Vonna-Michell isn't primarily an installation artist; he's someone who's perhaps too easily taken on, unexamined, the convention that an installation can be the remains of an event—not the schema but the debris it catches hold of.

But what Vonna-Michell really is, is a performer—or to be more specific, a talker. Put on one of the headphones and you'll find yourself in the midst of a not-quite-graspable narrative monologue. Part of Vonna-Michell's shtick is that his talks are supposed to be given in a predetermined duration—one that's always too short for the amount of material he has to convey. It's not clear what ratio of memorization to improvisation is involved, but the incredible rush of Vonna-Michell's seemingly free-associative verbiage is meant to sound almost out of control; there's something very seductive about the urgency with which he spits out his semicomprehensible, stuttering tales of, say, trying to explore the history of Berlin by way of its streets, subways, and train stations. Yet I can't help but feel there's something too evasive here, for all the admirable formal reflexivity and multilayeredness of the artist's self-refractive tale-telling; a tale told very slowly might be more enigmatic than one that runs away from you as it runs away with its teller.

Luke Fowler, born in Scotland in 1978, is one of a number of younger artists these days who are playing—I might even say toying—with the conventions of documentary film. Fowler has even set up a sort of movie theater in the middle of his space, with seats and everything, pretending to eschew the conventions of video installation even as he knows full well that building a cinema in the middle of an art gallery just is another way of making an installation. One film is a biography of an eccentric musician called Xentos Bentos. I took it as parody documentary about an invented subject—not a hoax, because it was all too outrageous to be taken for real, but a pastiche. But second thoughts and an internet search convince me that there really was a Xentos Bentos—although not much information is available about him and almost every occurrence of his name seems to be

preceded by the word "mysterious."Yet I still think the film is a parody—but the joke is all in the style, and the facts, after all, are probably straight-on. Stewart Home has called Fowler's style "a pop appropriation of underground film techniques," but the point seems to be that a ragged, verité style in which no strong authorial viewpoint seems to be imposed on the material is just as artificial as any other. *Pilgrimage from Scattered Points* (2006) concerns the British avant-garde composer Cornelius Cardew, who started out as a follower of Karlheinz Stockhausen and ended as a Maoist proclaiming: "Stockhausen serves imperialism." Made up mostly of period footage, the film has something of the ramshackle feeling of Cardew's own efforts to make music democratically with amateur musicians—yet from a disillusioned perspective that recognizes both the inspirational and the absurd aspects of the composer's failed quest. The delicately maintained neutrality is almost dreamlike.

What Fowler does for documentary, the Berlin-based Israeli artist Keren Cytter does for nearly every film genre imaginable—tear-jerker, melodrama, sitcom, thriller, Bergmanesque spiritual self-examination, you name it. She takes them to pieces and examines the fragments with loving yet ironic fascination. Like Fowler, she treats the makeshift as a stylistic apparatus: "When I shake the camera I suppose you could say I'm trying to impress by consciously employing a 'homemade aesthetic,'" as she once told an interviewer. Her medium is video but she calls her works films; it's hard to think of anyone who's manifested quite as voracious an appetite for cinematic sensation since Graham's old favorite, the young Jean-Luc Godard. At X Initiative she has installed her work—in contrast to the seeming purity of Fowler's approach—as an "immersive experience," meaning that the films are placed and sequenced in such a way as to set the viewer into motion. As one film ends, you can hear but not see another one start up somewhere else in the space; by the time you've reached it, you've already missed the beginning—you're *in media res*. It works because the structure of the exhibition echoes that of the individual films, which also seem without clear beginning or end and repeatedly take the viewer by surprise with abrupt shifts that are no more predictable than the changes in direction of the path through a labyrinth in which one is lost—trapped as her characters are trapped in the stereotypical roles they've taken on.

X Initiative, by the way, is the building that used to be the Dia Foundation's exhibition space on West Twenty-second Street. It was the home to some of the shows that linger most poignantly in my memory from the period

between the late '80s and the beginning of the present decade, among them impeccable, long-running presentations of artists like Robert Ryman (1988–89), Lawrence Weiner (1991–92) Jessica Stockholder (1995–96), and Fred Sandback (1996–98). Since 2004 the building has been empty; now a group spearheaded by gallerist Elizabeth Dee has got the use of it for a year. The use they're making of it has not gone without criticism; in *New York* magazine, Jerry Saltz, for instance, called its first round of shows, which I missed, "a bit dry (and too close to Dee's exhibition program: She has shown two of the three artists)." Of this second round, it has been widely noted that all three artists were also just included in the New Museum's "The Generational: Younger Than Jesus." Since X Initiative director Cecilia Alemani is the girl-friend of New Museum curator Massimilano Gioni, it's hard not to feel that an organization that idealistically calls itself "an initiative of the global art community, with a goal to inspire and challenge us to think about new possibilities for experiencing and producing contemporary art" has an exceedingly narrow, if not tribal, sense of the global. But the fact remains that X Initiative has done a great service by enabling these three artists to present their work on a scale far beyond what a commercial gallery could house or a museum could justify. For the year, at least, New York City has a *kunsthalle* big enough to suit it.

2009

Refutation of the Refutation: Jeff Wall

Jeff Wall is one of the best-known photographers working today, and he is one of the best-known artists. That pair of statements is not the tautology it may seem to be. Wall came of age during the heyday of "artists who use photography," among them the loose-knit group of artists known as the "Pictures Generation" whose work was featured in a big exhibition at the Metropolitan Museum two years ago. Contemporaries of Wall's like Richard Prince maintained an ironic distance between their own practice and any task as plebeian as creating an image; after all, the world is teeming with images, and all the artist needs to do is to treat them as readymades and repackage them under the aegis of a new idea.

 Early on, Wall also helped bring photography from the margins of the art world to its center, but in a very different manner. His aspiration was twofold: to make a kind of photography that would rival, both as visual spectacle and intellectual resource, the grandest works of the European painting tradition—to make an art worthy of museums, like Cézanne wanting to make something as solid as Poussin after Impressionism. In 1978 Wall began producing color images on a scale that was unprecedented for art photographs (which had typically been printed at about the same size at which they might have been reproduced in a book or magazine), using rich, saturated color. Two years earlier William Eggleston had caused an uproar by showing color photographs at the Museum of Modern Art. The dye-transfer process Eggleston used had been developed for commercial projects such as billboards, but he never considered printing his pictures at billboard scale. Wall did, though he used a different process. His works were color transparencies mounted on gigantic lightboxes. The presentation nodded to a form of advertising display, and the works' fluorescent backlighting gave them an eye-catching, almost aggressive luminosity. But the evocation of profane commercial culture was counterbalanced by understated yet insistent allusions to art history and critical theory. Wall's work was as certifiably intellectual as conceptual art, but without the visual poverty typical of

conceptualism. It was as slick as Pop Art, but without the vulgarity, and as formally rich and thematically resonant as the classic art of the past, and yet contemporary and immediate, not neoclassically stuffy.

In wanting to make photography an art for the museum—for the great hall, not the library or the print room—Wall has succeeded more than he could have hoped. In the last few years alone there have been three major presentations of his work: one at the Schaulager in Basel and the Tate Modern in London; another at the Museum of Modern Art, the Art Institute of Chicago, and the San Francisco Museum of Art; and a third at the Deutsche Guggenheim in Berlin. But there can be too much of a good thing; maybe Wall's work is becoming over-familiar. Certainly a reaction has quietly set in. Has Wall lost his edge, become too much the official artist? I've heard this opinion voiced, perhaps not in so many words, by more than a few colleagues. A more grounded expression of discontent was recently put forth by Julian Stallabrass in the *New Left Review*. Stallabrass attributes Wall's success to what he labels "the conservative and spectacular elements of his practice," which he sees as intensifying markedly in recent years, "increasingly accompanied by other conservative elements," by which he means a retreat from the leftist political commitment previously manifested both in Wall's imagery and his writing. For Stallabrass, this withdrawal is epitomized by Wall's remaking of his *Eviction Struggle*, from 1988, as *An Eviction* in 2004, which transformed an image of class conflict into an anodyne and universal "meditation on human imperfection."

On the face of it, Stallabrass argues a pretty credible case, and his target would hardly be the first artist to have grown complacently conservative with age. After all, success conspires to translate art's discoveries into platitudes, to divert the artist from making to managing (not only staff but one's career and the interpretation of one's work), and to focus his mind on interests that appear to coincide with those of the wealthy who sustain him through their patronage. Yet "Jeff Wall: The Crooked Path" (named after a 1991 photograph by Wall), an exhibition at Bozar, the Palais des Beaux-Arts in Brussels, left me thinking that to dismiss Wall as an artist past his prime, or to write him off as purveyor of mere "advertisements for what exists," as Stallabrass finally does, would be shortsighted.

The Bozar exhibition, curated by Joël Benzakin in close collaboration with Wall, is unusual in form, and suggests that Wall has not been so seduced by success as to have become insensitive to the dangers of overexposure. Although the exhibition has been conceived on a large scale and mounted

in ten rooms, it includes just twenty-five of Wall's works, ranging in date from 1978—the first of his lightbox images, *The Destroyed Room*—through 2010. Along with these are some 130 works by other artists (painters, photographers, writers, and film directors) who have influenced Wall or formed part of the context for his development. While the tight selection means parts of Wall's oeuvre are left out, the exhibition is far more revealing than it would have been if the entire space had been filled with works by Wall, as convention would have dictated. The approach reveals a lot about Wall's aesthetic and his connoisseurship but also, more broadly, about the complexity of any artist's formation, and especially the productive tension between his various and seemingly irreconcilable influences. The provisional resolution, unraveling, and renegotiation of these tensions gives the work much of its changing character.

One thing that's missing from the exhibition, unfortunately, is any more than a glimpse of what Wall had been up to before *The Destroyed Room*. He was in his early thirties by then and had already taken something of a crooked path. He'd studied fine art and art history at the University of British Columbia, and quickly began exhibiting text-and-photo–based conceptual works around Vancouver; some of these resemble the magazine pieces of Dan Graham and Robert Smithson (which have been included in this show, even though Wall's own works in this vein have not). His work was selected for "Information," an important international exhibition of conceptual art at the Museum of Modern Art. In 1970 he left his home town and his art practice to take up doctoral studies at the Courtauld Institute of Art in London, where he began researching a dissertation on Marcel Duchamp. He returned to Canada in 1974, the dissertation abandoned, but did not exhibit again for four years.

A hint of this history can be found in the show's first room, which includes Marcel Duchamp's *Manual of Instructions for the Assembly of Étant donnés: 1°: La chute d'eau, 2°: Le gaz d'éclairage* (1966), and a 1959 Duchamp collage related to the same project, the French artist's last work. The instruction manual is not properly a work of art, but one of those paralipomena that Duchamp's work generated in such quantity; the collage, on the other hand, is an artwork, at least according to Modernist criteria that undermine the distinction between studies and finished works (though Duchamp's thinking might be taken to undermine those criteria in turn). Besides evoking Wall's doctoral research, the two Duchamps point not only back to the kind of art that Wall had abandoned in order to study art history, but also forward to what Wall would undertake in 1978: the *Manual* evokes the conceptual art

that was starting to be made just around the time that it was compiled, while the collage, with its disjointed reconstruction of a landscape, indicates the possibility of a reconstituted "tableau" such as Wall has subsequently become known for. Duchamp stands here like a herm looking in both directions. And the show makes clear that Wall's turn toward tableau, the self-sufficient photographic image grounded in art history, was not his alone. Two works from 1977 by his close friend, Ian Wallace, show him already partway there; their art-historical quotations are too obvious—*The Calling* cites Caravaggio; *The Studio*, Courbet—yet they manage to make something striking of their citations.

The tension between the conceptual dissolution of the image and its self-conscious reconstruction as tableau is further developed by other choices Wall and Benzakin have made. Especially notable is the inclusion of divergent approaches to photography. On the one hand, there are conceptualists such as Graham and Smithson, as well as Chris Burden, Douglas Huebler, and Hans-Peter Feldmann, who used the medium with a kind of indifference. On the other hand, there are "classic" straight photographers like Eugène Atget, Walker Evans, or Weegee, and their successors such as Diane Arbus, Garry Winogrand, and Stephen Shore, who were fascinated with photography as a medium in its own right. At first, Wall's photographs were regarded as being closer in spirit to conceptualism, because of their evident constructedness, an absence of spontaneity that created a sense of mental distance from their ostensible subjects, as if they were diagrams disguised as pictures rather than true pictures. But Wall's emphasis on the autonomous image distinguishes him equally from conceptualism and from classic photography, in which images were typically subsumed into a photo-essay in a magazine, a book, or occasionally an even grander overarching sequence like August Sander's life project "People of the Twentieth Century." They were not primarily meant to be seen as isolated images on a wall.

Wall's somewhat younger German contemporaries Thomas Struth, Thomas Ruff, and Andreas Gursky, whose works appear in "The Crooked Path," were all students of Bernd and Hilla Becher. The Bechers' gridded arrangements of photographs illustrating building typologies (coal bunkers, coal ovens, blast furnaces) might be the ideal meeting point of conceptual and documentary photography, but while the students adopted the Bechers' deadpan eye, they ditched their typologies and, like Wall, went for color and big scale. Even Ruff, whose portraits from the 1980s, often compared to gigantic passport photos, insistently present his subjects as "types," uses

intense detail to present each quasi-anonymous person as a sort of self-contained alien landscape. In so doing he places the emphasis firmly on the individual image, if not the individual person. "In the light of these artists," Wall says in the catalog, "the Bechers appear to be the last of a lineage," crowning but also exhausting two traditions that subordinate the image to the system of images. (I would argue that the rise of the Internet has turned the tables once again and created a new opening for the subsumption of the image to system—but that's another story.)

Among the other works in "The Crooked Path" are several by the American Minimalists of the 1960s, their presence ostensibly meant to show their influence on Wall's use of scale (though one can't forget that the fluorescent tubes Dan Flavin used for his sculpture are cousins to those illuminating Wall's transparencies from behind). A film program includes such *auteurs* as Robert Bresson, Jean Eustache, and Terence Malick; there are displays with original editions of literary works Wall has used as sources (Franz Kafka's "Cares of a Family Man," Yukio Mishima's *Spring Snow*, Ralph Ellison's *Invisible Man*) or that have had more indirect influence on his work (*Nadja* by André Breton; *Documents*, the magazine Georges Bataille edited in 1929–30). Finally, there are works by younger artists Wall keeps an eye on, including some interesting painters, such as Luc Tuymans, Kai Althoff, and Kerry James Marshall. Their inclusion might be a perhaps inadvertent reminder of the otherwise marginal place of painting in the show (otherwise there are only a couple of early Frank Stellas in the section on Minimalism). This is only surprising because Wall's photographs are full of allusions to the history of painting, and because, despite his love of classic photography and cinema and his fascination with conceptual art, the European painting tradition from the Renaissance to the beginnings of Modernism (in the work of Manet) is the lineage Wall wants his art to be measured against. What Wall says of Marshall is clearly meant to apply to his own efforts: "If he's involved in what you might call a 'refutation of the refutation' of the pictorial tradition, that suggests that what he's doing is not simply a continuation of that tradition, but a new relation with both the tradition and the critique of the tradition."

Naturally, it would not have been possible for the Bozar to borrow *The Death of Sardanapalus* or *A Bar at the Folies-Bergère* for an exhibition like this. And even if it had, their glorious presence might have upset the balance: Wall might no longer have been the focus of the exhibition, only its occasion. Although as the show now stands his works are greatly outnumbered, thanks to their scale they still dominate; a dozen early-twentieth-century

black-and-white photographs can be shown on a wall that just one of his pieces would occupy. Besides, Wall's connections with painting from before the twentieth century have already been much commented on—too much so, according to Stallabrass, for whom "making art-historical references is one of the most reliable tactics to get a work discussed as if it is art." Apparently Stallabrass does not consider that artists become artists because they love art, because they want to steep themselves in it, and that the most natural thing in the world for them is to take the art they know as a reference point. For him, art that remembers the work of many masters is merely "a form of social display . . . indelibly marked with the inequalities of class, education, and the opportunity for cultured leisure." That these references are to painting, not to photography, is worse still in his eyes: Wall is somehow traducing his medium through a confected relation to one considered more prestigious.

But Wall came to photography through art, not to art through photography. Is it strange that his long view of art's development does not begin with the invention of photography in the mid nineteenth century? Although Stallabrass is a photographer as well as an art historian—and, like Wall, a product of the Courtauld Institute, where he currently teaches—one could almost imagine, reading his essay on Wall, that he'd had no contact with living artists or the process of art-making, imagining it only as a thing of use—either in the good cause of political agitation or the bad one of careerist self-advancement. For him art can only be radical sociology or conspicuous consumption.

Though Stallabrass sometimes pushes his argument so far that it would be inconceivable for any artist working within the existing gallery and museum system to satisfy its conditions, the question remains: Is Wall's an art in decline? Has it sacrificed life-giving conflict for an insipid harmony? Stallabrass is not the only one to think so. David Campany has recently published an in-depth, book-length analysis of one of Wall's most famous early works, *Picture for Women* (1979), which concludes with the damning observation that since Wall made that work, his art "has grown more likeable than admirable." Peter Osborne sees Wall as having sold his birthright—an art "distinctively 'Post-Conceptual' in its combination of a medium-based practice with a strategic conceptual content"—for a formalist pottage. Why? "Something snapped," is all Osborne can say; it seems that Wall grew tired of thinking so hard.

The source of Osborne's remarks, by the way, is his contribution to the catalog for "The Crooked Path"—the only catalog I've ever seen that admits

severely critical views alongside the usual encomia. This alone makes me wonder whether it can be claimed that Wall has lost all taste for conflict. Besides, *Eviction Struggle* and *An Eviction*, the pair of works that Stallabrass uses as a case in point, might not be entirely indicative of Wall's career (they are not at the Bozar). Wall's earlier pieces may not be quite as conflict-laden as they seem, or anyway not in quite the way they seem. *The Destroyed Room* shows what seems to be the aftermath of some catastrophe but not the action that caused it. And it underlines its own artificiality: one cannot but be conscious of it as a staged emblem of ruin rather than a record of the real thing. The photograph *Milk* (1984) shows a young guy with stubble and greasy hair squatting on the sidewalk; in one hand he holds a milk carton in a brown paper bag, its contents exploding in a rather spectacular stop-action splash à la Harold Edgerton. It is easy to see *Milk* as an evocation of the homelessness and addiction endemic to Vancouver—but then shouldn't it be whiskey, or at least Mad Dog 20/20, rather than milk in that brown paper bag? Wall seems to be playing a joke on the viewer's sociological eye, though without quite contradicting it.

In what might be the best of Wall's earlier works, *The Storyteller* (1986), some men and women, evidently First Nations people, are hanging out on a patch of scruffy terrain adjacent to a highway overpass. Wall's mastery of scale comes into its own here—the landscape, though hemmed in by a stand of trees of one side, the highway on the other, seems vast, yet it does not overwhelm the figures in it, however small they are in relation to the rectangle that contains them. Three figures sit around a small fire in the left foreground. One, presumably the eponymous storyteller, gestures animatedly; two others loll further back near the trees; one sits separate, far off to the right, on the rock pavement under the overpass. Why are they taking their leisure here, of all places? Can it be that, of a whole continent that had once belonged to their ancestors, this narrow and inhospitable strip of land is the only place left for them to relax? Yet undoubtedly the image's gently ironic pastoral overtones—the slight echoes of Seurat, even of Matisse (the pose of the solitary figure on the right recalls that of a figure in his 1910 painting *Music*)—have their place. In spite of everything, these people do have their storyteller and their story, and though we might not hear it, both survive within their dispossession.

The Storyteller is what Thierry de Duve (following Walter Benjamin) once called a dialectical image. Wall's most recent pictures, no longer mounted on lightboxes but still made mostly on his accustomed grand scale, are dialectical images, too. If they aren't quite as poignant for me as some of

his older works, I suspect that's mostly because I have had more time to think about the earlier pieces, to let their colors, allusions, and oblique imagery seep in. When I first began seeing those works they left me feeling a little flat and quizzical, just as the recent ones do now. They weren't quite answering my questions of them because they were inciting me to new questions I didn't know how to pose, and the same may be true of Wall's new pieces.

The most immediately arresting of them is *Dressing Poultry* (2007), which shows four workers in an industrial shed doing just what the title says. The woman in the foreground is laughing as she does her job; apparently someone's just cracked a joke. As Stallabrass says, "the scene is almost a cheery one"—which for him is suspect. Apparently, the workplace should only be represented in the form of an exposé. I don't see it that way. There is a place in art (and not only in journalism) for muckraking, but there's more to art and life (even under neoliberal capitalism) than that. I once worked in a place not too different from that shed, and what I remember about it is how my coworkers and I got through our day by singing Beatles songs. It's because work can be oppressive that part of the heroism of daily life is learning to make the best of it, to take it lightly. People working share forms of communication that go against the grain of their labor. *Dressing Poultry* draws its thoughtfulness and power from the way it registers this quotidian struggle. It means a lot to me that, although Wall is unlike most other people in his capacity to control his own work, his art can still meaningfully evoke a day in the life.

2011

A Fan's Project: Thomas Hirschhorn

The last big work of Thomas Hirschhorn's I saw was *Crystal of Resistance*, shown at the Swiss Pavilion of the Venice Biennale two years ago, an immersive environment in which, as I wrote at the time, "Information overload becomes a concrete corporeal sensation, yet individual details never stop arresting your gaze." Hirschhorn's latest effort, *Gramsci Monument*—either "commissioned" by the Dia Art Foundation (according to the Dia website) or "produced" by it (per gramsci-monument.com), not that I understand the difference—is a different kind of piece altogether, and has been created for a very different sort of context. I should admit that although I haven't yet been able to get to this year's Venice Biennale, I've gone there a lot more often than I've been to the setting of *Gramsci Monument*; and likewise I've flown more often to Paris or Copenhagen, from where my most recent columns for the *Nation* were filed, than I've taken the subway to the South Bronx, which is where Hirschhorn's new piece has been constructed on the grounds of Forest Houses, a project that is home to more than 3,000 people in four high-rise buildings built in the mid 1950s.

Among the things that art can do is change perception simply by changing the context in which perception takes place: Consider the still-ramifying effects of Marcel Duchamp's gesture of transporting a urinal from the plumbing supply store to an art exhibition. But it's not only by recontextualizing objects that perception can be altered; recontextualizing the perceiver sometimes works just as well. And so for myself (of course this might not be true for many others who've gone to visit *Gramsci Monument*) the unfamiliar context was in itself significant. I don't want to make too much of this—and I certainly don't intend to claim that getting middle-class people who normally never set foot in a housing project to make their way to one is any big deal, or Hirschhorn's primary intention. But it seems at least as significant as heading out to the Great Salt Lake in Utah or the plateau in New Mexico (where famous earthworks by Robert Smithson and Walter de Maria are located). If anyone ever thought that a quick visit to a housing

project could itself be enlightening, the idea is disproved by the fact that Mayor Bloomberg, whose job has surely taken him on ceremonial visits to many such places over the last dozen years, thinks that the best way to ensure the well-being of their residents would be to fingerprint them one and all. Call me naïve, but I didn't notice anyone lurking around who looked in need of fingerprinting.

In any case, Hirschhorn's monument to the great writer and political theorist (and co-founder of the Italian Communist Party) Antonio Gramsci—the fourth and last in a sequence of works sited in public housing projects that began with a *Spinoza Monument* in Amsterdam in 1999 and continued with a *Deleuze Monument* in Avignon in 2000 and a *Bataille Monument* in Kassel, Germany, as part of Documenta 11 in 2002—isn't simply located in a housing project the way other artworks are located in museums, private homes, or public plazas. Though not exactly a site-specific work, it would seem to have been made with the specific intention that it be a work of art whose primary audience is not assumed to be the art world. It's not necessarily for the residents of a housing project either, but potentially for anyone: no prequalification necessary. Or rather—since in fact most good artworks are made that way—it would be better to say that with *Gramsci Monument* Hirschhorn makes an issue of the potential equality of all viewers. Hirschhorn once said of his work, "The production must be able to interest an uninterested audience." The fact that he's constructed the work in a place where people who don't often go to galleries or museums live is only one of the ways that Hirschhorn evokes this egalitarian ethic of art. But still it's interesting, isn't it, that "project" is such a valorized word when people discuss the arts—no museum can lack a project room, and every artist wants his or her work recognized, not simply as an assortment of mere things, but as the expression of a genuine project—and such a maligned term when it comes to creating places for people to live? As a culture, we don't really believe that housing is or should be a project, that living in common is a project, and so for most of us a housing project can only be imagined as a last resort. But in response to *Gramsci Monument*, Fred Moten has written a poem that begins,

> if the projects become a project from outside
> then the projects been a project forever. held in
> the projects we're the project they stole. we steal
> the project back and try to give it back to them.

and ends,

let's do this one more time. the project repeats me. I am repleat
with the project. your difference folds me in cadillac arms.
my oracle with sweets, be my confection engine. tell me
how to choose. tell me how to choose the project I have chosen.
are you the projects I choose? you are the project I choose.

Knowingly or not, Moten is reiterating and extending the Romantic writer
Friedrich von Schlegel's observation that projects are "fragments of the
future."

If I wanted to be mean, I could say that Hirschhorn might have built his
Gramsci Monument in order to make a high-rise housing project look better
by comparison. Actually, though, the Forest Houses look pretty good
already—well-kept, from what I could see from the outside, and with lots
of green space. And then there's this little shantytown kind of thing that
seems to have landed in the middle of it, as if shantytowns could just come
down from the sky like UFOs: a set of unpretty jerrybuilt plywood rooms
clustered together with walkways and bridges between and around them.
It's a self-evidently antimonumental kind of monument, and not just because
of its seemingly ramshackle (or, as Hirschhorn himself likes to say, *precarious*)
appearance (and I emphasize the word "seemingly"—I think everything's
really nailed down pretty tightly; Hirschhorn is not Swiss for nothing, after
all). The really antimonumental aspect of the piece is the absence in it of
any point of iconic focus. For Hirschhorn, "the tendency to iconism is the
tendency to 'highlight'; it is the old, classical procedure of favoring and
imposing, in an authoritarian way, a hierarchy." He would rather be a leveler.
At no point does *Gramsci Monument* seek to present an "impressive" form or
assert a symbolically charged presence. Early in his career, Hirschhorn
countered Mies van der Rohe by proclaiming, "Less is less, more is more,"
but here he's asserting more of less.

In fact, I can imagine someone standing right in the midst of it and asking,
"Where's the monument?" Instead, there is this series of plywood rooms,
"impressively unimpressive" as an artist friend of mine put it, fitted out with
old furniture that's been wrapped with brown packing tape (one of
Hirschhorn's signature materials) to both keep stuffing inside them and
render them more uniform and less visible. In place of the overload of
collaged imagery that was so striking in *Crystal of Resistance* two years ago,
there is very little to "look at" here. Instead, there is a lot to read, or at least
to think about reading: from banners here and there spray-painted with

quotations from Gramsci's notebooks—his most influential work, written during his imprisonment by Mussolini from 1926 until his death in 1937—to an extensive library of writings by and about Gramsci (including Italian originals) and related topics by way of all sorts of photocopied documents affixed directly to the walls of the *Monument*, and a daily newspaper edited by two residents of Forest Houses. And the monument is a place for the spoken word as well, with a program of daily lectures, readings, discussions, open-mic sessions, and so on, as well as activities such as art workshops for kids and an "art school" for adults led by Hirschhorn himself. There is a "bar"—more of a luncheonette, really, with no alcohol but soda, coffee, and water, as well as two-dollar burgers and hot dogs—a radio station, an internet corner, and so on.

All of which is to say that *Gramsci Monument* is more of a place than a thing, closer to architecture than sculpture, a ground rather than a figure. Whereas in *Crystal of Resistance* it was hard to stop looking—often looking in horror, since much of the imagery included in it was intensely violent—in *Gramsci Monument* you're more likely to find yourself looking for something to look at, and most of the time you won't find it. But that's where the peculiar and rather perverse artistic success of the piece is to be found, I think: in the way it keeps telling you that something beautiful could be here—but only if you, meaning we, make it. Perhaps that's why Gramsci is an apt dedicatee for such a project: because of his insistence on collective agency and, of course, the famous edge he gave to optimism of the will over pessimism of the intellect.

His four "monuments" aside, Hirschhorn has often dedicated works to figures—artists, writers, philosophers—who mean much to him: there have been "kiosks" for the writers Robert Walser, Ingeborg Bachmann, and Emmanuel Bove, and for the artists Otto Freundlich, Meret Oppeneim, Fernand Léger, Emile Nolde, and Liubov Popova, for instance; and "altars" for Piet Mondrian, Raymond Carver, and, again, Bachmann—the great German poet and novelist—and Freundlich, the German-Jewish artist, a proponent of Dada and abstraction, who died in a concentration camp in Poland after having been deported from France in 1943. This propensity to append another person's name to one's art, to work in homage, is surprisingly rare among artists. It's often a peculiarly emotional gesture, almost mute yet poignant, and the artists who are given to making it seem by that very token to have something important in common. I can't help but think of this observation by Roland Barthes, in a famous essay of his about the

American painter Cy Twombly, some of whose works consist solely of an inscribed dedication:

> "To dedicate" is one of those verbs which linguists, following Austin, have called "performatives" because their meaning merges with the very act of enouncing them: "I dedicate" has no other meaning than the actual gesture by which I present what I have done (my work) to someone I love or admire. This is exactly what Twombly does: since it bears only the inscription of the dedication, the canvas, so to speak, disappears, and only the act of giving remains—and this modicum of writing necessary to express it. These canvases are at the boundaries of painting not because they include no painting at all (other painters have explored this limit) but because the very idea of a work is destroyed—but not the relation of the painter to someone he loves.

Dan Flavin was another artist who, like Twombly, was particularly given to the gesture of dedication—among his otherwise usually untitled neon light icons are dedications to Henri Matisse, William of Ockham, and, also, as it happens, Otto Freundlich; most memorably, perhaps, there is one "(to a man, George McGovern)." Flavin's art can seem at first cool and undemonstrative; these dedications point us to the passion that is what really lights the work up. They remind us that Flavin is a kind of Romantic.

Hirschhorn, too, is a belated Romantic. I emphasize the emotional tenor of his art, as conveyed by his dedications, because, with his love for philosophy and his political fervor, he is often taken for a theoretically driven artist, kind of intellectual by other means. So you might think, for instance, when a critic nods in approval at the way Hirschhorn, in his view, "updates the argument" of Walter Benjamin's essay "Author as Producer," or when another says that the imagery in one of his installations suggests "an empirical study of the subjects currently favored by the mass media." Hirschhorn is certainly caught up in Benjaminian issues like the political valency of an artwork, and he's clearly fascinated with the functioning of the media, but not in any cerebral or academic way. Enamored he may be of philosophy and philosophers, but in the nearly 400 pages of his hefty new publication, *Critical Laboratory: The Writings of Thomas Hirschhorn*, edited by Lisa Lee and Hal Foster, there is scarcely a single sentence of any philosophical bearing. Hirschhorn is neither analytical nor reflective. If you're wondering which arguments of Spinoza seem particularly convincing to him, forget it. What you learn is, simply, "I am a fan of Spinoza." Likewise, if you want to know

his precise view of Bataille's philosophy of transgression, you're in for a disappointment. Why Bataille? It's simple: "I am a fan of Georges Bataille."

Critical Laboratory is a tough read, and not because Hirschhorn is trying to turn intellectual cartwheels like the theory-savvy artists of the 1980s with their endless invocations of the Lacanian mirror stage and the Baudrillardian simulacrum. It's that there's rarely been an important artist quite as inarticulate as Hirschhorn. He can be almost excruciating at times, and I wouldn't recommend that anyone read the book straight through except on assignment, but you do eventually get used to Hirschhorn's blustery verbal awkwardness. Taken in small doses at a time, it offers valuable insights into one of the most original artists of the time, and finally it even becomes kind of lovable, not simply because it's utterly sincere but because sincerity clearly is the right guide for his art.

One way that Hirschhorn often describes his way of doing art is by using the word "headless." But "'headless' does not mean stupid, silly, or without intelligence," he insists; "'headless' does not mean being ignorant." Rather, his "headless" sounds more like what I'd call "headlong" or "headstrong": headlessness, he goes on, "stands for doing my work in a rush and precipitously. Other words for headlessness are restlessness, insisting and insisting again heavily, acceleration, generosity, expenditure, energy (energy = yes! quality = no!), self-transgression, blindness, and excess." All the Bataillean signifiers are there, but coming from Hirschhorn they don't sound secondhand, and it's impossible not to cheer him on when he continues, "I never want to economize myself and I know that—as an artist—I sometimes look stupid facing my own work, but I have to stand for this ridiculousness. I want to rush through the wall head-first; I want to make a breakthrough; I want to cut a hole, or a window, into the reality of today." It's true that every art school class includes an intense, self-absorbed, overly earnest young man who makes pronouncements like that; but at least some of the time Hirschhorn really does seem to cut a hole into reality, and therein lies all the difference.

But it's one thing for an artist to make a public disclosure of his private and impossible offering to William of Ockham or, as Twombly did, to Paul Valéry, and quite another thing to do as Hirschhorn has done, and put more emphasis on the public dimension of his passion's manifestation than on its inner force. Still, at a time when many artists are proposing to do collaborative works in marginalized communities, to intervene in real life, practically to become a species of social worker, Hirschhorn, by contrast, even when

he makes his work in the midst of a housing project, insists that it is autonomous art; when he approaches a community to propose a project, he makes this clear: "I don't want to help you or ask you how I can help. Instead, as the artist I am asking, Can you and do you want to help me complete my project?" The artist's generosity becomes manifest, not in an attempt to help others realize their needs, but when he reveals his vulnerability in asking others for help in realizing his own need.

But there's contradiction lurking here. Even as he invites others to help him accomplish his project, Hirschhorn would like to think his work is autonomous. "In my works in public space the context is never the issue," he writes. "I want to show my work everywhere, without making a distinction between important and unimportant places, just as I don't want to distinguish between important and unimportant people." All well and good, but then he needs to point to Gramsci as an important person, and rightly so. Just as he calls himself a fan of Bataille, he would probably call himself a fan of Gramsci; and to be a fan means raising your hero above the common herd. It's to make a person—or your inner image of the person—into an icon.

In pointing to this contradiction, I don't believe I'm pointing to a weak spot in Hirschhorn's art. On the contrary, I mean to point to its animating tension, the source of its power—which as he well knows is inseparable from its precariousness. It's a tension, a passionate indecision, that is insistently present throughout his work, between his desire to find the equivalence or equality between everything and everything else, between everyone and everyone else, and his love of individuals—precisely the individuals who have helped him in his project of leveling. This tension is what leads him to erect a monument that leaves out every trace of what would have made it a monument. The urgency of the contradiction is the form of the art.

2013

Signs of Protest: Occupy's Guerilla Semiotics

Art often means nothing more than things displayed in galleries, yet there are artists whose work can also be something happening in the street, the desert, a village, on the Internet, anywhere. (These days streets, deserts, villages may be just part of the Internet.) Likewise, though it may be less obvious, art is not always things made by people who call themselves artists. Besides, artistic skills—among them lateral thinking and a tolerance of precariousness—have become part of more and more people's job description. Don't get me wrong. I'm not advocating for a world without artists. And as long as we're stuck with a market economy, an art market is necessary not only to help artists earn their keep but also to sustain art's capillary flow into the broader culture. My point is simply that once you've gotten the knack of art, it shouldn't be difficult to recognize it in things not made by a professional artist. In a Molière play there's a character who's delighted to learn that he had been speaking in prose all his life without knowing it. Maybe you, too, have been doing art all along, innocently unaware.

Questioning the boundaries between art and everything else is a reflex inculcated by conceptual art. Definitions can be hazardous, but conceptual art is generally understood to have put the accent on language, and thereby shifted attention from the object to its context. Conceptual artworks have materialized not only in galleries, whether as paintings, photographs, or printed texts, but also as "interventions" in everyday contexts in the form of banners, classified ads, wall posters, illustrated magazine articles, and signage. For philosopher and art theorist Peter Osborne, such works repurpose "existing cultural forms of publicity ('media') in order to transfigure, and thereby help to transform, the structures of everyday life." The British artist Victor Burgin called this strand of conceptualism "guerrilla semiotics." Consider the Brazilian artist Cildo Meireles, who in 1970, during a time of military dictatorship, initiated what he called "insertions into ideological circuits." Meireles selected simple agitprop messages, such

as YANKEES GO HOME!, and had them stamped onto banknotes and inscribed onto refillable Coke bottles, relying on an existing system of circulation to disseminate them widely. His emphasis was not so much on the message but its serial repetition by a system that, if not for its tangential placement, would have censored it.

The relation between the two dimensions of conceptualism—text and context—may seem obscure, but look at it this way: while the rules of a language and its vocabulary are supposed to be universally valid, every utterance is a specific event in the here and now of its occurrence. As soon as we start to think about the relation between the specific and the universal in language, we are liable to find our heads spinning. Is there a relation? This sense of confusion can be artistically fertile. Working when contemporary philosophy was concerned primarily with philosophy of language, conceptual artists sometimes seemed to confuse their work with philosophy (some conceptual artists became philosophers, notably Adrian Piper). But a rule of thumb helps to distinguish the two: whereas philosophy attempts to clarify concepts, conceptual art tends to show that concepts assumed to be clear remain puzzling; the intent is not necessarily to eliminate the confusion so much as to transform it into a medium of self-reflection. In 1967 Robert Smithson observed that "the power of a word lies in the very inadequacy of the context [in which] it is placed, in the unresolved or partially resolved tension of disparates. A word fixed or a statement isolated without any decorative or 'cubist' visual format, becomes a perception of similarity in dissimilars—in short a paradox." This will to sustain rather than resolve paradox allies the artist more with the sophist than the philosopher.

One way conceptual artists cultivated paradox was through reflexivity. Consider John Baldessari's *Everything Is Purged from This Painting but Art; No Ideas Have Entered This Work* (1966–68), a white canvas bearing its title, painted in block letters. I hesitate to say much more about it, for the same reason I'd shy away from explaining a good joke. The pleasure the painting affords is the pleasure of paradox—of trying to grasp something that on the face of it is all idea and no art, and trying to see it as all art and no idea. Baldessari's paradox exists because of the word "this," which lets one imagine the statement's referent to be the canvas bearing the statement. But it didn't need to have been the case: imagine the same lettered canvas hanging next to an Impressionist painting. In that context, "this" could be understood to mean "this one adjacent," giving the painting's paradox a different twist.

* * *

It's been more than four decades since Baldessari and other conceptual artists began exhibiting their self-deconstructing tautologies. When encountered in galleries today, such work has all the surprise of an old card trick. But conceptualism's guerrilla spirit circulates elsewhere. Type "Occupy W . . ." into Google Images, and the first choice suggested will be "Occupy Wall Street." The second will be "Occupy Wall Street Signs"—meaning, presumably, that a vast number of Google searches have been done for Occupy Wall Street signs. One of the first images called up by my search was of a sign bearing the slogan I'M SO ANGRY I MADE A SIGN. Who is the "I" who made the sign? Who knows? Images that circulate on the Internet quickly lose any anchorage to their original context. All that seems certain is that this "I" is one of the "we," one of those who understand themselves to be part of the multitude, the 99 percent, albeit one with a sense of humor. Or is it? Detractors of the Occupy movement harp incessantly on what they see as the vacuity of its content—the lack of demands, of concrete proposals. A sign reading I'M SO ANGRY I MADE A SIGN could easily be the work of a satirist rather than a proponent of Occupy. But then, doesn't some of the genius of this movement lie in its ability to encompass those who disagree with it (who are also mostly part of the 99 percent)? I can't help thinking of Tristan Tzara's dictum, "The real dadas are against DADA." Or as another of the signs circulating online would have it, NYPD IS JUST A LAYOFF AWAY FROM JOINING US!!!

What if I'M SO ANGRY I MADE A SIGN has nothing to do with the Occupy protests? That it circulates on the Internet as a sign of the protests proves nothing. As a witty self-encapsulation of the inchoate animus behind the protests, it broadcasts what Smithson would have recognized as "the inadequacy of the context"—of any context in which the sign might be read as articulating a specific demand. One might say it makes an abstract demand. Still, the sign can be said to have at least two contexts: the specific demonstration or encampment at which it is supposed to have been raised and photographed (the second act having removed the sign from that context), and the no-place of the Internet, where it has taken on a new life as an image of protest detached from any clear link to the identity of its maker, or even the photographer. If there's one trait of protest signs today that validates the notion that protest signs have become a kind of conceptual art—anything but pure chronology, the false causality of *post hoc ergo propter hoc*—it's that they are now conceived of circulating in multiple contexts: the immediate one of the demonstration or encampment, and the abstract one of the Internet. The content of a protest sign is not just a message that

lives and dies as part of an event but also the half-life a sign gains by being photographed and then posted online. It's "guerrilla semiotics."

The use of signs by conceptual artists almost always pointed away from the potential message of the sign to the condition of its circulation. In 1968 French artist Daniel Buren hired sandwich men to walk through Paris with signboards bearing, in place of advertisements, his signature 8.7-centimeter-wide white and color stripes. Not exactly a message, not exactly an image. The self-mirroring emptiness of Buren's signboards is mirrored, in turn, by the reflexive verbal turns of many of the Occupy signs that have circulated widely. There's not only I'M SO ANGRY I MADE A SIGN but others like I ALREADY REGRET CHOOSING TO CARRY A SIGN AROUND ALL DAY AND MY ARMS ARE TIRED—acknowledgments that dedication to a cause is also a burden—and THIS SPACE LEFT INTENTIONALLY BLANK. That last phrase is a variant of one often used in the legal documentation of Wall Street deals, floating like an island of signification in what is otherwise a blank page. On the sign, the phrase fills the entire space: unspoken intention has been raised to the level of a roar. Other similar forms of reflexivity: YOU KNOW THINGS ARE MESSED UP WHEN LIBRARIANS START MARCHING, and MY CLIPBOARD CAN BEAT YOUR BILLBOARD.

In accordance with the more retrospective character of their work, neoconceptualists—artists who were not part of the initial conceptualist wave of the 1960s and '70s but who constitute a second or even a third generation working in the wake of the originators—tend to erase or at least bracket the message content of existing signs. Glenn Ligon's *We're Black and Strong* (1996)—on view in his exhibition "Glenn Ligon: America," at the Los Angeles County Museum of Art—is a massive enlargement of a news photo taken at the 1995 Million Man March in Washington. "I had a tiny image of it from a magazine," Ligon has explained,

> and started blowing it up on a Xerox machine, and I realized that when you blow something up, it sometimes gets lighter and lighter, and at a certain point, the text disappeared. I thought, well, that's kind of what I'm interested in—these images in which there's something there, and it gets bigger and bigger, and then that something disappears. The piece started as a four-by-three-inch photo and became a ten-by-seven-foot silkscreen piece in which the text on the banner had disappeared but returned as the title of the piece.

Ligon has also stated that the origin of the work lay in his interest in the specific absence of women from the march, which the absence of the banner text was meant to mirror. But the work took a different course. Blurring the image erased the visual evidence that there were no women in it. Instead, the disappearance of the message from the image—but with the title there to remind us what it would have been—signals a generalized pathos. The bravado of the assertion of strength has been effaced through its mere amplification: the message has become, literally, pale and weak.

Maybe Ligon's point is simply that the content of a demonstration always both exceeds and falls short of its ostensible message, that its purpose is somehow bigger but vaguer. This might be so when the message is misconceived, as I think was the case with the Million Man March. Ligon, too, seems to think that the march represented a self-misunderstanding on the part of those whose energies were invested in it, a failure whose symptom was the marginalization of women, which he found so notable.

Another neoconceptual meditation on demonstrations is on view at the Art Institute of Chicago as part of a small exhibition of three works by Sharon Hayes, a New York–based artist who made a strong impression at the last Whitney Biennial. *In the Near Future* (2005–09) is an ironic title for a piece that seems at first to be about the recent past. It uses thirteen slide projectors to display images of Hayes, alone, holding up protest signs on the streets of New York and various European capitals. The signs' slogans recall past struggles, albeit ones that are not over—from RATIFY E.R.A. NOW to I AM A MAN—along with others that seem universal: WIR HABEN EIN RECHT AUF ARBEIT, RIEN NE SERA COMME AVANT, WHEN IS THIS GOING TO END. In the snapshots that come and go on the surrounding walls, the lone protester is shown being observed quizzically or sympathetically by passersby and sometimes being engaged by them in conversation. She is questioned by a couple of cops, too. But mostly she is ignored. How serious, after all, is a one-person demonstration?

As curator Lisa Dorin writes in the Art Institute's exhibition brochure, Hayes's slogans "often appear jarringly anachronistic in the contemporary cosmopolitan contexts in which she reintroduced them." It's as if Hayes were the sole survivor among the once-hopeful warriors in these unfinished battles. Like that of Ligon—who has also, curiously, used the slogan from the 1968 Memphis Sanitation Workers' Strike, I AM A MAN, as a motif in his art—Hayes's work rides on an undercurrent of melancholy. She stresses that we, her engaged or indifferent passersby, are the people who have failed to crystallize into a crowd, the crowd that has failed to cohere into a movement.

But there's more than regret to the work. *In the Near Future* also depicts the individual who stands up, willing to communicate, to make her concerns public; she is the one person who could be many, who offers a cause around which others might gather. In counterpoint to its backward gaze, the piece offers a hopeful look forward that justifies its title.

It's no accident that Occupy Wall Street came to life in the wake of the Arab Spring. I never believed the latter was a uniquely Arab event; that every authoritative commentary relentlessly emphasized its importance for the Arab world suggested that the powerful had every interest in keeping the enthusiasm confined to that realm, and every reason to fear that they could not. One of the most touching sign-images of the Occupy moment came not from Occupy itself but was nonetheless addressed to it. The image is of a man who is not taking part in a demonstration and is holding up a sign that reads FROM EGYPT TO WALL STREET DON'T BE AFRAID GO AHEAD #OCCUPY OAKLAND. #OCCUPY OWS. Handwritten hashtags and all, it reminds us that the contexts in which one acts may be unforeseeable. In the face of such hope, the "left-wing melancholy" (as Walter Benjamin called it) of artists like Hayes and Ligon may seem out of place or out of date. But that's not the case, or would be only if by dwelling on the fact that movements go awry, projects remain unachieved, and desires languish unfulfilled, one were to forget that movements, projects, and desires are values in themselves and can act, for some of us, as salvation from stasis. But that's something every artist knows, and it's an idea older than conceptualism. Leo Stein, for instance, was aware of it when he wrote of the painter he admired most that "there can scarcely be such a thing as a completed Cézanne. Every canvas is a battlefield and every victory an unattainable ideal." He might as well have been writing about the pessimism of the intellect and the optimism of the will. If art and politics meet at all, it's in the obligation to work concretely in the present toward an ideal that may never be fully attainable.

That tension between pessimism and optimism, the ideal and the unattainable, can lead only to one thing: the irony that permeates so many of the protest signs seen of late, and not only at the Occupy encampments, just as it permeates the work of the artists who have been dwelling on the fate of the protest movements of the recent past. Yet irony is a hopeful symptom, because the beautiful enthusiasm that has expressed itself in these events has allied itself with an awareness of the disappointments that undoubtedly lie ahead. YOU CAN NEVER FIND A GOOD LEFT-WING MILITARY COUP WHEN YOU NEED ONE, reads one sign, in heavily outlined red

letters—which is to say that Occupy is not a project that can be imposed by force, let alone with a single stroke. Precisely because the conditions to be changed tend to persist, the will to change them must persist. Equally memorable in this context is a sign from one of the SlutWalks that took place last spring and summer: I'LL BE A POST-FEMINIST IN THE POST-PATRIARCHY. The woman carrying that sign, I'll wager, knows she's in this struggle for the long haul. The sign's eye-popping pink letters, jumping around with unruly abandon on a lemon-yellow background, suggest that she still means to have fun with it.

2011

Surviving the Moment: Christopher Wool and "Come Together: Surviving Sandy"

The price of things is crowding out the value of things. And the belief that an artwork's price is its sole value constitutes the peculiar accord between the hedge fund millionaires who are delighted to drive the price up through the stratosphere and the would-be revolutionaries who fantasize the art market's collapse along with that of the whole hideous economic system of which it is merely a prominent sideshow. Is it even remotely possible to see the exhibition hanging in the Guggenheim Museum right now—paintings, drawings, and photographs by Christopher Wool—as art instead of dollar signs, now that one such painting (not in the exhibition) has just sold at auction for $26.5 million, just a year after another painting of his sold for what then seemed an already outlandish $7.7 million? According to a recent article in the *Art Newspaper*, speculation on Wool's work over the past few years "indicates that Wool's art 'has become a parking lot for money,' says one high-profile European curator. Like the market for Jean-Michel Basquiat, Wool's market is in danger of being controlled by a small, powerful group of players, he says."

"Parking one's money" is apparently an everyday concept among those who have too much of it; a recent *New York Times* article headed "Record Prices Mask a Tepid Market for Fine Art" quoted a market expert who accounted for the popularity of contemporary art among hedge fund managers this way: "They can hang anything they want in their Manhattan co-ops or in Aspen and nobody can say that's ugly because contemporary art has not been subjected to sustained critical appraisal. There are no markers of good or bad taste that have yet been laid down. It's a safe place to park your money."

People clap, I understand, when record prices are achieved at auction sales. That sounds to me like cheering at an execution. What's being killed is the passion for art, which is being sacrificed to the passion for money. Eventually, it justifies all philistinism. It becomes easiest to say, with a

commentator like McKenzie Wark, that "contemporary art mimics the form of its key patrons, that fraction of the rentier class that lives off finance capital"—and have done with it. Easy, that is, unless you've ever had what some of us call an aesthetic experience, or to put it another way, have ever loved a work of art. In that case Wark's disdainful perception that "art is a portrait of its patrons, and nothing else" can be appreciated for its caustic wit but taken with a grain or maybe a whole fistful of salt. There is something else, and art is not going to take his stale advice—more than century-old already anyway—and "abolish itself" in favor of who knows what else. If he thinks he's enough of an artist to produce the post-art of the future himself, he should do it. But art doesn't take orders from outsiders.

That's not to say that there's not something pathetic about successful artists' attempts to evade capture by the market from which they benefit. It's a David-and-Goliath struggle without a slingshot. But look: an artist like Rubens, as we can see from his pictures, entertained no fundamental doubt that the interests of his patrons coincided with his own. Jumping ahead two centuries to the portraits of Goya, we can sense that the position of the artist has changed: he looks at the Spanish nobility with a corrosive gaze. Today, we feel closer to Goya: we want artists to be critics of society, and to bite the hands that feed them; they are not to be celebrants of power. It's impossible not to feel this. And yet—it seems to me that anyone who can't be thrilled by a Rubens just as easily as by a Goya cares nothing for painting, and should probably just leave it alone.

Is Wool more of a Rubens, or more of a Goya—an artist at ease with the social hierarchy that makes him possible, or at odds with it? Here's a clue: like Goya, Wool likes to paint with black-and-white. He's an artist of spleen, not of celebration. But his black-and-white also invokes a tradition closer to home, a specifically New York vein of willfully tough-minded painting that reaches back through the early work of Frank Stella—the twenty-something bad boy who in the late 1950s was taunting whatever public he thought he had with black enamel stripe paintings some of whose titles (*Die Fahne Hoch!*, *Arbeit Macht Frei*, and so on) evoked still-fresh memories of Nazi horror—to the first flush of Abstraction Expressionism, when artists like Willem de Kooning, Jackson Pollock, and Franz Kline felt the need to abjure the luxury of color, not in order to give primacy to drawing or composition, as the traditional polarity would have had it, but to find something more elemental in the act and the matter of their art. They were after "the necessities of painting," as Carl Andre would later say of Stella in a statement for the 1959

"Sixteen Americans" exhibition at the Museum of Modern Art. For Wool, likewise "introduced" to the public near the beginning of his career by a sculptor colleague (in this case, Jeff Koons), the work's internal debate concerns "the necessity to survive the moment at all costs, using its repertoire of false fronts and psychological stances."

Does Wool still hope to find some necessity that would afford him defense against the pull toward becoming just a servant to his own market? He certainly seems to be trying. One way to resist is simply not to keep making your most saleable work. In Wool's case, that would be the stenciled text paintings he was doing around 1988–92—for instance, the one that just sold for $26.4 million, *Apocalypse Now* (1988). It is not on display at the Guggenheim, though apparently it was meant to be, since it is reproduced in the catalog and included in the exhibition checklist in its back matter. The text it bears (taken from the movie) reads: SELL THE / HOUSE S / ELL THE C / AR SELL /THE KIDS.

The painting's recent owners have apparently taken this message to heart. "When the exhibition was being organized," according to the *Times*, "the painting belonged to David Ganek, the former hedge fund manager and Guggenheim board member. Mr. Ganek has since resigned from the board." Ganek (who along with his wife is also listed in the catalogue as chair for "the Leadership committee for the exhibition") sold it to someone else who immediately flipped it at Christie's. The painting's new owner, whoever that is, is the sixth to have filled that particular parking spot, meaning that Zsa Zsa Gabor has had better luck keeping husbands than this painting has had in finding a committed owner. But surely each of those people bought the painting for the same reason: "Because he could tell that's a masterpiece of the artist and he wanted to buy the masterpiece of the artist," said the dealer who handled the purchase on behalf of his anonymous client, explaining the latter's motivation. I guess for some people five years with a masterpiece is as much they can take—sensitive souls! We'll see how this new owner carries the burden. For the show, meanwhile, the museum is making do with a study for the painting, a work on paper.

Wool isn't making that kind of painting anymore, though if he were willing to do so he could presumably be even more bankable than he already is. The exhibition's anti-chronological hanging points up the artist's restlessness. He never entirely abandons anything he's tried his hand at—for instance, although he pretty much shut down his franchise in text paintings after 1992, there is a pair of late stragglers, one from 1997 and one from 2000—but

he keeps changing his tactics, trying new ways of creating his "false fronts and psychological stances." If anything remains consistent in his work, it's his conjecture that, while there may be many ways to carry on with painting, all of them are likely to involve ways of finding a critical distance on what for his Abstract Expressionist forebears was a potential guarantee of authenticity: the display of a direct, immediate trace of the artist's physical effort in the work's making.

In the earliest paintings here, starting just a little before the text paintings, Wool applied paint using patterned rollers. Their trivial patterns of what I want to call, following Keats, "retired flowers," and other such banal decorative motifs grow strangely harsh, almost morose, and yet somehow poignant, thanks to the recurrent imperfections and slippages in the realization of what seemingly should have been a clean and systematic allover structure. Soon came the stenciled lettering, and then in 1993 a technique that had been a standby of painters since first Andy Warhol and then Robert Rauschenberg began using it in the 1960s as a way of transferring found imagery to canvas: silkscreening. Soon after came the graffittist's preferred tool, the spray gun. With this last, Wool finally began to allow himself something like a free, impulsive gesture—but only at a distance. And the distance was redoubled when, in 1998, he started cannibalizing his own work, making silkscreens from earlier paintings and recombining details (or even whole paintings) on fresh canvases, often at larger than original scale. Again, there is an Abstract Expressionist grounding for this practice: it recalls the origin of Kline's first abstract paintings, inspired by the sight of his own drawings blown up by an overhead projector.

Perhaps most telling in all Wool's repertoire of anti-gestural gestures is his propensity, in his work since 2000, to paint by erasing—to wipe away with a turpentine-soaked rag the marks he's already made (with a spray gun or by other means). Taking into account the artist's view (as conveyed by the exhibition's curator, Katherine Brinson, in her catalog essay) of "his spraygun application of enamel as closer in spirit to drawing than to painting," the blunt, businesslike, but definitively deconstructive gestures of erasure are at once the most painterly marks he's made and the ones closest to the Abstract Expressionist ideal of directness and immediacy—but of course they are gestures of refusal, of negation. For Wool, his continual alternation of positing and removing is a manifestation of doubt—that mainstay of Abstract Expressionist art—as exemplified by the title of Dore Ashton's great book on Philip Guston, *Yes, But . . .* That the means by which he continues to go about this process seem closer to those of artists who manifested

their own kind of skepticism by a sort of anxiously playful stylization of their own painterly gesture—artists like Jasper Johns or Sigmar Polke—only makes him that much more of a scholar of his own fundamental tradition-alism. "The tools have changed and the ways of exploring visual things have expanded," Wool believes, "but it's not a paradigm shift, it's the same old paradigm." Doubt is the one idea in art that never goes out of date, because it's the one idea that's sure to keep reacting to changing circumstances.

It's a challenge for any artist's work to withstand the exposure of a grand museum retrospective. Wool's paintings do. Technically impeccable in their ultra-refined grittiness, on their own terms they maintain a great sense of unruffled presence, never recessive yet without palpable design on the viewer. They are just passively aggressive enough to possibly provoke a curious viewer to try and draw them out. THE HAR / DER YOU / LOOK / THE HAR / DER YOU / LOOK, as the last of the word paintings here, the one from 2000, would have it. The apparent tautology may not quite be one. I take it to mean something like, "If you're vigilant, if you're really attentive, you'll come across as a tough guy." It suggests the fundamentally self-protective position from which Wool likes to work.

Eventually, though, there's a limit to what can be achieved by never letting down your guard. Wool's stoicism is sturdier than I'd ever imagined it could be, The paintings manage to "hold the wall" even at the Guggenheim, where one could almost say they have no walls to hold on to. They conform so well to their own intentions. And yet I want to catch a glimpse of something bigger than a mere intention can contain.

Could Wool's defensive crouch represent what Wark would understand as his art's portraiture of his patrons? I doubt it. What if the financial wizards, like vampires, leave no reflection at all in the mirror of art? Decisions about where to park one's money are simply made by following the crowd, with "no markers of good or bad taste." One person decided to park some money there and the rest followed, but it could have been anywhere else. One artist's work is worth, at least for a day, $26.5 million and another's is worth $2,650. The explanations for the difference come after the fact and arbitrarily. At least I know that Wool was following his own doubt and not the dictates of his market. And what then if someone's art has no patrons—and most doesn't; who, then, is it a portrait of?

Anyone who thinks that art's mission is to abolish itself will probably not have bothered to go out to Industry City (formerly known as Bush Terminal)

in Sunset Park, Brooklyn, to see the massive recent exhibition "Come Together: Surviving Sandy, Year 1," which was curated by Phong Bui, the editor/publisher of *The Brooklyn Rail* (to which I am an occasional contributor, gratis) and himself an artist who lost most of his work to the floods of October 29, 2012. Bui just might be the most affable and energetic denizen of the New York art world, but (as befits a man whose mentor was Meyer Schapiro) he also has a deeper knowledge of what's gone on artistically in this city over the past sixty years than almost anyone I know. In "Come Together," with its more than two hundred artists, in many cases represented by several works each, he rustled together one of the largest exhibitions I've ever seen outside of some of the great international biennials. "Centered on the work of artists directly affected by Sandy," as the exhibition was described, it also included "work inspired by and referring to the storm, along with work by artists who were invited to participate in the spirit of solidarity." That means that it was in essence an exhibition of Bui's extended network of friends and friends of friends, and the participants range from out-and-out stars (Alex Katz, Shirin Neshat, Joel Shapiro, Kiki Smith) to complete unknowns who have no gallery behind them, let alone collectors.

Any art lover could come away from the show with some fresh discovery. I was particularly taken with a couple of funky assemblage sculptures by an artist named Jo Nigoghossian. Another treat was a very rare sighting of one of the modest yet tough abstract paintings of Robert Storr, the well-known curator, critic, and educator who seems to make it a policy not to exhibit his own work. (It's been about twenty years since I last caught sight of one.)

But my great find was Joanna Pousette-Dart, an artist whose work I didn't know but whose name I recognized, in part because she is the daughter of the Abstract Expressionist painter Richard Pousette-Dart. Her contribution to "Come Together" was a pair of large, eccentrically shaped paintings with exuberantly colored, hard-edged curvilinear forms that somehow manage to recall both Arabic calligraphy and Northwest Coast Indian art without indulging in any nostalgia for the exotic. But who knows when I'll get to see more?

Encountering Pousette-Dart's paintings in Sunset Park the day after seeing Wool's retrospective at the Guggenheim seemed serendipitous somehow. Wool had been a student of her father's at Sarah Lawrence College (he ended up dropping out) and it was from the elder Pousette-Dart, in part, that Wool learned how to be "a painter more interested in questions than answers." Together, Wool and Joanna Pousette-Dart curated an exhibition of her father's work at the Luhring Augustine gallery in New York

two years ago. There's a lesson here: the paths and projects of the market darlings continually cross with those of the outliers. Which category a given artist gets slotted in seems arbitrary. Which leads me to wonder: Pousette-Dart looks great with a couple of new paintings, but how would her work hold up with ninety works along the Guggenheim's ramp? Will we ever get a chance to find out? And I could ask the same about any number of other well-regarded mid-career artists included in "Come Together": Rita Ackermann, Cora Cohen, Lonnie Holley, David Humphrey, Donald Moffett, Gary Stephan, or Stanley Whitney, to name just a few. It's no insult to Wool to point out that the star system so beloved of art collectors (and the museums they sustain) has little or nothing to do with the value of what modestly successful or unheralded working artists make.

As an effort to show the breadth and energy of contemporary art at the grassroots, "Come Together" was a success, but it offered no cure-all for the capricious inequalities imposed on the art scene by the vagaries of the market in a time of ever-increasing upward distribution of income. Every underdog is someone else's overdog. One reason is that the art market is not the only market that artists have to contend with. There's also the one that trades in the one commodity many artists need the most: space. Bui and his exhibition have come in for vociferous criticism—most prominently on the *Art F City* blog—for his collaboration with Industry City, because its owners have been forcing artists out of their studios there in favor of higher-paying tenants. The *Times* recently named Sunset Park as one of "Brooklyn's New Gentrification Frontiers." Artists are harbingers of gentrification, but they rarely reap its ultimate economic benefits. The real estate market pits artist against artist. Hurricane Sandy was, ultimately, a man-made disaster, not a "natural" one. So, too, is the expectations gap of our economy, which keeps making it harder for most artists to live and work, even as a few become bargaining chips in a game being played somewhere above their heads. Art just might help us survive all this, if its market doesn't kill it first.

2013

38

Permission to Fail: Art's Educational Complex

I had this girlfriend once who was an artist. We used to go to galleries and see shows together. Periodically she would say, "Oh, that's something I did in art school." After a while it dawned on me that a lot of those things she dismissed as things she'd tried in art school—gambits she figured she'd outgrown—were things that I particularly liked. I started to think that this might be, if not a definition of good art, at least a kind of rule of thumb for identifying it in the field: If you can actually make art out of things that for other people were disposable exercises, Wittgensteinian ladders to be tossed aside once climbed up, then you are getting somewhere with your art.

Later, I came to realize that I shouldn't have been surprised that a lot of "real" art has a lot in common with art school exercises. As the art historian Howard Singerman pointed out in his invaluable and deeply humane 1999 book *Art Subjects: Making Artists in the American University*, the contemporary art school exists, not so much to show students how to make art as to show them how to be artists. Singerman, who himself went to art school before changing course and electing the life of a scholar, recalls that "in one assignment we were asked to invent an artist of another type than we imagined ourselves to be—since we were to know ourselves as types—and then produce an oeuvre, to make slides and do the talk, to model a speech or slouch." Fernando Pessoa meets Lee Strasberg: this art assignment stands in for all the others insofar as each of them is about tactically taking a certain distance from one presumably naïve pre–art school self and any unexamined sense of what it is to be an artist. "Whatever has called a student to enter the department," Singerman points out, be it "a love of past art, an excitement about the process of creation, a desire for personal growth, the ability to draw," the instruction the student receives is intended to demonstrate that none of these is sufficient or possibly even necessary to being an artist. "Among the tasks of the university program in art is to separate its artists and the art world in which they will operate from 'amateurs' or 'Sunday

painters,' as well as from a definition of the artist grounded in manual skill, tortured genius, or recreational pleasure."

While most art students may never be asked to method act a fully characterized fictional artist, they are constantly being asked to remove themselves experimentally from who they are—and concomitantly, since art is still broadly though ambivalently understood as having something to do with vision or visuality, from what they see. Thus the title of one of the more appealing recent books on art education, *Draw It with Your Eyes Closed: The Art of the Art Assignment*—a spin-off of the indie art magazine *Paper Monument*. The book was published in 2012, but I was reminded of it again when I saw the British artist Martin Creed's recent two-gallery show in New York (at Gavin Brown's Enterprise and the uptown branch of Hauser & Wirth). Creed has long taken a strictly conceptual stance; among his best-known works is the one for which he won the 2001 Turner Prize, the self-explanatory *Work No. 227: The Lights Going On and Off*. He's made paintings, too, but like his other works they were often, as one commentator put it, "all about restrictions: impersonal rules which require a quick, definitive line in space in order to complete the task." And, as with the conceptual artists of an earlier generation, such as Sol LeWitt, there was no particular reason that his paintings had to be executed by himself, any more than it was important that he be there in an empty room at Tate Britain switching the lights on and off every five seconds. (At the opening, he's said, he realized he'd mistimed it: "I thought, 'Oh no, I've got the timing wrong! It should be one second on, one second off!'") Creed's most recent paintings, though still as rule-bound as ever, are more about imposing rules on himself, and among them are "Blind Portraits" done, okay, not with his eyes closed, but while looking only at the subject and not at all at the painting itself. That, too, is a familiar didactic exercise, a way of bypassing one's aesthetic superego and letting less manageable factors enter into the picture. The student is likely to be surprised by the result; the realization that something striking can be made letting go of control, which means letting go of part of the "authorship" of one's art, may well have a lasting effect. Honing one's eye on a drawing that one has made without being able to see what was being done, the artist learns to be a witness as much as a maker—spectator and artist as one; and to realize, as well, that any spectator is always something of an artist, too. Which is why it takes a viewer, as Marcel Duchamp used to say, to complete the work.

What is it that an art student is learning when he or she learns to use his or her blindness, his or her ignorance as a tool? It's something that I was

certainly never taught as a college philosophy major, and I suspect I wouldn't have learned it if I'd studied chemistry, history, or French either. The fledgling doctor needn't learn how to be a patient. In none of those fields is it normally considered necessary that students learn to progress by systematically pulling the rug out from under their own feet. It's something that seems to be particular to contemporary art.

That artists are now minted by universities (and degree-granting art schools modeled on the university) may have done wonders for their social standing, but it's also been a source of worry to many, who feel something of great value might be lost by the professionalization of the artist. In 1969, Harold Rosenberg reported in his art column in the *New Yorker*:

> My mere citing of some figures—for example, only one of ten leading artists of the generation of Pollock and de Kooning had a degree (and not in art), while of "thirty artists under thirty-five" shown in "Young Americans 1965" at the Whitney Museum the majority had B.A.s or B.F.A.s—was taken by a prominent younger painter as implying that he and his age group were academic. "Academic" is still a bad word, even though no one knows any longer exactly what it means.

Notice that *in illo tempore* it was still notable that suddenly artists had been armed with bachelor's degrees. By now it almost goes without saying that an artist has an MFA, and poor old Rosenberg, sanguine though he was about the educationalization of art, is probably rolling in his grave at the rumbling of the studio art PhDs that more and more universities are launching into the job market.

Rosenberg was certain that university education had been an important influence on "the cool, impersonal wave in the art of the sixties," which had marginalized the tumultuous, heartfelt emotionalism of his friends the Abstract Expressionists. "In the shift from bohemia to academe, American art has become more conceptual, methodological, and self-assured," he thought. That's probably so, but in the meantime it's become impossible not to notice that, even as artists are becoming ever more adept in the ways of the seminar room, their art has not continued growing cooler and more impersonal; instead, the temperature of art has simply become more volatile. In the 1980s, the Neo-Expressionists, for all their flailing bombast, were every bit as well read as the prim and knowing Neo-Geos; today, one and the same school grants identical degrees to both an earnest proponent of

"social interventions" among the urban poor and a producer of diaristic zines inspired by the Japanese aesthetic of *kawaii*, or cuteness. It might be argued that the multiplicity of the work being produced by art students merely reflects the pluralism of the art world (and the art market) at large, but I suspect it is more of a cause than an effect; what Rosenberg thought was the "mental and psychic fragmentation of the typical college art department" has merely blossomed into the greater incommensurability of the products of the professional art world.

To get a sense of just what the "fragmentation" of art education really means, one could hardly do better than to leaf through a little book published a couple of years ago called *101 Things to Learn in Art School*. I don't know whether its intended readership is people who are actually going to art school—in which case it's a poor reflection on the institutions themselves, which apparently can't convey in the four years it takes to earn an undergraduate plus the two further years invested in getting an MFA what the book can set out in a text that would take an hour to read—or who only wish they were. But its author, Kit White, is a professor of painting at Pratt Institute in Brooklyn, and it was published by one of the best art book publishers, MIT Press, so it comes with a seal of pedagogical value. And rightly so: having taught in half a dozen art departments in this country and Great Britain, and having been a visiting critic at so many others (in those two countries and Canada too) that I long ago lost count, I can attest that there is nothing in *101 Things to Learn in Art School* that I haven't heard somewhere, sometime—and for that matter probably very little that I haven't actually said myself—at one or another of these schools. The book really does represent something like the collective wisdom of the contemporary art school. If a lot of that wisdom comes out in the form of platitudes—Polonius at a studio crit—that's partly because the real force of wisdom appears only in its timely deployment. It's not just what you say—it's saying it at the right time, when the person you're talking to needs to hear it; wisdom is really nothing but the timely application of the right platitude.

But even so, as a distillation of the common wisdom of the art department, the book all too effectively exposes how much its fragmentation has increased since Rosenberg's day. There are at least three different archeological layers of artistic thought at work here. There are the precepts of traditional representation: "Learn to draw perspective"; "The human figure is a complex construction composed of a rigid frame overlaid with soft, rounded, elongated muscles"; "Chiaroscuro is the dramatic contrast of dark

and light in an image." Then there are the principles of Modernism, which emphasized the artwork as a thing in itself rather than a representation: "All images are abstractions"; "Embrace the happy accident." And finally those of postmodernism and conceptualism, emphasizing the linguistic basis of art and its entanglement with its context rather than its autonomy: "Experience of most things is mediated"; "Context determines meaning"; "All art is political."

It's easy to see that these teachings often contradict each other. If "all media are delivery systems for content," it can't also be true that "a drawing (or a painting, photograph, and so on) is first and foremost an expression of its medium," and the postmodern faith with which the book begins, "Art can be anything," suggests that Modernist wisdom of Oscar Wilde's quip, "All art is quite useless," must be out of date: if art can be anything, it can be useful, too. The advice to "eliminate the inessential" seems to point toward the anonymous and impersonal in art; not so the recommendation to "cultivate your idiosyncrasies." If the contradictions latent in the postures that art students are supposed to fashion themselves after amount to an ideological incoherence, however, that's not to say that they can't be pragmatically useful. The student who is too self-indulgent can be counseled to eliminate the inessential and the one who's too uptight urged to nurture some eccentricity. Most of the things one should learn in art school are simply different ways to say: "Keep working"; "Pay more attention"; "Reconsider—are you really sure about that?"

Just as no one family of techniques can today be prescribed as the right content of art education, neither can any one set of ideas. That means that the instructor's knowledge and experience are always in principle too limited for the job they've taken on. They're supposed to be helping usher their students into the not-yet-known, toward what, in *Draw It with Your Eyes Closed*, the Canadian artist Jon Pylypchuck calls "another place where there was no grade and just a friend telling you that what you did was good." Teaching art, and making art, is always sooner or later about coming to terms with one's own ignorance. Maybe that's why the art world's favorite philosopher these days is Jacques Rancière, whose best-known book—published in France in 1987 and translated into English four years later—is called *The Ignorant Schoolmaster*. Its subject is Joseph Jacotot, a forgotten French educator of the early nineteenth century whose "intellectual adventure" was founded on a paradoxical—one might be tempted to say, nonsensical—principle: "He proclaimed that one could teach what one didn't know." The educator's job,

since teacher and student are assumed to be equal in intelligence, is nothing more than to "use all possible means of convincing the ignorant one of his power" of understanding. The teacher is there simply to remind the learner to pay attention, to keep working at it.

Rancière affirmed that Jacotot understood that his method, which he called "universal teaching," could never be permanently instituted: "Universal teaching *will not take*, it will not be established in society. But *it will not perish*, because it is the natural method of the human mind." There is no emancipatory institution, but there can be emancipatory teaching. However natural it might be, we can wonder whether such a method could ever be usefully applied to physics or history or any number of other university subjects. But something like it really does seem to be how things work in the art department—when things do work there, which is not always. No wonder that, once he discovered his method, Jacotot went on from being a teacher of French to subjects in which he was unqualified, like painting and the piano. Nothing in the world sounds more like an art teacher trying to get students to really look at a painting than Jacotot teaching an illiterate worker to read by confronting him with a written text:

> Tell me "the story of the adventures, that is, the comings and goings, the detours—in a word, the trajectory of the pen that wrote this word on paper or of the engraving tool that engraved it on the copper." Would you know how to recognize the letter O that one of my students—a locksmith by profession—calls "the round," the letter L that he calls "the square"? Tell me the form of each letter as you would describe the form of an object or of an unknown place. Don't say that you can't. You know how to see, how to speak, you know how to show, you can remember. What more is needed? An absolute attention for seeing and seeing again, saying and repeating. Don't try to fool me or fool yourself. Is that really what you saw? *What do you think about it?*

What's sometimes called formalism is essentially what Rancière calls the method of equality. Rancière comes close to showing that the exercise of equality in learning and teaching is the true meaning of Joseph Beuys's affirmation that every human being is an artist: "The artist's emancipatory lesson . . . is that each one of us is an artist to the extent that he carries out a double process; he is not content to be a mere journeyman but wants to make all work a means of expression, and he is not content to feel something but tries to impart it to others."

* * *

That this emancipatory lesson of art might be lost is why we should be worried when the making of art becomes a college subject like physics or history, to be handed on from knowledgeable professors to students who could not overcome their ignorance without their teachers' help. What's encouraging, to a reader of *Draw It with Your Eyes Closed*, is to see how many art teachers understand, however obscurely, that their job is to do what teachers in no other discipline are allowed to do—to propagate failure. Mira Schor, a painter who teaches primarily at Parsons, puts it most bluntly: "I issue something between a permission and an order: you have my permission to do what you think is a really bad artwork . . . You have my permission to fail." And what if her students fail to fail? Harry Roseman, a sculptor who teaches at Vassar, observes, "I often think that an assignment works when the students tell me things about it"—that is, about the assignment itself— "that I hadn't recognized. When this happens, I know that the assignment is broad enough, and it teaches me as well as the students."

As long as a certain amount of this kind of teaching is permitted to continue in art schools—as long as it does not perish, to use Jacotot's word—then within the very institution that encourages the self-limiting professionalization of the artist there exists a countercurrent that keeps faith with what puts art at odds with other academic subjects. Rosenberg recognized it: "The function of the university is to impart knowledge, but art is not solely knowledge and the problems proposed by knowledge; art is also ignorance and the eager consciousness of the unknown that impels creation. No matter how cultivated he is, every creator is in some degree a naïf, a primitive, and relies on his particular gift of ignorance." Harrell Fletcher, an artist who teaches at Portland State University, points out "a prevailing idea about assignments in art: that they are something you do in school but that you're not really supposed to do as a professional artist." I say that as long as artists keep feeling the need to set themselves something like school assignments, they are in touch with their ignorance and not merely operatives of a program.

One artist who was constantly giving himself assignments was Mike Kelley, whose retrospective is currently on view at PS1 MoMA in Queens. Long in the planning, the show became a memorial when Kelley committed suicide in 2012. And it can be grim: Kelley's raunchy yet dark, saturnine outlook is always apparent. Much of his work is, at least indirectly, about education, and he usually shows it as a form of abuse. But here's an assignment: remember as many details as possible of all the buildings of all the schools you've ever attended; then construct an architectural model combining them all

into a kind of self-contained miniature city. That's Kelley's *Educational Complex* (1995)—an airless, senseless labyrinth whose only redeeming feature might be its incoherence. This is the emblem of the stultifying education that confirms the student's inferiority. Some artists, with Jacotot and Rancière, think they see a way out; Kelley makes us feel that we need one.

2014